D1591519

Toller

CRANSTON

Toller CRANSTON

ICE, PAINT, PASSION

PHILLIPPA CRANSTON BARAN

SUTHERLAND HOUSE

TORONTO 2024

Sutherland House
416 Moore Ave., Suite 205
Toronto, ON M4G 1C9

Copyright © 2024 by Phillippa Cranston Baran

All rights reserved, including the right to reproduce this book or
portions thereof in any form whatsoever. For information on rights and
permissions or to request a special discount for bulk purchases, please
contact Sutherland House at info@sutherlandhousebooks.com
Sutherland House and logo are registered
trademarks of The Sutherland House Inc.

First edition, February 2024

If you are interested in inviting one of our authors to a live event or
media appearance, please contact sranasinghe@sutherlandhousebooks.com
and visit our website at sutherlandhousebooks.com for more
information about our authors and their schedules.

We acknowledge the support of the Government of Canada.

Manufactured in China

Cover and Book Design
Robert Hughes
Robert Hughes Design & Print, Arnprior, Ontario

Library and Archives Canada Cataloguing in Publication
Title: Toller Cranston : ice, paint, passion / Phillippa Baran.
Names: Cranston-Baran, Phillippa, author.
Description: Includes bibliographical references and index.
Identifiers: Canadiana (print) 20230566804 | Canadiana (ebook) 20230566847
| ISBN 9781990823572
(hardcover) | ISBN 9781990823657 (EPUB)
Subjects: LCSH: Cranston, Toller. | LCSH: Figure skaters—Canada—Biography.
| LCSH: Gay figure
skaters—Canada—Biography. | LCSH: Skaters—Canada—Biography.
| LCSH: Painters—Canada—Biography. |
LCGFT: Biographies.
Classification: LCC GV850.C73 C73 2024 | DDC 796.91/2092—dc23

ISBN 978-1-990823-57-2
eBook 978-1-990823-65-7

TOLLER CRANSTON

Ice, Paint, Passion

———————— TOLLER ————————

A lady once said to me,
"You know, I know someone whose name is Toller."

I replied, "Impossible! There is only one!"

TOLLER CRANSTON: *Ice, Paint, Passion*

TABLE OF CONTENTS

 If there is a recurrent image in Toller's paintings it may be these strangely mysterious circular icons. They appear in different postions, different colours, and different sizes but they are almost always there. We don't (yet) know what they meant to Toller. Suns? Moons? Something mystical? Symbolic? Eternal? In this book, they mark the beginning of each chapter.

DEDICATION

For Stuart

She would be so proud.
Of the colour, the courage, the creativity.

For Monte

He would be so proud.
Of everything.
Because he always was.

FOREWORD

By Phillippa

Who lives, who dies, who tells your story?
From *Hamilton*

My brother died suddenly in 2015. He was just 65. The outpouring of shock and grief was profound and came from all over the world.

Legendary Canadian Figure Skater Toller Cranston Dead at 65.
The Globe and Mail

He Did Everything for the Art.
CBC

The Nureyev of Figure Skating Dies at 65.
New York Times

Toller Cranston: Over the Top Until the Very End.
The Ottawa Citizen

Toller Cranston, Figure Skating Innovator, Dead at 65.
CBC

With Toller's death, Canada lost an icon. San Miguel de Allende lost a character. Figure skating lost a legend. The creative world lost a creative force. Those who knew him and loved him lost a friend, a mentor, a colleague, a champion.

Over the past few years, many of the people who were important to Toller and to whom Toller was important have become part of my world. Every one of them has a personal story. The people who knew him have stories. The people who never met him have stories.

Toller Cranston: Ice, Paint, Passion is not a chronicle or a biography. It is not a tell-all or an exposé. It is a celebration of a man who embodied, in every single thing he did, the values of courage, creativity, and expression.

But it is more than that.

An extraordinary group of people has coalesced around the journey to create this book. They have shared their stories, perspectives, and observations. The collective effort has transformed this book into a tribute—not just to Toller, but to Canada and to Canadians. To skaters and artists and fans. To everyone who has ever dared to be different. To everyone who found the courage and strength to make their way in a world that is not always kind.

Toller was vulnerable and he was shy. He was flamboyant and he was outrageous. He had an unshakable belief in his own specialness, his own destiny. He exhorted others to chart their own paths, follow the signs, and live without fear.

My hope is that readers will engage with the stories, with the arc of Toller's life and find something of themselves confirmed, illuminated, or reflected back.

He had an impact. He left a legacy.

When I was 10 years old, I reached the provincial finals of the Royal Canadian Legion public speaking contest. My speech was called *Why I Am Proud to be a Canadian*. Having spent the past years deeply immersed in my brother's life and achievements and hearing about Toller from so many people—well-known and less well-known—and about how Toller affected them, today, my Canadian heart is bursting.

I believe that my brother was a truly extraordinary talent. I believe that he deserves to be remembered. He was fearless. Creative. Dedicated. His work ethic was unparalleled. His belief in his destiny was unshakable. I like to think that Canadians share these values, and that Canada stands for these values.

I remain proud to be a Canadian. I am especially proud to share my brother through the perspectives, memories, and observations of an outstanding group of people.

Thank you more than I can say to everyone who has contributed to this book—writers, photographers, fans. From an image, to a single sentence, to adapted content, to text written specifically for this project—many have shared their thoughts about, or experiences with, Toller. Brief bios of the contributors and photographers are included. Throughout the book, photos are coded by an alphabetical letter that indicates the photographer.

Phillippa Cranston Baran
2024

Yes, they can!

INTRODUCTION:
FROM BLADES TO BRUSHSTROKES

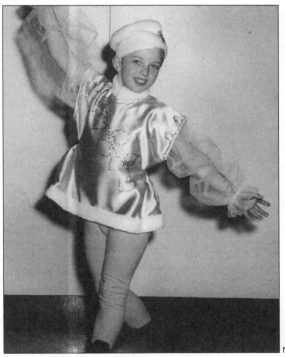

A prince in pale blue. Every sequin sewn by hand. Costume by Stuart.

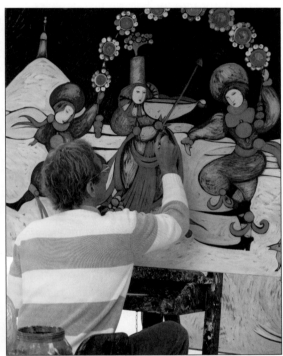

Royalty on canvas. Costumes by Toller.

Toller knew at an early age that artists are born. He knew that he was possessed of a vital creative spark. He knew who he was and what he wanted to do. He believed that "to be an artist, one had to have a suspicious nature and the willingness to take enormous leaps of faith." He considered his artwork the accumulation of his destiny and his hard work.

Toller was born in Hamilton, Ontario and spent parts of his childhood in Cambridge and in Kirkland Lake. He finished high school in Montreal and won one of fifty spots to attend the École des Beaux-Arts. He left the school early when one of his professors told him there was nothing more they could teach him.

Toller's skating career provided him the opportunity to visit museums, galleries, and cultural sites around the world where he absorbed the teachings of the old masters. One master that he particularly admired was Pieter Bruegel, the Flemish Renaissance painter whose dramatic rendition of human subjects and complicated, almost surrealist architecture left a lasting impression.

After years of skating—Olympic Games, world championships, *Ice Capades*, theatre and television—Toller left Toronto for San Miguel de Allende, a colonial-era city in Mexico's central highlands. The UNESCO World Heritage centre is known for its baroque Spanish architecture, cultural festivals, and thriving arts scene. Toller bought an estate with a garden paradise on which he lived, worked, and created until his fatal heart attack on January 23, 2015 at the age of sixty-five.

In addition to creating thousands of oil paintings and exquisite line drawings, Toller experimented with materials beyond canvas. He painted on ostrich eggs, wooden religious statues, furniture, and silk screens. He designed enormous and elaborate chandeliers, and candelabras in metal and blown glass. He created a series of handwoven carpets. He organized a fashion show of hand-painted leather jackets and trench coats.

Toller went through periods of inspiration and creativity as various themes emerged, like his obsession with strawberries that began in the 1970s. His Imperial Russia series was inspired by a visit to Moscow's Kremlin, where he was powerfully impacted by the opulence of the Russian elites. Catherine the Great's wedding dress made of spun silver and the ecclesiastical garments encrusted with staggering numbers of pearls and gems had an obvious and profound influence on his art.

A prolific artist, Toller had more than 250 solo art shows in Canada and internationally. He is a member of the Order of Canada and has been memorialized on Canada's Walk of Fame, in the Canadian Olympic Hall of Fame, Ontario Sports Hall of Fame, Canadian Figure Skating Hall of Fame, Canada Sports Hall of Fame, and the World Figure Skating Hall of Fame.

By the end of his life, he had guaranteed his legacy
in Canada and around the world.

Toller was a diva. A master of outrageous one-liners.
A big spender. A clever self-marketer.
A larger than life guy who always cut to the chase.
He was Toller.

You don't need to say Cranston to flesh out the spirit of the man:
Creative. Flamboyant. Outspoken. Voraciously well-read.
Colourful. Generous. Prickly.
There is only one Toller.

There will only ever be one Toller.

CHAPTER 1
THE DEATH AND THE DRAMA

 Jeanne Beker
@Jeanne–Beker

Devestated+completely broken-hearted: My dearest friend+mentor, the brilliant Toller Cranston, has died in his beloved San Miguel. #RIP

♡ 35 2:37 PM - Jan 24, 2015
💬 140 people are taking about this

TOLLER IS DEAD?!?!?
By Pj Kwong

Impossible. My CBC Producer sent me a text on the last day of the 2015 Canadian National Figure Skating Championships that I was covering for CBC, to ask if there was any truth to the rumour that Toller Cranston was dead. Jeanne Beker, media and fashion icon and Toller's dear friend, had tweeted that Toller had died and my producer wanted me to chase down the facts.

I was initially stunned into silence.

Memories came flooding back. I was about 11 years old and waiting at a backstage entrance during one of the annual Cricket Club skating shows when Toller swooped in beside me. We were alone waiting for our performance cues, and he told me about an uber-zealous fan who had flown in from Halifax to watch him skate. It was a fascinating touch of detail that was as surprising to him as it was to me, by his sharing of it.

There were other conversations over the years and there was a part of me that was awestruck with each and every encounter. For all of his confidence and boldness, I could feel Toller's shyness just below the surface that I imagined was the reason for him to occasionally respond in ways that were a little cheeky.

A contradiction in terms.
A definite rascal.

I liken it to being perched beside a grand, bold, and beautiful macaw when I knew that by comparison, I must have appeared as a drab baby pigeon. It was never the way Toller made me feel, but rather the truth I knew about myself.

The *extraordinary* making room for the *ordinary*. It may not have been everybody's experience, but as a youngster it was mine, and to this day, I appreciate his generosity of spirit in allowing me to feel, for just a moment, that I could or even did belong in his world.

I looked around the media area on that fateful day in January of 2015 and started asking colleagues if they had heard the dreadful Toller news. To a person, there was the same shocked expression. When a person such as Toller, who is larger than life, passes away, it seems unimaginable that their life could somehow be extinguished by something as ordinary as death.

Toller had the ability to galvanize a crowd. From the media room, a cluster of journalists sprang into action trying to get at the truth. It wasn't lost on anyone that this was the day of the men's final where a new champion would be crowned just as Toller had been so many years before. As we tried to get to the bottom of the "Is Toller really dead?" story, we chatted about how it seemed not at all surprising that while all of Canada's who's who of the skating world were sitting in a rink together and sharing in a 'skating moment,' that Toller would choose that particular time to leave this earth. A day later, and many of the people who cared would already have been scattered back to their homes and rinks across the country.

I was thrilled to find that as a group, most of the journalists covering skating at the national championships agreed to confirm the news to everyone else by whoever found out first. For my part, I phoned the art dealer with whom I had dealt to book Toller for a podcast two years before and got the answering machine. As a person who speaks Spanish, I phoned Toller's home in Mexico to try and get confirmation there. No answer.

I seem to remember it was a CTV/TSN producer who was able to confirm the sad, but true news. TV being what it is, a sports producer there knew another producer from the entertainment side, who was able to get in touch with Ms. Beker.

It was true.

The mood instantly changed in the media room. We had all gone from exchanging stories of the lengths we had gone to, to attempt to confirm the news. Our attention now turned to creating the stories and capturing the essence of this man's life, in a final chapter that needed to be written.

Toller Cranston. Gone but not forgotten.
How could he be?

TOLLER CRANSTON: *Ice, Paint, Passion*

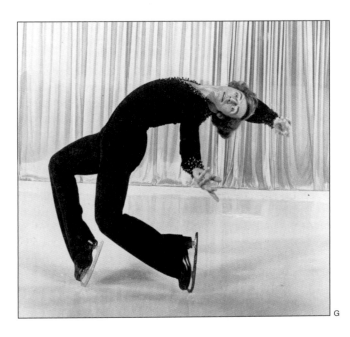

This is what I wrote for the CBC:

Toller Cranston,
figure skating innovator,
dead at 65
Revolutionary skater, analyst,
won Olympic bronze in 1976

It is somehow fitting that of all days, Toller Cranston would die on the same day that a new Canadian men's champion is going to be crowned.

Cranston passed away at his home in Mexico from an apparent heart attack, a Skate Canada spokesperson said Saturday. He won the bronze medal at the 1974 world championships in Munich and at the 1976 Innsbruck Olympics.

Cranston was a champion and more importantly a legend. International Skating Union vice president David Dore considered Cranston a living legend.

"I was shocked. He was one of the few living legends in any sport. He was the perfect living legend," said Dore. "His legacy will be that he gave the sport a stamp that exists to this day. Even though he was always going uphill, he never lost his focus. The sport won. We all won."

"He was one of a kind," said Brian Orser, a former Canadian and world champion, Olympic silver medallist and now in-demand coach. "Nobody will ever be like him. And such a great contribution to figure skating but for me, personally, it was his sense of humour and his outlook on life and his free spirit. He was somewhat of a rebel—always spoke his mind, wasn't always so accurate but he spoke his mind."

In the media room, we all looked at each other in shock when we first heard the news via Jeanne Beker's Twitter account.

His artistry was considered to be one of the driving forces behind the move from strictly stiff athleticism to more expressive men's skating. I believe that without Toller Cranston, there would

not have been the generations that followed which included Patrick Chan.

Toller admired Chan's skating and that he was glad not to have had to compete against him. "I'm on another planet watching Patrick Chan with binoculars and applauding along with the rest of the world," Cranston said from his Mexican hideaway in 2012.

Cranston, who was born in Hamilton and grew up in Kirkland Lake, Ontario, and Montreal, Quebec, never won an Olympic or world title but his dramatic showmanship had a profound impact on figure skating.

The legend won national titles from 1971 to 1976 and placed second at the 1971 North American championships in Peterborough, Ontario. He won Skate Canada International events in 1973 and 1975. He finished fourth at the 1975 world championships in Colorado Springs, and was fourth again a year later in Gothenburg, Sweden.

Cranston was 26 when he reached the Olympic podium at the 1976 Winter Games. He was later inducted into the Canadian Olympic Hall of Fame, Canada's Sports Hall of Fame, and was made an Officer of the Order of Canada in 1977.

I knew Toller. I remember him well from when I was a skater. He was older than me and maybe the most uninhibited person I have ever met. With all that freedom though, this was still a person whose vulnerabilities and sensitivity could make him challenging.

1964 Olympic bronze medallist and 1965 World champion Petra Burka was in the coaches' room at the Cricket Club when she heard the news by email. It was from her mother, Ellen Burka, who coached both of them.

1964 Olympic pairs silver medallist Debbi Wilkes remembered Toller this way: "I think in many ways, Toller represented everything we admired in an artistic sport. He was brave, uncompromising, and determined to take the sport where it had never been before. He had no patience or tolerance for people who couldn't see the sport's potential."

1962 World champion Don Jackson was in the stands watching skating at the national championships when I caught up to him: "He changed skating because he was willing to push the boundaries out and he didn't give up; and that's what changed skating all over the world. It's a big loss," said Jackson.

Truth be told, we all have our memories of Toller. Mine was trying to chase him down for an interview for my book. He blew me off the first time and then I phoned him to see if I could catch him. We had the most magical conversation that went on for a couple of hours as I frantically took notes. We connected. The next time we spoke was in a podcast at Worlds in 2013.

Artist. Skater. Visionary. Genius.
There is only ever one 'Toller' in a generation.

Arturo López, Funeral Director at Inhumaciones López
"Here in Mexico, we believe at this time of year, a portal opens up
that makes it easier for the souls to get through."

Graciela, Toller's maid of 20 years
"The last weeks it seemed that he had no time to sleep.
It was not normal. He painted all night long. He did not go to his room.
Sometimes he would fall asleep on the couch in the studio.

That morning, Antonia and me were in the kitchen waiting for him.
He was supposed to come early for breakfast.
He was never late for breakfast and he hated if other people were late.
We waited. He did not come. Finally with Adrian, we went to the studio to look for him.
That is where we found him."

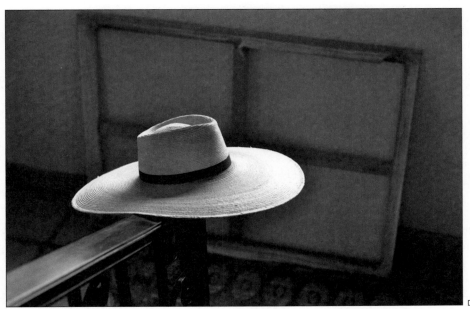

He left his hat. 2015-01-23

PHILLIPPA WROTE AN EMAIL

On Jan 31, 2015, at 7:52 AM Phillippa wrote:

Big day today. Funeral at 2.

I'm trying to write a bit of a eulogy.

I'm trying to keep in my mind all the things that I need to remember to get done, or arrange to get done, or consider having done. I am trying not to get too far ahead of myself and focus on the present, which very much needs focus right now. I am trying not to think of my brother dead on the floor of his studio, found by his very devoted staff. I am trying not to think about everything that lies ahead.

Oh yes, and I made a decision about the text for the tombstone. It will be:

Toller
Artist
1949 - 2015
Zero Tollerance*

I am also trying to make myself believe that the decidedly queasy feeling in my gut is just exhaustion. Anything else would be seriously inconvenient.

Also, one of the most strange and remarkable things is happening and I have yet to figure it out. It seems that apparently everyone, every single person in San Miguel de Allende was with Toller on January 23, 2015:

I had lunch with him. I met him for breakfast. I went shopping with him. I met him for dinner. I went to his house. He came to my house. I saw him on the street. I spoke to him at the bank.

It can't all be true. But it seems to be. I don't get it. But it is somehow wonderful. I am grateful that you are all a part of my life. I am a very lucky person.

Hugs,
P

*The title of one of Toller's books

TOLLER

I often have a visual metaphor in my mind of dying and making my way up to the pearly gates
and the angels directing me to the escalator going down to the smoky regions, saying,
"But you really tried hard. You're going to hell, but nobody tried harder."[1]

TOLLER CRANSTON: *Ice, Paint, Passion*

THE FUNERAL

By Phillippa

The cemetery in San Miguel is called the *Panteón de Nuestra Señora de Guadalupe.* It consists of a big Mexican part and a smaller gringo part. The Mexican part is jammed with tombstones of every size and description from simple headstones to huge, exuberant monuments. Most are adorned, festooned, and decorated with fresh and plastic flowers, and objects that might include little cows and horses, plastic cars and trucks, guitars, religious figures, and rosaries. Some have mystical stones and pebbles. The gringo part at the back is much more sedate. Solemn. Subdued. It is accessed through an arched wrought-iron double gate set in a tall boxwood hedge. All the tombstones are much the same. Neat. Tidy. This part of the cemetery is tended, but it utterly lacks the life and creativity of the Mexican part. The fact is that many of the expats who die in San Miguel do not have family. There is no one to visit. No one to care. No one to bring the plastic.

Toller's plot is #623. It backs against a tall hedge. Although his tombstone is pretty much the same as everyone else's, he usually has the most flowers—a reality that would please him.

During the Day of the Dead celebrations in early November, the *Panteón* is packed with mariachi bands everywhere, people singing everywhere, families hanging out all day drinking tequila and having a picnic at the grave of their loved ones. Toller always has a steady stream of people paying respects—some who knew him, some who knew of him. Some bring jellybeans. Some bring cakes. Many bring flowers. They say in

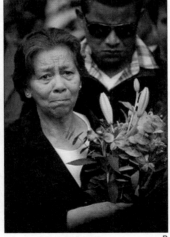

Antonia, Toller's cook for 23 years B

Mexico that as long as someone remembers you, you will never die. Toller's grave is now included on various City Tours in San Miguel.

At noon on January 31, 2015, barely a week after Toller died, we gathered in the gringo section at the *Panteón.* Masses of cut flowers had been stuck in the hedge around the gate and the wall of greenery behind his grave. The stone pathways had been strewn with flowers. It was perfect.

People trickled in. Many of the women were wearing their Toller silk scarves. Many of the men were wearing peach, red, blue, or green jackets that Toller had bought for them at the Tuesday Market.

The ceremony began with a procession headed by Sr. López, the funeral director who had been so lovely, followed by me and my brother carrying the ashes, then Toller's staff, and finally the mariachi band.

It was important to me that the staff have a place of honour at the service and that the remarks and every aspect of the proceedings be translated for those who did not speak English. There are no words for the devastation, sorrow, and grief on the faces of Toller's staff.

The minister was from the Unitarian Fellowship. He made a very nice speech, but he didn't know Toller. He kept calling him *Toler.* It didn't matter. Everyone else did know Toller. They knew him very well and their love for him was evident.

PHILLIPPA'S EULOGY

Buenas tardes everyone. Muchas gracias for coming. Thank you for being here today.

We have gathered at this spot, in San Miguel de Allende, to be together, to comfort one another, to remember, to honour and to celebrate an extraordinary life.

My name is Phillippa. Toller is my brother. I have been proud to say that Toller Cranston is my brother every single day for 65 years. Once or twice, along the way people would say to Toller, "Oh, you're Phillippa Cranston's brother." But that didn't happen very often. Mostly, it was the other way around. Toller was my brother. Toller was your friend. Toller was your client. Your patron. Your mentor. Your colleague. Your employer. He was many things to many people.

There were many sides to his personality. All of them are true. All of them are real. There is reflection. There is refraction. There is distortion. But most of all, there is colour, sparkle, and brilliance.

What one perceived depended on the day, the mood, the light. What one saw depended on where one stood. What one heard or remembered depended on the circumstances. There were layers to everything about Toller—just like his paintings.

There was talent. Huge talent. There were achievements. Huge, transformational world-changing achievements. There were mistakes. Huge mistakes sometimes.

Over these past days, we have all been taking a very unexpected and unwanted trip down memory lane. The outpouring from across the country and around the world has been dumbfounding. For all of us. From every corner of the country, from every street in San Miguel, from all over the world, the messages and tributes have been pouring in. It has been humbling, moving, deeply touching. He has impacted so many people in so many different ways.

When I began thinking about what I wanted to say today, I realized that it had very little to do with skating or painting or medals or championships. It was more about the multifarious facets of this man. Incidentally, he loved big words. Multifarious was one of them.

He lived life on his terms. He was much loved, and he will be missed.

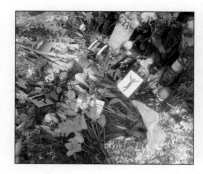
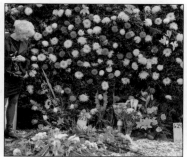
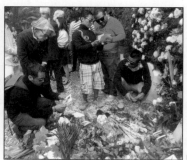

Flowers in the hedges. Photos on the grave.

TOLLER CRANSTON: *Ice, Paint, Passion*

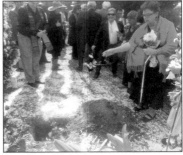

Donna Parker. He loved roses.

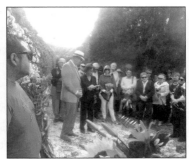

Adrian, Tony & June Eyton

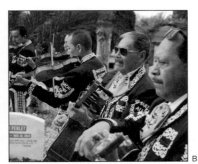

The Mariachis

Ambassador (Ret.) Tony Eyton spoke. He said, among other things, "June and I have lived and worked and travelled all over the world. Without question, Toller was far and away the most stubborn and the most irresponsible person I have ever met in my entire life. And he taught me more than any person I ever met."

June Eyton spoke beautifully of her special bond with Toller and she spoke in Spanish to the staff. She acknowledged each one by name and thanked each one personally for their service to Toller and their commitment and dedication to him. She knew that sometimes they went days and days without pay, but she also knew how much Toller loved and respected his staff and how much they meant to him.

Haig Oundjian, Toller's lifelong friend, spoke last. Haig was maybe one of a bare handful of people with whom Toller never had a falling out over decades of friendship, competition, and shared experience. Haig, wearing a red sports jacket that Toller had once given him, made a moving and emotional speech about their long history together. Everyone, already devastated by grief, was brought to their knees by the heartfelt remarks of his dear friend. People then stepped forward one by one, and amid tears, laid their flowers on the grave. Someone tossed a bunch of photos on the mass of flowers on Toller's grave.

The mariachis began to play. It was mournful. Solemn. Stirring.

Then Haig suddenly announced in a loud voice, "But wait! Wait! Toller would never want to leave without a standing ovation," and he exhorted everyone to join him in three hearty cheers and massive, enthusiastic applause. Cheers for who Toller had been, what he had accomplished and what he had shared with each person there. The tears were real. The applause was genuine. It was an extraordinary moment.

Janet Dunnett, Jaki Chan

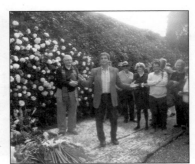

Haig

Hugo

TOLLER IS GONE

By Edythe Anstey Hanen

We had been spending a few weeks out in Sayulita prior to arriving in San Miguel when we got the message. I turned on the computer and the emails came pouring in. *Ping! Ping! Ping!* One after another. The subject lines read, *Sorry, Condolences, OMG, So Sorry, Thinking of you.* I opened the first one. And the next, and the next.

I turned to David and said, "Toller is gone."

Toller and I would often talk about getting to an age. He had a deep intuition. He once said,

"We all fly away one day.
It's only a matter of time."

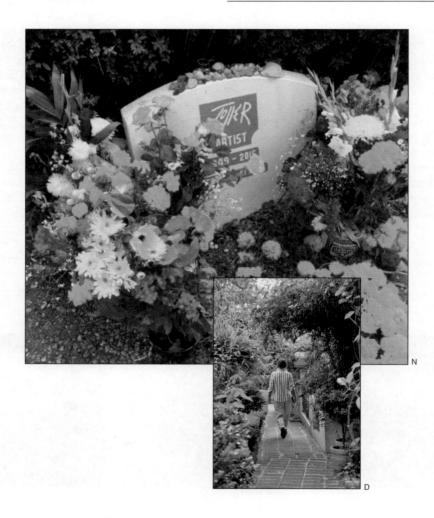

TOLLER GONE. UNTHINKABLE.

No more conversations over breakfast that inevitably spiral into brilliant and uncharted territory. No more hearing about how he'd need a *Valium drip* to get through whatever crisis loomed on his horizon. No more of those treasured moments when we might find him alone in the kitchen on a Sunday morning, lounging in bare feet, reading a book, then getting to spend two uninterrupted hours talking with him—about our lives, our foibles, our fears. No more dinners with cakes and roses and candies strewn across the tabletop, towers of ice cream topped with a single pink rose. No more lying in bed late at night, laughing until the tears came over one of Toller's particularly amusing witticisms heard over breakfast that morning.

No more breakfasts.

After arriving in San Miguel every winter, I looked forward to that first hug, that first welcome back. But this time, there was no welcome back. We did not continue the conversation we'd been having for the past couple of years: the one about the unwelcome surprises of the aging journey; our talks about the youth of today that he spoke of with both joy and longing, knowing that these young people have their whole creative lives ahead of them. His advice to my daughter was something she has never forgotten: *Be creative now.* It is the tenet he believed every young person should live by.

B

15

THE ROSEWOOD SALE
By Anado McLauchlin

A week or so after Toller died, there was an art auction at the Rosewood Hotel in San Miguel. It was a fundraiser for the Children's Art Foundation, a charity that Toller had supported for many years. Toller had donated a major painting for the sale, and he was to have taken the gavel as the auctioneer.

Hannah McCurley, Director of the Children's Art Foundation, asked if I would do the auctioneering in Toller's place. It was an honour for me to stand in for Toller. It was like standing in for, I don't know, maybe Marlon Brando. Toller and I were not friends. We came from different worlds, but I knew that Toller always knew how to work the room and I knew that he was an amazing marketer. It also occurred to me that here was I, the second most outrageous character in San Miguel standing in for Toller, the most outrageous.

Anado AA

I helped Hannah to hang the show in a way that presented the best work in the best ways. Everybody came. All the Canadians came. God love the Canadians, but bless their hearts, they are tight. They were sitting on their wallets. We had put small suggested prices. But nobody was bidding.

I suddenly got this idea. I pulled out my iPhone and I said, "Oh, wait a minute. I've got a call. Oh, it's Toller. What's that? What's that Toller? Toller says *you* have to bid more Mrs. So-and-So! What's that Toller? Oh. OK. And *you, you* over there—Mr. So-and-So…He says you have to bid again."

In the end we raised something like $25,000.

Toller was one-of-a-kind. I think I am sort of one-of-a-kind as well. I know how hard it is to be different, to be doing things in the way that you feel you must, to be true to yourself and to your vision. It is never easy.

Toller was extraordinary. He is an icon in the gay community. We have just passed the 50th anniversary of Stonewall. There was a phrase back then when we marched on 6th Avenue, *Out of the closets and onto the streets.* Well, Toller came out of the closet and onto the ice. It was a glorious situation. I don't think he had any idea of what he was actually doing or the doors he was opening. He did it out of his own flair, his own innocence, and that is what I find to be beautiful.

I don't know if Toller was openly *out* but ironically, a lot of people within this community have what's known as *gaydar* and the *gaydar* goes off when Toller is on the scene.

Exalting, adorning, and illuminating oneself—that is basically what he did. He illuminated his visage, he adorned himself, and in many ways, that is exaltation. That is *Look at me. I'm over here.* And he did a good job of bringing that to the fore. I think the exterior is what was manifested, but it takes some genius to do what he did.

Toller did so much for this community. He was totally good at heart. And he changed so many lives. I had not fully realized the intense depth of how he has touched people. He was absolutely revered here in San Miguel. He exalted so many people. He lifted them up in extraordinary ways.

TOLLER'S 66th BIRTHDAY AT HECHO EN MEXICO

By Phillippa

Many of the San Miguel regulars—snowbirds, friends, and clients—weren't in San Miguel in January 2015 when Toller died and consequently hadn't had an opportunity to pay their respects. I arranged a birthday celebration for April 20, 2015 when Toller would have turned 66. About 150 people showed up.

It was to be a breakfast celebration. Over the 23 years he lived in San Miguel, anyone interesting, outrageous, important, unique, or special (at least in Toller's eyes) had at one time or another been invited to breakfast. Toller's breakfasts were legendary. *Hecho en Mexico*, the flagship restaurant for gringos and Toller's absolute favourite spot in San Miguel, opened early for the occasion.

Toller's sweet tooth was well known. His sense of fun, his sense of the colourful and outrageous was infectious. *Hecho* went out of their way to accommodate every quirk. There were eggs and bacon and croissants. There were cakes. Lots of cakes. And sweets and candies. There were jellybeans on all the tables. There were 66 coloured balloons. Everyone was given a birthday souvenir made by my friend Anne Philpot.

In the main courtyard of the restaurant, there was a 12-foot video screen that played a video lovingly created by Chuck Rubin.

In another part of the restaurant, now known as the *Toller Room*, a screen was playing a continuous loop of skating videos. At one point, there was a group of waiters standing shoulder-to-shoulder, absolutely riveted by the video. The *Hecho* staff had known Toller as an artist, customer, personality, patron, and friend. But they did not really know about his skating or at least had never seen it. They were speechless. Every one of them had tears rolling down their face.

I made a few remarks. Toller's staff spoke briefly.

We distributed 66 coloured balloons and asked that people take one and think for a moment about Toller. Make a wish. Be grateful for the gifts he has given to them—the gifts of friendship, confidence, style, or trust. Know that he was always grateful for the gifts each person gave to him—love, support, understanding, acceptance.

We sang happy birthday.

 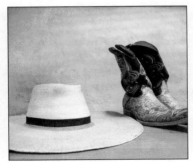

B

17

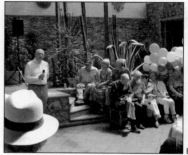

Tony Eyton

Toller's Sollano Gate in January 2015

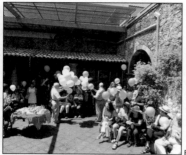

66 balloons

Then everyone released their balloons, which floated up into a perfectly blue cloudless sky and drifted off towards the spires of the *Parroquia*. We all watched, each in our own thoughts, as the balloons sailed off. They were pink and green, yellow and blue. There was one white one that went up all right, but well above the roof of the restaurant, it stopped. Then it came back down and, as 150 people stared transfixed, it wound itself around a white bougainvillea that was growing out of the restaurant courtyard.

Then we had cake.

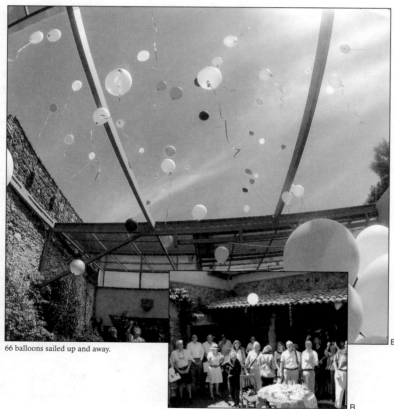

66 balloons sailed up and away.

One white balloon came back.

TOLLER CRANSTON: *Ice, Paint, Passion*

MICHAEL HOPPÉ GAVE A CONCERT AND THE WIND BLOWS

By Michael Hoppé and Monica Campbell Hoppé

Let me tell you about the day Toller died. He died at night, but nobody knew until the next day. The next morning our friend Anita called our house and she said that Toller had died.

We met at the house. At that time, Toller was still inside. They brought him out on a stretcher. He was wrapped up in a light white sheet. He looked so small. He was a big personality. But his body was not big. I took a sprig from a pot in his garden. I just grabbed it and I took it home and planted it and now we have that.

That evening we sat on our terrace. There was so much thunder and lightning. No rain. It sounded like Toller. And we sat there and we said, "That is Toller leaving. That is his exit." It was a huge storm. It was so beautiful.

And then, the next thing that happened was some months later at a concert of Michael's music in the theatre at Bellas Artes. They had set up easels and paintings across the stage. Michael was halfway through his concert when he got up and he said, "This next one is for Toller Cranston. My friend, Toller." And, all of a sudden, the doors of the auditorium flew open and the wind came through and the paintings on the easels all fell off and the easels all fell over. It was just so incredible. It was Toller.

And there was the time when we had a party for him on the Day of the Dead. I did a

Sam Perez took this picture. He calls it Thunderheart.

whole altar for him with jellybeans and the things that he liked. In the morning, Michael went down to get coffee and he said, "I think there is a rat under the altar." And there was. I called one of our guys to come and get this rat out of the house, but when I told June she said, "Toller liked rats. He had a huge sculpture of a rat. You see rodent creatures in a lot of his paintings." The rat went back to the arroyo. We got on with our day.

When we would walk down Recreo or Sollano to visit Toller we could often hear Michael's music from blocks away. Toller would play the same song over and over and over. The music somehow reached him. He completely got it. He was skating to the music as he worked.

He was outrageous. Sometimes, Toller would drive by with Adrian, his driver, and the car would slow down and this languid hand would just extend out the window and we would take his hand and kiss it—pay obeisance as it were—he never looked at us—just this hand would come out of the window.

He was extremely charming. He was a very, very charismatic and charming person and he had an extremely short attention span. We would be talking and suddenly, he would get up and whirl around and then be gone and never come back.

He changed our lives.

MEMORIAL CELEBRATION AT THE ART GALLERY OF ONTARIO

June 2015

Although Toller had died and was buried in Mexico, it was important that Canadians (colleagues, fellow competitors, former champions, people in media, arts, fashion, collectors, and friends) be given an opportunity to celebrate a truly extraordinary man. Toller's friend Jeanne Beker approached the Art Gallery of Ontario (AGO) who generously donated the venue. At the time, June 2015, it was not possible to bring paintings from Mexico, but thanks to the ingenious and tireless efforts of John Rait, we were able to round up, beg, borrow, and wheedle about 40 pieces from the collections of people in south and central Ontario. It was extraordinary that Toller had his first posthumous exhibition—albeit a one-night stand—in the prestigious AGO.

Jeanne Beker arranged for her friend, the incomparable Molly Johnson, to sing. Lindt Chocolates, who have always been a booster and supporter of figure skating, sent one of their chocolatiers to hand dip strawberries. They also supplied a gift box for each of the more than 300 invited guests. The Grange of Prince Edward Winery supplied cases of white wine. Friends contributed jellybeans because it wouldn't be Toller without strawberries and jellybeans.

The Legendary Ellen Burka

The guests included former champions and world competitors, ambassadors, media people and collectors, supporters, and fans.

The Canadian Olympic Foundation launched the Toller Cranston Memorial Fund.

The legendary Ellen Burka was there. At almost 94 years of age, Ellen attended the AGO Memorial with her daughters Petra and Astra. Mrs. Burka was one of the greatest coaches ever. Anywhere. Together, she and Toller created an approach to figure skating they called Theatre on Ice. They changed the face of figure skating worldwide. On this occasion, Ellen was resplendent in red. She utterly commanded the room, as she had for decades commanded her students on the ice. She had already brought more than 26 Canadian medallists to the world and Olympic level. That night, the skaters—stars, champions, medallists—from various countries and multiple generations crowded around Mrs. Burka to pay their respects and to celebrate and honour the woman who remains one of the most highly respected coaches and brilliant choreographers in figure skating history. She regaled the assembled crowd with a highly colourful and minutely detailed recall of Toller's first 10 days with her.

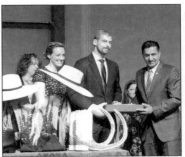

Brittany and Graham accepting the Peace Tower flag from the Hon. Bal Gosal, Minister of State for Sport.

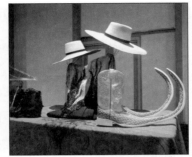

The last pair of boots made for Toller by Mr. Knebli.

The incomparable Molly Johnston, OC

Phillippa

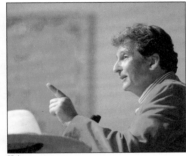

Haig

Ellen Burka

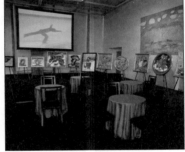

Toller's first exhibit at the AGO. A one night stand.

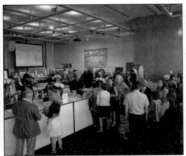

Friends, artists, skaters, collectors, fans.

Future Olympians

Gift Bags

Jeanne Beker

B

Launching the Toller Cranston Scholarships through the Canadian Olympic Foundation.

Memorial Celebration at the Art Gallery of Ontario

MY FIRST TEN DAYS WITH TOLLER

By Ellen Burka

I thought I would tell you about the first 10 days with Toller.

It was 1968. It was the Canadian Championships in Vancouver and they were making the selection of the Canadian Team for the Olympics. Poor Toller came fourth and didn't make the team. People were yelling and screaming at the results. They felt Toller had been robbed. I saw a very forlorn figure over in the corner and tears were running down his face. I put my arm around him and I said, "Don't worry, your time will come."

Some months later, he called me and said, "I know I didn't do well the past few years. Everyone has told me to get out. Even the Canadian Figure Skating Association said 'Get out. Quit skating. You are too old, you are 18.' But I love skating and I want to give it one more try. Will you teach me?"

The next day he arrived at the Cricket Club. I said, "OK why don't you do your program. Let me see."

He went through his program, which was not very good.
He came back to me.
He looked at me.
I looked at him.
There he stood.
Steam came out of his head. I had never seen that before.

I said "Toller, if you want to come here as a student, I will give you some advice. First of all, you are overweight. You have bad conditioning. We need a new program. You are not dressed properly for the ice."

He had arrived in a brown jump suit with a zipper from here to there. He had one in green and one in mustard yellow. It was the worst taste ever.

Two days later he came back. He stood in front of me, and he said, "Mrs. Burka, I will do anything you tell me." The second morning, he brought a big portfolio of drawings.

I said, "Are you an artist?"

He said, "Yes, Mrs. Burka. I am an artist. I have always been an artist."

I said, "Come to me at 7 p.m. I live around the corner."

He came that evening and showed me the portfolio and I was amazed.
It was so beautiful. I said, "Toller, what are you doing? How is your life?"

He said, "Well my life is not that good right now because I have been thrown out by two landladies because they don't want to smell my turpentine and paints."

He had no place to go. I didn't know that.

My mind went around and around. I said, "Well, you know what, I have a studio downstairs because I paint myself. It has an easel. It has a big table. It even has a bed. It has a two-piece bath. You can stay here for seven days."

He disappeared.

One hour later he was back.

Seven days he was supposed to stay.

He stayed for seven years.*

*In Toller's frequent telling of this story, he moved in for a week, and stayed for twelve years. Regardless, they found each other. They were together a very long time. They accomplished great things.

PEACE TOWER FLAG

By Phillippa

The Maple Leaf flag of Canada was raised for the very first time on February 15, 1965. I know. I was there. I was 18 years old. I was part of a drab, bundled-up crowd who assembled on the Hill at noon on a bleak and miserable February day. There had been so much debate and controversy over the design of our new flag, and I remember thinking *What the hell? All that debate for this? It's just a leaf!*

I remember that the old Red Ensign was solemnly lowered and the new Maple Leaf flag was raised. I remember that it just hung there. There wasn't a whiff of breeze and it just hung there. Lifeless. I think we all mumbled our way through *O Canada* and that was it. Honestly, it was less than thrilling. But it was a moment in history and it was ours. Less than two years later, Canada charged into her second century. We have never looked back. We never will. The flag is the most beautiful flag. Ever. Proud to be Canadian? Always.

I don't know why Laureen Harper, wife of the Prime Minister in 2015, thought to request the flag that was flying on the Peace Tower the day that Toller died, but she did, and I shall be forever grateful. That flag was presented to the family at Toller's Memorial

Charles Pachter. Acrylic on canvas

Celebration at the Art Gallery of Ontario by the Hon. Bal Gosal, Minister of State for Sport in the government of Stephen Harper.

Until then, I had not been aware that a new flag is raised on the Peace Tower every day and the old flag is given to anyone who requests one. It's easy to get on the list. There is an online application. Understandably, there is a limit of one per family, and you do have to be a Canadian, and there is of course a wait time which, according to the website, now exceeds 100 years.

Toller would have loved that he jumped the queue.

Toller lived life on his terms. He found his way of 'being' in the world and staying true to himself, a very, very difficult thing to do, as you know.

Like all of us, he wasn't perfect. But he was, at the heart of it all, good and decent and kind. He was funny, generous, brave, and creative. He was fearless. He was frail. He was adventurous and daring. He ensured that Canada would always have a place on the podium of world figure skating.

He was much loved, and
he will be missed.

CHAPTER 2
THE EARLY YEARS AND THE INFLUENCES
By Phillippa

I am often asked,

So…what was it like growing up with Toller Cranston?

The question always surprises me.

The answer always surprises them.

Ordinary.

The answer is ordinary.

We were a perfectly ordinary middle-class family. White-collar 9-to-5 dad. Stay-at-home mum. No divorces. No affairs as far as I know. Although for years, someone sent a Christmas card to our father that was signed "Bubbles."

Our father, Monte, played football for Queen's University, flunked out, got married and worked as a hard-rock miner in Noranda until he went off to war. He got a toe shot off in France, hooked a rug in rehab, and returned otherwise unscathed. He spent the next three-plus decades as a salesman for Joy Manufacturing, a company that made mining machinery. He was handsome, athletic, and a thoroughly good and decent man. I don't believe that he ever said an unkind word about anyone.

Our mother, Stuart, did not work outside the home for pay. She was a dervish, an artist, and a drama queen. She was outrageous, colourful, and flamboyant. It certainly cannot be said that she never said an unkind word about anyone. She could be thoughtful, generous, fearless, and amazing.

I remember travelling with my mother in India in 1998. Our Nepalese boatman had been singing cheery river songs including "Row, Row, Row Your Boat" in Nepalese during a wild, bone-chilling, way-beyond-wet December run down the Ganges River in a whitewater raft. Stuart, aged seventy-nine at the time, hopped out and inquired whether the Nepalese boatman would

consider selling his pants, which she thought were fabulous. "No problem," said he, and whipped them off right there on the spot and gave them to her. She wore them proudly and often.

Dad smoked Export. Mum had an occasional Matinée. Dad drank rye, Seagram's V.O. with water, not coke. By the age of eight or nine, we knew how to measure rye with his silver jigger and how much water to add.

There were four of us: me, Toller, and younger twins.

We made our beds. We did our chores—took out the garbage, fed the dog, cleared the table.

We got an allowance. I remember saving $6.95 for a doll from the Eaton's Catalogue. It took forever to save $6.95 in miniscule allowance-sized instalments. Toller saved for a pair of two-tone (tan and oxblood) cowboy boots. Of course, they were fabulous.

We said "How do you do Mrs. So-and-So?" and "May I please be excused?" We did not slurp our soup. We did not interrupt or speak with our mouth full. We were told that some day we might be invited to dine at the Captain's table or to meet the Queen and it would be important to have a firm handshake except for the Queen who had to shake so many hands that a limp handshake was acceptable in her case. Over his lifetime, Toller would meet many heads of state and I am

 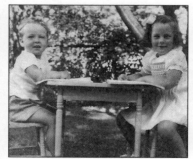 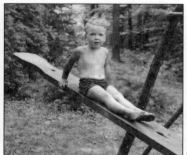

confident that except for queens, he always had a firm handshake and did not slurp his soup.

We went to school. We mostly did our homework. We occasionally played hooky. I was a good student who never got strapped. The boys were decent students who rarely got strapped.

We went to Sunday school. We learned the Apostles' Creed. We got confirmed. We quit going to church with occasional exceptions for Christmas and Easter.

We spent summers at the family cottage on the Ottawa River near Arnprior.

On sunny days, we stayed in the water till we turned blue. We organized competitions like fanciest handstand, most somersaults, or who-could-stay-underwater the longest. We ripped around in an old tub of a wooden boat with a 3.5 HP motor that would bounce off any time we turned too sharply. Everyone would pile over the sides and dive until someone found the motor and we'd haul it up, screw it back on the boat, pull the cord, and away we'd go.

On rainy days, we played Monopoly, Sorry, Parcheesi, Cribbage, Fish, and Canasta. We grew into Bridge. We listened to scratchy LPs of Buddy Holly, the Everly Brothers, and Paul Anka and show tunes from *Oklahoma, My Fair Lady* and *The King and I.*

Lunch was typically sandwiches or hotdogs and home-made lemonade. We never had bologna or peanut butter. I don't know why. We accepted as gospel that we would get deadly cramps and drown on the spot in agony if we went swimming before at least an hour after lunch. So, we didn't.

We put on shows. Sometimes with the younger brothers and cousins and sometimes just me and Toller. The afternoons would be spent in rehearsal and costuming—bath towels, curtains, hats, high heels. At the appointed hour, the grownups would be summoned and to their credit, they always showed up. I was the emcee with the ridiculously improbable stage name of Gloria Plutz. Toller would usually perform an interpretive dance à la Isadora or recite an original poem. His most enduring was about poodles and it began "Podles, podles, fluffy and white." If the performances were outdoors or on the beach, there would be acrobatics, tumbling, and other athletic feats. The shows would of course end with bows and applause.

We made forts. We wrote out the rules and nailed them to a tree: no spitting and no swearing in the fort.

We made sandcastles with dungeons and moats.
We all got poison ivy.
We all hated snakes.
We would be home before dark.
Growing up was pretty ordinary.
Toller…maybe not so much.

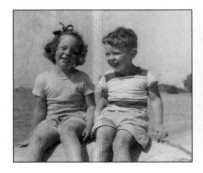

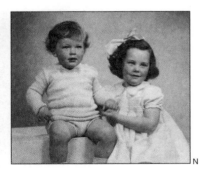

When he was little, Toller had an imaginary friend whose name was Glunk Glunk. I don't remember much about Glunk Glunk except that someone was always stepping on him—an offense that would produce outrage, shrieks, and wails.

When he was about three, Toller went downtown…by himself…stark naked…except for my mother's black suede pumps. He was returned by a very nice police officer who, as I recall, asked no questions and made no comment.

He once poked an orange crayon so far up his nose that it got stuck. It melted and dripped into a sad orange worm that had to be surgically fished out. And once, for reasons unknown, he ate a whole box of wooden matches and had to have his stomach pumped.

One afternoon, he fell out of the top bunk at the cottage and scraped his eyebrow off on the corner of the dresser as he fell. The screaming child and the little flap of skin with the eyebrow were taken to the doctor and the eyebrow was stitched back on.

Speaking of stitches, there was one memorable summer evening when a bunch of cousins and neighbours were playing zoo on the point. Each of us had chosen to be some kind of animal and had staked out our turf, our cage, our pen. Two of us were elephants trumpeting and making swaying trunk motions with arms locked together as we paced in our imaginary enclosure. Another was a lion roaring from a lair tucked behind the rocks and shielded by cedar boughs. Toller, in an ill-fitting faded yellow bathing suit, announced that he was a chicken. He launched himself from a high rock and flew clucking and squawking into the mountain of sticks and brush that had been gathered for the next bonfire. He flew in squawking, but he flew out screaming. The flight into the pointy nest had resulted in his balls being pierced. There were stitches. Two, if I recall correctly. That is when we all solemnly learned the word *scrotum*.

Grandmother and Gandy lived in a rambling Victorian house in Cobourg, Ontario. We loved it there. We especially loved the attic bedroom with its low-angled ceilings, dormer windows with cushioned window seats, and chintz wallpaper that was grey with pink peonies. One Christmas Eve, Toller and I were sharing that room. We had

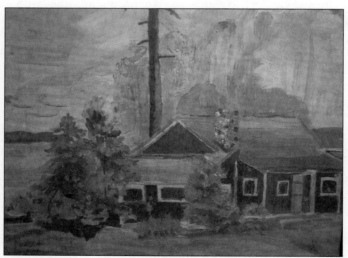

The Cottage at Marshall's Bay, by Stuart, Oil on board

been assured that Santa would know that we were at Grandmother's and not at home, but we had been sternly warned that if we didn't go to sleep, Santa would not come. We were wide awake when we heard the terrifying but unmistakable sound of reindeer hooves on the roof. We froze. We did not even twitch for what seemed like forever, certain that Santa would know that we were not asleep. We did not actually hear any "Ho-Ho-Ho!" or "On Dancer! On Prancer!" But we definitely heard reindeer hooves on the roof that Christmas Eve. Plus, the Christmas cake and eggnog we had left for Santa was gone in the morning.

Grandmother's house had double damask curtains, oriental rugs, a stuffed deer head over the mantle in the library, a pipe stand, a piano, and any number of vases, crystal bowls and decorative bric-a-brac. Clocks would bong and chime and cuckoo from every part of the house. There was Coalport and Royal Doulton china and blue glass salt cellars with tiny silver spoons. There was an ornate sterling tea service and a mahogany tea trolley that was used every afternoon at 4.

Over the years, we were taken to many lovely, *look but don't touch* homes and these lovely homes with lovely things obviously made an impression. Toller spent a lifetime acquiring lovely things. When he died in 2015, there were in fact more than 18,000 lovely things on his property in Mexico.

We didn't know it then but the destiny was set.

MRS. GILCHRIST'S DAHLIAS

Florence Gilchrist was the wife of George Gilchrist, the mine manager at Teck-Hughes in Kirkland Lake. They lived in a mansion on the mine property. Her garden was splendid—a riot of colour, set against the relatively bleak surrounding landscape of northern Ontario. There were foxgloves, delphiniums, snapdragons, and roses but the undeniable stars of the garden were Mrs. Gilchrist's dahlias. Toller and I were breathless the first time we saw them.

"What are those?"
"Those are dahlias, dear."

Dahlias. Da-a-ahlias. Even the name was exotic. We had never, ever seen dahlias before and these big showy flowers of extraordinary colour and fanciful form were astounding. For sure there are exuberant iterations of Mrs. Gilchrist's dahlias in the next 60 years of Toller's paintings.

BOOKS AND WORDS

Our house always had books. Stuart was a good reader and we grew up on the stories, fables, and fairy tales of Aesop and Grimm, Hans Christian Anderson, Beatrix Potter, and A.A. Milne. We knew Rapunzel and Goldilocks, Pooh and Piglet, Moley, Ratty, and Toad, and Charlotte. We never questioned the beauty of princesses or the magical powers of wizards. We knew that witches could brew any number of potions and cast any number of spells. We believed that it was entirely possible that rabbits lived in tiny burrow houses with rickety tables and chairs, a teapot on the gingham tablecloth, and a tiny, soft, pouffy bed. We knew a great deal about fairies, goblins, pixies, and dwarves. The magic realism of Toller's paintings, the costumes, the embellishments, the creatures, and the landscapes were almost certainly influenced by these tales from childhood.

We loved words—the rhythm of words, the lilt and the magic of words. Stuart was precise and correct in her speech. She had an excellent vocabulary and insisted that we understand and use words properly. She taught us the difference between pronunciation and enunciation. It was *flautist* not *floo-tist*, *athlete* not *ath-a-leet*, and *film* not *fill-um*. Toller went on to write nine books. I went on to write hundreds of scripts.

Toller was always sensitive about not going to university. One way he tried to compensate for his lack of formal education was to use big words. At some point, he acquired a book called *I Always Have to Look Up the Word Egregious*. He studied that book voraciously. Over his lifetime, especially when he was holding court in interviews or TV commentary, his speech was littered with words like *deleterious, perspicacious, multifarious, heinous,* and yes, *egregious*. Quite often, the words would be just ever-so-slightly off. I am sure that he believed that it gave him an air of *erudition*, a *je ne sais quoi* richness, dare we say *affluence* to his *elocution* that would make him sound more *sagacious, sapient* and *sophic*.

CARLETON UNIVERSITY HONORARY DOCTORATE

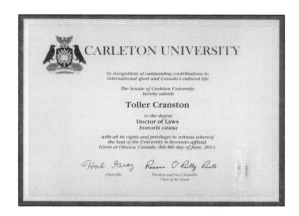

Without doubt, one of the highest honours of his lifetime, outside of skating and painting, was his honorary PhD from Carleton University. His 2011 convocation address to the Carleton graduates was about destiny, courage, strength, and persistence. In that speech, Toller said, in part: "A very important thing I learned in painting and in skating was how not to be afraid, and how to live one's life without inhibition.

"You have to say what you want to say, stand up for what you believe in, go after things, and never be afraid.

"To you, the graduates, as you begin to create your future, first let me say, I am terribly jealous of your degrees. I was unable to go to university because of my obligations to skating, but what I did do was read as much as I could. I studied vocabulary books. I travelled. And figure skating gave me the galleries and museums all over the world. That was my education."

THE WOMEN, THE RAPTORS, AND THE RATS

Miss Linton was the first. Toller would have been about five. Miss Linton was ancient—a tiny buttoned-up spinster with thin white hair fastened with hairpins. She lived alone on the second floor of a yellow brick house, just a few doors from us on Blenheim Road in Galt. Her apartment had lace curtains and smelled like Yardley's lavender. I don't know how or where they met, but almost every day, Toller would go to visit Miss Linton. I have no idea what they talked about hour after hour, but I am sure that Toller loved Miss Linton and I have no doubt that she loved this particular little boy. When we moved away, Miss Linton gave Toller a pomander on a black grosgrain ribbon that he had always admired. It was a lovely thing.

Miss Linton was the first in a long line of women who impressed, influenced, pursued, beleaguered, and commanded Toller over the next six decades. Miss Linton wanted nothing from Toller, but along the way, there were an astonishing number of Raptors and Rats who most certainly did want something from him.

The rich ones wore mink coats and bought him clothes and paid for dinner. In the early days, they slipped their hotel keys into his pocket. The greedy ones demanded that he pay their rent, buy them plane tickets, or give them money. The domineering and controlling ones dominated and controlled. The toxic and jealous ones spread vile gossip and insisted that he abandon long-standing relationships. The younger ones drew pictures and wrote letters and sent poems confessing undying affection. Among the cougars, fan girls, promoters and players were others who were just needy or lonely or wanted only to bask in reflected glory and share a little of his time.

There were also many, many wonderful women who validated him, supported him, listened to him, celebrated with him, consulted him, talked to him. Women, who forgave his occasional thoughtlessness, overlooked his tendency to be overbearing, and did not mind that he could sometimes be quite self-absorbed. These were women who understood and accepted him— women who wanted nothing from him but had a place for him in their lives as he had for them. Like Miss Linton all those years before.

On balance, he was a very lucky man.

A last word about Stuart and Monte. They always made each of us feel special. They supported each of us to become who we are. I say, without any reservation, that Toller was the most talented and most extraordinary of the four of us. He needed the most and he got the most in terms of time, money, and effort. But I can also say that never once, not ever, did I feel less important or less deserving or less special or in any way disadvantaged. To this day, I do not know how our parents achieved that, but they did, and I admire them immensely for it.

Looking over the recollections in this chapter, everything does seem ridiculously rosy and *Leave-it-to-Beaver-ish*. I could add a bit about how I nearly lost an eye when Toller threw scissors at me and I still have a scar on my left thigh where he kicked me with his skates because I refused to twirl him. Yes, we fought sometimes, and yes, I thought he was an asshole sometimes, but I never ever, not once, felt anything other than pride, respect, and admiration for his talent, his courage, and his commitment to his path.

Toller spent a lifetime creating his public persona. It was wrapped up in ego, differentness, and misunderstood-ness. He always and deeply believed that he was special. He believed in destiny. He believed in fate. He was outspoken and opinionated. He was who he was.

Over the years since he died, I have come to have a deeper respect and understanding of the profoundly positive effects he has had on so many people.

I am proud of him.

CHAPTER 3
DEEP ROOTS: THE TOLLERS, THE CRANSTONS, AND THE SHILLITOS

By Phillippa

Toller Toller!

In the German language, the word *toll* is a colloquial expression for great, super, fantastic, stunning, amazing, awesome. *Toller* means even more so—*toll, toller* is like *fast, faster* or *high, higher.* When Toller first started skating in Europe, he was understandably delighted to discover that headlines screaming Toller Toller! meant Fantastic Toller! Greatest Toller! Super Toller! Stunning Toller! Of course, he embraced this adulation. He always liked that his name was Toller although for a short while around the age of 10 he insisted that we call him Anthony.

I don't know when he started referring to himself as Shalitoe, maybe sometime in his twenties— but Shalitoe was not his name. Our father was Montague Shillito. Toller was christened Montague Toller James.

At some point in the process of creating an ever-more colourful and exotic public persona, he simply ditched the James in favour of Shillito which has for years been mis-reported by pundits and scribes as Shalitoe. Shalitoe...what an interesting name. Where did that come from?

I don't think Toller could have explained and besides, such details were unimportant to him. It was colourful, flamboyant and truthy-ish and that was enough.

It should be noted that Toller's rather loose approach to his name caused some real problems when I was trying to get his affairs sorted out in Mexico after he died. His name was different on every important document—passports, credit cards, electrical bills, birth certificate, deeds to the property, residency cards...everything.

The lawyers resorted to including everything: Toller Montague James also known as Montague James Toller also known as James Toller Montague also known as Toller.

In the end, none of this matters. For most of the world, he was simply Toller.

The tombstone in
San Miguel de Allende

He was Toller.

There was only one.

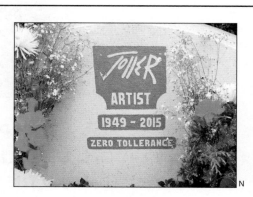

THE FAMILY NAMES

The background of the family names Toller and Cranston and Shillito is interesting. The roots extend deep into Canada.

On the Toller side, we appear to be descended from as many as nine original Mayflower passengers including John and Elizabeth Tilley, their daughter Elizabeth, and John Howland. The Tilleys were members of the pilgrim group while Howland was a servant of pilgrim John Carver. Howland, who married Miss Elizabeth Tilley, eventually rose in the Plymouth Colony to become Assistant Governor in 1633.

There are other prominent connections among the Tollers including Sir Samuel Leonard Tilley who became premier of New Brunswick and was one of the Fathers of Confederation. Sir Leonard too could trace his roots back to the Mayflower passengers. My father's brother (Uncle Hugh) was fondly nicknamed Hugh Tilley.

The connection continued in other descendants of Handley Chipman, including a great-great-aunt Alice who became the second wife of Sir Leonard. Lady Tilley's younger sister Annie married Col. Frederick Toller, who was Sir Leonard's private secretary and Comptroller of the Dominion Currency.

This brought the name Toller into the family and its use as a first name. Col. Toller was the first

in his family to move to Canada from Devon, England, where the Toller family had lived for more than 400 years.

On the Cranston side, our great-grandfather, James Goldie Cranston was a doctor and surgeon in the Ottawa Valley town of Arnprior, Ontario. Dr. Cranston had graduated with the first-ever medical class of Queens University in Kingston. Given the many lumber mills and logging camps along the Ottawa River, doctoring in those days meant dealing with an endless stream of dreadful accidents where guys had to be patched up, stitched, sutured, splinted, cauterized, and amputated. Doctor Cranston left a legacy of respected scholarly articles about surgery.

He married Miss Louisa Shillito. Our father, Montague Shillito, was named after her and that is where Toller appropriated the name that often appeared in articles.

The Cranston house was one of only 42 houses in Arnprior, Ontario when the Prince of Wales, the son of Queen Victoria and Albert, came to town in 1860. That house where our father was born in 1912 still exists.

A generation later, Grandfather Cranston (also James Goldie) married Mary Francis Toller, the daughter of Col. and Mrs. Frederick Toller of Ottawa. William Lyon Mackenzie King, who later became Prime Minister attended that wedding and gave the happy couple a beautiful set of crystal decanters that eventually came to Phillippa and that she

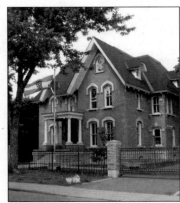

The Toller House M

passed on to her nephew Graham when he was married. Doctor Jim, as he was known, was much loved and the whole town of Arnprior closed down for his funeral. He died of a sudden and massive heart attack at age 63.

The next Cranston to die young of a sudden and massive heart attack was Toller in 2015 at age 65.

Toller women married into the Bryson family at Fort Coulonge. George Bryson Sr. was a Scottish-born businessman and political figure in Québec. He helped establish the Bank of Ottawa, later serving as a director, and he promoted the development of railway links in the region.

George Bryson Jr. was a Québec lumber merchant and political figure. He served as a member of the Legislative Council of Québec for Inkerman division from 1887 to 1937 as a Liberal member. Bryson was a director for the Bank of Ottawa, which later became the Bank of Nova Scotia. He was named a minister without portfolio in the province's cabinet in 1931 and became government leader for the Legislative Council in 1932.

The historic Toller House at 229 Chapel Street, in Sandy Hill, a neighbourhood east of Ottawa's downtown, was designed by Henry Horsey and John Sheard, architects of the original Ottawa City Hall and other notable buildings in Ottawa. Col. Frederick Toller, comptroller of Dominion Currency, and his family occupied the residence for more than 30 years. The extensive

grounds were the site for numerous weddings and family gatherings. The house is now the embassy for Croatia.

The Cranstons belong to the Scottish Clan Cranstoun and are entitled to wear the tartan and clan badge pictured below.

The Cranston crest is an image of a crane standing on a stone (crane-stoun) and the family motto is "Thou shalt want ere I want."

On the maternal side, the origins are English. Toller's mother, Stuart, was a Chubb. The same Chubbs who founded the world-famous Chubb Safes company more than 200 years ago and who, at one time, owned the Stonehenge estate in England, until 1918 when Cecil Chubb donated it to the State.

With thanks to Tony Scupham-Bilton and Wikipedia.

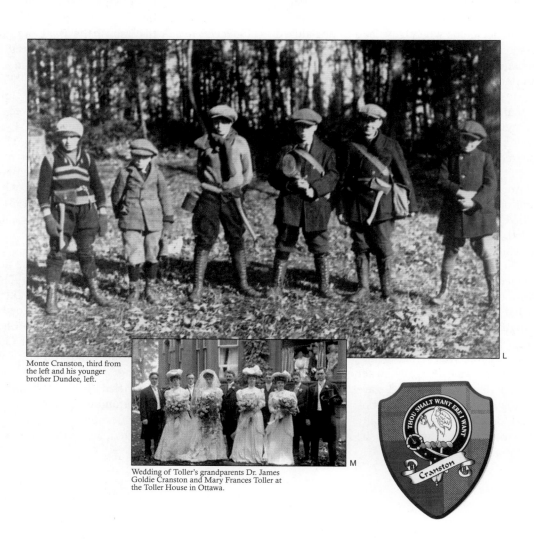

Monte Cranston, third from the left and his younger brother Dundee, left.

Wedding of Toller's grandparents Dr. James Goldie Cranston and Mary Frances Toller at the Toller House in Ottawa.

CHAPTER 4
INNOVATION ON THE ICE: COURAGE, CREATIVITY, EXPRESSION

THE TOLLER REVOLUTION
By Debbi Wilkes

I knew Toller before he was Toller.

More than five decades ago, I was finishing my competitive skating career while Toller was beginning his. He'd moved from Montreal to Toronto in search of a new coach who could continue to guide and support his two loves—painting and skating—and the magic each form brought to the other.

Although he'd not yet won a title, he was the talk of the town, even back in those days. I had certainly noticed his non-traditional style and the passion with which it was delivered. I remember very distinctly one day seeing him slumped against the boards. He had clearly been crying.

I said, "Hey! What's up? Are you OK?"

He said, "Everyone is laughing at me."

I said, "So?"

He said, "Well, it's hard."

And I said, "Toller, it's supposed to be hard!"

We stood there for the rest of the session while he talked about his confusion, frustration, and sorrow that there didn't seem to be a place for him in the skating world we both knew. We talked about his inability and his refusal to be like everyone else and about his desire to express

himself artistically. We talked about how if skating would never see the value in what he was trying to say, what was the point?

The conversation was about when you believe in something, you have to be brave, you have to push forward and you have to make people understand and, even though you might not be the best in the world at this point, you have to be the best in the world for people to take notice and that was kind of the story of his life. He was brave and determined and would not compromise in any way—and it was great for skating.

Not long after that day, I received a letter from Toller thanking me for understanding the path he wanted to follow and for reminding him that greatness didn't come from being like anyone else. I have cherished that letter for more than 50 years. It's been part of a crazy and wonderful small collection of my skating memorabilia, photos, documents, and memories that I hold incredibly dear. However, after moves too numerous to count, a variety of careers, family life, two children and two grandchildren, travel and education, I can't find that letter today! Why did I save it? I seemed to know even then, that I was witnessing something fragile and game-changing—the seeds of a revolution that would force the sport to examine what it considered *perfection*.

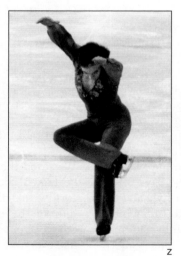

That day so long ago was the first of many Toller experiences, all of them full of unexpected conversations and outcomes, each one demonstrating what a unique and magnificent creature Toller was—uncompromising, honest, flamboyant, daring, egocentric, inventive, and ground-breaking. His performances and his art consistently challenged ideas and tradition daring the audience to

expand what was thought acceptable and even possible. Toller was never happier, or conversely, never more tormented, than when he'd upset the status quo.

Honestly, I never knew whether his often-outlandish behaviour was expressed to shake up the world or the reverse—to put the world's focus completely on him. I still don't know. But my guess is it was probably both.

I do know he was a tireless worker, whether training or painting. He seemed to know deep down that if his style was to be accepted, he had to be better than everyone else technically. Only then would the world take notice.

I remember another standout Toller moment one day on the set of the CTV-TV weekly series *Stars on Ice,* in which he made regular appearances. Toller and I were talking about his number and how difficult it was to shrink his choreography to the super-small ice surface. At the same time, he referred to the ice size at Radio City Music Hall for *The Ice Show*, (I was able to attend on opening night in NYC), and he was laughing about the fact he didn't consider himself a very good skater and, as a result, how many times he nearly pitched himself into the front row of the audience. He was the first one to make fun of *him* and he did it with a twinkle in his eye, hoping you'd deny what he'd just confessed!

After Toller moved to Mexico, our interactions became fewer and fewer. That said, my last Toller encounter was particularly special.

It was the 2013 ISU World Figure Skating Championships in London, Ontario. Toller had been asked to be the Artist in

Residence to attend the competition, to appear regularly on the concourse and to create a poster and commemorative scarf for the event. Of course, all his creations were spectacular, vibrant with colour and dynamic in their design, just like Toller's personality.

At the time, I was working for Skate Canada as the Director of Business Development. One of my responsibilities on site that week was to work with the local, provincial, and national governments to host VIPs and provide the support and information that would allow them to enjoy the event to the max.

One of those opportunities was to welcome and oversee the visit of the Governor General of Canada, The Right Honourable David Johnston and his wife, Sharon Johnston. During one of the breaks in the competition, Mr. and Mrs. Johnston expressed a desire to meet Toller, an item scheduled into their agenda.

I had warned Toller in advance, hoping he would follow suitable protocol, be respectful and friendly when the meeting actually happened. You never really knew!

When I led the Governor General's party toward Toller's area on the concourse, although he was aware of the timing, he looked like he was having a snooze, hunched lazily on the chair sitting with his feet up on the table and all dressed up in a Mexican themed wardrobe, orange serape and bright red sombrero. As we approached, he seemed to slightly acknowledge our visit but made no effort to stand or greet our guests appropriately. I was horrified and hissed in his ear, "Stand up!!"

Like everything else in which Toller engaged, you never knew exactly where things would go. That day in London, he led the Governor General and Mrs. Johnston on an unforgettable adventure with discussions about art and skating and life,

as if they were old friends who just needed a little time to catch up. Mrs. Johnston later confided to me that meeting Toller was one of the highlights of her week at the event.

Toller just had that way about him. Any discussion, any performance, any piece of art, any interaction…everything about him seemed to be designed to keep you off balance. His clothing style and daring costumes, his outrageously frank comments, his over-the-top reactions, and his inventive choreography—he was unpredictable, and he was newsworthy!

Although Toller flirted with convention when it might serve his purpose, my experience was he played entirely by his own rules. Not only did he love the limelight for himself, he cherished greatness and virtuosity in others. If Toller gave you a rare compliment, it meant something. If he criticized, which was often, it was likely delivered with blunt honesty. He never considered it important to worry about your feelings. Yet from day one, I sensed his own feelings were very close to the surface. Just like when we first met, he could be hurt easily, and had difficulty in a discussion understanding why you couldn't see what he saw. My opposing point of view could be dismissed with a toss of his head—the conversation suddenly over—yet, I was always left with something provocative to think about.

In the end, news of Toller's death was heartbreaking, happening at the 2015 Canadian Championships the day of the men's event. He would have loved the irony of the situation, as if he had orchestrated his death as his final and ultimate performance, his last piece of unexpected choreography, and the final chapter in his amazing revolution.

In the skating world, there are champions and there are *Champions*. The former win titles; the latter, like Toller, change the sport and those within it forever.

WHEN IT ALL BEGAN

By Phillippa

When Toller was seven, he announced that he should like to become a ballet dancer. It was a rather unusual request for a seven-year-old boy in Swastika, Ontario in the mid-1950s. Toller and I were taken to a "studio" in the basement of the fireman's hall in nearby Kirkland Lake. Toller thought there would be music and that he would express himself to the music. He learned that it was *pliées* at the *barre*. He thought he would get pointe shoes. He learned that boys did not wear pointe shoes. Ever. His ballet career lasted about 30 seconds. Ballet was not for him.

Later that year, Toller attended the winter carnival of the Kirkland Lake Skating Club. Sitting very high up in the bleachers, watching his sister, Toller reports a profound and startling realization. He knew in that moment:

That's what I want! It's not dancing that I want. It's that!

That was figure skating.

That's where it started.

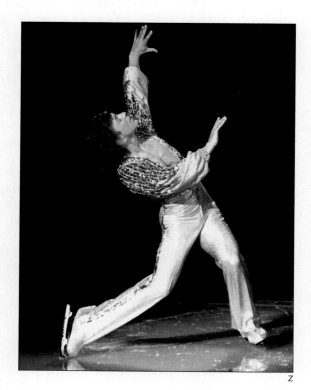

z

TOLLER

My mother always made me little woollen yarmulkes with pompoms on top. That was my costume for many years. In grade one, I did a crayon drawing on manila paper of myself in a perfect split jump under spotlights with one of those yarmulkes on my head and a big "S" on the front of my costume traced in pink, red yellow and green, I told my mother the "S" stood for skating.[8]

The "S" stands for skating. An early Original.

TOLLER

Once, at the age of nine, I remember flying into Ottawa from the Town of Mount Royal where I had been attending summer skating school. My father met me at the airport. Right there in the baggage area, I performed for him with great drama and flair everything I had learned that summer. My father was horrified but the other passengers who were looking on seemed to be quite thrilled by this unexpected performance complete with axels, twirls, and bows. Thinking back, it was maybe the beginning of a constant flaunting of self to the establishment, not getting the pat on the head that you hoped for but playing to an audience. That became a narrative of my entire life.[3]

HE WILL NEVER SKATE AGAIN

When Toller was thirteen, he developed a huge lump below both knees. Skating had become painful and jumping had become excruciating. He had a condition called Osgood Schlatters that most often afflicts growing boys aged ten to fifteen. The family was told that Toller would absolutely, positively, never skate again.

Toller spent the next many months with both legs in plaster casts extending from the ankle to the groin. When the casts came off, he was able to gradually resume walking, and then skating, but was warned that he must not run, and he must not jump. He continued to train. He began to jump. He won the 1964 Canadian Junior Championship.

Ellen and Toller

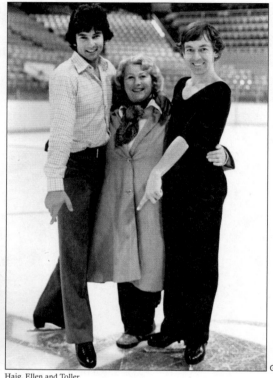

Haig, Ellen and Toller

FINDING ELLEN

Toller could never have achieved what he did without his long-time coach, the legendary Ellen Burka. Toller recalled. "In 1968, I had a goal of wanting to make the Olympic team. I was going to a French art school in Montreal called École de Beaux Arts. I was eighteen. All I really wanted to do was make the Olympic team but boys, or really anyone from the province of Québec, would never make the Olympic team because all the judges came from Toronto—from the Granite Club and the Cricket Club—all the judges came from those places. That has since changed, but this was 1968 and that is how it was.

I went to the Canadian Championships in Vancouver. I skated last. I skated fantastically and caused a sensation. But the Olympic team had already been ordained. I received marks ranging from 1st to 22nd. Dead last—22nd. I finished in fourth place—off the podium and off the team. Afterwards, this woman came and grabbed me, and she said, "They don't know what they saw. You are very far ahead of your time. They didn't understand." It was Ellen Burka.

That summer, I was working as the groundskeeper at the Mirror Lake Inn in Lake Placid. I was getting fatter and fatter by the second because I didn't get any money, I just got food. By September, all the other skaters had gone home and I didn't know what to do. My career was going nowhere. I was fat, out of shape, miserable,

and desperate. I stood in the lobby of the arena and looked up the number.

I called Mrs. Burka and said, "This is Toller Cranston. Do you remember me? Would you teach me?"

In those days, you really had to ask permission because the coaches had other important skaters. The next day she agreed to teach me. I found out years later that the other skaters said, "Well he's so fat and out of condition, we really don't care if you teach him or not."

I went and lived in the furnace room and stayed for twelve years and became three-time world champion.

Our lives can change in a second with a sentence. A meeting, a word, an opportunity, an

ELLEN BURKA

He's very disciplined.

At the beginning, I said, "Just move and be yourself."

And that's what he became—Himself.

A lot of skaters never become themselves.[5]

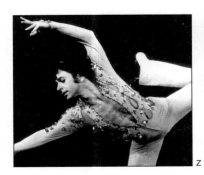
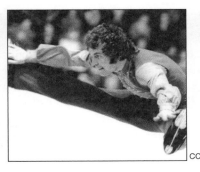
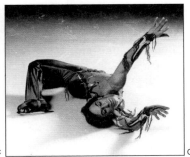

z

cc

c

Ellen Burka emigrated to Canada from Holland where she had been trained in ballet and modern dance. Canadian figure skating was rigid at the time. She encouraged her skaters to be more expressive, to show emotion and, for Toller, that meant moving his arms above his head which was not something the men were doing at the time.

The style became known as Theatre on Ice.

Ellen said, "OK, now listen to the music, think what you feel, and try to interpret it on the ice." Toller went on to win six straight Canadian figure skating championships, and made the Olympic team in 1976, where he won a bronze medal.

Ellen Burka's vision of having the athletes skate a story took hold. "People in Canada thought I was crazy at the time," recalls Mrs. Burka, who moved to Toronto after surviving the Holocaust. "But I could not accept that figure skating was so stiff, and the men all wore monkey suits that were so restrictive they couldn't even raise their arms. I am a dancer too, and I thought that figure skating should be different, that it should be about understanding the music, about using your arms, using your feet. Toller was the only one who understood that. He was the best tool I ever had, and after two years, we developed a style which is the style of today."

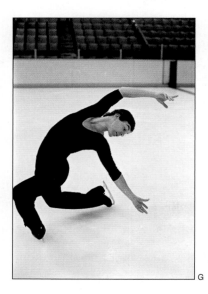

Don Jackson

Being an innovator came at a price. Initially the judges were against Toller. They did not accept him at first, and they didn't give him the winning points. To win, you have to have the judges on your side. But then TV helped him, because the general public liked what they saw, and they gave him standing ovations. The judges started to come around after that.

THE RISK-TAKERS REACH THE PINNACLE

By Ryan Stevens

It's fitting that an unconventional skater like Toller reached the pinnacle of his competitive success during a truly unusual era in men's figure skating.

In 1962, Donald Jackson had made history by landing the first triple Lutz in competition. Instead of inspiring the skaters that immediately followed him to attempt to duplicate his feat, many of the top-flight skaters limited the risks in their free skating programs. Most elected to skate clean, attempting two or three triples, rather than dare to risk the odds. There were a handful of exceptions, of course, but on the whole, men's skaters of the late sixties and early seventies were conservative, though confident and consistent.

By the mid-seventies, two groups of top-tier skaters emerged—the *risk-takers* and the *reserved*. In many international competitions, the results varied wildly from the school figures to the free skating. The introduction of the compulsory short program in 1973 only enhanced the range. In fact, Ondrej Nepela, Jan Hoffmann, Sergei Volkov, Charlie Tickner, and Vladimir Kovalev all won World titles in the seventies without ever winning the free skate.

It was in this climate that a small force of artistically gifted skaters carved their own niche. Toller Cranston, John Curry, Janet Lynn, and a small group of others juxtaposed a rare talent for interpreting music with superb technical skill. They were not, as some seem to surmise, artists who didn't give a thought to athleticism. They drew from the exact same bag of technical tricks as their peers and had the elusive whole package.

While others won World titles on the strength of their figures, Toller Cranston whipped audiences into a frenzy and twice won the free skate at the World Championships. It didn't matter who won the competitions—Toller was the skater that audiences remembered.

Plenty has been said of how the judges didn't *get* Toller. This is true. Most of them absolutely didn't. Yet, they were forced to evaluate him. That was their job. Presented with a style of skating quite alien to them, something truly remarkable, their task was daunting—assigning a numerical score to a way of skating so unquantifiable was akin to judging a cat in a dog show. On the whole, most judges relented. Though Toller received four 6.0s at the 1972 Canadian Championships, there were at times hold-out judges who wouldn't budge from their ideals and subsequently gave him less-than-perfect marks. These stalwarts ended up getting booed. It was a lot harder to find a detractor of Toller in the stands than on a judging panel. Most audience members, particularly those who were seeing him skate for the first time, were spellbound.

I have virtually no respect for practically any judge. Some of the judging at the
World Championship does not pass the laugh test. Judges should be professional and any judges who
are judging top international competitions should have been an international competitor themselves.
Judges should also be accountable, and in a public forum after important competitions they should
be coerced into explaining precise marks. As you should know, there's a certain elite snobbery that
permeates the upper echelons of the judging stratosphere, and most refuse to respond to any serious
or pointed question. A judge over the years is often concerned about fitting in the sandwich
between the two slices of bread and not wanting to be a pickle on a side plate.

Incidentally, what about having a dictator on the panel and simply having one person
(like me, for instance) decide who should really be the World Champion?
I think I'm made for the job![13]

What made Toller's success so remarkable was the fact he managed to win over judges from a different generation, judges with sensibilities so far removed from his own. While he held fast to his artistic vision, their conservative vision of what great figure skating was supposed to look like was challenged to the very core.

In her book *Artistic Impressions: Figure Skating, Masculinity, and the Limits of Sport*, scholar and author Mary Louise Adams aptly noted,

"It's not altogether surprising that Cranston and Curry would show up at the same time, in the mid-1970s, to challenge, in different ways, the narrow masculinity that had taken hold of skating in the late 1950s and 1960s. Space was opening for men to represent a broader range of masculinities in public. Alternative arts and styles that had emerged in the counter-cultural movements of the late 1960s were moving into the mainstream. Singers like David Bowie and Freddie Mercury were flamboyant, androgynous, visible, and popular. Feminism and gay liberation movements, while still marginal, had some success in forcing issues of gender and sexuality onto the public agenda. For skaters who did define themselves as athletes, the culture at large provided a lot of material for inspiration. A little bit of space had been created within figure skating for men to pay more attention to artistry. But not all skaters wanted to claim it. Cranston was all angles and passion and baroque embellishment."

Toller once said that although figure skating was very much a sport, "the final statement is artistic." He believed that once skaters mastered proper technique, they had the freedom to interpret music and choreography in ways that expressed their individuality. Yet, many skaters suppressed their true selves on the ice, instead parroting other skaters or mechanically doing what their coaches told them to. "To skate as you want," he said, "is a gift and a pleasure which few people ever experience." It was a special gift he shared with all of us—one we should treasure and make a point of sharing with future generations, so their ideals of *what skating is* are challenged too.

Toller's skating was what inspired me to take up

the sport and I admired not only his skating, but also his wonderful sense of humour, his art, and his insight into skating.

Toller's marks at the 1976 Innsbruck Olympic Winter Games showed that for both the short and long, not a single judge lowballed him. The marks were pretty much all 5.8s and 5.9s.

He was only seventh in figures, though and it wasn't uncommon in those days to bury great free skaters in the standings in the figures so that they would have a harder time winning. After Toller, it happened to both Denise Biellmann and Midori Ito. It was a pretty recurring trend in many careers.

TOLLER

"I became much more known outside the country. Canada didn't know what to do with me. The head of the Russian Federation, a man whose name was Mr. Pissé (why I remember that, I don't know), once said to Ellen Burka, 'Well, we know that your pupil is the best skater in the world, but you do understand that he can never win, you must understand that.' At that time, the Soviet Union was a block of countries, so you might have had nine judges that were judging you at the Olympics, five of whom emanated from the Soviet Union and if they didn't toe the Party line, they would end up in the Gulags. That was 1975.

In 1976, that was the big year when I was really supposed to win. But then, the most terrible thing happened. Those Olympics were in Innsbruck. I lost interest in skating. I didn't want to be judged by people who were there only because of seniority and not because of knowledge. I did my best, but I just wasn't into it. When I returned home with a tawdry bronze medal, I remember that the Customs guy at the Toronto airport said 'Oh, Cranston you really blew it.' But this loss is actually the thing that saved me. John Curry won. Truly, he was far better than me. He was three inches higher than me on the podium and I was two inches lower. But his life had climaxed and mine was just beginning. He died of AIDS at 44. I went on for another 25 years trying to prove myself."[13]

Barbara Sears
Cranston's day begins at 5 a.m. and leaves time for nothing but work. No idling away of hours over meals or talk or television—or people for that matter. He's very conscious of the gap this leaves.
"I felt like wandering around Skate Canada with a sign on my back.
WANTED: ONE AFFAIR," he says, a little wistfully.[10]

HE KNEW HE WAS RIGHT

By Dorothy Leaman

I remember a competition at Maple Leaf Gardens, when I had just judged the Senior Men. After the event, Toller and I passed each other in the hallway under the stands. Toller stopped me and started ranting and screaming, "You don't understand me! You never give me anything!" At the time, I confess I didn't like a lot of things he was doing especially with the music.

When he was finished, I said, "Toller! It is your duty to make me understand!"

It took a while. He began to understand what the judges were looking for—to make people understand the music. He was young. He was dynamite. He was amazing. And after he got together with Ellen, who was definitely an artist, he did a lot of changing. I think I came around as well.

I remember a competition in Bratislava. He had won the short program and was pretty near the top. He came out to skate the long program, which I had seen him skate at least 10 times. He got on the ice to warm up and he did nothing.

He just skated around. He did a sitspin. He fell. I thought to myself, *What I am going to do? I have to judge what I saw*. I met him afterwards and he just put his hand up and said, "I didn't give you anything to judge."

The next year we went to Munich. He was sensational. Everything he did was right. He should have won. I can't tell you how upset I was that he did not win. I had never given a 6.0 before. The only two people that put him first were the French judge and me. We were never called for it. Usually, you got told off if you were out of line. He did not win, but in the champions' exhibitions, the audience in the building would absolutely not let him leave the ice. He was spectacular.

I loved him, you know. I admired him. I have three of his paintings. He gave me one called "The Yes-No Twig." Everybody knew he didn't mean half of what he said. He just knew he was right and everybody else was wrong. Skating was something he did. His art was something he loved.

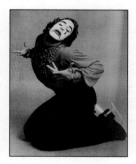

Benjamin Wright
The big moment was Pagliacci. The exhibition Toller gave in Munich in 1974 was the greatest exhibition of interpretive figure skating ever seen. It was a complete surprise.
No one expected an exhibition of that quality.
When you Google Pagliacci, they should have Toller right there.

Kurt Browning

He opened the doors for the rest of us. Toller made skating people and judges around the world respect Canada. He made figure skating cool.

Don Jackson

He was born with his leg over his head. He liked doing the spirals. He liked being so outgoing and so different. He tried many different moves that men then just didn't do. Toller took the brunt of the criticism at the time only because it was something new. But he changed the sport for the better.

Zsuzsi Almassy

I skated with Toller on some world tour exhibitions between 1968 and 1972. I remember the skating of course. But the best things were the night parties when we would get out the Ouija board and Toller would invite Sonja Henie's soul to join us. I also remember in East Germany the girls were going crazy for Toller—screaming and waiting for him in front of the Hotel.

Deirdre Kelly

Exotic, flamboyant, bizarre and exciting, Mr. Cranston was a trailblazer who represented a new breed of Canadian sports figure—the athlete as artist.

Dick Button

Toller Cranston! The most exotic skater that I think I have ever seen. If John Curry is the most elegant, this is the most exotic, the most bizarre, and the most unusual and extraordinary style that I have ever seen.

Brian Orser

If you've seen him skate. I guess you get an indication of his spirit and his soul.

WORLD FIGURE SKATING HALL OF FAME

Toller Cranston was inducted into the World Figure Skating Hall of Fame in Dortmund, Germany, March 25, 2004.

Toller didn't disappoint.

The most flamboyant skater of his era stepped onto the red carpet leading to the centre of the arena for his induction Thursday into the World Figure Skating Hall of Fame and, captured in a spotlight, he spun as if landing a jump.

He was in his element again.

Toller said, "By being chosen in the way that I was puts a period on the end of the sentence of a career that was exciting, erratic, and disappointing in many ways. But somehow I got the stamp of approval at the end of…like thirty years."

Getting inducted without having won multiple world titles speaks volumes for the impact he had on the sport in the 1970s when his artistry surpassed anything any other man had the nerve to attempt. He went where no skater had gone before. He created a new style of skating that was revolutionary in its day for giving men greater freedom of expression.

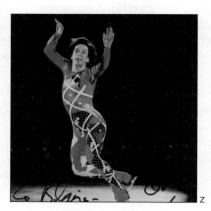

Ruth Ann Whipp
We were spellbound. As a teenager, I used to watch him float across the ice.
We had not seen anything like the creativity he brought to the sport of figure skating.
Toller changed the world of figure skating.
He was ahead of his time and in my opinion was robbed of the
gold medal that was rightfully his.

Brian Orser
Nobody will ever be like him. He was one of a kind.

CONTEMPLATING A COMPETITIVE COMEBACK AT 35

By Ryan Stevens

At the 1994 Olympic Winter Games in Lillehammer, Norway, the lines between amateurism and professionalism blurred when champions from eras past were reinstated to the eligible ranks in hopes of challenging the world's best Olympic-eligible skaters.

Less than three years after winning the bronze medal at the 1976 Olympic Winter Games in Innsbruck, Austria, the late, great six-time Canadian Toller Cranston was very seriously considering the possibility of attempting a comeback to the eligible ranks and competing in the 1984 Olympic Winter Games in Sarajevo. In an interview with Linda Jade Stearns in the December-January 1979 issue of *The Canadian Skater* magazine, Toller spoke of his plan in detail.

"Charles Snelling will have nothing on me. I have to perform for a couple more years. I want to do a movie and I know that I can't do that if I'm an amateur. Then I'm going to have to throw myself on my knees and ask the CFSA to give me back my amateur status, which will take a year. Therefore, I'm basically aiming for the 1984 Olympics. I'm going to do my comeback at thirty-five as opposed to Snelling in his mid-twenties. And he didn't train the way I'm training now. I just competed in the American Superstars show for TV, and my competitive instincts surged like wild. I became a tiger, a cutthroat, and I became consumed with the desire to win, which I had never really felt before when competing as an amateur.

"When I enter the 1984 Olympics—even if I have to skate out of Iceland to do it—I'll put skating in its proper perspective. I'm going to take it very seriously, but I know that my career will not hinge on how well I do. It's not like, 'Oh my God, what happens if Ronnie Shaver beats me? I'll be finished, I'll be through.' I learned how to be afraid in the worst way. When people say, 'Oh, you only came third at the Olympics, you blew it,' I reply, 'Third? It's a miracle!' I was so totally overwrought that when I stepped onto the ice, I couldn't believe that my legs were carrying me. I can do figures in my free skating boots now that are better than the ones I did in the Olympics in my figure boots. I realize that it's totally a question of control of the brain. It was nervousness, it wasn't that I had bad figures (that accounted for my low standing in figures at the Olympics). My figures were just as good as anybody's, but I did not have the ability to zero in, to totally concentrate. I wouldn't be nervous now because nothing is hinging on my performance. I'm not going to enter with the attitude that here's my big chance to win the 1984 Olympics.

"When you come back at thirty-five to compete in the Olympics, people will say, 'Let's see how good he is. Can he beat the champion from Luxembourg? Well, probably. But can he beat the French champion? Let's see how far he can go.' I know that I'm not going to out-triple my competitors because by then they're going to have to scrape them off the rafters. In the performance that I would give, the emphasis would be totally on performing. I would perform like wild. It's not that I wouldn't do a number of things, but I would say, let the skaters doing the quadruples and the eight triples do them. I would do all the things that they don't do. I would create a certain controversy."

In the end, the lure of professional competition won out. For seven consecutive years from 1980

to 1987, Toller competed at Dick Button's World Professional Figure Skating Championships in Landover, Maryland. More often than not, he didn't win. We will never know how the history books would have looked if Toller had in fact somehow managed a return to the eligible ranks in 1984. Against the likes of Scott Hamilton, Brian Orser, Jozef Sabovcik and the rest, he would have undoubtedly been at a huge disadvantage technically, but I don't think anyone can argue that he wouldn't have put on one hell of a show, as only Toller could.[13]

TOLLER

A performer can never perform at 100% with full capability in competition because one is constantly concerned about making a mistake. When you make a mistake in competition, that's the end. Your whole year is washed down the drain. I feel that this new career ahead of me as a professional will give me an opportunity to skate the way I want to.[13]

What most people will remember was the way he took hold of a crowd the moment he skated onto the ice. Even when he didn't win, Mr. Cranston was the source of conversation. Typically, it would revolve around what he did and how he did it, the flair of it all.

When Toller died in 2015, the Globe and Mail wrote that "Toller Cranston was an inimitable force in Canadian figure skating. His likes we may never see again."

The Canadian Press said, "One of figure skating's brightest stars and most colourful characters is gone."

Rosalynn Sumners, Toller, Brian Boitano, Katarina Witt.

TOLLER CRANSTON: *Ice, Paint, Passion*

CHAPTER 5

THE CANAL CAPER

By Barbara Berezowski

After years of sharing the same ice with Toller, I look back on all the special moments, those unbelievable opportunities I was fortunate enough to experience living in a world touched by Toller. From the countless hours of early morning trainings, the tedious compulsory figures, the countless sessions perfecting our chosen craft to performing alongside him on the world stage, I will be forever grateful for his friendship and all the experiences and escapades we shared.

Toller was an icon, a legend the world over for his creative genius. He was much more than just a skater. He was an artist living in the skating world of sport. He was brave. He insisted on marching to the beat of his own drum, and he felt caged when forced to conform and stick to the rules. Toller was a man with a larger-than-life persona. He was intense, passionate, generous, sensitive, both an introvert and an extravert and fun loving at times—enough to allow his inner child to enjoy the moment, without boundaries. He had the most joyful laugh that made his eyes sparkle.

He was truly an artist in his soul and expressed his creative genius, not only through his incredible paintings and art pieces, but also in his words, his thoughts, and in his skating through his artistic creations of expressive movement. I was always in awe of his strength of conviction, and his immense abundance of endless and extreme creativity and I was privileged to be considered a

friend and witness to some of his journey. I want to share one of my personal Toller experiences. It involves an event at a canal. But before I go there, I need to preface it with some of my personal insights, so you will better understand the *why* and what happened.

Toller was a gift. Artistic expression was in his blood, as was evident in the way he lived his life and what he created on canvas and on ice, in the way he spoke, in his books, and even in the way he dressed and carried himself. In our own respective disciplines, we were Canadian Champions on the World and Olympic Teams together and we travelled the world proudly wearing the maple leaf and performing before appreciative audiences.

I learned so many things from Toller—above all, how to be brave, how to believe in your passion, and how to be true to yourself.

It has often been said that Toller was before his time. His fans worldwide knew that they were witnessing something undeniably brilliant. Toller was one of the first skaters to inject artistry into his on-ice performances and although it took some time to be appreciated and recognized by the judges of our sport, he persevered and stayed true to himself because that was, in essence, his creative spirit that came through in everything he did and there was no stopping that powerful energy. In the great Ellen Burka, he found a masterful coach that nurtured him with an appreciation for his amazing talent and what they would create together. Toller was a Canadian Champion and the crowds, especially in Europe, went wild for him. He was unique and his performances were mesmerizing. Audiences were spellbound and couldn't believe the mastery of this one-of-a-kind artist before them.

After each competitive performance, they refused to accept any result other than what they believed to be just. They wanted the judges to recognize and award his greatness. They wanted to see him crowned as the best, but Toller was never really awarded the overall top marks he deserved on the world stage. The struggle was with the compulsory figure portion of the event and even though he was the crowd favourite, the marks he received for the compulsory event always seemed to hold him back when the final marks were tallied. His artistic athleticism had never been seen before and the judging structure was not designed to award that or account for it alone.

The big problem was two-fold: the combination of questionable judging (yes, dirty judging in figure skating has been a common occurrence for decades) and the impact of a mark awarded in the figure element of a skating event which factored in to determine a final score. Given the nature of how scoring was structured, it was easier for a shady judge to purposely deliver a low mark in figures to one skater with the hopes of giving another a better chance to win in the final. As a result, in figure skating, the best freestyle performance did not necessarily win the gold.

In the beginning and for many years, figure skating was the *skating of figures*. Then it evolved to two segments of a skating event, figures and freestyle. The segments were marked and counted in the total score. It was an archaic design that needed to be updated and changed to reflect modern times. Watching a compulsory figure being performed (a skater drawing out circles with turns and loops and tracing each drawing over one another in total silence) was a very skillful, but tedious event and about as exciting to watch as paint drying. By the '70s, with the onset of more television coverage, it was the freestyle skating event that really defined skating as a popular spectator sport and along with that, a great source of revenue for sponsors. It was evident that the sport was evolving and changes had to be made. Unfortunately, we all knew it would take quite a long time to see it happen, so it would have to wait for a future generation of champions.

Which brings me to the story of the
Great Canal Caper.

Toller last represented Canada as an amateur and Member of the Canadian World Figure Skating Team in March 1976 and, needless to say, he went out making a statement in spectacular fashion, as only Toller could do! We were all competing in the World Figure Skating Championships in Goteborg, Sweden during the week of March 2 to 7, 1976. Toller realized that this was the last time in his life that he would ever have to lay down another dreaded figure eight to be judged and marked.

It would be the last time anyone would have the power over him and determine his destiny by giving a grade that could ultimately destroy his dream of winning a world title. No matter what the outcome, he was determined to mark the occasion in style. It would be a day of personal satisfaction and celebration. It would be a day of taking back his power.

There was a buzz in the air. Toller had just won the Bronze Medal at the Olympic Winter Games in Innsbruck, Austria a month before. Everyone wondered if this last championship performance would be his best result. They lined up for tickets—daily. Journalists were eager for any news, but when you're in the midst of a competitive event, there is a dire need to remain focused on the task at hand, so it was all left to opinions and predictions.

A group of us on the Team heard the rumour that Toller had something planned. He hinted at it with a smirk and a giggle, so we knew he was up to something. Something was going to take place after he was finished with the figures event, but what? Our imaginations were running wild, imagining all sorts of brilliant schemes, but we had to be patient and let it play out the way things were meant to happen. So, we listened and

waited and watched and we followed, until lo and behold, we saw Toller jump into a cab carrying a black bag. Where was he off to? What was in that bag? We had to know.

So, we hopped into a cab as well, feeling every bit the sleuth one sees in the movies, off to solve the mystery of the century. It wasn't a chase, rather an excited request to just go where that cab is going. Subtle. When we arrived at our destination, we were more puzzled than ever. It was an old stone bridge over a canal in the City of Goteborg, not secluded or anything. People were all around the shops and buildings that lined the canal.

It was March and it was cold. I do recall that it was also a very grey and misty day. How apropos the conditions were for this kind of adventure! We saw Toller get out of his cab. Very stylish, like he always was, complete with a black fedora hat. Was he there to meet someone? We wondered who, and why here?

Then we saw him reach into the car for something out of that black bag. There was one object, then another. Strange. He crossed the street to get to the other side of the bridge and turned his back to the water. It was then we saw the mysterious objects in his hands. They were his skates! What? We still did not understand what was happening.

By this time, there was a crowd gathering around him. They recognized that this man was none other than Toller Cranston. Toller from Canada, the superstar ice skating champion! Those were the days before cell phones with built-in cameras but there were tourists in the area and tourists carry cameras. People started taking pictures and more people gathered around. We still thought that maybe this was just simply a Toller sighting and a picture opportunity so we contemplated heading back to the hotel but we hesitated, realizing that there must be more to this. Why did he have his skates? What he was about to do with them?

Putting two and two together, thinking about what he smirked about and hinted at and knowing that the Men's figure event was over and also knowing that skaters always carried two pairs of skates with them for competition (one pair for figures with specific blades and another pair with blades for freestyle), he was about to do something with those skates! But what? Sell them? Give them away? We had to stay and watch.

I wish I could remember what he said. But, I do remember that big beautiful smile on his face and his scream of excited laughter as he threw those skates joyfully over his shoulders and into that canal. His appearance suddenly changed, it was like a huge weight was suddenly lifted off his shoulders and you could see and feel his joy. I was so happy for him. I knew that burden was heavy, and he was now free of it and able to move on.

He signed a few more autographs, posed for a few more pictures, and then, in a flash, he jumped back into his cab and was off. We stayed in the area for a bit and grabbed a coffee and when we returned to the *scene of the crime* (that's what it looked like!), a huge crowd had gathered. Police cars and media were on site and everyone was watching the commotion down in the canal. There were now divers, with all the professional scuba gear, actually in the murky water. What the heck were they searching for? Did someone fall in? Was there an accident? After what seemed like hours, they started to pull up objects like old tires and shopping carts and odds and ends of junk that one would expect to find in a muddy canal. The crowd started to disperse. No excitement there, just an ordinary cleanup.

I think it was all a ploy though. The divers didn't want the public to see what they were actually spending hours searching for and what they were actually pulling up out of the water. They were purposely waiting for the crowd to dwindle.

Then a large white opaque bag was sent down to the divers. Clearly whatever they were bringing up was not to be seen. Perhaps they didn't want to explain why the City was spending their operating budget on retrieving—yes, you guessed it—Toller Cranston's figure skates!

There was a story that someone had paid big bucks to hire the divers to retrieve Toller's skates for his private collection. I don't know if that's true. Who knows? But I am glad that I stayed behind to watch it unfold. When we got back to the hotel, there was Toller, grinning like a Cheshire cat with a glint in his eye—one of those special moments in time and locked in my memory bank.

Fast forward to today. There is no longer a compulsory figures segment in a competitive event. What is judged today is the freestyle of skating alone, focusing only on the required elements and how well they're performed and the artistry of the performance overall. Some believe this change is good, some believe it's shifted too far from the origins. Many still agree that mastering figures will always remain the strong foundation in the development of a great skater, but not everyone agrees that it should have been done away with entirely. A better solution may have been to downgrade the weight of the mark for figures, putting more emphasis on the freestyle score to give the final mark a better balance of importance but then there will always be pros and cons.

Thanks to modern television coverage, dirty judging in figure skating was finally proven when caught on camera at the 2002 Olympic Winter Games, resulting in the scoring system being totally revamped to reflect what is actually being presented on ice. I can only imagine how different the outcome of Toller's skating career would have been had the transformation of the competitive skating structure happened earlier. Regardless, Toller was destined to continue making an impact.

It was now time for the next chapter to begin.

With competitions, figures, and the judging now out of the way, Toller was free to be free. It was time to turn professional and perform for the joy alone. Along with other North American Skating Champions, my skating partner David and I were thrilled to be invited to join Toller's new touring company and we did. We knew that Toller Cranston's *The Ice Show* was going to be an incredible adventure, a risky enterprise because we had to compete with the well-established ice-skating extravaganzas of the time, for a place in the world of entertainment. It was well worth it, given we were all part of something new, fresh, artistic, and exciting.

It was Toller's concept of presenting artistry on ice, purely and simply, no props or clowns or scenery. Our show was to be presented on a blank canvas of ice with champions performing their artistic creations. It was a new concept at the time but clearly, we were instrumental in doing something great, as the fans loved it. It was a chance to present the skating fan world more of what they wanted and deserved. It gave the fans the opportunity to witness live championship performances that previously were only possible to experience if you were actually in attendance or watched a championship on TV. Toller showed the way for the *Stars On Ice* performances of today.

We all stepped into the world of professional entertainment together—a chance to perform, rather than compete. We all knew Toller would thrive in this environment of absolute creative freedom and he gave us the vehicle to showcase what we all dedicated our lives to. We all wanted to be part of that history-making accomplishment and we will be forever grateful for being a part of it.

Ultimately, it is the audience that has always been the true judge of outstanding performance. Audiences know what they like, what moves them, what makes an impact by touching their soul. It is always difficult to watch the resulting placements not match what is expected. Hands down, the standing ovations and love for Toller worldwide was evidence enough that we were all witnessing something incredible. He most certainly left his mark and was a game changer in figure skating. For that, he will always be remembered as one of the best.

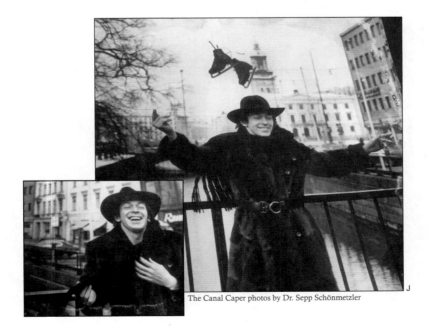

The Canal Caper photos by Dr. Sepp Schönmetzler

CHAPTER 6

THE ARTIST: A TERRIFYING OBSESSION

By Chris Talbot, Art Evolution

TOLLER

No one could criticize me for not being madly creative. It is a tsunami wave of creativity that I possess. As an artist, I don't question images or themes. This sounds arrogant, but it is fraught with experience. I never question my hand. I never doubt it. It starts and that's what comes out.[4]

A *terrifying obsession* is something that encapsulates who you are and what you are all about. Toller and I came up with a *terrifying obsession* as a perfect title for the Canada-wide exhibition that Art Evolution was planning for 2015. It is a concise analogy of how this man lived his life— not only in the creation of art, but in act of the creation.

Toller needs no introduction. He is, and will always be, the most famous figure skater in history. He was ahead of the curve. He broke all the rules and he paid heavily for his right to be uniquely artistic on the ice. What most people don't know about Toller is that most of his skating career was financed through the sale of paintings. Anyone who understands figure skating, knows that skating is a full-time endeavour. It is a demanding commitment with very little room for anything else and yet Toller was able to accomplish amazing things with his skating *and* to finance it through the sale of his artworks.

Art Evolution is privileged to represent some very famous artists from around the world. As an

international art dealer, one of the things that I focus on is the true value and the correctness of the artworks. There are millions of artists. Everybody knows an artist. Most people know a lot of artists. Basically, anybody who can hold a pencil or a paintbrush or a chisel could call themselves an artist. That said, I would venture to say, less than one percent make a living as a full-time artist.

How do you determine value? How do you determine what is correct, what is authentic? As a professional, I look at things very pragmatically. I break it down into three criteria that I use to establish the artists that I wish to represent.

The first thing I consider is, Is the artwork unique? Can you drive past it at 50 mph and say "That's a Picasso." Or "That's a Chagall." Or "That's an Andy Warhol." Artwork that is distinct is the Holy Grail. I've often said that the creation of art is the highest appreciation of the human condition. It is an attempt at immortality. Being unique is something that every artist aspires to in some form or fashion but very few ever accomplish. Toller Cranston's paintings are completely distinctive. You know a Toller Cranston the moment you look at it.

The next thing I want to know, especially when recommending investment quality artworks, is, Does this artist already have a history? Is there any dialogue behind him? Do I Google this person and find a couple of mentions or are there tens of thousands of entries as there are with Toller Cranston?

The final and most important criterion I want to consider is: *Does the art sell?*

Toller Cranston completed more than 300 exhibitions which is beyond extraordinary. There are only a handful of artists on the planet that have ever been able to do something like that. Picasso painted approximately 13,500 paintings in his lifetime and is revered as one of the most prolific and most sought-after artists of all time. Toller Cranston painted well in excess of 20,000 paintings and has sold every single one of them around the world.

For me, the most telling thing about the collectability of Toller Cranston artworks is that very few of his paintings have been offered up for sale since I announced to the world, his passing in 2015.

―――――――――――――― TOLLER ――――――――――――――

My skating and my painting are both artistic functions, both individual and both very much a part of me. The skating has definitely influenced my paintings because I am very much aware of fluidity of line, movement, and rhythms. I sometimes arrive at a motif on canvas and then I think maybe I'll just put that into a program.

I can go from morning till night working in whatever creative capacity I do. But it is like the red shoes. I can't stop. Many times, I have been out that door at 10 o'clock at night, but the paintings are like petulant children telling me "Come and fix me, come and work with me," and I go back and just do a little bit more. A painting that demands too much energy and attention because it is not finished will have to be turned to the wall. Then it can't speak to me because there's no voice. I leave every day, never satisfied, tormented that I haven't done enough.

It is never about what you have done, what you have accomplished, it is always about what you haven't done or what you should have done. The lack of self-worth is omni-present and it haunts you day and night because you are never satisfied with who and what you are.[6]

TRULY AUTHENTIC

By Donna Child, Donna Child Fine Art Gallery

I met Toller Cranston many years ago in the very early days of my art career. I was mildly aware of his skill as a painter and very aware of his achievements on the ice. He was wearing forest green baggy corduroy pants, a forest green turtleneck, and the most brilliant canary yellow pointy shoes I had ever seen. He *owned* this outfit and carried himself with the confidence of the champion that he was. This meeting set the stage for a twenty-five-year on-and-off business relationship that would impact and alter my career and my life in a manner that was completely unpredictable and on a trajectory for which the ending has yet to be written. That is a story for another book. Our relationship was often fraught with the trials and tribulations of an artist and an art dealer—but the mutual respect and admiration we held for each other never wavered.

The years of pushing forward the frontiers of the skating world and his bold and courageous personality gave Toller a confidence or as some might call it, an ego. Toller had the ability to walk into an exhibition opening and command amicable submission just through the sheer force of his personality. I think back to one of the last openings I had with Toller. Just before we were ready to open the doors, with more than 200 guests waiting to enter, and much of the exhibition already pre-sold, Toller asked me for our tallest ladder. As people entered, they couldn't help but be immediately drawn to Toller, ten feet in the air, "touching up the varnish" on a painting that was already ten years old, and in perfect condition. Without saying a single word, he had a completely captive audience, and the show did sell out. People were naturally drawn to listen and to observe him. He immersed them in the charisma that he radiated.

Toller had a deep personal commitment to his art and he stood by his practice. He rarely made public any of the most sensitive, thoughtful, and elusive processes by which his work emerged. This was also true of his personal life. The one question that is often asked about his art is "What was he thinking when he created this piece? Where was his mind?" On that, we can only speculate and he would love us to do exactly that.

Even though early on, the upper echelons of the art world were not always enthusiastic about Toller's art, Toller had faith and trust in himself. He never created art to meet the expectations of others. Over the years, I have sold countless Toller Cranston original oil paintings, drawings, limited-edition prints and collectables to private and corporate collectors from around the world. Toller was fantastical and his public audience, his clients and collectors craved him, and his art, and they still do.

How do I describe Toller as an artist?
He was never an imposter. He was truly authentic in everything he created.

THE FIRST BRUSH STROKE

By Scott Umstattd

I remember talking to Toller about an artist's intention behind the first brush stroke of a new painting. He told me that sometimes the artist waits for the canvas to express what it wants and so the intention behind the first stroke is like "Let's get started. Put something down and see where it goes." Other times, the intention behind the first brush stroke is calculated and it's more like "I know what I want from this painting and this is the first of many strokes I will make to get me there." Toller said that it doesn't matter how you get that first stroke on the canvas. Either way, you are painting and that's what you want to be doing.

THE IMPORTANCE OF CROWNS

By David Dunkley, Fine Millinery

Growing up in the 1970s, Toller's skating accomplishments and his trail-blazing personal convictions were hugely impactful to me, a young gay boy, attempting to discover my own identity. This bold, proud, Canadian man was an international star!

It wasn't until my late twenties that friends introduced me to Toller, the artist, and again, I found my life impacted by this great talent.

It was while studying millinery with Rose Cory, Milliner to Her Majesty Queen Elizabeth, the Queen Mother, that I began to understand more deeply the importance of "crowns"—actual crowns, heraldic crowns, or simple hats. In conversations, Rose would share that for Royals, and for simple folk alike, donning a hat could dramatically alter how an individual is perceived.

Many of Toller's subjects sport a hat or crown, embracing an old millinery secret: "crowning" a head forces all attention into the eyes of individual. If the eyes are the window into the soul, Toller understood the power of dressing those windows with the finest embellishments—millinery.

Through bold expressive faces with deeply eloquent eyes, Toller welcomes us into his magical worlds of fantasy and joy. Thank you, Toller, for this journey.

PAINTING IN SAN MIGUEL...BUT NOT PAINTING SAN MIGUEL

By Donna Meyer

Many artists come to San Miguel for the light. They paint the colour and movement and life of the Mexican scenes around them. Toller adores San Miguel. But he doesn't paint it. In fact, he often closes the curtains in the studio when he works. He says, "The colour from the gardens is just too much of a distraction. Artistically, I'm at the top of my game," he claims of his work today. "But I know time is finite so I am in a frenzy to create. I'm very cognizant of the now."

Many of his canvases are smaller now. "Splendid achievement has absolutely nothing to do with size," he says. "A queen can checkmate a king, but so can a pawn." But even these small pieces are filled with that distinctive sinuous line, so like his physical style as a skater, bold colour and perfectly executed detail. He calls the style of his work "mystic symbolism."

Toller Cranston and San Miguel de Allende have found the perfect point of balance, each adding to the other. He knows this is where he is supposed to be right now.[9]

TOLLER

Being creative and being true to your creative resources is the only thing that makes any sense. The people with the money, all they can do is buy this stuff. We make it. The talent, and the creative luxury of making it, far exceeds any amount of money in any bank. It is the creative people of the world that are the richest.[4]

The room where it happens.

BOLD COLOURS AND CAPTIVATING IMAGERY SPOKE OF TIMELESS FAIRY TALES AND LEGENDS—BOTH FAMILIAR AND OBSCURE

By Debra Usher, *ARABELLA*

There was no end to his creative use of colour, and woven in his almost medieval images, were tales both past and present.

A richness and exuberance came alive on the canvas that Toller painted. Both his human and animal creatures that inhabited the story paintings were all part of a procession, carrying the eyes of the viewer down the proverbial rabbit hole. Where you allowed Toller's paintings to take you was your choice, sometimes, and there was always a myriad of choices available to you the audience.

In the beginning, when I first saw one of Toller's paintings, I noticed the almost Scandinavian folk art quality. But as was Toller's wont, no true pattern was painted—just a swirling, dancing collection of imagery from the master's mind.

His collective subconscious, where these delightful creatures came out to play, was carefully thought out and constructed. These were not aimless ramblings but high storytelling at its best. He understood the museums, castles, and cultures of the past. From his many trips, great ideas were stored until, at last, they could race and play on the canvas created by Toller's hands and mind.

His artistic expression and unsettling creativity was bold, gorgeous, and audacious. Toller was an innovator and expressed brilliance in his masterful strokes and combinations. Always there was movement, colour, and his fearless use of brushes produced a harmony that was always in discord with a pattern.

No matter the painting, there was always humour somewhere and always, always laughter.

When I first saw some of his earlier artwork, I didn't pay a lot of attention. I was collecting complicated landscapes and wasn't really into figurative or artwork with people. But I was deeply into stories and tales deep from the artist imagination.

I rediscovered his work a couple of years after my first impressions—which never really are a good guide of where you are going to end up. Here, looking at the bold use of colour and imagery, I became captivated by the paintings of a mischievous angel. The paintings seemed to be moving, whether swirling on icescapes, racing on horses or riding the air—the players in Toller's stories were quick and never quiet.

Toller was his own culture—his own country—and always set a tune that other artists could not hear. Always bold and never subtle, always colourful and never dull, Toller lived life out loud and we should always choose to follow when someone larger-than-life offers to lead the way.

I am in this hard price range. It is like plowing into a wall. Anything from $10,000 to $20,000 is like frozen. To get over $20,000 is really hard. Many people would accuse me of being commercial which then negates being a valid artist because in their minds to be a sincere and real artist, you have to be Van Gogh, cut off your ear, and starve to death. That, of course, is ridiculous. The criteria for genuine art is basically a three-pronged fork—originality; a style that is easily identifiable; and, most important, a technical excellence that is conspicuous.

My paintings are exactly like my skating. Very me, good or bad. Very decorative, good or bad. And very unusual, good or bad. I am a painter first and a skater second.[4]

John Rait

Part of the fun of working with Toller is that his mind is as elaborate and as detailed as the detail in his paintings, if not more so. You never know who's going to be there with you on that day, on that journey and I think that is part of the fun of it.

Toller knows he is a commodity. I think that he knows what he represents and where his niche is in the world. Do I think that he paints with a price tag attached to the canvas? No. Do I think that happens after he's completed the creativity? Yes. Is he aware of it? You bet! You don't last as long as he has lasted as an artist without knowing where your pennies are, and he is definitely aware of that.[4]

Melissa La Porte
Executive Director, Curator Temiskaming Art Gallery

One of the most striking things about Toller Cranston—his work, his skating, his personality—was how distinct he was from his peer group. Growing up in Northern Ontario in the 1950s, a little boy who figure skated (who had even dreamed to dance ballet), instead of playing hockey, would have been an anomaly. Rather than letting criticism overwhelm him or derail his art, Toller seems to have embraced his difference. He took it up as his mantle. Toller's larger-than-life artwork, bold colours, and ostentatious sculptures reflect the fissure he made in the world for others to express their creativity more freely as well. By being so bold, so over-the-top, Toller made it easier for others to express themselves with less censure by bearing the brunt of criticism on his wide, undoubtedly well-clad, shoulders.

Gary Slipper

I remember the silence and then he would come swooshing out on his skates.
He sure could skate.
He was a good man.
He was nice.
But he was difficult.

A

Charles Pachter

I have some photos taken at my farm in Oro-Medonte on Canada Day, July 1, 1978 that show Toller in his prime, age twenty-nine, at the height of his skating career, looking elegant, urbane, sociable and mischievous. We were buddies for a while in our youth. However, I would have liked to know him better. He was actually quite shy. His skating talent never failed to astonish me. His output as an artist was unusual, with a style distinctly his own. He was a true original.

V

ICON ON FIRE

By Chief Kris Nahrgang

As a child born in the 1950s, we lived in a different world. Our priorities and lives were so different. The events on our six-channel televisions were the highlights of our country in politics, regular television shows, and the world of sports.

One of these highlights was figure skating, and the incredible talents of our Canadian skaters. We all watched in awe as these artists took to the ice to live their vision, and to include us in their journey.

I feel fortunate to be of this time, and to have been able to enjoy the talents which captivated this world when it was a simpler place to exist.

I, myself, was a dancer as a child, and I lived many lives along the way. In the end, I became a professional artist, and found the art of a childhood icon.

Toller Cranston embodied the true definition of an artist. His infusion of colour, imagination, and grandeur are truly a sight for all to partake in. Sadly, I never had the opportunity to meet the man, but I have been honoured to enjoy his vision through his works of art, and to enjoy his jackets that speak to us all as I wear them in his honour.

His presence in this world will never be forgotten, and his attention to detail, and colour, will always be a memory in my thoughts of his gifts shared with the world.

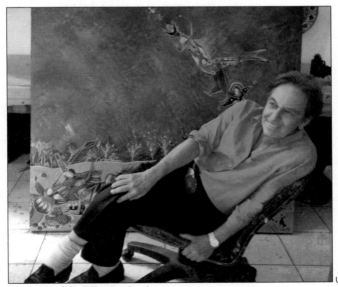

Toller in front of *We All Float Away Someday*

German Llamas, Antigua Llamas, San Miguel de Allende

I used to go in the afternoon to visit him and help him to arrange all the paints because he has hundreds and hundreds of paints in a big, long table—so beautiful—the best studio that I ever see. His painting was so magical. Magical and very realistic. At the same time, he was doing those kind of faces that always exist in human history and but he dressed them like kings in Middle Ages.

Jeanne Beker

I'd go over to his house and he'd be there with paint under his fingernails, paint-splattered chinos and a sweatshirt, just doing his thing—dragging his hands through his hair as he always did, being inspired, and gleaning inspiration from everything around him. An artist, truly an artist through and through. It just saturated every fibre of his being that artistry and that desire to express something deeper and larger-than-life.[4]

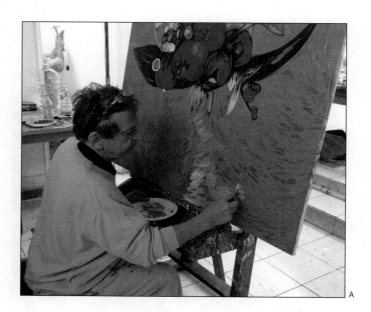

TOLLER'S DRUMMERS AND THEIR SERENADE OF HOPE

By Nadim Kara & Karim A. Remtulla

Our profound encounter with Toller's artwork happened in the early spring of 2018. On an unusually warm and languid evening, we relaxed in our lounge and enjoyed an intensely spicy charcuterie spread, a deliciously textured jumble of fragrant cheeses, and a defiantly sweet cabernet sauvignon. To us, this was a repast very reminiscent of Toller himself.

As twilight encroached, our conversation inevitably turned to "Drummers" (2011), the most recent acquisition in our collection of Toller Cranston original paintings. We spoke about how uncommon "Drummers" was within Toller's body of work in that it depicted two male protagonists: the drummers. We noted how the winding, twirling, swirling mélange of sensations, emotions, and colours manifested as the two danced and drummed together in a state of utter reverie; gazed at each other intimately with expressions of longing, secrecy, and mischievousness; and, were lost to the world in an ecstasy of relentless rhythm, celebration, and togetherness. We riffed on the indigos, turquoises, and antiqued golds that intermingled and intertwined with accents of colonial ivories and blood reds. And we bore witness that in the span of a single shared glance, the drummers sparred, dreamed, soared, and made love. They shimmered and glistened in a bacchanalia of percussion, pulsation, and pounding.

Our dialogue then took on a more serious tone. A closer read of "Drummers" exposed something far more poignant. We understood this work of art to be quintessentially postmodern in its approach to representation. The externalized depiction of unrestrained merriment might arguably have been juxtaposed against an internalized and seething alienation. The drummers became an ironic testimonial to those LGBTQ+ peoples who may have found love, and yet still chose to honour their relationships stealthily within an otherwise hostile society.

"Drummers" was perhaps also an artist's subtle deconstruction of overly simplistic views around aesthetics, work, and identity for LGBTQ+ peoples. Whether in Canada or around the world, many LGBTQ+ people who came from diverse walks of life including artists and athletes were still living each day in hiding, feeling shame, and fearing political persecution, economic marginalization, cultural exclusion, and social isolation. Sadly, the very sense of openness, companionship, dignity, and acceptance depicted in "Drummers" also eluded Toller many times throughout his life. "Drummers" quickly came to signify for us the concurrent jubilation and melancholia of our own life journey.

We are the drummers. We are a same-sex, cisgendered, East Indian male couple. One of us was born in Dar es Salaam, Tanzania, and the other in Montreal, Quebec. We have been together for almost twenty-five years. Our relationship spans the late twentieth and early twenty-first centuries and is also an inescapable bricolage of artistic, athletic, LGBTQ+, and global influences. And this was the moment when we began to talk very seriously about getting married and someday, maybe even raising children.

We got married in Toronto in the summer of 2018. Our wedding was themed An Homage to Love, Life, and Art. We and many of our family

members and friends represented love. Like the drummers, our jubilant wedding day also had a tinge of melancholia as we could not celebrate with those members of our families who did not approve of or accept our love.

The symbol of our life together in Toronto and our love of art came from the place where we got married: The Aga Khan Museum, Toronto. We were the first LGBTQ+ couple to hold a civil marriage ceremony at that

Karim Remtulla (l) and Nadim Kara (r) x

museum. Given its significance in the origin story of our nuptials, we used "Drummers" as a central inspiration in choosing our wedding colours and grooms' sherwanis. We also placed an image of "Drummers" on our wedding invitations and in our wedding album.

We use the term stewardship whenever referring to our art collection. For us, this term connotes the simultaneous assuming of a duty-of-care for a work of art itself as well as accepting of social responsibility and cultural accountability for praxis towards the fulfillment of the artwork's intent. Stewardship brings with it a continuous commitment and intentionality to preserve silenced and oppressed histories and then later liberate them into many possible and better futures. A vision so eloquently and touchingly articulated by the drummers and their serenade of hope.

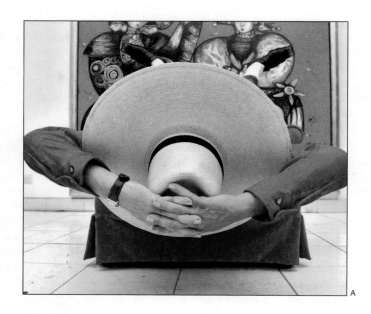

A

TOLLER CRANSTON: *Ice, Paint, Passion*

INDESCRIBABLE BY DESIGN

By Jeanie Gooden

Toller would make an impression one way or another. He loved the stunned looks followed by smiles and jaw drops when entering his home. He couldn't add enough to be enough.

His property and creations were indescribable by design. He was never random or scattered. He was simply laser-focused on 20 or more things at once. I believe that all chaos quieted when he rested inside his paintings. In the hours at his easel, I sensed Toller was at ease. I believe that the studio was his real home. The lavish property was simply a wonderland that he created to share.

Toller's influence on me as a painter is deep and lasting. He never tried to teach me painting techniques. He was more likely to call to me as he raced by, *"Think Pink!"* Each time I open a tube of pink paint, I remember those words with his laugh as an exclamation point.

I realize now that I learned by watching. Toller's process began with a drawing on a raw white canvas. He was quick to say how excellent he was at freehand and indeed he was. He was adamant about informing collectors that his drawings were not projected. Each was drawn and it was amazing to watch. He could draw a figure in a flourish. Toller could freehand a line so straight that it looked like a rule was used. I watched him work many times and never once did he make corrections as he sketched. Toller's drawings were that precise and fluid.

Once drawn, he would begin to add colour to the drawing. Just as the figures of fantasy were beginning to come to life, he would brush the entire painting with a thin purplish glaze. When dry, he would breathe life into the paintings with layers of brilliant colours.

One afternoon, I entered the studio to find the floor covered with 'purple phase'. The paintings were glistening wet but I could see the colourful images veiled beneath. While maneuvering around them, I stumbled and stepped firmly into the middle of a large painting. Horrified, I saw my footprint glaring back at me. Toller wasn't in the studio and I panicked. What to do? My decision was immediate. I ran to find Toller.

 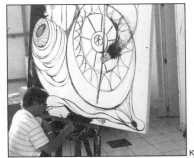

With a frantic recital of despair pouring from my mouth, he listened. With a grand pivot toward the studio, Toller said, "A painting is never ruined. Remember that." I did and I do.

Toller was intentional and he made it impossible to capture anything about him in simple terms. He was layered and I adored his joy in collecting. Our bond was in enjoying similar things—art and Mexico.

We shared a little craziness that we liked to tease about, particularly when it came to art. His work as an established and renowned figurative painter was drastically different than mine as an emerging abstract painter. While many of his collectors passed my easel with zero interest, Toller made sure that I knew that he found my work interesting. He understood that his support was a gift to me.

In retrospect, I have a greater understanding of just how deeply Toller influenced me. At the time, I was simply amazed at his energy and non-stop creativity. I knew his talents, but now I fully appreciate them. He would tell me that being creative was the ultimate goal. He was a teacher and his work was his classroom.

During our time as friends, I never produced a show that Toller did not review. In late summer of 2014, Toller arrived at my studio in a heavy rainstorm. Protected by his hat, he took a seat as I began pulling paintings into view. One by one, he looked carefully. He always had rankings and favourites. He was never critical. That alone amazed me. The moments sharing my art with Toller are my most cherished, for I know that it also meant something to him.

Early in our friendship, there were many photos taken of Toller with guests. He allowed them but, with time, preferred not to. I didn't wish to appear that I would exploit his privacy so I chose not to take photos with him. I regret that, as the only photos of us are pinned to the walls of my memory. The memories of Toller and me are forever mine.

He adored Mexico as I do. Experiencing Toller changed my art forever. His red reading glasses stay close in my studio and his words rest in my ears. He would like that.

Writing about my friend is easy for nothing must be embellished.

Toller was embellishment. He knew that to live forever, each memory must be as big, bold, and bright as he could possibly create.
Viva Mexico. Viva Toller.

LIFE WITHOUT ART? *INTOLLERABLE!*

By Christopher and Elaine George

ARABELLA, 2013

Talented, flamboyant, outrageous, a genius. Whatever else he may be, Toller Cranston is undoubtedly a Canadian treasure. Not only has he achieved prominence as an athlete, Toller has also been hailed as a painter extraordinaire. We have precious few cross-platform artists who have been acclaimed in so many ways. Membership in the Order of Canada, recipient of two honorary doctorates, Olympic and world championship medallist, and representation on Canada's Walk of Fame are among the numerous accolades he has received. This list alone puts his accomplishments well ahead of any other Canadian artist.

Toller's ability to switch from world-class athletic performances to finely detailed, and indisputably original, painterly offerings is proof of a chameleon-like facility that rarely, if ever, has been duplicated. He has a true Olympian work ethic. The stamina that allows him to paint eight hours every day is, according to Toller, the direct consequence of the intense physical training needed to excel athletically on the world stage.

Even as a young child, Toller had art in his soul. He exhibited maturity in his drawings that was hard to classify.

In the late 60s and throughout the 70s, skating took Toller to Europe countless dozens of times. He took full advantage of the opportunity. While most of his fellow skaters would head directly to their hotels (or to bars) after a trans-Atlantic flight, Toller would visit the art museums. Being able to visit the Louvre, the Uffizi, the Hermitage, the Tate, the Prado and other major art collections allowed him to absorb the techniques and scrutinize the brush strokes of the masters.

For Toller, creating art has been his single most important undertaking. It is this activity that is as necessary to his life as is breathing.

Most days, he is up before dawn and at his easel. He does not need to summon the artistic muse that often eludes writers, painters, and other creative types; he feels it there immediately. As brush hits canvas, he says that he is enveloped by a great calm.

Unlike most artists, he does not draw preparatory sketches, but goes directly to his canvas and begins to outline, in black oil paint, the concept that is present in his imagination. In the same way that Mozart was said to have merely written down the completed symphonies that existed in his mind, Toller transcribes his vibrant visual orchestrations into painted sonatas.

One can easily identify a Cranston painting from a distance. There is a strong level of continuity in the artistic renderings of this prolific painter from the very early years to the present. He admits that he was born with a predilection for the styles and the art of Asia: its rich patterning, vivacious colours, textures, and geometric ornamentation. His paintings are often large, quixotic depictions of individuals set in extravagant costumes and richly constructed landscapes. Vibrant and sometimes bold pigment usage challenges the viewer to look past the pleasing hues and consider the mythical, symbolic and imaginative world presented in the piece.

Toller's artworks, therefore, seem to be emanating from times past, when horses were the mode of transportation and the aristocracy, clothed in

fabulous finery, were mounted upon them. You won't often see a car in a Cranston work; the paintings offer a Tolleresque vision of the past. It is no shock, then, to find the equines bedecked, in the same regalia as that found on the humans. The mythical head-gear and finely detailed livery are partly based on historical fact but mostly influenced by the creativity of the painter.

When horses do appear in a canvas, they are regularly in a supporting role to the theme of the piece and are rarely rendered alone. Consider the masterpiece "Rein of Destiny" in which riders and horse together make a cumulative fashion statement whilst a menagerie of sometimes wild looking, but never threatening, birds, animals, insects, and reptiles, find their way to join in the frolic. Toller loves words and plays with the homophones "rein" and "reign" inviting viewers to focus on the horse's blue control strap as it connects the two lovers riding into the future over which they will be sovereign. It is often, but not always, in the naming of his work that Toller plays with you.

His goal is simply to paint the pictures that inhabit his head. Toller likes to jokingly steal a line from René Magritte, the Belgian surrealist painter, saying "the only thing behind my paintings is the wall." In truth, his images have an important nuance that pertains to his deeply-held beliefs concerning fate, destiny, dreams, struggle, performance, failure, and effort.

Skater, painter, designer, creator, innovator— Toller will undoubtedly continue his multi-faceted artistic exploits until time and age unceremoniously steal his brushes from him, preventing him from doing what he was born to do.

In the vast, colourful palette of Cranston's life, we find a man of extraordinary ability whose creative productivity appears endless. We have seen, on deeper examination, not just an artist to collect but also a man to be admired.

Well-fêted for his athletic endeavours, and internationally celebrated for his artistic offerings, it is both frustrating and curious that, to date, no major retrospective show has been mounted to commemorate the feats of this multi-disciplined, unique Canadian superstar. It makes one wonder what has to be accomplished to be worthy of such an honour.

It is time for the top museums in the country to acknowledge what people the world over already know; he is a one-of-a-kind painter and athlete, the likes of whom will rarely, if ever, be matched.

If he doesn't merit such a celebration,
it is hard to imagine who
possibly would.

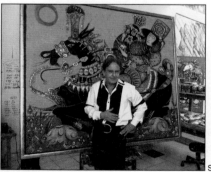

Rein of Destiny

TOLLER WAS AN ENIGMA

By Barbara Lamb

Toller was an enigma. Quiet but flamboyant. Solitary but social. Ethereal but athletic. Spiritual and yet grounded in the present. He presented himself as an artiste, an outrageous performance artist who deliberately and constantly challenged and demanded responses from the thousands of people he drew around him over his life.

His home and property in Mexico were performance art—a fairyland of beauty crammed with colourful objects. It commanded awe. Yet, his inner life, as manifested through the art he created was quite the opposite—quiet, solitary, and deep. His art was anything but outrageous. He lived with a daily discipline well beyond what most of us could ever conceive. His studio was monastic, designed for one purpose. To create.

Few of us could manifest such dualities without being stark-raving-out-of-our-minds. But Toller really was able to live in two almost entirely different realities each and every day.

TOLLER

I am unique because I became world class in two things.
Da Vinci was never the figure skating champion of Italy.[1]

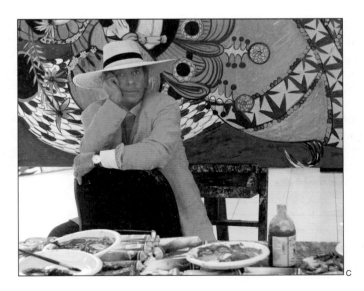

PORTRAIT OF A SKATER AS A YOUNG ARTIST
JUST WHAT DOES TOLLER CRANSTON HAVE TO DO TO PROVE HIS GENIUS?

By Barbara Sears for *Maclean's*

As the tempo of his training increases, Cranston retreats more and more into his painting. "It keeps me sane. It's something I can grasp onto," he says. In the long run, painting is probably more important to him than skating—he'll certainly go on painting years after competitive skating is a physical impossibility. Harold Town once dismissed him as a "Sunday painter" but more than 500 people crowded into the gallery on the opening night of his showing in Germany. "I really like Canada," says Cranston, "but you have no idea how much more I'm appreciated in Europe, both as a skater and an artist.

"I can walk down Yonge Street in Toronto for hours and nobody would recognize me. In Munich or Moscow [where he skated to a packed arena in December] I'll wave down a taxi and the driver instantly knows my name."

The fantastic, sometimes ferocious, paintings that constitute Cranston's finished work all start as totally formed images in his head. His paintings have immense detail and are the result of anything up to 500 hours work.

At 25, Toller Cranston has been Canadian Figure Skating Champion for four years and has twice won the free skating section of the World Championship. The first time, in 1972, was something of a surprise, the beginning of what has become a remarkable international reputation. Last year, when he again won the free skating gold medal in Munich, he was described by the German press as "the skater of the century." Canadian press reaction to his performances has been decidedly less effusive, which still annoys Cranston. "As a skater, I would never have been as successful as I am had I not made it outside this country first," he says. "When I won the free skating in the World's at Calgary before a panel of international judges, Canadians took a different look at me. After Munich, they took another look. All of a sudden, the freak became something more expressive, more profound, more pleasing to people." Cranston sees a close parallel between his skating and his other career—painting, where he has met with similar indifference from Canadian critics. His magic realist style has been much more successful in Europe, particularly in West Germany, where he had a one man show in December and sold several of his canvases, some for as much as $6,000. "I am now determined to spend five years becoming known outside Canada. What good is it for me to exhibit in Winnipeg, Vancouver, Montreal, Toronto—who gives a damn?" The Canada Council didn't—it turned down his application for a grant.

"Do you have any paintings by Toller Cranston in your gallery?" Maia-Mari Sutnik, a curator at the Art Gallery of Ontario was asked after Cranston's death. "No," she replied quickly. "His work doesn't fit into any of our collections. His work is decorative art. And then he left the country. He wasn't part of the community. If you have a Toller Cranston piece, just keep it and enjoy it."

FANTASTIC. FLAMBOYANT. KIND.

By R.M. Vaughn

Wearing a white fur coat cape-style, the collar clutched around his neck, he burst out of the CHANEL store looking furious, upset, and ready to run. Or at least hail a taxi.

"Mr. Cranston!" I blurted out. He stopped, gently shook himself, and then said hello. I was too young and too stunned to do anything but say, "I enjoy your work", or something equally flat. He said thank you and walked on.

Then and now, this remains my idea of glamour. Glamour is in a hurry but never forgets to be kind.

When we talk about Toller Cranston and his work, we forget the sweet, the cheery twinkle, and focus, too, too much, on the bitter—on his sense of being an exile, of being overlooked and dismissed first by the Canadian figure skating community and then the Canadian art world.

Yes, his work is fantastic and flamboyant and arguably even, at times, lurid. Well, what's wrong with that? Have you seen any Canadian art? Not a lot of colour, not a lot of light. The Canadian art world idea of a glamorous life is a tenured position at a mid-range university. Toller Cranston wanted more.

More colour, more dreams, more flights of fancy. In other words, freedom.

TOLLER

I do want to be taken seriously as an artist, but yet, I really don't have to have somebody put the seal of approval on me because my life is the real deal. I am an artist. I know that. And if nobody else knows it, I know it.[4]

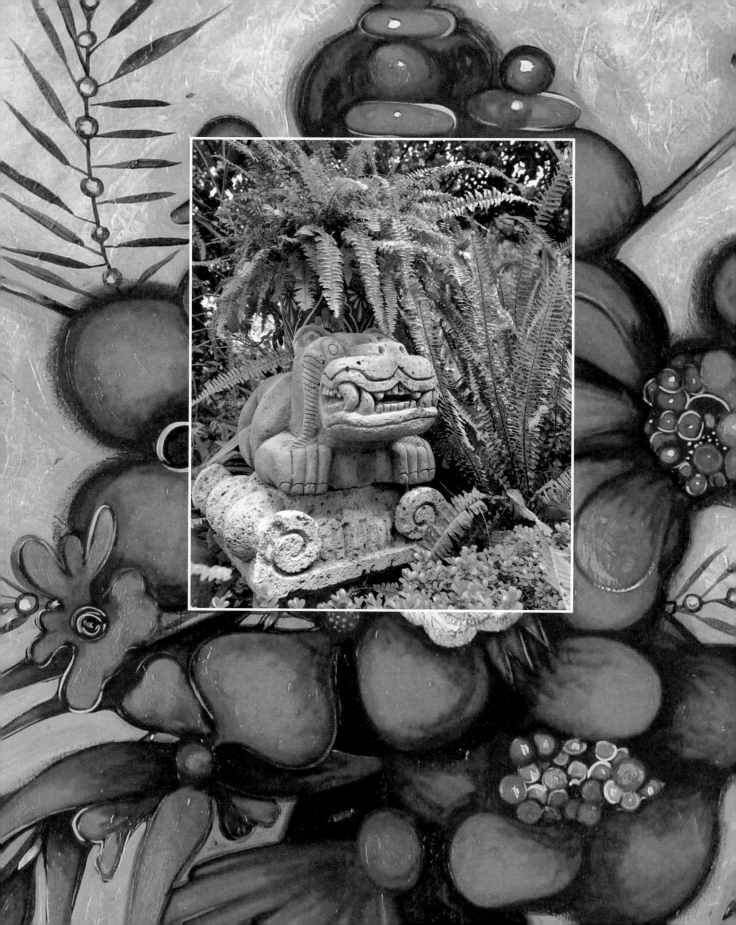

CHAPTER 7

OLÉ! CASA TOLLER: THE MEXICAN PERIOD AND THE PROPERTY

By Phillippa

"He upon whose heart the dust of Mexico has lain will find no peace in any other land."
Malcolm Lowry, *Under the Volcano*

After years of triumph and heartbreak, Olympic Games, World Championships, *Ice Capades*, Broadway, Television, years of fighting the skating hierarchy, years of being adored by the public, Toller left his base in Toronto for San Miguel de Allende, a 16th century colonial city in the central highlands roughly four hours north of Mexico City.

San Miguel is the cradle of Mexican independence—the city from which the patriots launched the revolution against Spain. It is known for its baroque Spanish architecture, narrow cobbled streets, fine arts, fine crafts, and culture. It was named a UNESCO world heritage site in 2008.

San Miguel is built on quartz. It is said that the city either embraces or repels everyone who arrives there. San Miguel embraced Toller. The attraction was powerful, mutual, and immediate. In 1992 he bought the property on which he lived, worked, and created until his fatal heart attack on January 23, 2015.

There are those people who think that you choose to come to a place and that is one way of getting there. But the place could summon you as well. Or invite you. Or your own personal destiny could get you there.

Many years ago, I had a tarot card reading and the lady said, "You have to get out of Canada. It is not the right country because the culture is too new. You must go where the earth is ancient and it is there you will become the person you are supposed to become."

San Miguel was my destiny. At the time, things were strangling me. My life had become too lavish. I resolved to buy a place in Mexico and surround myself in white.[1]

I arrived in 1989 and was taken to the Santa Monica Hotel for a drink. I remember thinking I like it here. I want to stay.

Before I had even really set my foot on the ground of San Miguel, I asked the owner of the hotel if she could recommend a realtor and I got into a car and began to look for houses. I looked at houses for the next three years. I was a realtor's worst nightmare. I liked things but I wasn't biting. My realtor finally said with terrifyingly frightening politeness, "What is it you are looking for?" and I replied, "I will know it when I see it."

This property wasn't really on the market, but there was a rumour that it could be. The main house dates from the 17th century. It had been a tannery for more than 200 years and later a home for delinquent

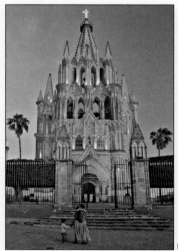
The Parroquia

Up to the Studio

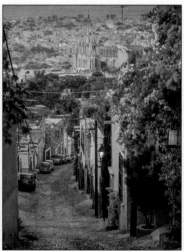
Down to the Parroquia

teenagers. I arranged to see it. When the door opened, I took one look and said, "This is it." Then for the next year, I tried to acquire the property. There was a point, and this has happened to me several times in my life, when I told the lawyers, "Oh, by the way, if you can't come through with this deal, I'm going to have to kill myself, just so you know." I had already given them cheques for 90 per cent of the asking price. I had no receipts, no paperwork, no proof. I had sold everything I owned, so basically if the deal fell through, I would have to kill myself. I felt like I was in a racecar going down a highway completely out of control, but for some reason staying on the road. At some point, all the papers were signed except that my name wasn't yet on the deed and in this town unless your name is on the deed, you don't own the property. I decided to go see a lawyer—one of the tough guys in town. After so many roadblocks, I was convinced there was a great conspiracy against me. So, when he didn't show up at his office, I went to his house and sure enough, there was the book of deeds on his table. I signed the deed across the entire page like d'Artagnan with his sword, and the place was mine.

Incidentally, this positively fabulous property was a veritable ruin and a dump, but I have always seen it as wonderful. I've made a number of changes, but I would never change the essence of the property—the charm of it, and the layout. The negative space and the flow of air here is very special.

The biggest influence, which is absolutely an appendage, almost like another arm of my life, my existence, my being here, is this garden in which I live. The garden wields a huge influence in every conceivable way.

One sees colour combinations that you would never see in normal life. The colours you see in nature have a huge influence on the colours I choose as an artist. Irregular shape is something which is important to me and it is always found in my images for paintings.

This property, in all its complexity and confusion, is really a property where kids walk in the door and get sucked into a certain enchantment. They can run. They can hide. They can play. The child-like enchantment does not mean that an adult can't experience the same thing. Everything has a sophisticated sense of amusement.[1]

I am forever being dazzled by Mexico—visually, culturally, architecturally, horticulturally—everything.

Toller created a jungle in the central highlands of Mexico

Years ago, I had a big auction at Waddington's and sold everything I owned to raise money
for this place. My idea was that I was going minimalist. Now, when people walk into this property,
they look at me and say, "Well, you've been busy. What happened to your minimalist?"
And I say, "Oh, well I got over that."[4]

Toller makes no secret of the fact that he is always at risk of living beyond his means. His house and
gardens are filled to capacity. Where one beautifully painted plate would be enough for most of us, there
are fifty. Where one glass ball would suffice, there are 100.

His large expenditures necessitate constant production and courting of the market. In every corner of
the many buildings that dot his jungle landscape, there is evidence of his voracious visual appetite.
Curiously, Toller's studio is a stark exception. It is white, entirely bare—an empty space waiting to be
filled. He admits that he applies the same discipline to his painting as he did to his skating career. He
paints until he exhausts himself.

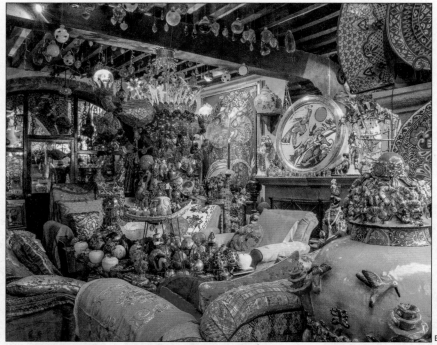

Meriké Weiler (City and Country Home) described Toller's property as "a romantic, cluttered, colour-saturated, extraordinary
treasure trove that is ultimately, an extravagant self-portrait of Cranston himself."

My sense of design re houses is exactly the same as the paintings, exactly the same as the gardens which is launched from artistic self-indulgence, so the environments here are done for only one person, which is me. The resident is the very person that creates the thing which is different from the resident buying them or the resident hiring a decorator to do things.

Beautiful things have nothing to do with money. It's an eye that can find them.
And in this town, you can find them on a street corner.

Buying in quantity one might say is a classic example of obsessive compulsiveness but in fact, where the workmanship is so great and the prices are so great you would be totally remiss and foolish not to buy these totally great things. In the final analysis, they are the components of a collection.

Money is to spend. You can't take it with you.[4]

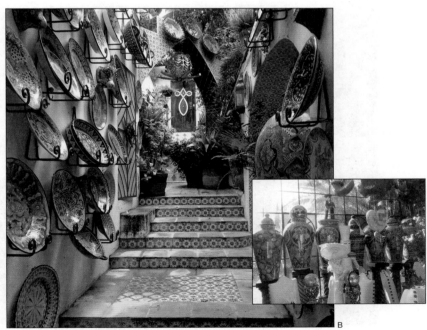

If something is worth doing, it is worth overdoing.

Tony Eyton

It is widely known that over a weekend, he can sell a couple of paintings and have $25,000 in his pocket and a couple of weeks later he'll be rooting around in the couch cushions to find a few pesos to call a taxi.

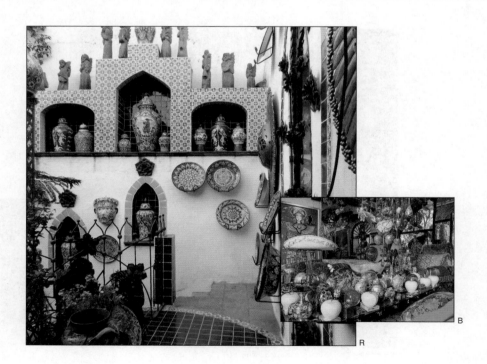

NOT GOOD WITH MONEY

By Tony Eyton

Toller was never very good with money. He financed his activities and essentially his lifestyle here in San Miguel by running up to an ATM machine in the middle of San Miguel and withdrawing money on a daily basis—sometimes two or three times a day. That was his banking system. Of course, he had no financial records. He just went running up to the ATM and got the money. But one day, he went running up to get the money and the machine refused to give it to him.

Then he was in a bit of a panic because he didn't have access to any money, so he called me…we lived a block away at the time. Given his complete lack of computer knowhow, he had relied on me for several years to track his main account at the CIBC via internet, basically to keep him informed of impending overdrafts. I went down to his house and he explained his predicament. He wanted me to sit there…well, actually he wanted me to make the phone calls…but I said *No, Toller, you are going to make the phone calls*. Essentially, we were going to phone the CIBC to ask them somehow to get money from another small dormant account he had at the Royal Bank in Toronto and transfer money from that account to his CIBC account. That would in fact be enough that he would be able to run up again to the ATM machine in the centre of San Miguel to withdraw money from his CIBC account for which he had a well-used debit card.

So, we phoned up the CIBC and we were directed in the first instance to a person who explained that he could not authorize a transfer from another bank and that Toller would have to phone the Royal Bank where the account with money was lodged. He would have to phone them to make the arrangements so that the money could be transferred over to CIBC. So, we phoned the Royal Bank and the Customer Service person, a young lady with a slightly foreign accent, listened patiently as Toller explained what he wanted to do and she said, *First things first, I need to have your password*…and Toller said *Password? I have no idea what the password is. I am an artist! What does an artist know about passwords?* And she became increasingly frustrated with him to the point where Toller said to her *Look, I can't explain it any better than I have, but I have my accountant sitting beside me who will explain it all*. Of course, the accountant in question was me. I have nothing to do with accountancy. I am a retired Foreign Service Officer with the Canadian government and here I was on the phone with this young woman with the foreign accent at the Royal Bank of Canada explaining that Toller was an artist with absolutely no knowledge of computers, passwords or anything related to the 21st century. He didn't have much knowledge of his own finances even and I suggested that surely there was another question she could ask that would prove he was indeed Toller Cranston for real and who simply wanted to get access to his money. *Well,* she said, *No, he has to have the password.* I said, *Oh, for heaven's sake, just give us the name of the manager of the Royal Bank branch where his money is lodged and we will speak to that person and we'll start there and work backwards.* She refused to give us the name. I explained that this is ridiculous. The name of the manager has got to be public knowledge and she should be able to release that, at which point she hung up. So that was that. That was customer service at the Royal Bank. Hopefully it has improved by now. Toller was crestfallen and I returned to my home since there seemed to be nothing more to be done.

And then I had this bright idea that without Toller around, I might be able to make more progress. So, I phoned up the Royal Bank and I talked again

to Customer Service but this time, it was a man on the phone. I explained to him that I was an artist, that my name was Toller Cranston, and that I was an artist in San Miguel. And he said "What is your password?" And I said, "Oh heavens. I don't know. I'm an artist, What do I know about passwords? What does an artist know about passwords? I've never used it." And he said, "Well you have to have a password, otherwise we are not going to get very far." But he took some pity on me and then he said, "Maybe I'll just give you a little hint…and it has something to do with a sport." And since Toller was a champion figure skater, the first word that came to mind was "skate." I said "skate!" And he said "That's it!" And all of a sudden, I was given access to the particulars of Toller's account and he allowed me to set up with his help an on-line banking connection to the account. All that was done without Toller being anywhere near. He was in his house and I was in mine.

So, I was able to use that information after the phone call was over and I went through the internet into Toller's Royal Bank Account and I made a transfer to his CIBC account. I then phoned Toller and told him what I had done. He was so relieved and he immediately ran up to his bank in the middle of San Miguel de Allende to withdraw his cash. The day was saved. Toller lived for another day. He had some money in his pocket at least until the next day and one more crisis had been averted.

Accounts receivable were routinely jotted down on the studio wall.
Accounts payable were routinely ignored.

HE WAS A PAIN IN THE ASS

By Jorge Pena, La Union

We are his packing and shipping company. To be honest, he was a pain in the ass. He wanted everything fast. He wanted everything cheap—and we never know when he was going to pay us. When he sold the property by the park, he called me and said "I need you to come and pick up everything and store it for me." And I said "Really? Everything?" There were a lot of things. He said "Yes." There is no way I could say no because with Toller there is no way to say *no*. So, I ended up taking to my warehouse something like 170 paintings. He never asked how much I am going to charge him. He never went to see the paintings in the warehouse. He just knew that he had some paintings somewhere. I thought that some day he would call me but he never called me and the years went by.

We still do all his packing and shipping, but he would always send his driver to make arrangements. He would stay in the car. I am thinking he doesn't want to talk to me because I am going to ask "when you are going to pay me?" So, I say to myself "fine…if he don't pay me…I have a lot of his paintings." When the news came that he died, I said "Fuck! That can't be true! That can't be true! He owes me a lot of money!" It was not that he owed me money that I was bitching. I was upset that he died. He became part of me and a part of the business and a part of everything. I find out who he really was. He was good with his workers. I see how he worked. He was living a life in the moment, in the present. He was always in the present. He was doing what he was supposed to do that day and that was it.

There are very few people like him. I really miss the guy. I want to see him…but I hope not too soon.

TOLLER

A woman here in San Miguel once sat down with me and she said "you have such a lack of self-respect. You don't like yourself. And, you hate…money…you have no respect for money"…That is an interesting concept. Both accusations are absolutely true. I always think, naively…because other people think that having a bank account is a better idea…but I always think that I'll spend it and I'll just add something to the property and yes, I don't have any money but don't worry, next week I'll make some. I'll work three times harder, and I will get it back. That has been a consistent scenario that has played out for fifty-seven years.[1]

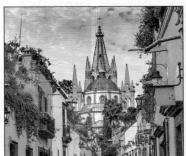
Calle Aldama

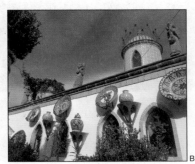
Platters on the walls. Angels on the ramparts.

Los Voladores

German Llamas, Antigua Llamas, San Miguel de Allende

I meet Toller around fifteen years ago. *Si*, he was very strange kind of customer. He came here at the store to buy some glass apples. He would just come in and pick up bunches and bunches of merchandise, hundreds of things…glass hearts, chandeliers, lamps. He had it in his mind exactly where he going to put them. He pick up everything that he see and he would just leave a bunch of money. He never ask "How much is this?" or "What do I owe you?" He just leave a bunch of money. And he says "If you need me to pay a little more, you let me know." But he never leave less money, he always leave a little more.

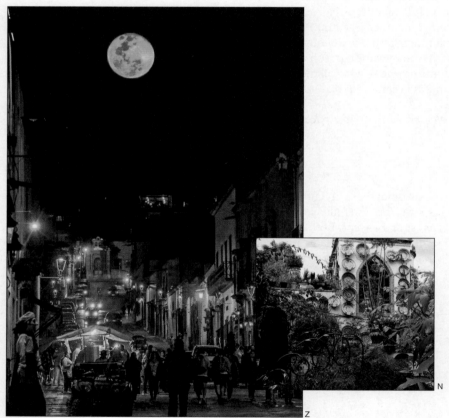

San Miguel de Allende *en la noche.*

THE ARTIST VIEWS ART

By Mayer Shacter

We usually require an appointment to visit Galeria Atotonilco, our folk-art gallery. Toller never bothered with an appointment; that was not his style. But I loved whenever he would wander in unannounced. He always took his time. Sometimes, we'd chat and catch up. Sometimes, he made it clear that he was on a mission and wanted to concentrate on viewing the works of art. We could not wait to see what he would select this time.

His taste was as eclectic as the wild and zany setting any piece he chose would be destined for. A primitive clay giraffe with a playful turn in his long neck, which we later saw *in situ,* fit in beautifully with the distinctive décor that was only Toller. Next time, he selected a complex lacquer carnival with moving parts, exquisitely decorated with minute detail.

Toller was unusually knowledgeable about art and he was decisive about what he was drawn to. He had a keen eye. He was engaging and fun for me to talk with, because he was so well-informed about what he was seeing. We had deep respect for each other because we shared a similar propensity for the unusual. It manifested in different ways for each of us, but it was a similar sensibility. We knew that we shared that. I'm not sure it was ever spoken about, but it was clearly there between us. I appreciated Toller's commitment to supporting young artists, and the way he generously opened his studio to talented young painters and encouraged their work.

Toller's flamboyant presence and his excitement about art were a pleasure to experience. He would walk around the gallery saying, "I want this piece. I want this piece. I definitely want that piece. Hold it for me. I'll be back when I have a little more money." He was saving up for the carnival piece that I had put aside for him, but tragically, did not live long enough to come in and buy it. After he died, we decided to keep the carnival in our personal collection and brought it into the house from the gallery. Of course, I always think of Toller when I see it. It would have been perfect in the ordered chaos that was his home.

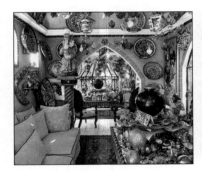
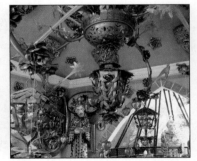

B

B

TOLLER

I don't believe in the word retirement if that means people ceasing to work in their former jobs. Here, it is not about slowing down. It is about gearing up. It's about reinventing yourself. Discovering things that you have always wanted to are very available here. One catches a new wind here. One catches fire here.[3]

I am just like everybody else…quite normal. I did not have a secret life. I had a life that was a result of work. A few years ago, there was a movie being made in Mexico and the guy kept asking my staff about who do I sleep with? And what drugs do I take? But if you look around and see what I have accomplished, what do you think I am doing? I am doing whatever is necessary to accomplish work.[2]

A lawyer called me the other day and asked if my place was for sale and I said, "Well not really, but everything is for sale for the right price." Life is about chapters and there is nothing about San Miguel that I don't like. But, like Adam and Eve, after a while, people can opt to leave paradise even with the conscious knowledge that you can never have anything better.

That is one of the great human flaws. Men frequently walk conspicuously and knowledgeably to their own deaths. So, if you wanted to write me a large cheque, I would sell this property knowing that I was making a mistake that I will never experience anything better than this, but I hunger for change. Change is a rebirth, it is creative, it is embracing a new chapter, and for that I would do it.

I can't imagine the act of dismantling this property. Everything is in its rightful place. Can anything be in a better place than where it is? But the reality is—if I sold it, all I would be left with is money. It would be gone in a week. But I would consider it. I would have to leave San Miguel because after living here as a first-class citizen, I could never have anything better than this. In fact, there is better, but not for me better. This is as good as it gets.

I have a horrible acknowledgement. It happened once in skating and it is happening as we speak. This is the most fecund and enriched period of my life. This is when it is really good. Like all things, skaters, artists, you and me, we live in a circle. We don't live forever. We don't live in a linear way. I can say this to

you but it's almost a secret. I am on top of my game. I have endless energy. My memory is at its height. My knowledge and experience is fuel for me, but I know that it can't last. Sooner or later, it will end. It all has to end. Nothing lasts forever. Some artists, as they age, paint out of desperation. They believe that just by painting another painting they can live forever. I am so weak in some areas but part of me is very resilient. I accept that my life will end.[1]

TOLLER

One of these days, and it is probably not in the near future, I may wake up. I may face reality. And I may grow up. But, I am not there yet.[4]

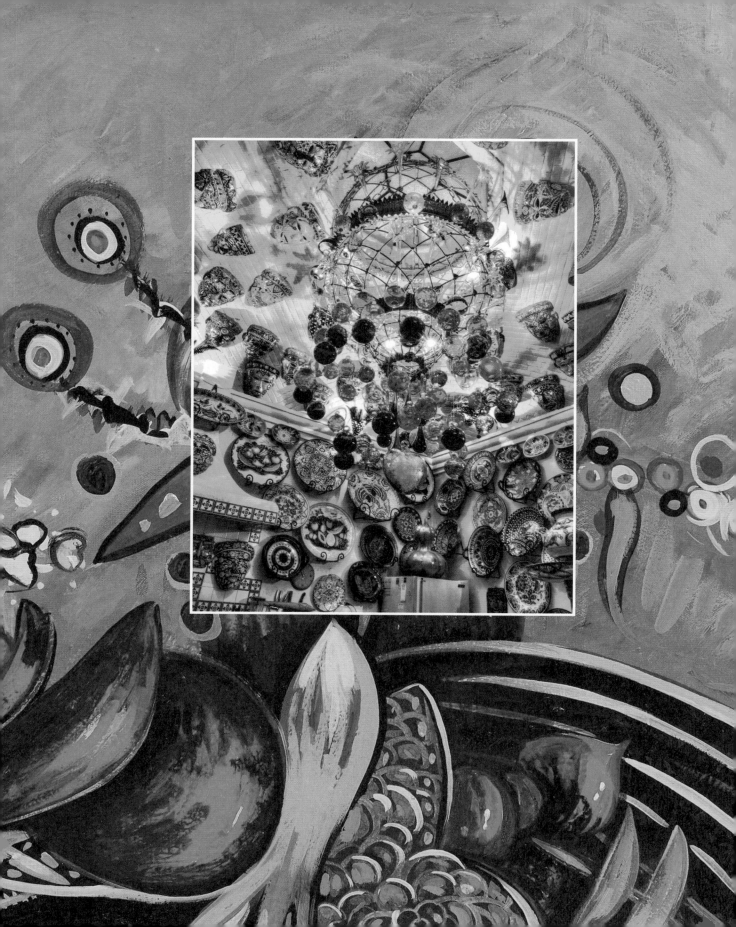

CHAPTER 8

THE STAFF: ALL DAY LAUGHING. ALL DAY WORKING.

El Personal: Todo el día riendo. Todo el día trabajando

By Phillippa

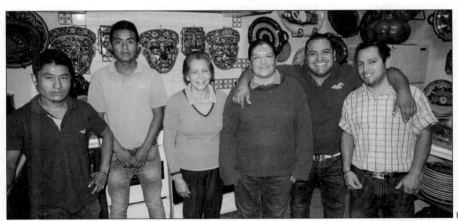

(l to r) Jaki Chan, Alejandro, Antonia. Graciela, Adrian, Hugo

For the past several decades, Toller's life was in Mexico. He loved Mexico. He taught. He inspired. He learned. He absorbed.

The life he chose, the life he created, the life he envisioned was only possible because of his staff. Toller's staff was his *familia*—his everything.

There were six...

93

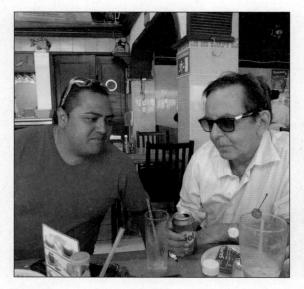

Adrian...bright, attractive, charming, funny, thoughtful, and caring, came to work for Toller when he was sixteen. He came to Toller because he "pregnant his girlfriend" and he needed a job. For the next fifteen years, he was at Toller's side—fixing, navigating, protecting, repairing, driving, and finding a way out of any number of messes, predicaments, and difficult situations often because of his employer's unpaid bills with the gas, the tax, the phone, the electric. Adrian was like a son to Toller. In fact, Adrian often called him Daddy Toller. It was Adrian who taught Toller Spanish. One word a day. It was Adrian who taught Toller about Mexican music. In turn, Toller taught Adrian about Strauss and Ravel. It was Adrian who punched holes in the studio floor when it flooded in the epic rains of 2015 and it was Adrian who got the paintings moved onto pallets so they were safely off the floor. It was Adrian who found Toller in his studio on the morning of January 24, 2015.

Hugo...smart, dedicated, capable, observant, sensitive, creative, ambitious. Jumping the border is a rite of passage for many young Mexican men and boys. Hugo did it when he was fourteen. He made the terrifying three days and four nights trip with the coyotes and got himself into Texas. Being undocumented and underage, he didn't have/couldn't get a driver's licence and was busted at age fifteen for driving without a licence and crashing his cousin's car. He was given a suspended sentence, some hours of community service, and was required to attend a course that would instill in him that this behaviour was not to be repeated. By the time he was seventeen, he was based in the area between Dallas and Tyler and he was running a crew of much older, much bigger men. He and his crew were sent all over Texas and into Louisiana and Mississippi to work on the oil rigs. Things were pretty good. Eight years later, he was stopped at a routine traffic check and although his papers were legal and in order and he had done nothing wrong, something about the eight-year-old episode with the community service came up on the computer of a highly racist Texas

B

cop. He was handed over to an even more highly racist Texas judge who agreed that this tattooed Mexican punk should have gone to jail eight years before for the offense of driving without a licence. Lack of conviction and community service be damned. In the view of the judge, it was never too late to make things right and Hugo was summarily bundled off to Immigration. He spent the next twenty months in a detention facility. His father, who was living in Texas, was unable to help because he lacked papers and could not show up at the facility to bail out or bribe out his boy. Sr. Sanchez did hire lawyers who saw Hugo exactly twice in twenty months, but continually assured both father and son that they were on the verge of springing the young miscreant and just needed more money and more money and more money.

Hugo was never charged. His paperwork got lost. Eventually, after more than a year and a half in detention he was brought before a judge who said "*Sorry for the delay but you are deport.*" He was taken to the bridge at the border and ordered to walk across to Mexico and not come back. There were guys in watchtowers with guns trained on the bridge to ensure that he continued south. It took him seventy hours to return to San Miguel. A year

or so later, he was working with his uncle Antonio in a carpentry shop. The *carpinteria* made ornate wooden doors and railings and did all the usual carpentry things—but they also made frames for paintings. Antonio, Hugo's uncle, is a skilled artisan and an expert frame maker, one of the best in San Miguel. He is also a very good, very decent, and very kind man. Sometimes, Hugo would go with him to Casa Toller to help hang a painting or install a frame.

Since the small carpentry shop didn't have enough work to support everyone, in the afternoons, Hugo would go door-to-door selling chocolate brownies that his mother had made. He quickly learned that Sr. Toller was a reliable repeat customer and every few days, he would ring the bell. Toller began to refer to Hugo as Brownies. Hugo was never entirely sure if Toller liked brownies, but he certainly liked to buy them and that was good enough.

Still, it was clear that there was not a lot of money in door-to-door brownie selling and one day, Hugo asked Toller if he would use his influence and friendship with Eric, the owner of *Hecho en Mexico* to help Hugo get a job as a waiter. Toller

promised to speak to Eric but told Hugo that in the meantime he could do the studio floors which had years of every imaginable colour of paint spills and splatters all over the white tiles. Hugo got to work. Toller also asked Hugo to organize the paints. At the end of every day, he was to put all the caps back on all the tubes and line them up according to colour—all the reds, then the yellows, the greens and so on and side-to-side from the full ones to the empty. After one month, Hugo had scraped and scrubbed and cleaned every tile on

the studio floor. It was spotless. The paints were immaculate. The job was done. Hugo was sad that this work had come to an end but when he went to thank Toller, he was stunned to find a huge mess. There was paint spilled everywhere. As Hugo stared in disbelief, Toller threw another can of paint across the floor and told Hugo "Are you thinking you are finished? No, you are not!" They both began to laugh. Toller told Hugo that from then on, he would work regularly. He would come every day at ten.

Jaki Chan When you meet Jaki and ask *Como te llamas? (What is your name?)*, he will promptly flex his bicep, blind you with a wickedly intense smile and say *Jaki Chan*. His name is Cornelio. But for many years, and for obvious reasons, he has been called Jaki Chan. He is every bit as cheeky, as lovable, as much of a prankster, and as full of derring-do as his famous namesake. This Jaki Chan is crazy strong—in fact, we often called him *Jaki Fuerte*. He is capable, funny, intense, creative, fearless, and emotional—a family man with a love for every living thing. He can build, fix, plumb, wire, and jerry-rig. He can juggle sticks, walk on his hands, and climb anything. He can breed cacti

and bring almost dead plants back to life. He can turn a pool that is green with algae back to blue and sparking. There was the unfortunate time that he killed the fishes, but that is a different story.

Jaki Chan lives in a village called La Huerta which is home to the UNESCO world heritage Arbol Sabino de la Huerta, a 450-year-old bald cypress that is the second biggest tree in Mexico and one of the largest trees in the world. La Huerta is sometimes 25–30 minutes, sometimes one hour from Centro depending on traffic, whether the river has flooded, or whether a tire blows. The ride is bumpy by bus, dangerous by

moto, and expensive by taxi. The last kilometres are unpaved and the final approach is through a very long, very dark tunnel that is carved through the mountain. Many taxi drivers refuse to go there at night because *el túnel* is rumoured to be haunted. The taxi drivers say *"In the night is no good for coming because you see the ghosts."* Before Toller, Jaki worked in the nearby town of Comonfort as a clown and a window cleaner. He would juggle for cars that stopped at the traffic light and send them on their way when the light changed with spotless windows and a smile on their faces. Toller and Jaki found each other when Jaki was washing cars in the Parque Juarez. Almost daily, Toller would walk through the park on his way to meet a friend, charm potential clients at Hecho, or stop in at German Llamas' shop on the Ancha to buy a few dozen somethings…and he would always see Jaki washing cars. After a while they would acknowledge each other and after a while they would exchange a few words. Jaki's reliability and warp-speed work ethic must have made an impression because at some point Toller asked him to come and do something that needed doing. After a while, he invited Jaki to come regularly, two hours a day, twice a week. The other days, Jaki returned to his place washing cars in the park. After a couple of months, Toller asked Jaki if he wanted to stop washing cars. He could work every day—do the garden, look after the pool, sometimes be a waiter, and look after the fish.

Jaki Chan was nothing if not resourceful. Sometimes for extra money, he would catch a big snake in the *campo* and he would stuff it into a box and strap the box to his motorcycle and take it to a guy who had a store in town. Sometimes, if the guy was there, he would buy it. If not, Jaki would take the snake back to the *campo* where it might become stew. Or a belt.

Alejandro is from a small *rancho* outside San Miguel. Although he had worked for Toller for several years, he was young, and strong, and aspired for more than the *campo* could offer. He had a burning desire to seek his future in the U.S. to chase *el sueño américano*. This desire was not a secret. Everybody knew that Alejandro wanted to go to the U.S. When Toller asked him why then, if this is what he wanted… why didn't he go? What was

B

holding him back? Alejandro confessed that he couldn't swim and he was terrified of drowning in the Rio Grande with his dream in sight just across the river. Toller promptly ordered Jaki Chan to teach Alejandro to swim so that he could face the last few hundred metres without fear. Alejandro was immediately and unceremoniously tossed into the pool where it became horrifyingly clear that he really was terrified and really *could not* swim. All of them piled into the pool to rescue him and *gracias a dios* Alejandro did not drown.

The morning after his first child was born, a son, Alejandro hurried to bring the happy news to Sr. Toller. It was January 24, 2015 and Toller had just been found by Adrian. Alejandro never got to deliver his news.

One Monday morning a few months after Toller died, Alejandro simply did not show up for work. He had not said a word to the guys or to his family.

He had jumped the border. He crossed the river.

He calls every now and then. He has been working as a roofing contractor in Oklahoma.

B

Antonia and Graciela, the cook and the maid, moved through the house with grace and calm. They kept things immaculate. They kept the beds made, the water jugs filled, and the 18,000 things dusted. They were never intimidated when another delivery of things would appear. They would roll with the ebb and flow of the day. Lunch for twenty in one hour? No problem. Four extra people for the night? No problem. Antonia presided over the kitchen that, although large and spacious, was frankly a bit of a dump. It was equipped with appallingly old appliances, crappy pots and pans, a terrible coffee maker, and a cheap tiny microwave. But it did have in its floor-to-ceiling cabinets, dozens of full sets of dinnerware, an extraordinary array of serving platters, and at least 200 drinking glasses and goblets from which to choose, or from which to coordinate a table setting or a buffet. When it rains, the ark-worthy rains as can happen in San Miguel, at least twenty-seven pots and vessels are required to catch the drips and leaks—just in the kitchen. Antonia never complained. As the estate sale went on and day by day the sets of dinnerware dwindled, she was eventually reduced to serving almond croissants and fine pastries on Styrofoam plates. Antonia memorably observed that it was *muy elegante*.

Toller would sometimes take his staff to lunch at *Hecho en Mexico*. He would take them to the nearby town of Dolores Hidalgo for ice cream or *carnitas*. Or to Queretaro for shrimps. Or to any one of a number of secret places for shopping. He taught them to dance. He inspired them to value beautiful things. The staff liked how they were treated. They liked that it felt like family.

Toller called his workers *Papoosh*. They never had the slightest idea what *Papoosh* meant—if it was a foreign word, or if it was even a word—but they took to calling each other *Papoosh* and they still do.

Toller would scour the Tuesday market to find uniforms so that at his next entertainment, the waitstaff would coordinate with the theme of the event. On party days, he would instruct them to light a bazillion candles and put fistfuls of incense at both entries so that the whole garden flickered and twinkled and smelled of *incienso*.

Not often, but from time to time, Toller would have a screaming meltdown or a temper tantrum about something or other and take out his anger on one or other of the staff. During those times,

they would invariably prop each other up and keep each other from quitting. Even the time when Jaki Chan killed the fishes. He had been cleaning their pond and was called away to do something else and got sidetracked and went home. He just forgot. *Pescados muertos.* Once Toller calmed down from that rage, he painted a huge canvas of dead fishes and propped it against the wall so that Jaki would feel guilt and shame. Which he did. But he did not quit. He just repeated one of the few phrases he knew in English. *One thousand sorrys.*

Toller was fair with wages and generous with tips, except when he ran out of cash, which was often. The staff never seemed to mind. They loved each other. All of them.

They worked every day as Toller taught them to find a way to make things more useful, more beautiful, and more functional. They laughed every day about any number of things. Like the times when they would go to the *supermercado* Comer and Toller would demonstrate some of his best skating moves by sliding theatrically across the slippery shiny freshly polished floors.

The staff see everything and they hear everything. They know who treats Toller with respect and who does not. They know who is greedy, selfish, or dishonest. They know who is a jerk and who is a phony. They also knew that the last weeks before Toller died, he was barely sleeping and that he was working like a madman. They would see a growing pile of finished work or newly started work that would appear overnight. They would see his untouched bed. They observed the endless cups of black coffee—all day and all night. They knew that Toller was not well the last few weeks. They implored him to seek help, but of course he blew off any such suggestion.

The staff also sensed that he seemed to want them extra close to him. They went to Dolores for ice cream. There was nothing odd about that, but it was odd that Toller fell asleep in the car both coming and going. He never did that. They said he looked tired, that he seemed to have a pain.

In those last weeks, Toller made a point of speaking privately to each of the staff. He explained that he was going to be selling the second house and he

wanted to know what each of them really needed. For example, with Jaki—Toller thought perhaps he might need a car because he had a wife and children and he lived so far out of town. Toller told them that there were going to be a lot of changes. There would be a brand-new studio and gallery out beyond the pool. There would be more work and more hours. He wanted his staff to know that their future was bright and secure and that their importance and value were recognized. He had plans. Things were good.

Early on the day Toller died, he had asked Hugo to wait until he finished with a client because he wanted to speak with him. Toller told Hugo about his plans. Hugo was excited. The plans meant extra hours, extra work, extra money. It meant that he could get some of the things he needed. It meant that he could move in with his girlfriend. Hugo left Toller and went immediately to Coppel, the local department store where one can buy anything on time and he plunked down the 500 pesos that Toller had just given him on a microwave, a blender, and a phone. Yes. Things looked good.

The next day, Hugo arrived at ten as usual. The property was in lockdown. He was not permitted entry. Adrian told him by cellphone what had happened. Hugo sat on the curb for hours and hours and waited. His mind was racing: *"The first thing I am thinking is I got to go right back to Coppel, because now we don't know if we going to have work, we don't know nothing."*

The funeral was a few days later.

One of the many things Toller collected was eyeglasses. He was as acquisitive about eyeglasses as he was about glass hearts or dinnerware. He kept a massive *talavera* bowl containing dozens and dozens of pairs of glasses that he would buy at the Tuesday market. Glasses in every colour, shape, and size. The morning of Toller's funeral, Adrian, Alejandro, Hugo, and Jaki each chose a pair from the great bowl. Alejandro took the tequila from the house and Adrian took the red wine. They went to the cemetery. And they proceeded to get hammered. They talked about Sr. Toller and what he meant to them. They revisited the memories. They did not talk about the future. At that moment, they had no idea what was to become of them. All they knew was that everything had turned upside down. The future

B

that only days before had looked so bright was now very dark and uncertain. And they knew that they would need to stay together. They were brothers. To this day, Hugo carries those glasses in his backpack. He never uses them, but he is never without them.

Toller meant the world to his staff. He changed their lives. They changed his. Hugo expressed it well: "We really appreciated Sr. Toller because if we never meet him, we never be raised up…we never aspire to more. We be stuck like before.

Sr. Toller teach us how you can appreciate yourself—that there is no difference in colours, or in people. He say you never discriminate whether tall, short, white, black, or different…everyone is the same. You don't care if people have a lot of money and you don't have money, they are not better. People can have a lot of money, but sometimes you can do a better job or be a better person. He showed us how creative we are, and he showed us what we can do.

He would say "don't be scared to try to do some things." Sometimes, he would let us do the background on the paintings. I really had a lot of nervous and I don't want to make a mistake and he asking me "why you got scared?" and he say "don't be scared to try to do something. If you want green, put it. It's ok, we can do it again." He told us to never be scared of colour.

It was the best job because you got everything. You got your breakfast, you got your laughing with everyone. When you just coming, you feel like you are coming to your family. When I was working with Toller, I didn't have a father. Sr. Toller took care of us. When you need somebody, he be there…you feel better because you feel like someone is waiting for you. He wanted everyone to be there. He wanted his workers around his table.

He give it to us too much—what you call it when you are secure in yourself…*confianza*…confidence…He make us to be confident in ourselves.

How I can describe this work is all day laughing. All day working."

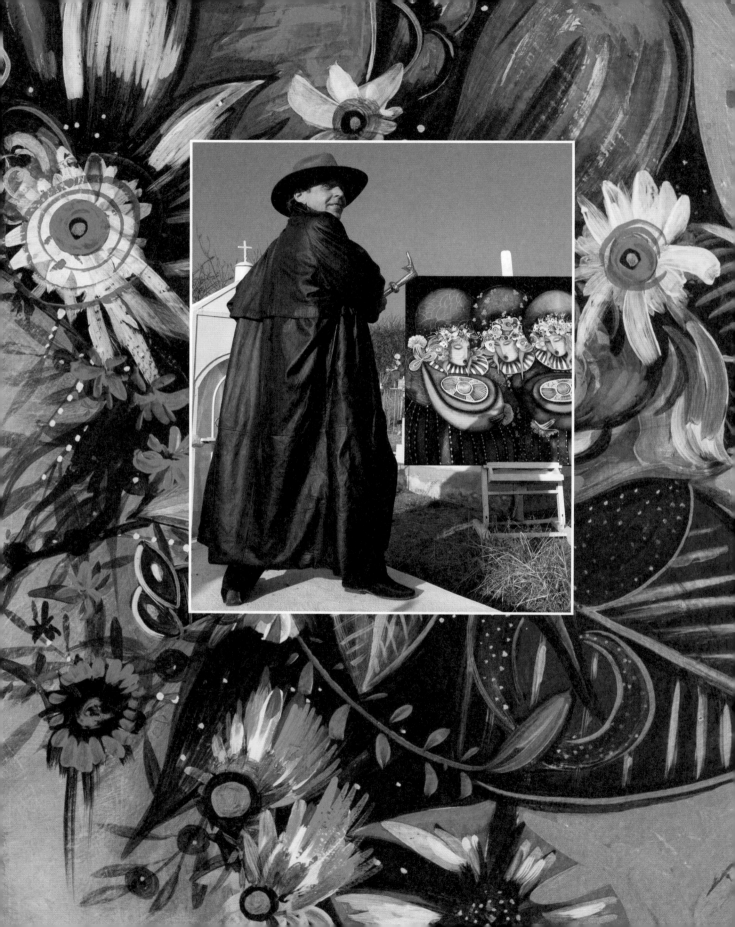

CHAPTER 9

THE ENTERTAINMENTS: A TABLE FOR ALL

Toller's entertainments were extravagant. His generosity was legendary.
His sweet tooth was well known. His sense of fun, the colourful,
and the outrageous, were infectious.

DINNER PARTY FOR MARGARET ATWOOD
By Susan Page

When Toller Cranston learned that fellow Canadian legendary genius, Margaret Atwood, was to appear at the San Miguel de Allende Writers' Conference and Literary Festival, he set about preparing a feast for her that would befit her status and at the same time, display his incomparable exuberance.

Opening the door to the enchanting jungle of a garden was already breathtaking for Margaret. The sight rocked even her usual deadpan demeanour. The tables were set with a riot of vibrant flowers, pouffy napkins, and coordinated brightly coloured place settings. Margaret placed herself in one of the quieter corners, where her table was somewhat isolated.

When the food began arriving, it was as beautifully presented as it was delicious. Every bite took place in an atmosphere of lavishness. I'm not sure why Toller was not seated at Margaret's table. I was there and remember talking with her about a short story of hers that I had recently read in the New Yorker, about a perfectly executed, forever-mysterious revenge murder.

Then, we were invited inside to see a dessert table that made us all laugh with delight. There were tiers of cakes and pies at different levels among the flowers and there were ice cream cone clowns dancing on top of them all. There were plates overflowing with cookies and cupcakes, so many items it was impossible to sample even a tenth of it all. Toller's home, crowded with massive, imposing, totally fun and stunning sculptures and works of art, organized so that one could barely find a path among it all, was adequately complemented by this extravagant dessert table.

This dinner party brought together all of his virtues into one outrageous evening. Ironically, Margaret's understated enthusiasm and famously droll humour were possibly the opposite extreme of Toller's flamboyance. But she loved it! This was an historic event when two much-beloved icons of brilliant talent honoured and were honoured with a remarkable happening that will forever be remembered by all who were there.

Toller outdid himself.

BREAKFAST AT TOLLER'S
By Edythe Anstey Hanen

Breakfast at Toller's is an informal affair with formal parameters: you must have been invited, or have a standing invitation and breakfast begins promptly at 9 a.m. Toller begins his painting day at 5 a.m. and arrives in the kitchen for breakfast at exactly 9 a.m. The table is set for the exact number of people who have been invited and the seating arrangement is decided by Toller when he arrives.

Breakfast is fresh-brewed coffee, waffles or hotcakes and maple-flavoured syrup (real maple syrup is hard to come by in Mexico), toast and *mermelada*, sometimes eggs scrambled with peppers, bacon, and always fresh fruit (mango, pineapple, banana, strawberries and papaya). Today, there is chocolate and vanilla coffee cake as well.

Antonia and Graciela have worked for Toller for years. Sweet and always gracious, they move through the glass sculptures and the masses of roses, serving each person individually, silently appearing at your shoulder to refill coffee cups.

Toller has great difficulty taking care of himself. He cannot drive, cannot operate a DVD player, has no idea how to use a computer. He can barely use the telephone. Don't even utter the word cellphone.

Toller is not well today. He is suffering from a sinus infection and is on antibiotics which, he says, "flatten me." It is his busiest time of year and high season for selling his paintings. He personally accompanies anyone who wants a tour

of his gallery. He looks even smaller today than he is, huddled in a rust-coloured jacket that he bought in Egypt. He looks exhausted.

There is always an appointed time—and one feels its approach the way one becomes aware of the family cat, slinking into the room and under the table, wrapping itself around your leg, waiting for food or a rub, or love—when we know that breakfast is over. We begin to make leaving sounds. We shift in our seats. Toller stands. "I have to go," he says. Sometimes he abruptly vanishes, leaving the rest of us to fumble over goodbyes and find whatever or whomever we came with.

Today, Toller doesn't disappear, but grabs a blue wineglass from the shelf, pours in a splash of Maalox and downs it, leaving a white Maalox mustache like a child with his glass of milk. I see him reach behind a blue pot and grab a couple of pills and swallow them down. I overheard his friend Marion say that he has had health problems but won't go to the doctor. "He doesn't want to know," she says.

My heart aches a little for Toller, but I know I can't say anything. He chooses to think himself invulnerable. But it is that childlike vulnerability that I see once again. It is this that brings us back to more breakfasts at Toller's. It is that understanding that, for reasons I could not guess at, he really does want us here, even though the conversation revolves mostly around him. It's all he knows, and it is what he knows best.

He is both as colourful and as outrageous as his paintings and as closed and private as anyone I've ever known.

Toller's home is both an open door to anyone who wants to view his gallery, to his staff and to those who rent his casitas, and a very private world that includes only those he chooses to allow in. Those he likes and trusts. Loyalty is everything to Toller. His radar is finely tuned for even the slightest whisper of disloyalty or disingenuousness. He is a man who must be—and is—in complete control of his environment.

Despite his successes, his flamboyant reputation, his look-at-me posturing—the face that he presents to the world—he is so very vulnerable. At close range, that shadow is always there and so visible to anyone who is paying attention.

That is the real Toller.

THE MOST OUTRAGEOUS LEATHER PARTY
By Joann Hetherington

Some years ago, Toller received a major commission from Vinuchi to create original designs for a collection of high-quality silk scarves that would be marketed internationally.

He submitted his designs to Vinuchi, who were ecstatic. Then he went to a leather factory in Léon and bought a bunch of black leather garments. He bought long trench coats, bomber jackets, and short blazers. It seemed that he bought every leather garment in the city of Léon which is known far-and-wide as the leather capital of Latin America.

And then, he had a huge fashion show. It was the hugest and most outrageous fashion show. I am a fashion merchandiser, and this was far and away the most outrageous event of my entire life.

The taxis were lined up around the block. When you walked in the door...it was dark...except for the candlelight...he had a bunch of probably

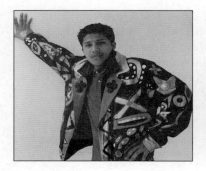
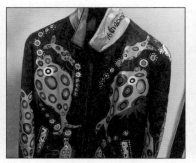
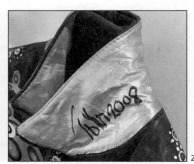

six-foot-high giant candelabras lit with hundreds and hundreds of big fat white candles that were dripping and flickering and overflowing with wax. He had all these tin star lights hanging from the trees and the bushes and suspended in an ark high above the pool. They were twinkling from all over the place. There was incense curling up from everywhere. It was so outrageous. Don't forget that San Miguel is in the high desert. It is semi-arid. But here, you felt like you were in the rain forest. So lush. So much greenery and flowers. Overflowing lushness.

And the music was blasting. Emma Shapplin, a pop opera star similar to Sarah Brightman, but better, was belting *Carmine Meo* at the top of her lungs and it went all across the ethers of this whole block. So, Emma is singing and floods of lava are coming off the candelabras and the incense is billowing up. It was the mood that he set in this outrageously overgrown but controlled garden. The night was pure magic.

At some point, we were moved upstairs to the studio for the fashion show. Then, from out of

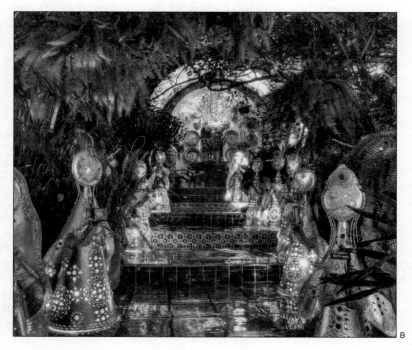

TOLLER CRANSTON: *Ice, Paint, Passion*

nowhere, came the models—women and men, in dramatically outrageous makeup and wearing the most unbelievable garments. Toller had hand-painted every one of the leather garments with the same designs as the Vinuchi scarves—big bright paisleys in gold, and hot green. Shocking, bold designs, and wild tones. Every single one was over-the-top breathtaking. They were works of wearable art. The one that knocked me out the most was a long black trench coat with huge paisley designs on the back.

Each piece was sold by the time the model finished their up and down through the studio because everybody wanted them. They all sold immediately. They weren't cheap and they shouldn't have been.

Toller was the commentator. He was funny—dry funny, smart funny. But, you know, he actually didn't need to say a whole lot because the clothes did the speaking. They were outrageous and colourful and had an air of a kind of wild elegance. OMG! With all these models floating around, everything was other-worldly.

It was done masterly…it was the whole scene… and the music…OMG the music. We were all on Toller's doorstep the next day and we said "Who is this music?" The music that was other-worldly celestial. We all said, "We have to have it!" And we all rushed off to the store where Toller got it. The guy in the store said, "Do you know how many of these we have sold today?"

We were knocked out because the whole thing was so outrageous and stunning and sophisticated. Sexual. Sexy. Sensuous. But, sophisticated.

After that, when he would do events, Toller would run full-page ads in the *Atencion* so that everyone would be able to attend, but he would usually do a *vernissage* the night before for his inner-group. Nobody ever turned down an invitation to Toller's events at any level.

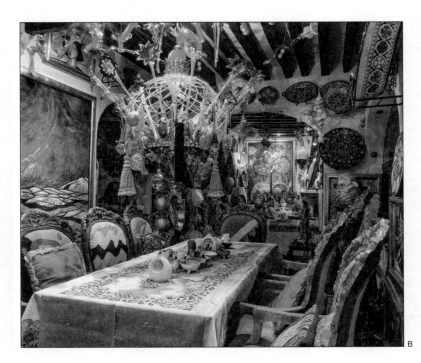

B

THE YOUNG PRESIDENTS CLUB OF WINNIPEG
By Stephen and Adriana Benediktson

When we retired to San Miguel de Allende in 2001, our Canadian friends all said, "that's where Toller Cranston lives." In due course, I made a point of calling on Toller.

Toller and my wife Adriana hit it off right from the start. Whenever we would attend one of Toller's gatherings, he would always direct that Adriana sit beside him and they would talk and laugh. Through the years, we had many meals together both at his house and at our house and we met many interesting people in the process. In fact, the morning I was told at the supermarket that Toller had passed away, he was scheduled for lunch at our house.

Toller would arrive at our house dressed as only he could, sometimes alone, but frequently with a friend or friends. I remember once he was invited for lunch and he arrived with ten other people.

Toller's shopping trips were legendary, and he frequently insisted that Adriana accompany him. He even shared with her his most secret shopping locations that I don't believe he ever shared with anyone else—like the place where you could get an exceptionally good price on immensely beautiful and huge ceramic urns. She chose one. He chose a dozen. Maybe two dozen.

I have a friend from Winnipeg, a fellow Icelander by the name of Arni Thorsteinson. We used to meet every summer at the Banff Centre where he was the Director. In actual fact, we sponsored a couple of Fellowships at the Banff Centre—one for Icelandic artists and one for Mexican artists. One summer a few years ago, he told me, "We are coming to San Miguel this winter." And I said, "Oh, wonderful. You will have to come up to the house and watch the sun go down." And Arni kind of grunted. Then round about mid-February, Arni sends an email that says "We will be there next week—the weekend of the 26, 27, 28, and we would like to take you up on your offer." He said "get some food in, we'll have a dinner and we'd like to meet some local people and oh, by the way, we are ten couples." I looked at Adriana and I just said "OK. We'll get a caterer." Then I thought, I am going to find the strangest, most interesting and most colourful people I know. Toller, of course, was at the top of the list. In the end, there were more than 100 people. We had mariachis and lots of food and dancing on the terrace.

Arni's group, who were initially called the Young Presidents Association and are now called the World Presidents Association, were all from Winnipeg. They all knew Toller from his years as a figure skater representing Canada on the world stage.

The next day, Toller invited the whole group to visit his property. They were met with an array of cakes, candies, hors d'oeuvres, and flowers. Toller had the studio all set up and he personally conducted the guided tour.

Between them, they bought twenty-five paintings. It was fortunate that one member of the party had come down in his private plane and was able to take everyone's new pieces back to Winnipeg.

Toller was very important to us. We liked him a lot. I think he liked us. We still find it hard to believe he is gone. We do have some twelve of Toller's paintings that we acquired through the years including a large wedding painting that I gave Adriana on one of our anniversaries.

Ready for the party: Jaki, Hugo, Toller, Alejandro

TOLLER

It is too cavalier to say that artists don't care what people think. The nature of an artist is to do something and express something that can affect people, command attention from them, and possibly we want what we do to evoke a reaction to make the pat on the head come more quickly.

The artist who has created something or has done something with quality is rendered completely vulnerable because all you can do is wait and hope that somebody comes. Wait and hope that somebody likes or approves what you do.

You hope that somebody will buy one of your paintings.[4]

Donna Meyer

Everything he did was a presentation and a show. Everything was coordinated. I remember a lunch where we had some kind of a seafood pasta but served in these giant bowls from the ceramic centres in Dolores. You would think it was a Top Chef contestant doing the plating. Toller had a strange combination of being "Fuck you! I'm going to live my life the way I want" and being very vulnerable and, in some ways insecure. He wanted people to understand who he was. I loved both.

TOLLER

I believe charisma…the ability to entertain…showmanship…much can be taught…
it is not all natural.[2]

CHAPTER 10

THE ESTATE SALE

By Phillippa

So, damn…what do you do?

How do you dismantle a property that took a creative genius more than two decades to collect, create, arrange, and assemble—a property that had essentially become a living work of art?

How do you dismantle a property consisting of multiple houses on multiple levels containing more than 18,000 things—most of which are fragile, heavy, and awkward—including a dozen horses made of wood, metal, and stone; piles of oriental carpets; hundreds and hundreds of ceramic masks and platters; dozens of stone angels; thirty-five chandeliers; and at least thirty-three full sets of dinnerware?

How do you do it in a way that respects Toller, his art, his passion, his home?

How do you do it in a way that respects his friends, clients, and collectors in San Miguel?

How do you do it in a way that respects his staff who had looked after and cared for the property and for Toller with every fibre of their being for more than two decades?

How do you do it in forty-five days?

I considered calling in the army, moving everything down the street to the bullring, holding an international online auction, or sending everything to consignment. These options were quickly rejected as impossible, impractical, and unfeasible. None of the consignment stores would touch this sale. They lacked the manpower, the storage, and quite frankly, the nerve. The bullring was too small. The army wasn't available. None of the international auction houses would entertain the idea either.

It would be too expensive to catalogue and inventory everything, not to mention advertise, manage, pack and ship, not to mention most of the stuff (excluding the original art) wasn't hugely valuable and it simply wouldn't be profitable for them.

I needed help.

San Miguel de Allende is full of beautiful homes that are constantly being bought and sold and filled and emptied and there are people with experience, but none of the first five people who were interviewed would touch this challenge.

This is way too much for me.

Maybe I could come in at the end and deal with the dishes and the cutlery.

And then there was Marge.

Margaret Failoni was like a ship in full sail. She exuded confidence and she completely took charge.

Of course, we can do this! We will have an Estate Sale.
We will have it in September.

And that's what we did.

You know how when there is going to be a sale and the word is out that there is good stuff, people show up early and line up at the gate?

It wasn't like that.

You know how people squabble and grab and fight over stuff?

It wasn't like that.

You know how they bicker and bargain and want discounts and want cheaper?

It wasn't like that.

It wasn't like that at all.

It was quite magical.

All ten weeks of it.

Have a look at the video of the place before it was dismantled. https://youtu.be/YcZ6SBWVWUY

Marge defined the strategy and approach. She is an experienced curator, arts writer, and sales professional. She knew Toller. She knew the property. She knew art. She knew Mexico—the culture, the craft, and the people. Most of all, she knew what she was doing. She spent a month doing research with carpenters, masons, metalworkers, weavers, and the Talavera factories. Everything—all 18,000 things—was priced. Prices were written on glass, pinned on tablecloths, stuck on furniture. The process took weeks.

Marge was adamant that things had to be seen as a deal. Although there was some value in the star quality because it was after all the estate of Toller Cranston, the priority was to clear the property. Everything was priced to sell. The valuable items like the paintings were treated separately but everything else—no matter how interesting, unique, and bizarre—was priced at roughly 40 percent of wholesale.

Another challenge was the property itself. It was huge and opened at both ends onto narrow cobbled streets with zero parking. It was not designed for crowds. There was no way for people to pass on stone walkways already constrained by foliage, metal angels, giant candelabras, and statuary. How on earth to even keep track of who is on the property and where they are at any given time? There was no place to gather. No place to assemble. It was abundantly clear that we could not simply advertise and open the gates.

The answer, Marge said, was appointments. People would be invited to schedule a time and would come in ones and twos at the appointed hour. Each would be given a sheet of coloured stickers and a pen. They were free to roam the property and put initialed stickers on whatever they wanted. If they could carry an item to check out, they would. If the items were too big or too heavy or too inaccessible, our staff would help. Most importantly, everything was offered as is and buyers would be responsible for moving their stuff off the property.

Before the sale actually began, I personally invited each of Toller's close friends and anyone who had been important to him to come and tour the property one last time. I wanted to let them know that I valued and understood their relationship with Toller and the property. I wanted them to revisit the place where they had enjoyed so many breakfasts, galas, art shows, or simply hours of conversation with Toller on subjects ranging from silly to serious. The property was about to be taken apart and I wanted them to carry good memories. These A-listers were also given priority to put their stickers on anything they wanted. They would pay when the pricing was done. From my perspective the tours were a pilot test that provided an

Luis

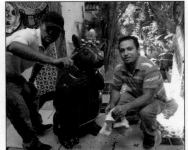

Raimundo and Hugo
The colour is always Toller Blue.

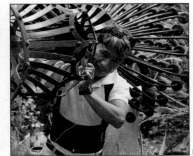

Jaki Chan

113

opportunity to fine-tune logistics in anticipation of the Sale of Sales.

One way and another, word got around. Appointments were made. People came. They came to look. They came to pay their respects. They came to tell their stories and to share their memories. They came to buy.

Invariably, they would come through the gate, freak out at the staggering, magical overwhelmingness of it all, maybe buy one or two little items and leave.

But they would be back. And back again. The sale was like a drug. It was the September 2015 addiction in San Miguel. Word spread. We hadn't even advertised at that point and the appointment board was filled. The sale went on seven days a week for the next ten weeks.

Linda Hampton
I just took what I could see. And then I came back for more.

Early on, I bought more than $1,000 worth of ladders, ropes, and safety equipment for our guys who had been making do with stuff that was rickety, wobbly, dangerous, frayed, and massively unsafe. Their first instruction was to take down anything above six feet—all the platters on the exterior walls, all the heavy masks on the kitchen ceiling, all the stone angels on the ramparts. Before long, there were nearly 600 Talavera platters stacked on the pool deck. The staff wore their new weight belts like prized armour and they worked tirelessly, cooperatively, and joyfully seven days a week for the next ten weeks.

And so the sale began…

There was no need to bargain because the prices were ridiculous and everyone knew it.

There was no need to fight and bicker because there was so much stuff.

Looking for a dinner set? Great! There are thirty-three to choose from. Drinking glasses? What colour?

Interested in cushions? Did you want embroidered? Silk? Woven? With tassels or without?

Couches? No problem…we have pink, yellow, orange, blue, silk, suede, brocade.

Statues? Sure…saints, skeletons, animals, or angels? How about a five-foot-tall green rooster? He's a little wormy and rotten, but the price is right. What about a giant blue rat?

Ceramic pigs? Flower pots? Fruit trees? No problem…we have dozens and dozens.

We had dozens of pretty much everything except… except…there was only one of a particularly gigantic ivory silk tassel. The only meltdown in 10 weeks was from a woman who fell apart over that tassel. "I put my sticker on it and somebody took it. I had it right here! Where is it? OMG! OMG! It's gone!"…Hysteria over a silk tassel may be the very definition of first-world problems.

There was also the guy who bought one of the massive blue and white planters. He began to remove the dirt to make the pot less heavy and, in the process, the pot broke. Even though everything was sold as is and prices were stupidly cheap, this man made a great scene. It wasn't worth fighting over a few hundred pesos, so I told him to just forget it and leave. Wouldn't you know that while he was being such a jerk, someone smashed into his improperly parked car outside Toller's gate. Karma? Maybe.

Apart from that, things went well. There was very little breakage. Probably fewer than a half dozen things.

The buyers were amazing. Many had known Toller. They had stories. Many had known of him. They had stories. Some were furnishing new homes, casitas, hotels and B&Bs. They had stories. There were chefs looking for restaurant decor and Canadians looking for a piece of a legend. There were antique stores looking for the unusual. They were especially popular because they bought by the truckload. For weeks and weeks, every yellow truck taxi in San Miguel carried wooden horses, trees, statues, fountains, mirrors, ceramic, and furniture through the narrow, cobbled streets. Toller's 18,000 lovely things found new homes. Someone observed that it was like organ transplants and it was. It was very much like that. New life from old.

Here are some stories.

Toller's initial staff of six were Adrian, Antonia, Graciela, Hugo, Alejandro, and Jaki Chan. For the sale, three more guys were hired—Neftali, his father Luis, and Raimundo who was called Moreno because he was so dark-skinned. Raimundo had no front teeth and would not smile. He absolutely would not smile. He had perfected a look of gangsta intensity that rarely changed despite Marge giving him her best tooth-baring grin every time she saw him.

The staff were amazing. There are no words for their courage, initiative, ingenuity, problem-solving ability, and sheer physical strength. They could lift, wrangle, move, engineer, or dismantle anything and they did.

Hugo

Marge

Sr. Crunchy and *papas fritas* for everyone

Although I am not sure that we ever spoke of it, the staff and I were aware of how things needed to be. Toller had a certain reputation in San Miguel and he wouldn't want people pawing through his underwear and he wouldn't want people to see that he had any crappy stuff. There could be NO JUNK. The staff took it upon themselves to clean, polish, fix and freshen up with new paint everything that was to be sold. They replaced light bulbs and frayed electrical cords; they shined brass, spray-painted metal flowers, and power-washed outdoor furniture. They kept the property immaculate. Every day, many dozens of people would traipse through the property and every day, many hundreds of items would be carried out leaving behind detritus of bubble wrap, newspaper, and packing materials. Antonia and Graciela swept, mopped, and dusted constantly. The guys kept the walkways clean, the plants trimmed, and the garbage managed. The staff made it a beautiful and attractive place to shop, and people opened their wallets and their hearts.

The task was immense. I made it clear to the staff that they could work as many extra hours as they wished. They tracked their *horas extras* on a whiteboard and overtime was paid in cash each week. There was never, ever, in more than ten weeks of the sale, a complaint, a frown, a sigh, or even a yawn. More than once, when they would be moving something heavy, they would have to stop as they collapsed in laughter about something they were discussing and then they would continue to lug an 800-pound stone lion up the steps. It was an astoundingly joyful time. The work was heavy and hard. The hours were long. Their energy and attitude was unflagging, positive, and remarkable.

The staff had been told that they would be getting severance pay at the end of their employment and that they would also receive a cash bonus as a gesture of thanks for their years of service to Toller. But in addition, I wanted them to have something from the estate that had meaning to them or would be useful to them. Hugo came up with the idea of Toller Dollars.

Toller Dollars were like virtual pesos. The staff could put their name on anything on the property up to the value of their Toller Dollars. Antonia, the cook, put her sticker on one of the humongous bookcases from the studio. It gave her a way to display all her beautiful things including colourful dishes and hand-blown glassware she had also chosen. Graciela, the maid, chose a bed with carved rabbits and matching side tables. Jaki Chan took a kitchen stove, garden pots, a large standing fountain and a tile-top outdoor table and chairs. Hugo took a bed, the stereo and a carved wardrobe. We gave him a wormy termite-infested metre-and-a-half wooden rabbit that he debugged, sanded, and rehabilitated.

Toller had instilled in his staff a love of beautiful things and he fostered a creative spirit in each of them. The Toller Dollars enabled them to acquire things that they would not have been able to justify buying. It pleased them that they were given precedence in choosing even ahead of the gringos. It pleased us to see the staff redeem their Toller Dollars with such purpose and pride.

The dusting was endless. The work was heavy and hard. The hours were long.

I remember one evening when the staff had left for the day and I was alone on the property. I heard voices coming up the path from the Sollano entrance. One of our staff, Neftali, appeared with an armed policeman who had spotted him leaving the property with a large ceramic lamp under his arm—a lamp that just an hour before, Neftali had chosen with his Toller Dollars. The young police officer had known Sr. Toller and did not recognize this fellow letting himself out the gate at dusk with a ceramic lamp under his arm. He did not exactly have Neftali by the ear, but that is how it seemed.

I explained that I was Sr. Toller's sister, that Neftali was one of our guys, and that everything was OK. Next to where we were talking was a table littered with small objects like blown glass hearts, painted boxes, and sparkly costume jewelry. I invited the young officer to choose a souvenir as thanks for looking out for Sr. Toller all those years. After much consideration, he tucked a little enameled cream pitcher in his vest and left with warm *adios y gracias Señora*. I can say that in all the many months from the time Toller died until the property was sold, there wasn't one single break-in, not one single theft, not one single instance of vandalism and damage. And I can tell you that the very night the keys for the property were handed over to the new owner, the place was damaged and vandalized. What I conclude from that, is

that Toller was well-known and well-loved in San Miguel. His staff were well-known and well-loved and they protected that property. As long as they were in charge, as long as it was their place, nothing bad could happen. Once it became not their place, the property was damaged.

Every Tuesday morning, Adrian would take Toller to the Tuesday Market, the *Tienguis*—a legendary pop-up market about the size of three football fields that springs to life on Tuesday mornings in San Miguel and is gone without a trace by evening. The Tuesday Market has everything: canaries, hammers, electronics, oily engine parts, gaudy wrestling masks and every kind of flowers, and food. Every Tuesday, Toller would buy clothes—new, used, knockoffs, originals. Hundreds and thousands of items over the years. Every merchant at the *Tienguis* knew Sr. Toller and they saved their finest merchandise for him. Sr. Toller had first crack at every silk shirt, cashmere sweater, studded belt, and trench coat that came into San Miguel. At the time of his death, there were shirts, scarves, shawls, and sweaters stuffed into every drawer on the property. The hanging closets were bursting with sports jackets in every colour, beaded blazers, leather coats, and floor-length capes. Toller delighted in diving into his vast collection to produce the perfect gift for the perfect person… "This embroidered coat is made for you! You must take this peach shirt." He outfitted the staff in uniforms for his parties and he accessorized everyone he met.

He would often entertain his guests with an impromptu fashion show that he choreographed and styled himself. He loved the shopping, and he loved the sharing. When he died, it took two or three people days and days and days to sort and pack the clothes. Of course, the staff were free to choose whatever and how much of whatever they wanted. The more colourful and outrageous things were set aside to support future museum shows and exhibitions. Everything else was crammed into 106 shipping cartons and given to a wonderful charity called Alma.

Some months later at a fundraiser, I bumped into Linda who was the head of Alma and she told me that in the fall of 2015 word had spread that Alma had received 106 boxes of clothing from the fabulously outrageous Sr. Toller Cranston. There was great anticipation for the next Alma sale that would happen on the last Saturday of the month. Linda told me that during that time when the Alma staff was sorting and organizing the 106 boxes of clothing for the first of many Toller sales, a ragtag group of Mexican labourers appeared at the door. They explained, with great humility and politeness, that they worked in San Miguel during the week but returned to the *campo* and their families on the weekend. "Could they, by any chance, have an opportunity to shop?" The Alma staff was delighted to accommodate them.

The next day during their lunch hour, the men showed up. There were six or seven of them. Linda recalled one young man, maybe in his early twenties, who tried on a full-length camel hair coat. She said that what happened right before their eyes was stunning. He seemed to grow in stature, handsomeness, and coolness. He chest puffed out and he radiated strength and confidence. Linda recalled that the entire group of *trabajadores* and the Alma staff stopped dead, dropped what they were doing, collectively gasped, and burst into spontaneous applause. I have many times since thought of this young man with his full-length camel hair coat out in the *campo* charming the ladies. I hope that both the young man and Toller's coat have gone on to a new and interesting life.

There was a substantial coffee table in Toller's casita. The base was a twisted tree root and the heavy top was a single irregular-shaped piece of glass about two metres long and a good eight centimetres thick. The woman who owned the antique shop near the main square had her eye on that table. She had already bought many things on many visits to the sale, but she kept returning to look at that table. I would say "Señora, seriously, you should have this table. This is the very table where Toller fell and cracked his head. You would have such a story to go with this table." She hemmed and hawed and finally said OK. She brought her guys to load the table and off it went. It only had to go a few blocks to her shop on Calle Aldama but while they were taking the table off the truck, the glass top slid onto the ancient cobblestones and shattered into a million pieces. This table apparently was not to have another life.

Toller's library however does have another life. His much treasured and massive collection of books on fine art, architecture, and design was donated to the Biblioteca. The collection, including many first editions and rare volumes, filled 103 cartons. The Toller Collection is now a permanent reference library in San Miguel providing a significant English language resource for artists, scholars, students, the interested, and the curious.

Jaki Chan, Raimundo, Hugo

La Union guys at the warehouse

Preparing to ship 400 paintngs

Toller was a consummate salesman and he well knew that not everyone could afford a painting for many thousands of dollars but there was a market for something that he had created in the $500–$1,000 ballpark.

When Toller died, there were something like ninety wooden *santos* on the property. They stood on pedestals, guarded bedsides, and were grouped in hallways and entrances. The *santos* were wooden statues of saints that were about one-metre tall. Any good Catholic could instantly recognize a St. Francis, St. Paul, or St. Jude. Toller had bought them unfinished and then painted and adorned them with glass beads, necklaces, and tassels. Usually, some kind of heavy brass knob or metal flower was screwed into their head.

Again and again during the sale, someone would buy one of the *santos* and return in a few days for one more. I didn't initially understand the attraction. I thought the *santos* were cheesy and a bit garish but they grew on me to the point where I actually brought nine of them back to Canada. They make me laugh every day. In the past few years, my *santos* have been touring the province visiting different galleries in support of various painting exhibitions.

Towards the end of the estate sale, there were just a few *santos* left. It seemed disrespectful to those who had bought them at full price to discount them at consignment stores, so Marge suggested that we donate. She called the Parroquia and the Anglican Church of Saint Paul's to come and

choose. I was a little apprehensive when the senior priest of the Parroquia arrived with three younger priests all looking very smart in their clerical collars. I feared they might be appalled by the *santos*' garish punk hair and painted toenails, but they were instantly delighted. They giggled like kids and fussed over which they would choose. The Catholics settled on a mixed group of six and the Anglicans pounced on a Saint Paul. They

also bought wooden pedestals on which to display them. A few days later, a Mass for Toller was celebrated in the Parroquia. This was an unheard-of honour because usually this iconic baroque church must be rented by wealthy families for celebrations of any kind. This was the priests' way of acknowledging appreciation for the gift that had been made in Toller's name. We all put on our Sunday best and attended the Mass.

Through September and into October 2015 the property gradually emptied. Names on the appointment board became customers, became repeat customers, became friends, became family. Life stories, career paths, goals and aspirations were exchanged. Smartphones were produced to show new Tollerized environments popping up all over San Miguel. People shared where they hung their platters, where they put the rug, or the table, or the chairs, or where they hung the painting.

As the days and weeks ticked by the staff grew in capacity, pride and confidence. They had taken ownership of their role in the sale. They organized the truck taxis. They loaded vehicles and made deliveries. They moved stone sculptures, hung paintings and lugged a green rooster up three flights of stairs to his new home in Guadaloupe. In the process, they got to know the *gringos* and, in many cases, their staff. They were building networks.

To help the staff take advantage of these networks and move forward with confidence and without

fear, near the end of the sale, I organized mini employment workshops. With Hugo translating, we met as a group and looked back at the physical, emotional, and financial challenges they had faced since Toller died. I reviewed the skills, talents, and capacities that I had observed that made each one a valuable employee with a bright future. They were from the staff of Toller Cranston. That had value. They are clearly creative, innovative, loyal, honest, and dependable. Day in and day out, they proved that they have a great deal to offer. They do not have to settle. They do not have to compromise. The takeaway is that they don't need a job as much as a good employer needs them. They just have to make the connection.

I provided each with a personalized letter of reference in English and Spanish. There is no question that they left their employment with Sr. Toller more secure in their talents, looking forward to their next chapter, and able to make their way without fear.

The end of the sale was marked with a lunch of

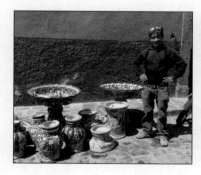

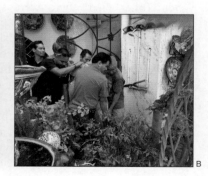

papas fritas (french fries) and Sr. Crunchy which is the San Miguel version of KFC. Marge, the staff, the packers, the shippers, the property manager, a handful of favourite customers—we were all together—laughing and sharing stories. A few days later, when the staff assembled to hand in their keys, there was joy and laughter. There was no fear. No tears. No regrets. There was hope. And hugs.

With his severance and bonus money, Hugo upgraded from a bicycle to a motorcycle. Jaki Chan took Hugo to buy the bike and taught him to ride it. Raimundo upgraded from walking to Hugo's bicycle and with his new transportation, he was able to start a *papas fritas* business. Jaki finally had the resources to take time to work on the house that he had been building for years on a plot of land in La Huerta that his grandmother had given him. Neftali was able to plan for a new baby. Adrian and Alejandro left for the U.S. Graciela and Antonia spent some time at home before returning to work which, when they did, they did on their terms.

Marge stayed awesome.

Along the way, Raimundo learned to smile.

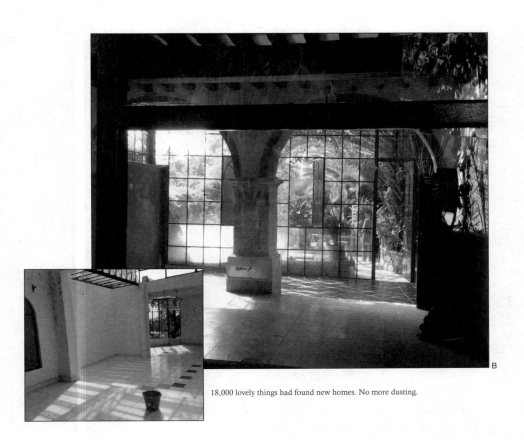

18,000 lovely things had found new homes. No more dusting.

CHAPTER 11

THE PERSONALITY: DOING AND OVERDOING

Toller was a diva. A master of outrageous one-liners.
A big spender. A clever self-marketer.
A larger-than-life guy who always cut to the chase.

A

———————————— TOLLER ————————————

Everyone has a moment to bloom. There is also a time to drop lightly
to the garden path like a drying petal.

TOLLER CRANSTON
By Jeanne Beker

He was Nijinsky on ice, an impassioned artist with a sense of drama and daring, whose bold and elegant moves enchanted and mesmerized us. A big Ice Capades fan growing up, I had always adored the unabashed glamour of sequined skaters. But I never imagined what creative heights the sport could scale until Toller Cranston wowed the world at the 1976 Olympic Winter Games. I was living in St. John's, Newfoundland at the time, working for CBC radio. Enigmatically, I'd just spent a year in Paris, studying mime, and had developed a keen appreciation for the art of corporeal expression. I was dumbfounded by what I saw on my TV screen the first time I watched Toller perform. The next day, there was a photo of him in the paper, wearing a black gaucho hat and cape. A teen fervour washed over me as I cut out the picture and tacked it to the bulletin board over my desk. Here was an exquisite new hero to worship—a dashing champion who intrigued and inspired.

Fast forward three years. I'd moved back to Toronto and got a fantasy job co-hosting Citytv's *The New Music*, the groundbreaking magazine show that explored rock's underbelly. I went apartment hunting and found a cool attic pad in an old Victorian house in Cabbagetown. On the second floor, there was an art gallery that displayed Toller's paintings. Serendipity! The landlady was none other than Ellen Burka, the legendary coach of Toller, who happened to live across the road. Eager to meet my idol, I popped by his house for a visit. He was in his sunny kitchen, where he often held court, wearing paint-stained chinos, coffee mug in hand. "Oh, you're the one on that music show," he commented. "I can't understand how you can talk to those spaced-out rock stars." Toller had just watched me attempting to interview The Ramones, and a couple of members did indeed appear comatose. He was fascinated by how I handled it, and I was incredulous that I'd made any

kind of impression on this major talent. We clicked instantly, and it wasn't long before Toller became my closest confidante. He especially delighted in playing the role of style mentor, constantly dishing out style advice. In 1981, he asked me to be his date for the Genie awards, and presented me with a dazzling Wayne Clark evening dress for the occasion: a white, strapless gown with a satin bodice and large, crystal-studded organza petals that cascaded over the short tulle skirt. It was my first real designer creation, and thirty-five years later, it's still hanging in my closet.

The heady, salon-style parties that Toller hosted in the early 1980s at his art-filled home were legendary. Some featured poetry readings or performing dancers, and were attended by the most eclectic guests imaginable, from socialites to starving artists. I met countless extraordinary people at those memorable soirées, everyone from Leonard Cohen to Arianna Huffington. For one elegant dinner, Toller asked his guests to dress as their secret fantasies. Few complied, but determined to humour him, and much to my host's delight, I showed up dressed as Madame X, complete with full corset and a riding crop. Toller approved wholeheartedly.

He was style personified in his dramatic capes and hats, with a wardrobe of the finest cashmere sweaters, in exotic shades of persimmon and banana. When it was cold, and he took his two English Setters, Lapis and Minkus, out for a walk he would wrap luxurious, ultra-long scarves around his neck. When he wasn't out practicing at the rink or immersed in painting in his studio, I'd drop by his kitchen, where he'd greet me in paint-splattered old clothes, and go on amusing tirades about everything and anything, with deliberate physical gestures so studied and larger-than-life that he could have been wearing a skating costume. Life was theatre for Toller, and he always knew precisely how to work the stage.

An avid collector of Canadian art, Toller's walls were lined with hundreds of assorted paintings, and dozens more were stashed in his basement. He made it his mission to educate me about art, and he bought me my first little piece: a watercolour by his great friend, the late Marion Perlet, who died in San Miguel in 2013. "It's imperative to show support to struggling artists," he announced. Toller knew too well what it felt like to crave support and not always get the attention one deserved.

Generous, loyal, and compassionate, he had a wicked sense of humour and an outrageously acerbic wit. Besides advising me on style, the highly opinionated Toller relentlessly provided guidance on affairs of the heart and though he may have seen himself as a romantic misfit, his capacity to love his friends was enormous. And all those he loved, loved him right back. When he did an about-face in 1991, selling most of his art, furniture, and collectibles, he seemed to be going into a kind of monastic phase. But his brush with minimalism didn't last. Soon after he moved to Mexico, the collecting resumed in full force. Toller created a Shangri La for himself in San Miguel de Allende—a tropical garden paradise behind gated walls. My daughters and I visited him there for the first time in 2002. It was my 50th birthday, and at the behest of my sister, he hired a seven-piece Mariachi band and fêted me with an intimate champagne and pizza dinner in his second-story, glass-walled studio, where, with wild abandon, we danced the night away. Toller was an exhausting dance partner—whenever he was through with me on a dance floor, I felt ravaged, but extremely fulfilled.

Taking my daughters to San Miguel to spend time with Toller will always remain one of my life's greatest joys. A shining example of a dedication and discipline, he rose every morning at 5 a.m. to paint his heart out. He charmed us all with his curious nature, intent on hearing every detail of our lives, constantly grilling us and dispensing advice non-stop while offering insights that were often profound and always entertaining. He adored glamour, old movies, flea markets, jujubes, and Christmas—yet he proclaimed himself an "emotional iceberg." I never bought it for a minute.

Though estranged from most of his relatives, Toller desperately yearned for a family. And so, his closest friends became just that—a precious inner circle of those who would never judge, but simply love him unconditionally, luxuriating in this wondrous artist who marched to his own drummer, battled his own demons, and made up his own rules as to how to live a life of passion. In his 2012 autobiography, *When Hell Freezes Over*, Toller wrote: "The great moments in figure skating occur when a performer is true to his own nature, and puts his heart and soul on the line with no holds barred." And that's precisely how Toller approached life: boldly, unapologetically, and ultimately, artfully.

TOLLER

A good day for me is when I can go to bed so tired, I fall asleep immediately. I need to push myself to that point or I feel dissatisfied with what I have accomplished.[9]

SIX DEGREES OF TOLLER CRANSTON
By Richard Lander

I am Canadian.

Toller Cranston is Canadian.

Therefore, I know Toller Cranston.

Toller is one of the many famous people in San Miguel.
I would go further to say one of the most famous.

If you come back from San Miguel with no Toller Cranston story,
you might as well not have gone.

Seems that everyone in San Miguel has met Toller Cranston except me.
I have been told that I should knock on his door and say I am a
Canadian because he likes Canadians.

But I am only one degree of separation from Toller Cranston. Some day, I will be
no degrees and I can then say I know Toller Cranston.

Until then, I will walk past his house near Parque Juarez
and pretend I know Toller Cranston.

TOLLER CRANSTON: *Ice, Paint, Passion*

THE BROTHER I NEVER ASKED FOR
By June Eyton

Every Sunday, local artists display their paintings in the Parque Juarez and Toller would always go and look. These artists all knew who he was. They knew exactly who he was. Toller was well-known in the area and anyway his style was unique. He usually wore oversized clothing with the pants held up with a wide belt and a huge buckle on the outside of the loops. The pants were invariably stained with paint and his hands had splotches of paint up to his elbows. He was considered to be a prominent artist in the town, and he would usually buy something. It could be a painting or some piece of art. He didn't really want or need it, but it was his way of encouraging young artists.

Toller was a bit of a hoarder and Mexican ceramics were a favourite. He collected literally hundreds of colourful painted ceramic plates, for instance. There was so much that many were hung on the outside walls of his houses, there not being enough room on the inside. The kitchen ceiling was another favourite place for hanging ceramic platters and masks. When I asked him about that, his retort was "the ceiling is the last frontier." Whenever we had visiting friends or family, we would take them to visit what we dubbed the #1 tourist attraction in San Miguel, which was Toller of course. The visitors invariably emerged utterly enchanted with the encounter and the proud owners of at least one new painting.

I think of Toller as the brother I never asked for.

DIVING INTO THE URN
By Faith Fuller

I once asked him for his passport so I could set up his PayPal account. He strode briskly across the room to a gigantic urn that was like four feet tall. There was a whole row of urns, but he went directly to one in particular. Without a moment's hesitation he dove right in. He reminded me of a cartoon character so far into this urn that just his feet were sticking out. He was rooting around and pulling out wads of crumpled up paper. It was a mess. Finally, at the very bottom, there it was. The passport was all moldy and rotted together with unopened letters from the government, collection agencies, cards, notes and overdue tax bills. That was the moment I fell in love with Toller.

He just made life feel magical. He almost took it upon himself to make people feel like that. He could figure out what everybody needed or wanted—and he gave it to them.

Toller and Lapis

The dreaded pointing finger.

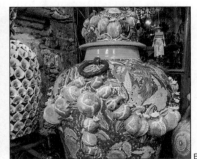
Urns are useful for stashing passports and all unopened bills.

127

THE NAME IS IMPORTANT
By Eric Nemer

The first time I met Toller, it was maybe 18 years ago just after we opened *Hecho en Mexico*, I was standing at the entrance. Toller sailed through the door and he stumbled and then he went flying across the landing. He caught himself and he composed himself, and I said, "Well that was graceful!" And he looked at me in that mischievous way and he said, "I'll have you know I was once a world-class athlete." Then, he threw his head up and walked in. That is how I met him. I got to know him well over the years. We had a lot of conversations. His other favourite expression was: "Well, that is enough about you now let's talk about me. Would you like me to educate you about the royal family of Russia?"

When my children were being born, I consulted him about what to name my son. Toller was hooked on this idea of Indigo Blue. He said indigo was a magical colour and he had read a lot about Indigo children. My wife and I were in disagreement about names. She wanted to name the baby Nicholas. I wanted to name him Lincoln. Toller said, "Do not give in and name that boy Nick. That means nothing. It is just a common name. I never would have been Toller Cranston if I were not Toller. The name is important and Lincoln is different. Do not give in." And I didn't.

TOLLER TAUGHT MEXICANS ABOUT CANADIANS
By Mario Alvarado

He would come in here to *Hecho en Mexico* two or three times a week, sometimes every day. It seems that this was his favourite place. Sometimes he would have meetings with clients and sometimes he would bring his employees to enjoy the same food that he was enjoying.

I found out that he was actually a celebrity in Canada and that he was a great athlete. People loved him. In the season, we have people from Canada that come running from the winter. They come here sometimes for dinner but they come in sometimes just to admire the paintings.

Toller taught the Mexicans a lot about the Canadians. He showed us how Canadians can be so nice and human. That is the way I perceive Canadians. I tell you one story. My friend, who is a tour guide, told me that once he picked up a tourist at the airport in Léon. The guy had come to San Miguel just to see Toller's paintings. My friend had never met Toller. He did not know him, but he knew where the house was. He dropped the tourist at Toller's gate and told him, "Just ring the bell, Toller will come out." A couple of weeks later, Toller came around looking for my friend. He wanted to give him some money because the tourist he brought to Toller had bought a big painting. Toller gave him a commission. I think it was $500. My friend was so shocked. He said nobody does that kind of things—but that is how Toller was.

FAME IS SO INTOXICATING
By Clive Caldwell

I first met Toller Cranston when I was eighteen years old. I am now sixty-nine. I was a member of the Toronto Cricket, Skating and Curling Club, where Toller skated. I didn't pay much attention to him or the other world-class skaters who had been around the club for decades. But one day, I saw him on television, and he just electrified me. The shapes that he was creating and the emotions that he was able to get out of his audience, were like nothing I had ever seen on ice before. He reminded me of Rudolf Nureyev and Mick Jagger—and I have kept that view to this very day.

My mother, Priscilla Caldwell, knew Toller, but not very well and I insisted she invite him for dinner. She did and we became great friends over the rest of his life.

He was my son Dylan's godfather, and he actually named Dylan. Thank God we didn't choose other names that he suggested like Titus or Zephyr. He was incredibly creative. He was also the most ambitious, intelligent, and well-read person I ever knew.

But this is my favourite Toller story, and it goes back to the early years. He had a home, one block west of Parliament on Carlton, and we decided to have lunch at the original Four Seasons Hotel, on the northeast side of Jarvis and Carlton.

While we were having lunch, a woman came up to Toller to ask him if he was Toller Cranston, because she just loved his skating and his art. Toller turned away from the woman, looked straight at me and said, "Fame is so intoxicating." I'll never forget it and it just summed up everything about Toller. Loved the fame, but a quick, wicked, and twisted sense of humour.

He lived a very independent, alone life—but he was never alone. He was a driven painter and he hated distraction. Solitude was necessary to create. He was always the life of a party. He wasn't the guy sitting in a corner, feeling sorry and sad because he was alone. He was hell-bent and determined to take over the world, and he was trying to do it every day.

He was a special man and friend,
and I miss him to this day.

WE PUSHED EACH OTHER
By Shelley MacLeod

I had the privilege of skating with Toller as one of his lucky female partners. Only a few women can claim such an honour. We skated together each night at Radio City Music Hall and we taped several numbers for *Stars on Ice*. These opportunities meant the world to me.

And it was Toller who physically accompanied me through my transitions from skating into being a sculptor, a mom, a cancer patient, and ultimately, a composer. We were still arguing and pushing each other right up to the bitter end! And I miss him!

I was good at eccentric. The truly eccentric don't know they're eccentric. They just are. I knew exactly who I was and what I was doing and I used it. I used eccentric elements to hone my image and make it work for me but as far as really being eccentric, I could not be more boring. I am in some ways the boy next door. I am a worker and a kind person…but…I used some elements.[2]

DEAREST TOLLER
By Shepherd Clark

Toller's life was multifaceted, colourful, and accomplished. And he was funny. I remember staying in his house in Cabbagetown. The room in which I slept proudly exhibited a framed vintage show poster of Sonja Henie and scrolled magnificently, boldly, curvaceously across the bottom were the words, "Dearest Toller, Only You Will Compete With My Legend." In that moment, I recognized something wonderful about Toller. His sense of humour was original, bold, and in that case, prophetic. I am a Sonja Henie historian. I can do the math. He had signed the poster himself of course. But in fact, he did compete with her legend, and he was, perhaps, the only one ever to do so.

He once told me that he frequently dreamed about being cornered in a dark alley by an individual who he was convinced was going to rob him, or worse. Toller's strategy was to roll over onto his back with his feet and arms in the air like an animal and fight for his life. He would then leap up and perform the choreography from his Olympic program, at which point the attacker would freak out and flee from this clearly deranged, wild, frightening individual. I actually believe that Toller's approach to self-preservation has merit.

My biggest advantage throughout my life has always been that I am completely uninhibited.[9]

THE MAN BEHIND THE MYTH
By Edythe Anstey Hanen

His name conjures up dramatic images: a whirling dervish flying across ice, an inventive genius, who by every account changed the face of figure skating forever. A man who has lived a life of outrageous eccentricity, a life few of us can even imagine—Toller Cranston. But there is another Toller—the one we came to know.

Toller is a small man with greying hair, half-dyed but growing out. The day I met him, he wore a brilliant lime green corduroy shirt and a wide hand-made belt lashed just below his waist in his trademark style that held up grey cotton pants. He nodded toward his pants and said, apropos of nothing, "breakfast pants."

David and I had begun reading his two autobiographies, and we had gotten a perspective on the life he has lived. Most of it was spent rubbing shoulders with artists and stars of every ilk. But as we got to know him, we both sensed a deep loneliness, the loneliness of a man who lived most of his life in what he called "a cage." He had lived as outrageously as any person on this planet and he often referred to that way of life as his way to get love, attention, the pat on the back that he desperately needs, even today. He spoke of that need often and openly. He once told me that he has spent his life looking for love, a love, he said, that he has never known and to this day, has never found. For all his glamour and fame and wealth, he harbours a deep sadness that was painfully evident.

The house and gallery were always full of flowers and I once asked him about his penchant for roses. Ten to twelve dozen roses are delivered three times a week. He chooses soft pinks and salmon colours—a "soft clash," he said. A "hard clash" would not ever be acceptable.

Much of Toller's life has been over the top and outrageous—a life like most of us could never imagine. He has a huge following and his art is brilliant. His work hangs in galleries all over the world. Yet, he is alone, despite the fact that he is still a "star."

While we walked to the restaurant, people waved to him from the street, from cars and bicycles. He loved it. One woman stopped him and asked if he was Toller Cranston, then asked him if he had gotten her email about wanting to be buried in his garden.

"Yes," he said, "but I'd much rather you came and swam in my pool."

I remember once when we were leaving, all of us exchanging addresses and drifting back into our other lives, Toller seemed suddenly alone. At one point that evening, as I sat on the sofa with him (while he brilliantly quoted Oscar Wilde), he had said to me, "Something is missing in my life. Something went terribly wrong." He then quickly turned away. There was nothing more to be discussed. Utterances like this occurred frequently when he and I talked. But afterwards, the door was always quickly slammed shut.

The subtext of many of his stories was the hurt and betrayal by people he has trusted and to whom he has given so much. He has by choice and—I believe—out of fear, shut himself off to human feelings. He had said that before, told us how he cannot let love in, cannot allow his emotions to

have any part in his life. Yet, sadly and ironically, it is his unwillingness to open his heart, to allow himself to be vulnerable that causes him so much sadness, so much pain. I don't know that he understands this connection or recognizes that it is he who has turned his back on love.

The first time he walked us to the gate down the long dark path that was unlit—one of his staff had forgotten to turn on the lights, he said, and we said our goodbyes. We hugged him as we always had, but this time he stood rigid. He would not hug us back. He could not let us—or himself—know that he cared. He could barely say goodbye. We walked back home down the warm cobblestone streets, amazed at this lovely ending to our time in San Miguel. It had been an unforgettable night. We had been asked to be part of a very small group of people he liked and trusted. I don't think there are many. Many acquaintances, perhaps, but few close friends. We were honoured. But the hugs eventually came and the last time we saw him before he died, he hugged us harder than he had ever hugged us before. Perhaps he knew something we could never have guessed at.

Z Donald Trump, The Simpsons, and Toller

A

TOLLER CRANSTON: *Ice, Paint, Passion*

CHAPTER 12

BEYOND PAINTS: DESIGN AND CREATION

TOLLER

Most of the artists in San Miguel, and this is not a criticism, are pretty one-dimensional. The painter paints. The sculptor sculpts. But I have always embraced and tried many different things within a vocabulary that is very specific.[4]

In addition to creating thousands of oil paintings and exquisite line drawings, Toller experimented with materials beyond canvas. He painted on ostrich eggs, wooden religious statues, and silk screens. He designed elaborate chandeliers and huge candelabras in metal and blown glass. He created a series of hand-woven carpets. He organized a fashion show of hand-painted leather jackets and trench coats.

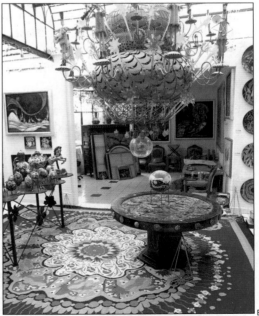

B

He designed the carpet, inspired the glass blowers, directed the metal workers, instructed the tinsmiths. And he painted the eggs, the platters, and the paintings.

THE ECLECTIC BEAUTY IN THE DESIGN WORLD OF TOLLER CRANSTON
By Margaret Failoni

On any given afternoon during the quiet mid-weeks of San Miguel de Allende, Mexico, the phone would ring and Toller would invite me over for a cup of tea or coffee, depending on the weather and his mood. I knew it meant a new monograph on some renaissance master or another. He was the most self-taught art history buff I have ever run into, with a deep knowledge of great painters and their techniques.

Upon entering through the Sollano Street gate, I would move through incredible gardens that he designed—a city-block-long curving walkway past flower beds interspersed with statuary, fruit trees, and overgrown vines of star jasmine and bougainvilleas in several different colours. Halfway up the path would be a pair of wrought iron midnight blue, multi-armed candelabras of Toller's design, which, on festive nights, would illuminate the path with dozens and dozens of fat white candles. Entering the studio area, I would walk past a gleaming silvery metal basket with several dozen blown glass strawberries, all lit from below. Never before have I seen a lamp so original and beautiful.

While chatting over tea on the value of Lotto versus the Parmigianino, I would gaze at the several paintings leaning against the wall—skaters with magnificent costumes, somehow reminiscent of Russia. It reminded me of a theatre setting. I could see it presented in the winter instead of, or alternating with, the Nutcracker Suite. His paintings always reminded me of something musically theatrical. In short, I always thought of Toller as one of the great, undiscovered designers. His work would have been Oscar-award material.

I would tease him with this subject, remembering a fundraiser fashion show which he designed, with beautifully painted leather jackets and scarves, hand-woven woolen rugs, entirely designed by him, scattered around. The rooms lit up with his exquisite, multi-layered chandeliers which he designed and made with glass flowers, crystal balls, and lacquered leaves, but to describe a few.

He could, and did, design anything and everything. He created wildly fanciful objects of beauty.

If only he had preferred the neuroses of the Milan design world, or that of Hollywood, or of Broadway instead of the placid, laid-back beauty of semi-retirement and sunset Margaritas in scented gardens, living a Bohème life in sunny Mexico—oh, if only.

A

THE STUDIO IS THE SANCTUM
By Christopher George

Wherever you go in the hacienda, his inventiveness is found on the walls, the floor, on your chair and above your head. He creates unforgettable pieces from unadorned, wooden, Mexican statues of horses and religious icons that he then completely embellishes with paint and multi-coloured glass beading. In his studio, classical or Mexican music is often playing at ear-splitting volume. With the appropriate mood set, he enters a solitary sanctum, staying there for long hours at a time, exploring his own whimsical world. The studio is his safe harbour, a place of refuge where the power of the mind rules and is made tangible.

By Guillermo Hernandez, Metalworker
His design goes in every direction. His mind is way out there.
And it is always something you have never seen before.

TOLLER

Creativity on a high level has to be done in a solitary way. I have learned as an artist that I cannot have any music playing if I am genuinely conceptualizing. Everything becomes a distraction. A stranger could be down on the garden path and my hair would stand on end and I become hysterical and want to murder them. Being alone with your thoughts, being alone so that the channel is clear, so that there can be no interruption or interference is the only way that you can create.[4]

PAINTING PLATTERS
By Anita Dhanjal

The week I spent working in his studio, he had Adrian pick up fifteen large unfired platters so that he could paint each with his style and theatrical creativity. He worked on many at a time each day. While some were still drying and some were dry, he had them varnished and he found interesting effects that he had not expected. He said, "People would think that I knew what I was doing not realizing that the effects happened because I was not letting them dry in their proper time to get them finished." The effects were amazing. The parts that air-dried naturally were so smooth and the parts that were varnished and not dry gave a crackled effect like ancient ruins. It was incredibly impressive how each piece turned out. Toller was very happy with the results.

TOLLER

There are people here in this incredible town that can interpret to perfection
everything that the designer has designed for them.
Everything you can imagine.[4]

CREATING IN 3D
By John Rait

The truth is that he had an ability to take an idea and process it into so many different areas, to take what was originally a concept for a line drawing and to think about it becoming a three-dimensional object and to think about the colour and how it is going to best pop for the person that's bought it.[4]

B

TOLLER AND THE ARTISANS OF OAXACA
By Joann Hetherington

Toller would often go to Oaxaca, which is a bastion of indigenous culture and without doubt, the craft centre of Mexico. Like rays shooting out from a central sun, a whole host of little towns surround the markets of the old colonial city. Each town is unique. For instance, in one town, if the great-great grandfather was a ceramic artist and only made black pots, then for generations, the whole town would only be making black pots. The next town might be a tapestry town, *tapetes*. In Teotitlan del Valle, for example, everyone is a weaver and has been for generations. They hang their extraordinarily beautiful Mexican weavings and tapestries all over the trees and on racks in front of their homes and shops and you can buy a tapestry or a carpet from them right there. But here is what Toller used to do. Toller knew very well that they were all fabulous artisans and technicians in whatever their art form was—ceramics, tapestry, glass or whatever—they had been doing it for generations. He would go to their towns and meet with them and discuss design ideas, and he would inspire them, push them, challenge them to go beyond. For example, with the weavers—well, after Toller, they weren't just weaving rugs with images of sombreros and donkeys. He would inspire them to do all these outrageous things starting from his own designs. He would bring his paintings or copies of his paintings and they would re-create exactly or reinterpret. I remember

being in the studio once, and on his floor, he had actual tapestries that reflected the actual paintings that were hanging on the wall.

He taught these artists that they didn't have to just weave cactus and burros. He inspired them to do much more with their talent. And the same thing with the glassblowers. He created an amazingly outrageous glass structure in a high arc across the swimming pool that was studded with blown-glass blue calla lilies that would spray water. The artisans were basic glassblowers from this area and he taught them to turn their traditional glass hearts into lilies and flowers and fantastical things that went way beyond what they had been doing.

His house was full of the work of all of these beautifully-talented artisans. He moved them. He gave them the vision to push themselves—to be artists. I have always said that Toller probably influenced more young Mexican artists than anyone else, because the tide rose in the artistic world in Mexico for these people that he touched and inspired. We all know that they are great technicians. But too often, they have kind of boring subjects. Toller said, "Here, let's get you beyond donkeys." It was an amazing gift that he shared with them. He wanted to help them become greater—and he absolutely did.

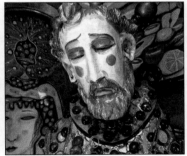

B

CARPINTEROS, FRAMERS AND FLOWER SELLERS
By Phillippa

After many trips to San Miguel to deal with my brother's property—including his 18,000 lovely things—I had become as captivated by San Miguel as Toller and I knew that to spend more time there, as I intended to do, I would need to learn better Spanish. I could bumble along with limited vocabulary and hand gestures but the idea of a verb or a tense was completely foreign.

My friend Mimi and I enrolled at Warren Hardy Spanish—Level 2, The Past Tense. On our first day in school, teacher asked each of us to say where we were from and what had brought us to San Miguel. By then, I had learned to say that my brother was an artist here in San Miguel and after he died, I came to look after his things. Our teacher, Rocio, asked what was my brother's name. When I told her, it was as though she had been struck.

A wave of emotion crossed over her face. She said that her neighbourhood, or *colonia* as it is known in San Miguel, was absolutely devastated in 2015 when Toller Cranston died. Her *colonia* is home to many workers and tradespeople, carpenters and drivers who had known Toller and had had dealings with him for years. There were the flower sellers who delivered four-to-five dozen roses to the house every single week for years; the framers who created thousands of frames for Toller's paintings both for international clients and his own exhibitions; the ironworkers who took Toller's visions and ideas and created an endless series of lamps, candelabras, magical beds, arches, ornamental gates, and chandeliers; the tin workers; the upholsterers; the packers and shippers and movers. All of them had dealings with Señor Toller.

Their devastation was not just for a significant loss to their business. The framers told me that Toller had taught them to respect their own work.

To honour their work. To be professional. If they promised to deliver on Tuesday, then they must be relied upon to do so. They said Toller made them better business people. The ironworker commented on Toller's creative energy and how Toller was a perfectionist in everything he did and that from Toller, the ironworker learned to be a perfectionist himself. He said that he "grew up so much" working with Toller…just in the business sense.

Toller spent a lifetime making, designing, creating, and producing beautiful things. Perhaps because of his flamboyance, a lot of people had no idea how hard he worked. When he died, there were two hundred and some paintings hanging in the kitchens, salons, hallways, bathrooms and bedrooms on the property. There were more than thirty chandeliers designed by him and easily some ninety hand-painted wooden *santos* along with dozens and dozens of painted ostrich eggs. Midway through the estate sale, it emerged that there was a quantity of stuff stored in a warehouse outside of town. I remember thinking "OMG! That must be where all the crap is. That must be where he stashed all the mediocre stuff." But there was nothing mediocre. There were another 187 paintings and drawings along with a full-size hand-painted horse. There was nothing mediocre. The overall quality, as with everything he put his hand to, was astounding. Even more remarkable, almost all the paintings dated from 2012 and later. It wasn't as if stale work from 2007 or 2009 or 2012 was stacked up in the warehouse.

Toller was an extraordinary salesman and for more than 40 years, he managed to create a staggering amount of very high-quality work—not just paintings and drawings, but carpets, upholstery, *santos*, painted leather, metal, candelabras, garden art…even painted frying pans. I know. WTH!

By German Llamas

Everything he do was beautiful. He was creating things that doesn't exist
but he make them to exist.

Anita with her Toller silk scarf

The green chandelier

The blue bed

DAY OF THE DEAD OFRENDA
By Mario Alvarado

The first year after he died, here at *Hecho en Mexico* we made the big *ofrenda* for the day of the dead, *Dia de los Muertos*, when we celebrate the life of people who passed away. In Mexico, it is a big thing. I remember the altar for Toller was very spectacular. We had one of his rugs that covered the whole room and we had one of his horses and his hat and his boots. The energy around was an energy you won't feel ever. I think he enjoyed the creation of that and his soul came back. I felt the energy. It was magic.

The last thing he cared about was himself. For Toller, it was more about the creation.

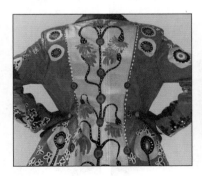

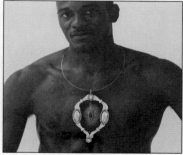

A

CHAPTER 13

THEATRE ON ICE: BLADES ON BROADWAY
By Veronica Tennant, C.C.

Ahh, Toller! When I say from sweet memory that he swept me off my feet,
I mean it in more ways than one!

Where do I begin?

Is it after having been awed, indeed mesmerized, by Toller Cranston's extraordinary tour de force triumphs; marvelling at how he revolutionized the art of figure skating and innovated ice dancing? That is the key word methinks—dancing. Toller's signature for us in the ballet was his dynamic arabesque. The arabesque line separates the great dancers from the good ones—and Toller's was indeed the first and the greatest on ice.

And reliving that unforgettable visit to Toller's home in Cabbagetown with my National Ballet colleagues—experiencing the shock, the revelation that art could cram, entice, breathe, and delight on every square inch of surface and wall in that heritage house—enthralling! To sit with Toller, (draped and reclined), to hear his drawl of stories fantastical pierced by his wry infectious smile—was transporting!

Toller Cranston, the artist, was a true original and equally so in his two mediums. He brought an arresting sensuality to skating, and to his canvases. He courted the exotic. He defined panache. And he was possessed by daring to expose his imagination.

Let me count the memories.

We hosted *Dancers for Life* in Victoria, B.C. together, and I never knew what he was going to say off-script. Toller lived in the moment and thrilled in throwing curve balls. Yet, he was generous to a fault.

We collaborated on *The Nutcracker* for McClelland and Stewart, a limited edition and instant collectors' item. The technique of our pairing process was like an artistic relay. Toller created initial images, oil paintings and I re-imagined and re-told the traditional story by E. T. A. Hoffmann. With each chapter sent to him by our M&S editor, Lily Miller, he would return his stunning illustrations which would then inspire me on to write the next passages. I will add that I wrote much of the book flat on my back with a cursèd recurrence of a ballet injury, a herniated disc. Toller was compassionate about that. When I

learned about the months he spent in a cast with Osgood-Schlatters Disease, I understand how much he understood.

And now, let me tell you of the rapture of dancing partnered by Toller in a swooping circling of the rink. It was for CBC television, a Hagood Hardy Special with Ann Ditchburn choreographing a *pas de trois* for Toller, Frank Augustyn, and me. Quivering with cold and apprehension, there I was on pointe—on a circle of plexiglass placed on the ice. YES, Toller swept me off my feet, his partnering arm lifting me tight, locking our waists, both of us arched in arabesque at a speed unimagined, racing, swerving. Such exhilaration! And the rush of this memory sums up his unique power—to exhilarate.

That is the Toller I shall never forget.

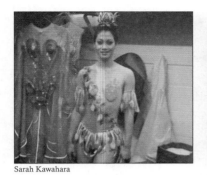
Sarah Kawahara

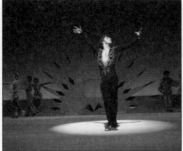
Toller

John Rait and Shelley MacLeod

STRAWBERRY ICE

Strawberry Ice was an original fantasy story with skating, singing, and dancing, starring Toller Cranston, with Peggy Fleming and special guest star Chita Rivera.

Strawberry Ice was the first time the special effect Chroma Key Blue was used to create different worlds, from the light world to underwater world, fire world and animal world to the strawberry court.

It was filmed for the CBC in April, 1981 and aired in March, 1982.

I COULD HARDLY CONTAIN MYSELF
By Chita Rivera

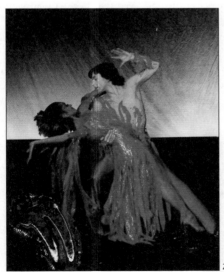
Toller and Chita Rivera

I was watching the Olympics a number of years ago and saw this amazing skater.
I had to know who he was because he was brilliant.

I found out it was Toller Cranston and I had to meet him. Well, not only did I meet him, but we became friends. I had the great thrill of dancing with him, me on a stage and Toller on the ice. It was so exciting, I could hardly contain myself. The show was called *Strawberry Ice*. His power, technique and speed was like no one else and, on top of it all, I have the most beautiful painting Toller did for me hanging in my home. So, you see Toller is with me always.

An artist extraordinaire, with a brush, and on the ice—
I am lucky and happy our paths crossed.
My life is better for it.

Chita Rivera, August 22, 2019

143

MY STRAWBERRY QUEEN MEMORIES WITH TOLLER
By Sarah Kawahara

In 1980, Toller guest starred with *Ice Capades*. My first time on a billboard was with Toller in Philadelphia in February. While touring, we became good friends. Between shows one Sunday afternoon, we went shopping in the antique district. Toller bought three very large copper-oxidized weathervanes. One was a Canada goose. One was a grasshopper. For the third, in his typical dramatic fashion, he hurled his maxi-length silver fox fur coat to the floor and asked, "How much for the windmill?"

While with the *Ice Capades*, Toller met the show's travelling coach, Nancy Rush. She was a renowned world figure skating coach who also coached Julie Lynn Holmes. Nancy had a strawberry fetish and collected strawberry-themed furniture, chandeliers, drapery, and thousands of knickknacks for her strawberry cottage in Glendale, California. On a visit to California, Nancy showed Toller her Strawberry Cottage. This inspired the birth of *The Strawberry Queen*.

In the summer of 1980, Toller summoned me to his house on Carlton St. in Toronto. He showed me what he had just pitched to the CBC. There were large black and white photos mounted on foam board that depicted his artist-self and his alter ego. His alter ego rose out of his body while he slept, and helped him finish his paintings.

When Toller told me about his concept for his show *Strawberry Ice*, he shared with me that he was looking for the "face of the Strawberry Queen" and wanted me to be his muse. The fantasy story was woven through his different paintings of different characters. Peggy Fleming was to be the underwater princess; Chita Rivera, the Fire Temptress; and throughout the show, we would visit many other "worlds." One minute I would be a butterfly, the next an archangel. It was a dream come true for me to play so many different characters. He would see my face in all these worlds and finally be able to finish his *Strawberry Queen* painting with me as the Queen.

We would meet at his place, which was a dream in itself, with hanging golden cherubs on each wall and overhead, every inch of wall was painted with detailed colour and texture, over which his paintings were mounted. We listened to hours of music together. He surprised me with his penchant for Stevie Wonder's "Pastime Paradise." He loved the spirit of the lyrics "They've been spending most their lives. Living in a pastime paradise." Which, indeed he did.

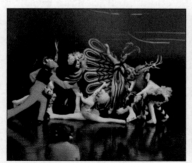

Toller, Sandra Bezic, Shelley MacLeod, Amelia Prentice, Jamie Lynn Kitching

Sarah Kawahara and Toller

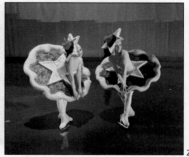

The Tarts: JoJo Starbuck, Shelley MacLeod

STRAWBERRY ICE: TOLLER CRANSTON AT HIS VERY BEST
By Ryan Stevens

You couldn't have put together a better production to showcase Toller Cranston's gift as an artist than *Strawberry Ice*. At times psychedelic, at times spiritual, at times playful and theatrical and exciting from start to finish, Toller's TV special *Strawberry Ice* had it all. The opening music grabs you immediately and for everyone who grew up in the 1990's, like me, it instantly says "Gangsta's Paradise" and the Michelle-Pfeiffer-movie-turned-Annie-Potts-miniseries "Dangerous Minds." It's Toller in the city and the story is staged out of a flat where he's opted to take a nap among his amazing art. An out-of-body experience almost depicted like astral projection takes Toller on a series of dream-like adventures on the ice that combine fantastic music, emotive skating and the most expressive and dynamic movement you can ask for to create this fascinating flow of different stories that piece together one by one.

It's got everything—not just Toller's larger-than-life skating and his brilliant "Firebird" program, but Sarah Kawahara, Peggy Fleming, Allen Schramm, Sandra Bezic and the most amazing costumes, which were designed by four-time Canadian and two-time World Champion Frances Dafoe as well as incredible stage sets and imagery. *Strawberry Ice* came out in 1982, but it is not dated at all! It was ahead of its time and still has relevance, excitement, and freshness. The soundtrack itself is a gem—full of music perfectly suited to each fantasy sequence. Chita Rivera also complements the skating cast with her rich voice. She shines here just as much as she has on any Broadway stage singing "Fever" in a skating/music marriage with Toller.

It really is special and we could honestly all use a little more Toller Cranston in our lives.

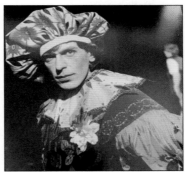

Toller - Strawberry Ice

Strawberry Ice in its entirety https://www.youtube.com/watch?time_continue=51&v=fpbnfL0CKdM

THE TRUE GIFT OF CHRISTMAS
by Sarah Kawahara

After the resounding success of *Strawberry Ice*, Toller asked me to choreograph his next TV special *The True Gift of Christmas*.

He first cast me as Jules Nissan an impish gender-neutral elf that was to thread together the elements of the story. I was given a long beard, which, in my memory, will forever be historical (hysterical?).

The characters ranged from skating Poinsettias, where each of us was a section of the stamen, so that when our heads were together, we made a complete blossom. I remember that JoJo and I were delirious to have had this out-of-body experience together.

The candy canes were unlike any other skating costumes imaginable. We were made-up so the stripes crossed our entire face with a continuation of the diagonal design. JoJo and Kenny, Toller, John Rait, Shelley MacLeod and I were complete mirror images of one another.

I choreographed the candy canes with the goal of precision in mind. Toller called me up to say that David Acomba was "going to ruin the numbers in editing by adding a prism effect to the choreography" (which actually disguised our flaws and accentuated the choreo). Toller was in such a dither; he actually flew me in to confer.

THE TRUE GIFT OF CHRISTMAS: FOLKLORE AND FABULOUS SKATING
By Ryan Stevens

An otherworldly adventure from start to finish, Toller Cranston's 1985 CBC special *The True Gift of Christmas* is at turns whimsical, dark, and inspiring, and always spellbinding.

The story opens with a young runaway named Chris (played by child actor David Hebert) stumbling upon a ceremonial rite portrayed on ice by an ensemble cast including 1980 Olympic Gold Medallist Robin Cousins and 1984 Olympic Silver Medallist Kitty Carruthers. Wearing elaborate theatrical masks and bearing torches, the eerie scene pays tribute to the first Christmas tree, which according to folklore, came to be in the eighth century A.D. when St. Boniface was converting Germanic tribes to Christianity. These tribes worshipped oak trees and decorated them in celebration of the Winter Solstice. St. Boniface is storied to have cut down one enormous oak tree that was central to the tribe's worship and instead, a fir tree grew in its place. The evergreen was then seen as a symbol of Christianity and the converted Germans decorated the tree in celebration of Christmas.

In the dreamlike fog, Chris meets and befriends a woman named Befana (played by Gemini award-winning actress Martha Gibson) and quickly learns that she is stuck in a kind of limbo or purgatory, where every year from midnight on Christmas Eve until dawn, she roams this dreamland in search of a true gift. Similar to the Santa Claus tradition, many of the children will write notes to *La Befana* and even leave out food and wine for her (sausages and broccoli in some parts of Italy). It is a fairy-tale story of the good witch/bad witch, depending on how you behaved during the past year.

Befana's freedom from this limbo (and we soon learn Chris' as well) hinges on Befana's ability to find and give a true gift. The various characters they meet along the way all seem to provide a piece of the puzzle of what a true gift means, although

Chris is much more adept at picking up on (or choosing to hear) the not-so-subtle clues along the way. Noting the mystique of their dreamlike environment, Befana exclaims "once you end up here, time and place don't mean anything." Their goal is to find the three wise men and the child king and give them this true gift.

It is truly just beautiful. In the final main scene, before a storm stirred up by Toller's Pan-like character, we are taken to an early Russian Christmas scene with some beautiful skating by Kitty and Peter Carruthers and Kawahara. In this storm, Befana loses her bag of gifts that she's been almost obsessively collecting in search of a true gift to give the child king and Befana and Chris encounter a frozen girl who Chris recognizes as the Little Match Girl. Chris finally gets through to Befana that a true gift is one given unselfishly without one expected in return and she wraps her shawl around the frozen girl who comes to life and skates brilliantly.

A final banquet scene set to "O Holy Night" features Chris, Befana and the entire skating cast—Cranston, Cousins, Sarah Kawahara, the Carruthers, Starbuck and her partner Ken Shelley, Norbert Schramm, Simone Grigorescu-Alexander and Shelley MacLeod and John Rait. The skating itself in this scene is wonderfully choreographed by Cranston and Kawahara and brings a joyous conclusion to an at-times dark, but wonderfully-told story. Kawahara looked back fondly on Cranston's vision for the production: "He was very driven by music, although the story always came first. Toller has a wonderful sense of humour and loves the absurd. I'll never forget when he wanted to have synchronized swimmers as shrimp in the tomato soup at the Christmas banquet." Following the final scene, as Befana has given her true gift, she is freed from her holiday limbo and Chris awakens in the bedroom that he ran away from in wonder and no doubt with more appreciation for what the real holiday spirit is all about.

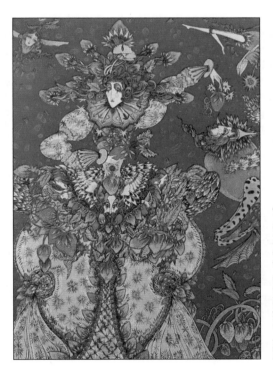

The creation of the *Strawberry Queen* in 1974 kicked off Toller's decades-long obsesssion with strawberries. When critics began to disparage this infatuation, he made efforts to leave the berries behind. But, he confessed, "sometimes a strawberry pops out of nowhere and lands on the canvas."

TOLLER CRANSTON VISITS *THE MAGIC PLANET*
By Ryan Stevens

Broadcast in both Canada and the U.S. on CTV and ABC in March of 1983, *The Magic Planet* was a futuristic ice odyssey like no other. It was narrated by none other than William Shatner himself and directed by David S. Acomba. Skating acts were fused with performances by dancers from the Alvin Ailey company of New York and the George Faison Dancers. Although music was provided by the London Symphony and recorded in England, it was scored and conducted by Canadian Paul Hoffert. Like in Toller's other specials, costuming was designed by Olympic Silver Medallist and two-time World Champion Frances Dafoe. The cast included Cranston, actor/musicians Ann Jillian and Deniece Williams, and skaters Brian Pockar, Sandra and Val Bezic, and Wendy Burge.

The premise of the show was that of an astronaut (Cranston) having his NASA space capsule hit by an asteroid. When the craft lands on a strange magic planet, Cranston's skating wins the heart of the Queen of The Outerworld People. Cranston's character is confronted by Fraze (Pockar), an evil leader of the Outerworld's rival Underworld. Fraze seeks the Queen's (Burge) hand in marriage, but after a scuffle, Fraze is banished from the Outerworld. Fraze abducts the Queen, taking her to his kingdom. A sorcerer approaches the astronaut and gives him a pair of magic skates which aid in his efforts to rescue the Queen.

In a 1983 interview regarding the show with Lynne St. David, Toller Cranston said "What's most exciting about *Strawberry Ice* and *The Magic Planet* is that we have been able to combine skating with the more traditional elements of entertainment, such as dance. It's ironic, because in the field of entertainment, Canadians are usually thought to be two steps behind the United States. But this is an area where we are breaking new ground. Working with the most sophisticated electronic equipment and techniques that television can provide, we were able to incorporate the different mediums into a visual delight. In all my travels, with all of the work I have done, the most clever and creative individuals I have worked with, bar none, have always been Canadians. My costume designer, Frances Dafoe, is a perfect example. She is better than anybody, the best internationally, but nobody knows her name." He claimed that his 1983 production "goes far beyond skating. Often you forget that the characters are on ice at all."

The Magic Planet was classic Cranston at his best with great music, costuming, theatrics and skating melded together to create a unique storybook that (though at times, a little kitschy) captures your imagination like a book you just can't put down. I still think that's what made Toller the enigma he was. You just couldn't look away.

TOLLER

The difference between a great performance and a mediocre performance is primarily a matter of conviction. The skater must make the audience believe in him as fiercely as he believes in himself. It isn't a question of how many triple jumps he can land or how many times he falls. What really counts is the degree of personal involvement—the total overall impression.

TOLLER

Once I was asked to go to Ottawa to skate at the Minto Skating Club. The building had been taken over, and it was just Prime Minister Trudeau and his wife, and King Hussein and his third wife, and I was the show. I was the entertainer for the King.

I also remember a show in the old Soviet Union where I did, like, eleven encores. They told me I was an instrument of the West that inspired freedom—freedom of individuality and freedom of expression.

I guess I was just the right thing for the audience at that time.
From *Maclean's* magazine, 2004

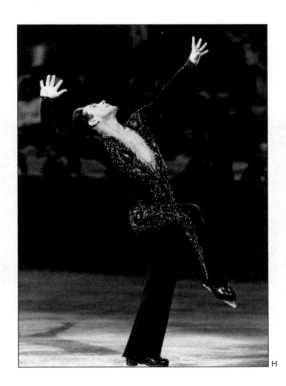

PORTRAIT OF A SKATER AS A YOUNG ARTIST
By Barbara Sears, *Maclean's*, 1975

Just what does Toller Cranston have to do to prove his genius?

"The most creative skater of the century . . . the Nureyev of the skating world, ladies and gentlemen, Toller Cranston." The announcer's superlatives grate, but the audience erupts into prolonged applause, which says we agree, as the small figure in black skates to centre ice. He pauses in intense concentration, waiting for the music.

The bitter, ironic laughter of Canio, Leoncavallo's clown, echoes across the arena and for a moment you feel that there has been a dreadful mistake: that some befuddled official has put on the wrong record. Pagliacci is just not played at ice rinks, and skating to the aria *Vesti la giubba*, in which Canio laments the life of the performer, seems like an invitation to disaster. The Kitchener audience, accustomed to a diet of light orchestral music, or at best Tchaikovsky, responds to it in a strange way. When Cranston jumps and spins, their applause is muted, as though they cannot quite break the show business habit of recognizing a good trick, yet at the same time they know that it is wrong to interrupt. But as he glides into a final agonized pose, some have tears in their eyes. There is a moment of silence, followed by applause that is very loud and very long. The audience rises, throws red roses to the ice, shouts bravo, calls for encores. It is the kind of reception that Nureyev and Baryshnikov receive. Toller Cranston gathers up the roses, and, in a gesture of flamboyant showmanship, distributes them among the lady skating judges.

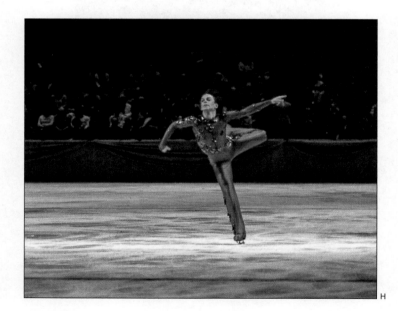

UNSEEN FORCES: INTRODUCING THE BOYS IN TOLLER CRANSTON'S BACK ROOMS

By Ron Base

Opening night on Broadway, an event whose glamour, this evening, is marred by a weaving black man with a toothless grin, standing before the Palace Theatre on 47th and Broadway, slamming a stack of yellow cards against the palm of his hand, yelling in a loud, whiskey voice: "Check 'er out, now. Check it out." He tries to shove the cards into the hands of passersby. The cards advertise the business of Broadway these days, which is not theatre, but sex: "No rip-off! Luxury For Less. $10 complete satisfaction. Beautiful girls. No other charges." The theatregoers milling in front of the Palace grimly ignore the black man. They are intruders here, camped along the edge of the sewer that is Broadway, desperately searching for some sign of opening night panache.

There's Julia Meade, the girl who used to do the commercials on the Ed Sullivan Show. Julia Meade? No big star to be sure, but better than the reality of this Times Square hawker.

Andy Warhol, his pale face resembling the skull on an SS officer's cap, scoots by the black man. In the main foyer, the producer of the new show, a man named Dennis Bass, greets everyone. He pumps hands as if trying to draw water and embraces people in huge, affectionate bear hugs. His eyes are fiercely bright. His smile looks as if it had been drawn shakily on his face by some kid with a crayon. Beside him, and a couple of steps to the rear, stands Bass's partner and co-producer Robin Cranston. He is more restrained, but his eyes also burn with a weird intensity. He is younger, a thin Henry Fonda with a grin like a knife blade.

In the gold and red plush of the 1,680-seat theatre, Julie Newmar, a long and slinky actress who once had a fling with Howard Hughes and who now retails a line of pantyhose, purrs against her fiancé, a Texas lawyer. She stares out at the stage, blinks, and looks again. Then she reaches for a pair of opera glasses. There, protruding out from the gold leaf of the Palace's proscenium arch is . . . ice. A sheet of it, measuring 48 by 56 feet, done in powdery blue. The stage where Bob Hope and the cream of vaudeville once performed, where Judy Garland sang, and where Lauren Bacall opened in *Applause*, is now a glorified ice rink.

Below, in the grey-brick bowels of the theatre where legend has it a ghost still lurks, the star of the new show, Toller Cranston, sits on a brushed corduroy couch in his chocolate brown dressing room. He leans forward carefully lacing his black Knebli skates. His face, as usual, betrays no emotion, although in a few moments he will be onstage with fifteen other skaters introducing Toller Cranston's *The Ice Show*. If the night works out for him the way he fervently wants it to, he will soon be Broadway's newest star. He will have lifted ice skating out of the community centres, away from the funny animals and leggy chorus girls of the *Ice Capades* and the *Ice Follies* he despises. The night before, during a preview performance, he had been nervous on the ice, seemingly afraid of its narrow perimeters. Afterward, Toller's supporters were chanting "bad dress, [rehearsal] good show," like nuns reciting Hail Marys to ward off evil. Broadway cynics were doubtful of the show. It was the wrong time of the year, they said. The producers were asking a ticket price of $15 top ($16.50 on weekends) for an ice show no one knew anything about, which offered no orchestra (the music had been taped by a 54-piece orchestra in London), and a star who outside skating circles was unknown to a New York audience.

There were other problems that cynics and supporters alike knew nothing about. The story

of Toller Cranston's arrival at this moment, with the hawker outside handing out promises of a dirty time and a first night audience inside wondering if *The Ice Show* would ever succeed, is one of deception, intrigue, sexual innuendo, brash showmanship, and plain lies. Tempers were lost, friendships were broken, harsh accusations were hurled back and forth, even sabotage was suspected. The cast of characters included a producer who had never before been involved in a Broadway show, yet cheerfully threw nearly one million dollars into this one; disgruntled backers who resented being left out of the planning; a mysterious manager who exercised a strange power over the show's star.

And the most intriguing character of all, Toller Cranston from Kirkland Lake, Ontario, who fell in love with skating at age seven and grew up knowing someday he would be a star. He is a painter of talent, a writer, at twenty-eight an enigmatic personality who suggests great character strength, but also a sad vulnerability. One felt sorry for him, the suspicion taking root that everyone, no matter how good his intentions, was trying to manipulate him in some way. In his dressing room, Toller finishes with his skates. Upstairs the other performers are swirling on the ice. He can hear the strains of Toller's theme, written especially for him by Academy Award winners Al Kasha and Joel Hirshhorn. It is time to go onstage.

The first advertisement announcing Toller Cranston's impending Broadway debut appeared on a full page of the Sunday New York Times, twenty-five days before the show opened. The headline read: "An Apology to the People of New York—Only 48,000 of you can see Toller Cranston's *The Ice Show*. Sorry ..." No apology was necessary since the ad was not true anyway. If *The Ice Show* was a hit, it would run as long as audiences wanted to see it. If the show flopped, it would close immediately. In the meantime, there was no harm in trying to hype the box office by making it seem as though only a limited number

of people could see it. The ploy was somewhat successful. In the days following the ad, ticket sales, previously almost nonexistent, picked up. The first salvo in the campaign to promote Toller Cranston to New Yorkers had been fired.

The next week, Dennis Bass hurried up to Toronto to open phase two of the campaign—publicize a Canadian tour of the show planned for next winter. At a press conference, he accused the *Ice Capades* of trying to stop Toller from touring. He claimed *Ice Capades* and *Ice Follies* operated a virtual monopoly. *Ice Capades* demanded agreements from arenas stipulating no other ice show play ninety days before or after the Capades. "Toller," he said with great solemnity, "believes totally in the freedom of ice." Pause. "And right now," he sighed heavily, "there is no freedom."

In the following weeks, Bass was seemingly able to uncover all sorts of wild plots against his show. Attempts were made to lure away his staff and performers. Eighty thousand posters disappeared, and those that went up in the Broadway area were torn down. Someone, he said darkly, was stalling completion of the ice surface. He solved the problem by issuing a few warnings to the Sicilian workmen in their own tongue. Intruders tried to get into the theatre, forcing him to hire armed guards.

Finally, Bass's paranoia appeared to bear fruit when Metromedia, the entertainment conglomerate that owns the *Ice Capades*, citing a conflict of interest, canceled a radio and television advertising campaign for *The Ice Show* on its New York outlets. Throughout, it was difficult to tell whether Bass was agonizing over these obstacles or enjoying every one of them. He was either a shrewd entrepreneur or a pretender who concocted wild schemes such as organizing a write-in campaign among Canadian figure skaters to invite Prime Minister Pierre Trudeau to the opening.

In the end, he was a man who thought ice was

something you add to Chivas Regal. The mystery was how he got involved with the show in the first place.

In 1976, Toller Cranston retired from twenty years of amateur competition with three world free-skating championships, an unprecedented six consecutive years as Canadian men's champion, and a third-place bronze medal at the 1976 Winter Olympics at Innsbruck. He celebrated his retirement by throwing his skates into a canal in Sweden. "It sounds dramatic," Toller says, "but actually it was done as a tremendous joke." He thought seriously of devoting himself full-time to painting. But then a group of backers was brought together to form a company called Theatre on Ice, and Toller created his own touring ice show.

For tax purposes, the head offices of Theatre on Ice were located in Holland, although much of its financing was raised by a Toronto lawyer, Arthur Smith. Cranston owns half the company. He gets a salary of about $150,000 a year, a home in Bermuda, and a New York apartment across the street from Carnegie Hall. Theatre on Ice contracted the promotion and booking of Cranston's ice show to Hurok Concerts Inc. Hurok was more at home booking ballets than ice shows and, to make matters worse, the founder, Sol Hurok, had left his company in desperate financial straits, when he died in 1974. After a confused Canadian tour, Cranston was fed up with Hurok. "They treated us like animals and screwed up like I couldn't tell you." But the company remained tied contractually to *The Ice Show*.

"Someone came up with the idea of Broadway," Cranston says. "For a minimum amount of publicity, you can put a show into a theatre and possibly have a hit." Hurok tried to do it on a shoestring. For example, a total budget of $15,000 was allocated for advertising. Yet a full-page ad in *The New York Times* alone costs $16,000. Not that it mattered much because in January, two weeks before the show was to open at the Uris Theatre, Hurok representatives announced to the cast they

had not "reached financial commitments," and closed the show.

"I was ready to place a pistol to my head," Cranston remembers. "It was so degrading, I can't tell you. If I had the funds, I'd have been on my way to Tahiti, paint brushes in hand, ready to paint myself to death." Instead, the next morning he boarded a plane for Los Angeles. Lately, he had become friendly with his cousin, a twenty-nine-year-old Californian named Robin Cranston. The son of Senator Alan Cranston, Robin helped develop the McCloud television series. Now he was involved in business dealings with a shopping centre developer. And Robin wanted Toller to meet him.

One morning Robin showed up at the Beverly Hills Hotel with a Rolls-Royce that once belonged to King Hussein and whisked Toller off to Bel Air where they descended through iron gates and down a drive that swept past an uncanny replica of the White House. Dennis Bass, wearing jeans and a T-shirt, thick, with unkempt hair spilling over his head, bounded from the house to meet them. His was the sort of Horatio Alger story that makes small boys want to grow up to be rich. Bass was raised in New York's tough Bedford-Stuyvesant and led his own street gang. He started out with $80 which he used to purchase a real estate salesman's license in Los Angeles at the age of twenty-one. Two years later, he owned a real estate brokerage business with which he launched the Bass Financial Corporation, a multi-divisional company that today is worth $250 million. In his mid-thirties he was deeply involved in Democratic politics.

"I thought he was the mob," Toller says. "I had no idea who he was. I was convinced he was Mafia." Bass poured champagne. Toller sipped a couple of glasses, then, because he hadn't eaten all day, passed out on the floor. But not before Bass had agreed to back his ice show.

Dennis Bass quickly alienated Arthur Smith, the Toronto lawyer and his wife. They felt they had

stuck with *The Ice Show* through the bad times and were now being left out in the cold by Bass's high-powered salesmanship. They disliked his harping criticism of Hurok, a company they considered honest, albeit misguided and under-financed. And they distrusted his super-heated efforts to make headlines. And they resented Bass's implication that he owned *The Ice Show*. Theatre on Ice owned it. Bass had merely taken over the booking and promotion from Hurok.

On a seamier level, the spreading of sexual innuendo became almost a business tactic. Toller's manager was a mysterious, one-eyed woman named Elva Oglanby. She had left her family in Vancouver to enter Toller's life and exercise a Rasputin-like control over him. For her he bleached his hair and constantly wore black, just as she did.

The sexual name-calling that surrounded Toller during the rehearsals was perhaps understandable. Like Mick Jagger or Rudolph Nureyev, part of Cranston's fascination lies in the question of his sexuality. He tends to blur sexual boundary lines. When all has been said about his skating style—the wildly exaggerated and expressive movements verging on high camp—he is a man unafraid to appear feminine. Historically, the ice world has had a stem aversion to men who were anything less than masculine in their skating style. The Ice Follies, the original ice show founded in 1936 by a couple of skaters named Shipstad and Johnson after they got tired of touring carnivals, was very straight. The *Ice Capades* which followed had strict rules against gay skaters in its ranks. But Sonja Henie, a marvelous show woman, welcomed gay skaters and loved their flamboyant style.

It was Toller Cranston who finally broke the constraints on men's figure skating. He performed spirals, and ran around on the tips of his skates, employing movements that previously had been done only by women. His performances awed audiences and shocked competition judges, which is probably why he never placed better than third

in Olympic competition. "Toller is the single most powerful force in skating," says Gordie McKellen Jr., a New York skater who has often competed against Cranston. "Everywhere you go, he is the one audiences have got to see."

Toller is aware of the debates about his sexuality. "The higher you climb, the more liable people are to take pot shots at you. But I can live with it because it's all so unfounded. People can say anything about you—that you're a nympho or you're into boots and whips—and you have to realize these allegations are made because you're in the public eye."

Would he like to marry? "Yes, I would. And eventually have children, too. I thought the time for that would come after I retired from competition, but now I'm more of a slave to work than ever before."

He rehearsed seven hours each night, closely watched by his long-time coach and confidante, Ellen Burka. As opening night approached it became apparent that his style and charisma had to carry the show. The other skaters, with the exception of McKellen whose flashy athletic routines brought an audience to its feet, lacked panache. They were, for the most part, competition skaters who could not understand the demands of the Broadway stage. It was a problem that worried the show's choreographer, Brian Foley, and the director, Myrl Schreibman.

In the upstairs bar at Sardi's a week before the show opened, Schreibman said: "The success or failure we have in making those skaters into performers may decide whether this show hits or misses." He stopped and stared into his drink momentarily. "The show is going to be a hit," he said finally.

Sitting beside him, Dennis Bass shrugged. "Even if it isn't," he said, "we gotta know we tried."

Two hours after he had finished tightening his skates, Toller Cranston left the stage of the Palace

154

Theatre. Behind him, 1,500 people were on their feet, shouting and cheering the way Broadway audiences are supposed to shout and cheer on opening night. The curtain calls were wildly ecstatic, but it was hard to ignore the fact that this was an audience loaded with friends, relatives, invited guests. When Toller first appeared, outfitted in a black jump suit, swinging from a wood and metal replica of the sun, everyone reacted as if he were some doll-faced Messiah.

But, at the end, the cynics were still unsatisfied. Was this icebound blend of ballet and Broadway dance, brimming with classic excesses of Thus Spake Zarathustra and the syrupy love theme from Nicholas and Alexandra, a hit? Or was it a pastel-lit oddity, full of fresh-faced but lacklustre kids, doomed to close early amidst the snickering of an arrogant Broadway audience?

Such questions are answered only by the theatre critics. At the U.S. Steak House around the corner from the theatre, a glum crowd awaited the reviews. At 11.30 p.m., the first copies of The New York Times arrived. Cyril Ritchard, the actor who played Captain Hook to Mary Martin's Peter Pan, was asked to read the review by a second-string dance critic named Anna Kisselgoff. Ritchard stood, straightened his ill-fitting jacket, cleared his throat and, in the kind of resonant voice only forty years of speaking to back rows can provide an actor, began to read:

"He has the bold-faced appeal of a successful rock star and the virtuosity of a great dancer. He is Toller Cranston, and to say he is an ice skater is not the half of it." Ritchard was interrupted by the noise of the crowd, more a howl of relief than a cheer. He continued: "At Toller Cranston's *The Ice Show* which opened last night at the Palace Theatre, the former Canadian men's and world's free-skating champion and 1976 Olympic bronze medalist is every bit his outrageous self. He is terrific."

At that, Dennis Bass threw back his head and laughed. A few feet away, Toller Cranston allowed a smile to interrupt the carefully arranged boredom of his face. *The Times* review was a rave. It ended by simply saying: "Go see him." On Broadway, you can practically cash reviews like that in at the box office. For the moment, Toller Cranston had attained his ambition: he was a star on Broadway. The following day, however, there were no lineups in front of the box office, the usual signal that the theatre-going public has picked up on glowing reviews. But one familiar face showed up. The black hawker, slapping the yellow cards against his palm. This time his presence was more relevant. He seemed to be speaking for Toller Cranston's future on Broadway. "Check it out," he called. "You check it out now.

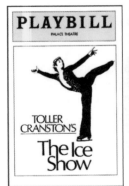
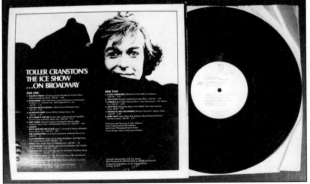

THE ICE SHOW
By Deirdre Kelly, *The Globe and Mail*

"A Nureyev on skates," is how The New York Times described Mr. Cranston in 1977, a year after he turned professional and appeared on Broadway in a skating spectacular called *The Ice Show*, in which he was the undisputed star.

Performing choreography by Mrs. Burka and Canada's Brian Foley, Mr. Cranston wore lavish Folies Bergère-style costumes and made his entrance down a spotlighted staircase with his hands held high over his head. It was definitely a look-at-me gesture, outrageously camp and a deliberate poke at the staid skating establishment.

But critics agreed that his talent matched his ego and welcomed his out-sized personality, recognizing his uniqueness.

"Like Mr. Nureyev, Mr. Cranston is a wayward spirit in his own art," wrote dance critic Anna Kisselgoff, comparing the skater to the most famous dancer on Earth. "And like Mr. Nureyev, he has a strong discipline that allows him to keep the basic form of his technique while breaking the rules."

Break the rules Mr. Cranston did,
and not just on the ice.

By Jeanne Beker

He was such a celebrity. You know, everywhere I went with him, people would want to talk with him. He was constantly having to fend off people because everyone wanted a little piece of him. I felt like I was with some kind of a rock star. He had such a fantastic sense of style. He was just a vision. I think that it was something that everyone in Toronto was starved for. I think still, all these years later, we are still starved for that—these people that are larger than life, these glorious colourful characters. Canadians aren't often known for their theatrical qualities and certainly they are not known for dressing to the max and being over-the-top, but Toller was all of those things.

By Alex Trebek

Toller was so innovative. He did his signature move on *Stars on Ice* and I was blown away.
But what impressed me more, was how he interacted with our skating crew.
They were in awe of him, but he made them feel comfortable
and a special part of his performance.

By Brian Orser

I got to tour with him for eight or ten years. There were a lot of tour buses, and a lot of stories. He has so much to give to the sport and I am grateful for that. At the beginning, I don't think he was really *out* although he was *out*. He was not a hypocrite and he didn't lie about anything but I don't think it really mattered to him. I don't think the skating world saw it any different. Being Canadian, the fans embrace you and respect you regardless of anything and that is the legacy he has. He was a very flamboyant skater and he made it OK for men to be artistic. So, people who followed in these footsteps…guys felt it was OK to express themselves in any way they wanted. He paved the way for that.[12]

By Debbi Wilkes

I think he saw life in colours and the brighter the colour, the better the experience, so his life was lived pushing to the extreme in everything he undertook. So, if the discussion was about being gay or about homophobia, he wanted to shock people. He wanted to use that shock technique to make people listen. That was his goal—whether it was about the gay community or artistic skating or painting. Even if you might not be the best in the world at this point, you have to be the best in the world for people to take notice. He was brave and determined and he would not compromise in any way.[12]

TOLLER

The older I get, I find that the more I perform, the more vulnerable I become,
I know what I have to offer to the world of skating. It is not how high I jump because I could never jump as high as Robin Cousins. But it's in the motivational value that I hope I can give to an audience.
When I go out to skate it's a primary intellectual concern for me to think
in terms of "giving a memory."[13]

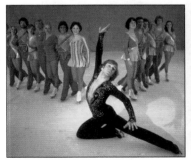

I remember once skating in Arnprior because they had a new arena and my uncle
who was the former mayor had asked me to come and there are certain ties there. The building was
absolutely filled. You couldn't get a seat. When you have that kind of enthusiasm, that kind of support,
you can't be slick about it. You can't ignore it or take it for granted. When you step on the ice in
Arnprior, you perform the same as you would in Madison Square Gardens—in a grand, crazy way.

When I went to Arnprior, I thought these people don't know much about skating.
They will probably never see too many skaters of superior quality in their rink. So, when I went
out on the ice, I felt a tremendous vulnerability and nervousness. In a way, I suppose, in retrospect that
that's reassuring, because it is very important to me to go all out the one time I skated in Arnprior.
I really hope that twenty years from now, they'll say, "you know, one time I saw Toller Cranston come
to skate in Arnprior and I'll never forget it." That's the way I tried to skate as opposed to thinking that
they don't know anything, so I'll just do a lot of split jumps.[13]

Individuals have a certain ability. They come to a certain level and at that point they split.
One way is to become a personality, an entertainer. The other way is to become an artist.
There are two distinct ways. The slickness comes when, all of a sudden, one become the
personality, the entertainer. If you are constantly aware of maintaining a certain artistic integrity
you can't become slick because you are still striving. You still want to become better.
You still want to create a different emotional subtlety while of course
maintaining technique too.[13]

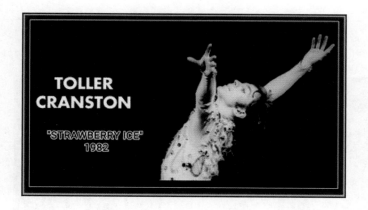

CHAPTER 14

FLASH FROZEN: PHOTOSHOOTS AND BOOKS

THE PHOTOSHOOTS

Whether in front of the camera or directing what winds up on film, photoshoots

were an important part of Toller's art.

HIS SPIRIT AND HIS BEAUTY IS IN HIS BODY
By Cylla Von Tiedemann

I was very honoured when Toller asked me to do a photoshoot with him but also a little bit intimidated. He was already a big superstar and I thought how can I possibly capture him? I was thinking artist and theatrical and ice. So I had smoke—no mirrors but smoke—and plastic, and white background and black background.

And so, we started. Toller is truly a dancer and his spirit and his beauty is in his body. It is in his every muscle. Plus he had just come from a CBC special and he was in fantastic shape. Although he was very big, he was also very open and vulnerable. That's what was so beautiful about him. You could connect deeply, emotionally with him and at the same time he was a performer and he would give you the greatest show.

We worked relentlessly for three hours without ever talking. Toller gave everything he had. I gave everything I had. It was the first time where I completely connected with another artist. It was this amazing dance. I have thought about it many times since and I think it was the most important

thing in my career to tune into someone else's creativity and spontaneity. When it's over it's over. We have only the photographs to show for it. But there is something very beautiful about this deep, deep connection between the camera and the creator.

Afterwards, I drove Toller home, and on the way he said, "one day these pictures will make you very famous." Now in 2022, this is the first time we have shown them. Back in the 1980s, everything was over the top. But now, I think it is the perfect time to show these photographs and for all of us to live with Toller. In just the past year, the photos have been exhibited in Toronto and Victoria, as well as San Miguel de Allende, Mexico, and São Paulo, Brazil.

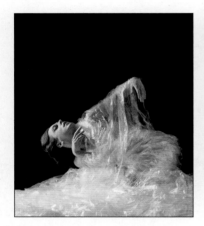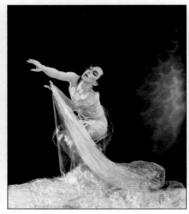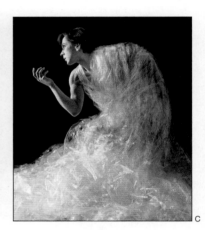

DON'T WORRY. JUST BRING YOUR CAMERA
By Lander Rodriguez

I never knew what was going to happen when he would call me. He didn't ask my opinion.
We never had a meeting ahead of time. He would just say, "Don't worry. Just bring your camera.
We are going to shoot tomorrow."

When I would get there, I would find that he already brought everything—the fabric, the easels, the
boat, a dog—once, a live goat—and we would just build the scene right there in the moment.
We would just do it. You have to adapt to him but he always allowed me to do everything
I needed to do to make it happen. The pictures seem natural, but there is a lot of work
and afterwards a lot of photoshop hours.

Toller was a very good art director. He knew exactly what he wanted. It is easy for a photographer
when the director knows exactly what they want.

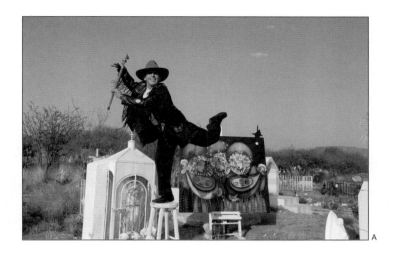

HE WAS A GREAT ENCOURAGER
By Jeanie Gooden

He was the great encourager of artists. Toller would meet an artist he admired and extend an invitation to him/her to present a show on the property, typically in his studio. He did that for me and, as I recall, he wanted to do a photo shoot of me in an elaborate iron bed, which would have to be lowered into the middle of a river. I just didn't have the energy or courage at the time. Regrettably, I said no. Toller couldn't fathom that I wasn't game for it. Looking back, I should have laughed while he hoisted me into the river. What a memory I would have for this moment.

161

_C

A BRILLIANT SKATER, ARTIST AND FRIEND
By Duncan McLean

Toller Cranston lived in a grand Victorian home on Pembroke Street in downtown Toronto in the 1980s. Waddington's was on Queen Street East at that time, on the other side of Moss Park, a short walk away. For those who don't know, Waddington's is a Canadian auction house that has been dealing in fine art, luxury goods, and collectibles since 1850.

Toller was a regular at all our auctions, which in those days included twice-weekly estate auctions offering anything and everything to be found in a home. Toller was always on the hunt for the wild, the colourful, the outrageous, the beautiful and anything over-the-top. His favourite expression when he saw something he had to have was: "It's beyond the beyond!" Pieces Toller had to have included an Italian Murano green glass indoor fountain that was destined for his bay window (where it actually worked, once installed); a huge black metal sculpture of a flying raven; as well as every antique, carved wood cherub he could find. One evening, I was hanging out with Toller and Bill Kime, another friend from Waddington's. In our conversation, Toller declared that it was time for him to start selling a few pieces to help spark a change in his life. This was during a difficult period for Toller, in the twilight of his skating

career, and feeling unappreciated by the art world. I remember a large canvas he had recently painted. It depicted classically Victorian-dressed skaters on a frozen outdoor pond. On a hill next to the pond, a sinister-looking tree with another skater hanging by the neck from a branch over the frozen pond. That was Toller—dramatic and dark-humoured.

Bill suggested that the best way to sell his pieces was not a few at a time, but all at once as a big event that would generate excitement and create a buzz in Toller's world of art and entertainment. Toller loved the theatre of big events, and he was immediately excited by the prospect. In June 1991, after many days of working closely with Toller to catalogue the collection and produce a catalogue, Waddington's offered the contents of his three-storey house over a three-session auction. Invitations to the preview party were highly sought. Fans, collectors, voyeurs, and media spilled out our front doors the evening of the first auction. And, as predicted, the sale of his home and its contents allowed him to "reinvent himself." Toller bought a magnificent estate in San Miguel de Allende, Mexico's artist colony, where many ex-pat Canadians, including Leonard Brooks and Toller's good friend Gary Slipper, were already settled. A new chapter of his life began.

THE BOOKS

Toller's creativity has flowed from the ice and canvasses onto the printed page.

Much has been written about Toller and by Toller over the years. His books serve as another chronicle of his skating and painting career.

Zero Tollerance
By Toller Cranston with Martha Lowder Kimball
A Review by Tim Falconer

Just as Wayne Gretzky and Tiger Woods are familiar names to even those who disdain hockey and golf, Toller Cranston became well-known among people who don't know a Lutz from a Salchow. The six-time Canadian figure skating champion went on to a successful career in ice shows and then became a controversial skating commentator for the CBC. Along the way, he earned a reputation as a respected artist, an idiosyncratic collector, and a flamboyant character. In his new autobiography, *Zero Tollerance*—sub-titled *An Intimate Memoir by the Man Who Revolutionized Figure Skating*—Cranston emerges as the Norma Desmond of sports.

Repeatedly calling himself the *Patineur du Siècle* (Skater of the Century), Cranston declares his life's numerous triumphs in prose filled with unparalleled self-love. It's true that as a competitive skater, he was not popular with the skating establishment, which, by all accounts, is a petty, political gang of weasels, but in Cranston's telling, every competitor is unworthy, every judge incompetent, and every bureaucrat corrupt. On the other hand, all his performances are masterpieces, all his costumes are

dramatically gorgeous, and all his entrances are brilliant.

In fact, his co-author, Martha Lowder Kimball, catches him out a couple of times. When Cranston claims he won the short program—introduced for the 1972/73 season—all nine times he skated it, the footnote points out that he won it eight of nine times, finishing third at the 1975 Worlds. Later, he returns from an exhibition of his art in New York to find his answering machine filled with 93 messages congratulating him on winning his wrongful dismissal suit against the CBC. But the footnote reads: "The number of messages grows larger with each telling."

Cranston's over-the-top self-aggrandizement, combined with the incessant name-dropping, threatens to turn the book into either annoying drivel or hilarious parody. But it never does, and the book remains an oddly compelling read. For one thing, unlike many athletes, Cranston has had a fascinating life away from the rink. His skating took him all over the world, from Sweden to South Africa and from Haiti to Hong Kong, and he took the time to explore more than the hotel and the

arena. His art took him to New York and Europe and his celebrity took him to Wichita, Kansas to judge the Miss U.S.A. Pageant. In the process, he hooked up with many intriguing people, including the Happy Hooker, Donald Trump, and Leonard Bernstein.

Cranston is also a far more complex person than many athletes, even if his book does attempt to accentuate the positive. Although he admits to suffering from a cocaine addiction in the early 1990s, for example, he glosses over the gory details. And, with the exception of one brief, but apparently passionate, affair with a married man in Paris, Cranston refuses to open the kimono on his sex life.

Still, *Zero Tollerance* is a revealing portrait. Eventually, the I-am-the-greatest bravado begins to ring hollow and reveals a Toller Cranston who is a bit sad, a bit lonely, and not nearly as confident as he wants everyone to believe.

By Chipper Roth, Haida Gwaii

I just finished *Zero Tollerance*. I just wanted to say how remarkable was his honesty and self-awareness. He said arrogance was his main characteristic, but the final impression is a man who paid homage to his fellow skaters.

When Hell Freezes Over, Should I Bring My Skates?
By Toller Cranston with Martha Lowder Kimball

This 1997 book tells the story of Toller's life after the Innsbruck 1976 Olympic Winter Games.

He has been described as "bold, brazen, and totally unabashed," "one of a kind," and "clearly a genius." He is an artist, celebrity, costume designer, broadcaster, choreographer of skating routines, coach, bon vivant, world traveller, art collector, legend, and enigma. And Toller Cranston has stories to tell.

Like the time at Lake Placid when a woman drove her car directly into his bedroom and seduced him, and the groupie who broke into his

house and waited for him naked except for a few strategically arranged rose petals. He writes about his encounters with the great and famous. (On meeting Joni Mitchell, for example, he asked, politely, "You sing, don't you?").

This is not so much a sequel to Toller Cranston's previous best-selling memoir, *Zero Tollerance*, as a companion volume. There are skating stories and stories from the world of art, there are stories of good times and of bad, high times and low. But this is chiefly an entertaining look back on the first half of an eventful, unusual life by a great Canadian artist and performer.

The Nutcracker by E.T.A. Hoffmann
Retold by Veronica Tennant. Illustrated by Toller Cranston

Principal dancer with the National Ballet of Canada, Veronica Tennant, and champion skater and established artist, Toller Cranston, have pooled their talents to create a fresh, re-told version of the E.T.A. Hoffman classic story of *The Nutcracker*. With Tennant as writer-narrator and Cranston as painter-illustrator, *The Nutcracker* is a beautiful work of art in storybook form. The result of this interpretation is magic. The combined talents of two accomplished artists and their individual interpretation of the Hoffman work is an interesting and distinctive one.

Toller Cranston is well known for his expertise in both championship skating and art. In *The Nutcracker*, he has the characters appear in ballet form as if from the ballet production itself. It is difficult to think of *The Nutcracker* without thinking of the National Ballet of Canada and Veronica Tennant. Henceforth, it will be difficult not to think of Toller Cranston when *The Nutcracker* comes to mind.

Ice Cream: Thirty of the Most Interesting Skaters in History
By Toller Cranston

The skaters included in this book all made a strong impression on the skating world, contributing to the development of the sport through commanding athletic prowess, unusual aesthetic characteristics, or sheer force of personality. Certainly, none of them could be called boring, the deadliest sin in Toller's lexicon.

Readers and fans are aware of Toller Cranston's way with a quip and his outspoken opinions. In *Ice Cream*, they will also learn more about his deep knowledge of skating, his sensitive artistic judgement, and his acute observations of fellow skaters.

Ram on the Rampage
By Toller Cranston

Ram on the Rampage is a book of funny fantastical sketches of Super Ram.

Toller
By Toller Cranston, Elva Oglanby, and David Street

It is clear that Toller Cranston felt his destiny from a young age and, although he definitely suffered from rejection at times, this never stopped him from doing what felt right. This story explains much about Toller Cranston.

He said, "Inhibition is the deadly enemy of all performers. It places limitations on their art so that they are never truly great. Something is held back—the results are never total. I had not realized the extent to which I was inhibited until one night at a party I really let myself go. I danced a gypsy dance and poured my soul into what I was doing. I forgot the other people in the room. I was in a world of my own. I astonished everyone. Someone said to me, 'You idiot! Why don't you skate that way? It would be sensational!'

And that's exactly what I did. I never have been inhibited since then, not even the slightest bit. You only have to do it once. After that it becomes quite easy. There is no need to be afraid."

One commenter said about the books that "the incisive, literate, shriek-aloud funny autobiographies present the artist far better than any tribute could."

CHAPTER 15

A PREORDAINED COLLABORATION

By Martha Lowder Kimball

From childhood, Toller simultaneously experienced events and stored them in his mind as highly detailed tales in living colour. Over the years, he rehearsed, refined, and embellished them. Many he stored in secret, holding them for the right moment. In March of 1996, the stories were fairly bursting within him, straining for release. It was my fortune to be on the scene when that moment arrived.

Sometime in the early 1990s, the Canadian Figure Skating Association tasked me with a magazine profile of the great man. I met Toller officially via telephone interview. It went well. He subsequently mailed me a letter declaring that I had understood him better than he could understand himself. My husband thought the letter remarkable and told me that I had found a new subject.

I later learned how improbable it had been that Toller had been able to assemble all the necessary tools at one moment in time, in one place in the universe: notepaper, pen, envelope, stamp, my address. That was a lot. A creative genius though he was, he could not claim organization as a strong suit, nor did he aspire to it.

Improbable continued to be the operative word. In fact, if you don't believe in fate, or the hand of God, or the benevolent intervention of angels and departed souls, this might be the time to start. It's called synchronicity, and here is the definitive example. By early 1996, I was working on a biography of Robin Cousins. I arrived at the World Figure Skating Championships in Edmonton, Alberta, armed with a dozen letters addressed to members of the skating community whom I

hoped to interview for the book. It was bitter cold in Edmonton, and particularly windy, as I waited in the lobby of the press hotel for a complimentary and generally reliable shuttle bus to take me to the "official" downtown hotels and then to the arena. A taxi pulled up just then to discharge its passengers, and I uncharacteristically— involuntarily, it seemed—ran to the cab and slid in, subtly altering the day's timetable.

The wind had blown me to three of the luxury hotels along the numbered streets off Jasper. I had delivered my letters to all but one of their intended recipients. Only Toller's remained in my heavily-gloved hand. As the desk clerk at the fourth hotel was telling me that Toller was not registered there, who but Toller blew in on a mighty gust and strode over to speak to the very same desk clerk before heading to the hotel restaurant to order breakfast. I didn't need to take two steps to say hello and make my request.

The next morning, I met Toller at the same hotel for breakfast and a lengthy, humour-filled interview. Somewhere between a pair of Toller's Robin Cousins anecdotes, he dangled, "Maybe you will do *my* book." Before lunchtime, I had agreed to appear in San Miguel de Allende, Guanajuato, Mexico, during my conveniently-timed spring break several weeks hence.

It was midnight when I arrived in San Miguel and was admitted through a decorative wrought iron gate into a walled compound that ran on a steep incline from one block to the next. I was instantly swallowed by a magical kingdom full of sloped, winding paths, twinkle-lit arbors, plants in colourful ceramic pots, a life-size wooden horse, concrete lions, and large metal crocodiles and conquistadors illuminated from within. I had passed through the looking glass.

Toller warned me at the outset, "I will disappoint you." I brushed off his pronouncement. Disappointment requires expectations, and mine were few.

Whereas I thrive on organization and sequence, Toller did not. Not only did he *not care* whether the stories that ended up in what turned out to be three separate books followed any chronology; he preferred—no, demanded—that the sequence be random. He wanted patchwork, a certain amount of artistic clutter that mirrored his everyday existence.

Toller postponed the most emotionally painful tales: the saga of coaching drug-addicted American skater Christopher Bowman; the financial and legal troubles that attended his Broadway show; and, most painful of all, his Olympic "failure." Since 1976, he had wallowed in his loss at Innsbruck, Austria. He grudgingly admired the gold medallist, Briton John Curry. They were different but equal, troubled souls both, and Toller had bettered his worthy rival in the Short Program event. What he could never get over was the fact that his seventh-place Compulsory Figures placement had allowed him to slide below the workmanlike Soviet, Vladimir Kovalev, by a miniscule .26 points. It might as well have been a million. Kovalev had placed sixth in the Short, fourth in the Free, but third in figures, just behind Curry. I asked Toller to admit that he had won the bronze medal rather than losing the silver, but it was no use.

The great raconteur started off with some upbeat stories, the ones that he had most rehearsed and embellished over time. After I returned home to the laborious task of transcribing, editing, organizing, and filling in blanks in what I'd like to say approximated Toller's own voice, I drove up the New York State Thruway and the QEW to Toronto and presented Toller with several chapters.

It was only May, but he was like a child at Christmastime, gathering friends and reading aloud to them, enjoying the stories as much as his audiences did. Those tales still make me laugh out loud: the prostitutes trolling Pembroke and Dundas streets wearing Toller's accidentally

discarded costumes; Toller terrorizing the caddies on a South African golf course. I often challenged, "Is that true?" His answer was always, "It doesn't matter. That's the way I remember it." Try telling that to a libel lawyer.

During those days, Toller spent most of his time in Toronto in his walk-up loft at 619-A Queen Street West. The apartment was ideal for Toller's needs. He entered from the second-floor landing, turning to the right directly into his studio, a vast open area full of tables laid out with hundreds of tubes of paint and many dozens of assorted brushes. A hired man came by from time to time just to clean the brushes. Toller's rickety white-painted desk by the door was always strewn with receipts, bills, coins, memoranda, pens, CDs, keys, and the sole house telephone. That old-fashioned contraption was streaked with paint, its long cord gnarled like arthritic cypress knees. As he listened on the phone, Toller wrote numbers and messages on the wall above him. I asked what would happen when the wall needed fresh paint. Simple. He would start the collection all over. That was his practice.

Off the studio, to the left of the entrance, was Toller's tiny, messily functional bedroom. Continuing past its door, one came to an equally tiny and messy kitchen alcove that never saw actual cuisine. It reeked of oils and paint thinner. You could never be sure of a clean glass or cup. Beginning at the kitchen and continuing across the back wall of the studio were wooden shelves that groaned with books on every topic, notably history and art, on which subjects Toller's knowledge was encyclopedic. And he loved biographies.

To the right of the entrance and halfway along toward the wall perpendicular to the bookshelves, a wide opening contained several steps up to a salon, arrayed as an art gallery, where Toller occasionally entertained on a grand and inventive scale. The lime-and-black party, with all guests requested to dress for the theme, was a particular hit. There was also an imaginative sunflower dinner party one summer. On the landing, to the left of the steps from the studio to the salon, an abnormally deep closet stored profuse contents that almost glowed in neon. What was left of the dozens of shirts that a tailor had custom-made for Toller during his visits to Hong Kong stretched along the rack like a segmented rainbow.

At the farthest end of the salon, overlooking Queen Street, was a comfortable living room grouping where we worked: deep couch, sturdy upholstered armchairs, and a heavy coffee table that always held an ample bowl or jar of hard candy, jelly beans and gummies. Usually that was flanked by a vase or two of fresh flowers, enormous ones resembling a bright funeral display: mixed gladioli or perhaps calla lilies. A sidewalk market down the street kept Toller well supplied. Pillar candles in tall metal holders were omnipresent as well, enhancing the drama quotient of his everyday life.

Toller had few practical skills. He didn't cook, clean, launder, nor pay bills. Why did God make restaurants, housekeepers, dry cleaners and accountants if Toller was meant to do all of that for himself? He had a "cleaning lady *savant*," as he called her, who came once a week or so to make a feeble show of tidying up. He realized that he should fire her for inadequacy, but she appreciated his artwork. Occasionally, she saved up and bought a piece for herself. Besides, he knew her personal circumstances and couldn't quite bring himself to deprive her of income. He was kind at his core.

Toller was genuinely interested in how others lived and thought. He mixed with, and we regularly bumped into, Members of Parliament, Olympic champions, well-known dancers, opera singers, and his many wealthy art clients. They did not intimidate him, perhaps because he was comfortable within the elaborate persona he had created for himself as a shell. On the other hand, he somehow related to his cleaning lady *savant*, and he genuinely loved the Mexicans who worked for him on his San Miguel property. He knew about the various relatives and their struggles. He found them kind, open, and family-centred,

Photoshoot for the cover of *When Hell Freezes Over Shall I Bring My Skates?*

with a sort of simplicity that he may have envied. However, his essential humility ever warred with his outsized ego.

While Toller had a habit of collecting people, often quite eccentric ones, he might then reject or alienate them somehow—before they could reject him. He did that to his closest friends and allies, pushing them away, though he must have known that he would need them in the future. Perhaps that's what happened within his nuclear family, too. He had a famously strained relationship with several close family members, notably his mother and one of his twin brothers. I couldn't quite process the dynamics. If he told me a tale of horror, I could easily imagine how different the situation might look from the other side.

Toller told me a number of times that, when he was a boy, his mother, Stuart, locked him out of the house to force him to play outdoors. If strictly true, that was extreme; yet I can imagine a good mother removing her son's nose from his oil paints and thinners in favour of fresh air and sunshine, much as parents today wrest their children from electronic obsessions. Because he gave it to me for safekeeping, I know that his proud mother meticulously filled a scrapbook with documentation of his every skating milestone and achievement; yet he couldn't credit her with supporting his endeavors. His problem, he said: he and his mother were too much alike.

I enjoyed Toller's enormous intellect and international breadth while experiencing Russia's

Hermitage, China's Ming tombs, and Vienna's Demel café through his eyes. He read voraciously, keeping up with political events and societal trends. He had an opinion on every *cause célèbre*. He was particularly interested in the American political scene. He had once mounted a painting exhibition at Trump Tower that was personally hosted by Donald Trump. No doubt that personal contact fueled future inquisitiveness.

Toller questioned others incessantly via his famous "chats." It didn't matter if his queries were excessively personal. What was *that* like? What do *you* think? The interest was genuine. I noticed that he was distressed by unfairness, and especially child neglect or abuse. Paradoxical in light of his flamboyant contrived persona, he seemed rooted in standard Judeo-Christian ethics. Perhaps that was why he sometimes felt the need to punish himself for excess.

One of our favourite games during our time away from manuscripts was "What's That Colour?" On a walk, Toller might spot a flowering shrub or a painted house and demand to know its precise hue. In that game, my answer was automatically deemed invalid. His contest entry, the only accurate one possible, would be pure poetry that included references to paint pigments, nature, chemical elements and random inanimate objects, with a few spare modifiers thrown in. Of the names of his hundreds of paint supplies, French ultramarine blue was a favourite. Toller lived in a world of primary and secondary colours. His choices in paints (as in clothing) were not

subtle. They made statements. He delighted in his Mexican property in bloom, overflowing with tall red poinsettia bushes grown to the height of trees, the profuse bright blue plumbago that surrounded his swimming pool, and the massive purple jacaranda trees that were framed from within by every upstairs window.

Another favourite game involved word choice. Together, we were dueling copies of *Roget's Thesaurus*, debating the relative merits of near-synonyms as he read through the pages I had produced and brought for his approval. During such esoteric conversations, odd questions often popped out of Toller's mouth. "Have you ever had an intellectual crush?" he queried once. I had never heard that phrase and decided that he had just made it up. I said, "I see what you mean. Yes, but it was a long time ago, a television commentator…" He interrupted with "Dick Cavett," confirming my suspicion that we read each other's minds, or at least that we had shared similar intellectual crushes.

We returned to San Miguel at Thanksgiving 1996. I believe that was the only time we flew together round-trip from Toronto to Mexico City. We arrived rather late in the evening, and the Benito Juarez International Airport was swarming with dubious characters. As we made our way toward the taxi stand, Toller said under his breath, "Don't look now, Martha, but we're about to get raped and murdered."

"Very funny, Toller," I thought, as we dropped our bags behind a cab and slid in for the ride to a nearby hotel. Almost immediately after check-in, Toller came knocking on my door, saying with hysteria rising that he had to return to the airport. A suitcase was missing. The next day, he recounted the details with great fanfare. Upon his return to the airport, he had summoned the nearest policeman and had confidently led him straight to the man whom he had predicted would commit rape and murder. In fact, mere robbery was the objective. Toller's suitcase was in the guilty man's car trunk.

Colonial-era San Miguel was where Toller was truly at home. He loved the people; the quirky cobblestoned streets; the central Jardín with its artisans and towering church spires; the Parque Benito Juárez, which we crossed to a favourite hotel breakfast patio; the rooftop vistas; the tiles and massive pottery pieces; the houses in ochre, vermilion and gold, each door unique, central courtyards mysteriously invisible from the street; the fresh mountain air and clear colours.

Sometimes, intriguing characters occupied available accommodations on Toller's property. In one case, a tall, lanky, elderly woman had rented the entire main house on her own. Late at night, Toller ventured unsuspectingly up the garden path toward his swimming pool and found her on the patio, stark naked in a modified lotus pose, arms outstretched, anticipating the coming winter solstice. He was less startled by her appearance than eager to add another story to his repertoire.

In March 1997, the World Figure Skating Championships arrived in Lausanne, Switzerland. Toller had managed to secure a concurrent painting exhibition at the World Figure Skating Hall of Fame. He had brought along parts of our *Zero Tollerance* manuscript. That was the perfect time and place for him to gather skating friends for readings in various comfortable alcoves, and those occasions were among the highlights of my trip. Besides, I was thrilled to sit with him at events and receive the same droll, precise, opinionated commentary for which I used to send away for taped copies.

Our galleys were due back at McClelland & Stewart in Toronto that July. *Zero Tollerance* came out in October. We celebrated with a launch event at the Cricket Club. Then Toller embarked on an extensive book tour. He was the toast of many towns.

If that was one of his high-flying moments, Toller hit his lowest point prior to his televised tribute show and farewell performance produced

by his long-time management group, IMG. One weekend that fall I drove the four hours up the Thruway and the QEW, climbed to his door and found that a drug dealer had arrived just ahead of me. Toller had not remembered that we planned to work that weekend. Until that point, he had been careful never to let me brush against the slightest evidence of his drug-taking. I knew it only as theoretical. That Saturday, he opened the door just a crack (that's actually not meant as a horrible pun) and announced, "You'll have to go. This is not a good time." There at last was the predicted disappointment: major disappointment number one, and on several levels. I was more than annoyed about turning around and driving straight home, but I was horrified by the dangerous behavior.

Toller had to knuckle down and train for his last performance. He did so, if inconsistently, on the ice of the Cricket Club. One day, for a laugh, I brought along my own skates (an expensive pair of professional boots and blades that I had bought to up my game but could never break in) and asked him to just pull me around the rink so that I could experience some sense of his speed. He complied. It was terrifying. Then he nodded toward fellow Canadian champion and Olympic medallist Brian Orser training at the far end of the ice and suggested, "If you want to try that with a real skater, you should ask Brian." Toller was losing his confidence.

On the night before his December 8, 1997, Varsity Arena tribute show, *Toller Cranston the Skater*, he felt so vulnerable, so low, so poor an athlete, that he checked into a hotel suite and asked me to stay on the couch to make sure that he didn't go off the rails. It was the one way to be certain that he would not open the door to an opportunistic drug dealer.

The show was fine, of course. In fact, it was spectacular. Ice dance champion Tracy Wilson served as emcee. She helped me out with an embarrassing problem during the morning rehearsal. Having left his apartment the previous day without thinking everything through, Toller had found himself without what the former high school pole vault champion still called a jockstrap. Tracy calmly told me to phone a particular dance supply shop and request a "dance belt, size medium." The shop sent one straight over to the arena by taxi. Emergency averted. I hoped that nobody had seen me in the parking lot furtively receiving a package.

Toller skated his wistful numbers in three simple costumes, identical but for the colours: one red, one blue, and one a slightly limey yellow, like Fisher-Price toys. Greats of the skating world, friends all, performed in his honour and skated particularly well: Scott Hamilton, Brian Orser, Kurt Browning, Katherine Healy, Liz Manley, Josée Chouinard, Gary Beacom, Christopher Nolan, Caryn Kadavy, Barbara Underhill, Paul Martini; and Shawn Sawyer as a representation of the young Toller learning lessons in a circle-of-life narrative.

The Circle of Life, of course, was the reason for Toller's funk. He could no longer perform to his own standards, and he had no young Simba to whom to pass the torch. Some have partners and family to soften the inevitable blow, but Toller felt unloved and disconnected. There had been a wonderful time when his artistic impulses were able to find kinetic, three-dimensional expression on a vast surface of ice. From now on, he would have to content himself with surfaces of canvas. He never truly gave up figure skating, though. He continued to skate nightly in his dreams.

In 1998, we began work on our second book, *When Hell Freezes Over Should I Bring My Skates?* Toller had many stories left to tell. In my opinion, those were some of his best. We continued to have non-literary adventures, too. We went backstage to congratulate his old friend Chita Rivera after her Toronto performance in *Chicago*. When he

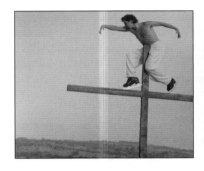

z

Photoshoot for the cover of *Zero Tollerance*

had really been flying high internationally in the late 1970s and early 1980s, Toller had known a who's who of stars and global personages. Even now, he was able to pick up with them right where they had left off. Toller and Chita had a particular bond. As Toller felt he suffered in John Curry's light, so Chita, he told me, suffered in the light of Rita Moreno, who had scored the career-making lead in *West Side Story*.

In the summer of 2000, we attended the "Miracles of Gold Summer Ice Revue" at Lake Placid, north of my Albany, New York, roots. Toller had become the elder statesman, the event narrator. Instead of having skates on his feet, he had Tara Lipinski on his lap. At night, he was ensconced (how he loved that word) in the lovely old Mirror Lake Inn. Grand historic hotels were one of his greatest pleasures and indulgences. He mounted an art exhibition concurrent with the on-ice event.

In April 2001, we returned to San Miguel to finish work on book two. In what I thought was a stroke of pure genius, he created the cover image by diving into his San Miguel swimming pool naked but for his black skating boots. I don't know how many takes that required because I was not present. McClelland & Stewart's art department created a tasteful image; but nobody could salvage the skates, his last pair ever.

That September, *When Hell Freezes Over* came out. It remains my favourite of our three books, with its vignettes from every period of Toller's life,

many of them comical. Even the saddest have their humour.

We met at the end of October with our McClelland & Stewart editor to discuss a third tome, *Ice Cream: Thirty of the Most Interesting Skaters in History*. That book was Toller's tribute to the most notable within his personal experience whom he hadn't previously discussed in detail; the skaters in whom he had recognized rare qualities; those athlete-artists who had "illuminated their times and environments," as I wrote in the prologue. The book jacket didn't promote "An Opinionated Listing by Toller Cranston" without good reason. Ever unique, so he thought, in his deep devotion to skating history and his interest in the personal lives of the practitioners who created it, he hoped to provide knowledge and generate controversy.

Toller still had his own chronicles to reveal, personal experiences that involved his subjects; but those stories were shorter and less well rehearsed than his earlier material, so they came with more effort. We were writing biographically, which ideally requires truthful precision; but that went against the grain with him. It simply didn't seem as important as how he remembered the details and atmospherics. I found a great deal of charm and insight in those tales, even while I struggled to stay as close as possible to objective truth.

Our *Ice Cream* manuscript was due in the middle of March 2002. On the twenty-fourth day of that month, Toller's mother, Margaret Stuart

Cranston, passed away in Arnprior, Ontario. His affect reminded me of the famous opening lines of Albert Camus's L'Etranger: *"Aujourd'hui, maman est morte. Ou peut-etre hier, je ne sais pas."* (Today, mother died. Or maybe yesterday, I don't know.). There was a palpable disconnect. As had been the case with his father Monte's passing, Toller seemed to me to be perplexed, empty, and oddly more interested in the overarching story and its details than he seemed to be grief stricken. Surely feelings ran deep, but he couldn't let them rise to the surface, much less acknowledge their existence.

As the *Ice Cream* deadline loomed and passed, my longtime hairdresser mentioned that my hair was noticeably thinning. Was I under any particular stress? When the book was published at the end of August, I heard critically from Peggy Fleming's assistant. Fortunately, she understood how I had missed several errors in Peggy's chapter when she learned of the pressured-filled context of their editing. Almost everyone who knew him had experienced Toller's lack of dependability. For the most part, it was forgiven because Toller was Toller. There was plenty to love, admire, and laugh about.

In the fall of 2002, Moira North of the prestigious Ice Theatre of New York invited Toller to its annual benefit gala at Chelsea Piers to receive its achievement award. At Toller's somewhat reluctant say-so, I booked two round-trip plane tickets to New York. In the end, I went alone to convey his apologies—and absorb the cost of his flights. He was in a downward spiral. He could not summon the physical and emotional energy to attend the celebration of his enormous contributions to figure skating. He should have been there. He would have loved it. The beautiful etched-crystal award was heavy in my carry-on luggage.

I visited Toller in San Miguel another time or two. He always had a project with which he wanted help; or perhaps he just wanted company. His mind churned with creative ideas: turning his artwork into socks, scarves, ceramics, painted leather coats and jackets or ornamental glass. And he wanted us to write a book about the idiosyncratic denizens of San Miguel. I would have liked to do that.

In 2006, the World Figure Skating Championships returned to Canada. We had a grand time in Calgary. Toller was flying high again. The Artists of the World gallery put on a fancy painting exhibition for him. He brought along two of the young workers from his Mexican property so that they could see something of the world beyond their small-town horizons. Thanks to his generosity, they had the times of their lives.

Toller met old and new clients at the gallery and lots of old friends at the arena, many of whom were ensconced like us in the VIP seats. I was again the beneficiary of witty commentary. At the end, I kept the VIP ribbon that had cordoned off our section because that pleasure will not come my way again. Toller was disinclined to attend the closing banquet, so he made me go in his place. The food was great, but I fear that I bored Yuka Sato to tears.

There came a time when Toller asked me to join him in Mexico, but I had to say no. I was busy with other things. Besides, I couldn't conveniently afford the trip at the time. Toller offered to purchase my plane tickets, thoughtful as always, but I knew how that would end. I'd pay for the flights myself, as I did the six hundred dollars' worth of books he had asked me to have McClelland & Stewart ship to him in Mexico. As most of his friends knew, Toller operated under his own system of reckoning. He figured that he gave, in the form of unusual experiences, a lot more than he owed. That was often true.

I met up with Toller for the last time at his exhibition at the Pentimento Fine Art Gallery in Toronto. I didn't suspect that Toller's final chapter was nearing its close. I remember our

final conversation, just two or three months before his death in early 2015. He waxed rhapsodic about Playa del Carmen and was optimistically considering divesting himself of the San Miguel property and moving to the Mexican coast.

Toller never did take care of his health. He actively disliked visits involving any of the branches of the medical and dental professions. Had he listened to San Miguel friends' advice and seen a doctor on his last afternoon on earth, he might still be here. It occurred to me, though, that he wouldn't have liked old age. He would have made a terrible octogenarian, bothered and depressed by the inevitable physical limitations (though his mind, I feel sure, would have stayed sharp). Maybe he would have sold off all his belongings, as he had more than once before, and ended up penniless. Perhaps he would have offended every last friend. That was the pessimistic view. In reality, he always seemed to land on his feet like a cat, make new friendships, and reinvent himself somehow.

Toller certainly didn't expect to shuffle off this mortal coil as precipitously as he did. When he thought of his eventual demise, it was to ask to be buried in an elaborate figure-skating costume, with full stage makeup, so that when the trumpets sounded and he arose from the dead, he would be prepared to entertain. That was Toller.

He signed my copy of *Zero Tollerance*, "Working and collaborating with you are among my greatest pleasures in life." I'm glad to remember that when I mourn his passing, and I do. Several times since his death, Toller has appeared to me in vivid dreams. In truth, these events seemed less like random dream inventions and more like visitations. I wonder how many of his family members and friends still feel very much in touch with his singular spirit.

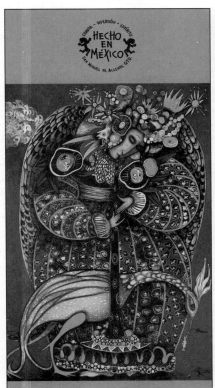

The design for a new menu for *Hecho en Mexico*.

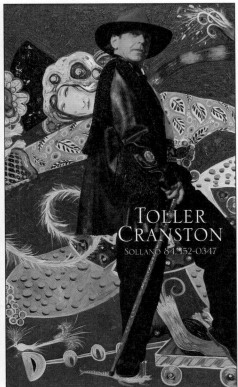

The cover of an exhibition catalogue.

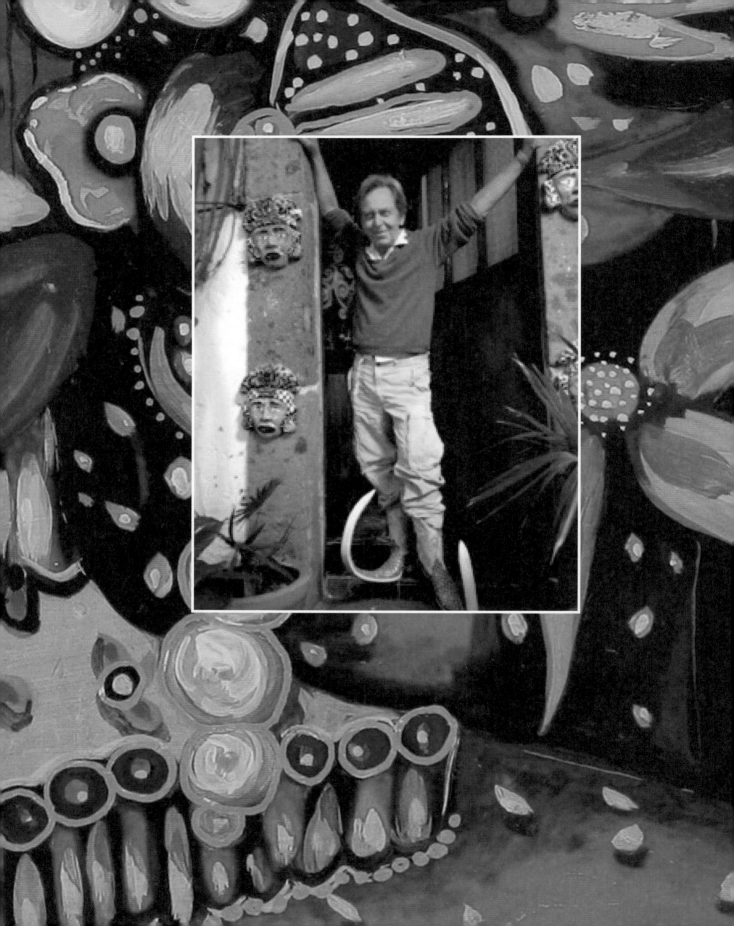

CHAPTER 16

NINE LIVES

By Margaret Paul

For her 2014 book *Conversations with Artists in San Miguel de Allende*, author Margaret Paul of Victoria, B.C., travelled to Mexico to interview a number of artists, including Toller. Here are excerpts of her wide-ranging conversations with Toller, which took place just a year before he died.

Preamble

Some years ago, on an extended vacation in San Miguel de Allende, I had an idea to check the local library for some information about San Miguel's artists. After all, the small Mexican city in the state of Guanajuato had long had a reputation as an artist's destination, particularly since the Second World War when Canadian and American institutions began awarding scholarships to the

art school there. To my surprise, I couldn't find anything in print about the artist colony in San Miguel and because I had recently retired, I decided I should write something myself. I didn't do it of course, and instead went backpacking in India for three months. My trip was drawing to a close when in a little bed-and-breakfast in Trivandrum in southern India I started a conversation with a woman who was sketching in the garden. I asked her where she was going next and she said she was heading to an ashram to the east. I, in turn, said I was going back to San Miguel de Allende in Mexico and she replied, "That's my home. I grew up there."

Astonished as I was, I described my idea to write about the artists that have lived in the city and she generously gave me the name of a woman who

had a gallery, Casa Diana, in San Miguel and could introduce me to some of the city's best-known artists. From that moment on, the universe took over and I became a passenger, unexpectedly along for the ride. This project eventually became a collection of marvellous stories told by some of the extraordinary artists who have made San Miguel their home.

Once I was underway, one artist recommended another and I simply followed the trail although admittedly, Toller Cranston was the exception. I knew of Toller by reputation as the Canadian skater and Olympic medallist who changed the nature of men's figure skating in the 1970s. I knew he lived in San Miguel and I knew he was a painter, but I was much too shy to approach him. As fate would have it, I was in the bank one day and looked up to see a familiar face. "You're Toller Cranston," I gushed and then, because he didn't seem in a hurry to leave, and I was already committed, I went on to describe my project and to request an interview. He responded immediately by inviting me to his home for our first conversation. Over the next four years, we met to talk a number of times and even if we just bumped into one another around town, Toller always asked, "How is the book coming along?"

Finally, when my article about Toller was complete, I made a date to read it to him. This was a ritual that I went through with all the artists because I wanted to have an opportunity to judge their reactions and to get a sense about whether I had captured some truth about them which is what I had tried hardest to do.

I was nervous about how Toller would react. If he didn't like what I had written, I was sure he would let me know in plain terms and I dreaded failing in his eyes. He had encouraged me and scolded me over the years while I worked on the book, and it was largely thanks to his insistence that I keep moving ahead with my interviews.

I finally arrived at Toller's door, wondering if I was going to survive the next hour. We sat close together on one side of the large round table in what was a kind of reception room, surrounded by over-sized plants and ornate glass objects hanging from the ceiling, the table itself covered with colourful baubles and items that Toller had accumulated to excess. I began to read, certain that Toller would interject at any number of points in the narrative, but he didn't utter a sound and when I was finally brave enough to lift my head and read his reaction, I found him listening intently, which is how he remained until the very last word. I waited.

"That's wonderful. That's the truest thing that has ever been written about me. You're like Gertrude Stein. Canadians! Extraordinarily talented people in the most unlikely packages!" Because I am a plump woman in her sixties, I chose to take this as a compliment.

I don't for a minute believe I am anything like Gertrude Stein, but I was deeply touched by Toller's words. It meant a great deal to me to know that he thought I had portrayed him accurately and honestly; that I had glimpsed the person he really thought he was, and when he died suddenly, I confronted the vacuum he left behind everywhere in San Miguel. I still encounter the empty spaces that used to be filled with Toller, here in the community we both loved. I will always lament the loss, the absent energy and the audacity, the self-doubt and the anxiety about the future, the generosity and the creativity, the rare illumination that was Toller Cranston.

The Interview

Today I am trailing a mountain lion. Tousled tawny-coloured hair glinting in the sun, compact athletic body in constant motion, tail flicking, Toller Cranston leads me on through the lush vegetation surrounding his spacious home in San Miguel. Although we had met a number of times, I still had little more real understanding of what lies

behind those penetrating eyes than a mouse could tell you of any of its cat acquaintances. Toller is a private man, yet he luxuriates in the attention of an audience and by his own admission, has always thought of his life as being lived on a stage.

Toller Cranston is best known to baby boomers and anyone else who takes an interest in ice skating, as the Canadian who changed the skating world forever. He eschewed the standard athletic jumping that was the rule for male figure skaters in the 1970s, and introduced a more evocative, modern dance equivalent of figure skating. To see him for the first time in those days was surprising, and unsettling, not least because for that generation, the divide between genders was still very distinct. To see a man being so overtly emotional in his gestures and expressions, even in a skating competition, was definitely treading new ground. I recently watched a film of one of his early performances and was delighted, overwhelmed once again by his beauty and skill. In his twenties, on the ice, Toller Cranston was unequalled, the personification of confidence and contemporary style.

It may be the dual nature of the man that shields him from the world. On his most public and accessible level, Toller Cranston is a star, a former Olympic medallist, a prolific painter and publicist of his own work, a person on a grand scale. To see only the outer appearance is to overlook the humbler version of himself that is extended but is frequently obscured by the celebrity atmosphere that is everywhere evident around Toller. In San Miguel de Allende, where he has lived for more than twenty years, he is known of by many, but is an intimate of few.

I am invited to sit in a large, beautifully furnished room surrounded by his paintings and by some of Toller's many decorative acquisitions from Mexico and the world. Small talk is quickly put aside and Toller proceeds to trace his artistic beginnings much as one would get on with an assignment for which there is a deadline. As the afternoon

unfolds, he relaxes and I have the pleasure of seeing his keen intelligence and humour revealed.

TC: The first thing that I remember about my artistic life was doing a crayon drawing, an abstract in grade two in Galt, Ontario, a city we now know as Cambridge. Basically, the idea was to draw black lines all over the place and where the lines intersect and form shapes, you colour them. I remember mine was absolutely and totally different. It was only in black, turquoise, and purple and it was like a paisley design— eastern, Indian. It probably would have been understood in New Delhi but this was grade two in southern Ontario. The die was cast at that time. My mother was an artist. She painted. She actually was pretty good. but would not have had what was ultimately necessary for me which was an adherence to discipline. She was artistic. but all over the board. I used to do too many artistic things, but I no longer do. Because I know that to actually achieve anything in art, the competition, which is a competition of artists that have lived for the last 20,000 years, the competition is so steep, you can't afford to be all over the board. You have to concentrate, so I'm quite narrow even though someone else might think I am quite broad because I do many different things, but it's under one umbrella. The response to my grade-two effort wasn't good, but mistakes are only mistakes if you don't learn from them or derive a positive end. This was a lesson in life.

I auditioned for the art school in Montreal, Ecole des Beaux-Arts, which is a fine school. A thousand applied and only fifty students were accepted. Fantastically, and this was great, the teachers who were involved in admitting the students, were looking not for finished work but for potential. Real creativity. The school taught me everything and it taught me nothing. The very first day I went to École des Beaux-Arts, we went to a sculpture class and there was this mad Italian with freaked out hair and he was doing sculptures with wire and clay donuts that went twenty feet across the room. I was making, this isn't a joke,

179

dolls out of paper. That was important, because I was not a sculptor. I was two-dimensional and decorative, but the best thing was they encouraged individuality—do whatever you think, be yourself, and I was doing paper dolls with flowers in their hair, I suppose quite fantastic in their own way. I failed sculpture, but I was a little more confident by my third year and told the teacher, "You know, I'm not really a sculptor so I really don't think I should be doing this. This is not who I am and by the way, I am having an exhibition in Toronto next week. Would you like to see some of the pictures?" This exhibition was the big time with three famous artists in Quebec: Ulysses Comtois, Jacques de Tonnancour, and Robert Wolfe. I had gone to the bank and borrowed two thousand dollars. Don't ask me how a seventeen-year-old managed it, but I got the two thousand dollars for the frames. One thing I have always been guilty of and I encourage other people to do it, but they often don't because they don't have the ability is, *Think big. Do it right.*

So, after I failed sculpture, I left the school with their blessing and did what I wanted to do, which was to paint. The exhibition in Toronto was a great success. I sold every painting and I became "rich." I had $6,000 in my pocket in 1967. When you think about it, it's quite fantastic. *Think big.*

My magical mystery tour re my painting career afforded many, many adventures, highs and lows, incredible, mad things happened to me. But the basic discipline, subject matter, work ethic, and hunger to succeed would never be appeased. It was always in fast forward. My work, I don't say it is better because artists aren't allowed to say that because something done at an earlier age could be much more intense and visceral than something done better with an acquired technical ability but is in fact less. But there has been no difference, from the time I was two to the time I am in my sixties.

Because of my skating career and my voracious appetite to learn, I developed, from the age of

seventeen, a desire to see the greats of the world, so I was aware of every great museum in the world. As a suburban Montreal boy, I was familiar with the Louvre, the London National Gallery, and many more. That was a huge luxury because I saw what great was. I saw the high-water mark. I'm not against exactly, the Group of Seven. I almost feel they are more historically important than artistically important because they painted things that simply weren't being painted. But I was not seeing Tom Thomson. I was seeing Fra Angelico. That education started to distill my artistic sensibilities. Like the skating, I was almost self-taught, self-invented.

MP: *I find myself interjecting to ask Toller how he was able to continue the intense work on his skating while he was exploring the art museums of the world. He doesn't hesitate.*

TC: My skating was a religion. Most people would have been overwhelmed by it. I wasn't most people. I said I was a child of destiny but don't ever think that the world was my oyster. I left home at the age of sixteen, never to return. But you see, one of the most important things was that I had a master foreman at the controls, Ellen Burka. I was in the hands of a master. I learned about the adherence to work and discipline. I learned, as Da Vinci did, if I may use him, about something many people today don't have a clue about, refinement, beauty, grace, and sophistication. That was, by accident, my reality. I had a great desire to see and learn. I have never mentioned this before, but in the Olympics in Sapporo, there was an eight-hour wait in the airport. The whole team was lying on the floor asleep and I hired a taxi and went to see the National Museum of Tokyo. A zillion years later, I mean it is insane but it is also true, talking with a friend here, I became aware that there was a flaw in my artistic education. I realized that I hadn't seen the Prado in Madrid which is in the top three, no top four, no top three museums in the world. I flew from Mexico City to Madrid, got off the plane and went to the Prado. Usually, if I know I am going to see something important, I will

study for six months because I don't want to go in and say wow. I want to go in and see something I know. I want a confirmation. The Cairo museum is a wonder of the world, but the Cairo museum is only Egyptian art. The Louvre is everything. The Met, according to Kenneth Clark, is equally important. He did the book *Civilization*, which I still read almost every year, because it acquaints me with the greats and with the significant periods in art. I don't have the knowledge of Kenneth Clark, but he fails on one level, and it is the level that I don't fail on because he is an academic and I am an artist. I have a deeper, an overawed response to something. He is guilty of being too intellectual, too scholarly. In my opinion, art is joined to the human condition and passion or emotion. I don't think one can discuss artistic endeavors on a high level without emotion. Vincent van Gogh's work is a good example of emotion frozen in art.

The creative process in an artist is the most uniquely fascinating aspect of being an artist. Most artists, although it is so dangerous to generalize, work with more spontaneity of concept and idea rather than being too thoughtful. That being said, after a work is finished, whatever it is they have done can be traced to the source of influence or source of creation. In other words, it is not quite as casual as you think. One of the most interesting, not the best, there is a difference, but most interesting artists, was Henri Rousseau. Henri Rousseau is an artist who hit me straight between the eyes because I am thrilled and fascinated by art that is naive and at the same time, sophisticated. He was a customs official, absolutely blue collar, but why is he painting lions and sleeping gypsies? Where did that come from? It did come from somewhere. As a matter of fact, he was influenced by the Botanical Gardens in Paris and other images he saw at the time.

MP: *I am curious to know whether Toller thinks the personal lives of great artists matter outside the context of their work. Do we need to know for example, what kind of person van Gogh was or Picasso?*

TC: I don't know if Leonardo Da Vinci or Picasso or any other artistic genius can really be judged in the same way we would judge an ordinary person. How nice they were or how much you like them is unimportant, because what they do is historically important. Something that I read in a biography of Marcel Proust impressed me. He said, "The thing that I abjure the most is the criticism by people, of the private lives of genius." The private life of Rembrandt is completely unimportant to us in the 21st century. His contribution is his artistic achievement, not was he nice. That being said, years ago, my friend Marion Perlet had the most fantastic and personal revelation about Rembrandt. She and I were on our way back from Egypt and in Amsterdam she went to the Rijksmuseum and discovered Rembrandt. She had been aware of Rembrandt her whole life, but on this occasion, she really saw his work for what it was. She realized how beautiful his paintings were—not the physical beauty so much as the humanity. She told me that she sat on the steps of the museum and she cried. Rembrandt and Bruegel were Dutch and they understood Dutch life. They portrayed the life—peasant weddings, children's games—that they were so familiar with. For those artists, their paintings reflect a celebration of a culture and an intimate understanding of that culture. I suppose for, let's say, a Canadian, Bruegel is easier to grasp because it is so visual and joyous and colourful. The Rembrandt palette, for some, is somber but is, of course, positively glorious within those hues. The thing about Rembrandt that seems to astound, is his ability to paint casually but meticulously, the flesh, you can see the blood under the skin, and his ability to capture light, which was a preoccupation of Dutch seventeenth century masters. Vermeer was even better at it than Rembrandt.

Rembrandt and Bruegel, and this becomes a very esoteric subject which is fun to talk about, were deeply interested in humanity and capturing the truthfulness of people's lives. In the Kunsthistorisches Museum in Vienna, there are

two Rembrandts hanging in one corner of a room: an old man and his wife. In seeing them there, I discovered I couldn't see one without being aware of the other. They had emotionally or chemically grown together. The beauty of one was contingent upon the attention of the other. This is different from what one experiences in Rome where you might see saints hung upside down and slaves stabbed and who knows what. The subject matter is so unappetizing that you can't really get to the mastery of the painting because you just can't look at that. Rembrandt, for some, might have painted themes that were not particularly appetizing, like the Prodigal Son, but the humanity of those paintings is unsurpassed.

Picasso, who was deeply and patriotically Spanish, was bent upon something quite different, which was to become extremely inventive and radically creative within painting and artistic mediums that were precedent setting. The ingredients to the genius of Rembrandt and a genius like Picasso were very different. As a rule, an artist builds upon the achievements of artists that have preceded him. Hieronymus Bosch painted before Bruegel and sometimes it is possible to mistake one for the other. Picasso was unlike anybody else. Incidentally, I am not Breugel or Bosch, alas. And not Picasso, alas. But being creative in my own way is very important to me. The word that should be chiseled on my tombstone is *neo*, new. I was new as a skater, and even though my paintings aren't what you would call new, it is a neo interpretation of things that we already know.

The *way* that people paint is also important and an inspiration to me. Take the Canadian painter Lawren Harris, who you might think couldn't be further away from me. I like the tactile way he applies paint, particularly when doing snow. I learned from Lawren Harris that snow has every colour of the world—there is an iridescence to it. I have been very influenced by that and yet, you wouldn't necessarily see the similarity, unless I pointed it out. The *neo* means having absorbed and understood artistic styles and movements and then taking bits and pieces from all things and redoing them in a *neo* way, in an original way which in fact, isn't original. A lot of it has been inspired by others, which binds me to and links me to the history of art. We are talking about tradition within art as opposed to someone who flauted tradition like Jackson Pollock. He didn't make love to his work I don't think, and the understanding of art in the context of Pieter Bruegel was the antithesis of what Jackson Pollock was. Bruegel's works mirrored culture, structure, classical composition, magnificence in how they were painted, attention to detail, enmeshed and mired in discipline. Pollock was against all that. I'm a great fan of Pollock, yet his initial approach was different. Pollock would not have had a structured or academic drawing underneath the picture. Paintings of Bruegel and Rembrandt were steeped in academic knowledge and masterful technique that is so obvious. One can't see that in Pollock because it doesn't exist, which makes it extremely new and interesting.

You can interpret the signs of the Zodiac positively or negatively. Aries is the most dominant, it's the, "my way or no way sign." I have a reservoir of creativity. I am unique because I became world class in two things. Da Vinci was never the figure skating champion of Italy.

I realize it is a unique privilege. I am humbled by the knowledge of what has preceded me. I know that I am not Da Vinci, but I have a creative energy propelling me forward, even against my will sometimes. I have one thing, a terrible albatross that most people can't relate to. Even as I am sitting here, I am squirming a bit because I still have energy to go back to my studio and work longer and unless that energy is exorcised each day, I am frustrated and not in harmony with myself. I think that comes from Olympic training, coupled with a natural inclination to be that way. I often have a visual metaphor in my mind of dying and making my way up to the pearly gates and the angels directing me to the escalator going down to the smoky regions, saying, "But

you really tried hard. You're going to hell, but nobody tried harder." And I did. A member of the French figure skating association and a former competitor of mine, told me once that he watched me performing in Sapporo, my second Olympics. He said, "Watching you skate around the ice ended my skating career. The look in your eyes made me realize I could never be like you." I was intense, probably too intense. The greatest artists can do what they do seemingly without effort. On the other hand, that's what I was.

Because of my experience, I couldn't say education, but experience that became education, the history of art and the knowledge of art is very important to me. I would guess that very few people in San Miguel would have more knowledge about the history of art than myself because a) they wouldn't have travelled as much, and b), it is extremely important to the development of my work. I want to know what has transpired before me. I want to be absolutely familiar with the abilities and techniques of all artists so I can make my choice. I always think of it as a kind of weapon. The books I have are aggressively acquired, because the more books I have read, the more knowledge I have. That knowledge of art is a crucial ingredient to what I do.

The culture of the artist, whether it be Italian, French, Russian, or whatever, stretches my artistic vocabulary. Art and culture, although related, are not the same thing. *Deus ex machina* is Latin for "god from the machine." Basically, what it means is that someone or something can cross your path unexpectedly, thereby changing your life forever.

If one talks about tradition and culture, one does not talk about Egypt and Canada in the same breath. Like the Jackson Pollock, the brand new, almost without culture, is exciting and innocent and spontaneous and wonderful whereas a Bruegel is rooted in the understanding of a culture. In fact, the Bruegel and Rembrandt paintings, in many ways, are as Dutch as they can be. The paintings push a cultural button for Dutch viewers that ignites joy. I don't think we have any Canadian artists that do that for us, and if we do, it is limited. An artist that comes to mind is William Kurelek, who came from the Ukraine and painted rural life on the prairies. Cornelius Krieghoff doesn't do it either. He was French Canadian, a *coureur du bois*. Frederick Verner painted buffalo. The Group of Seven, I suppose might be considered, but Canada is too new. None of them harpoon our culture like Bruegel did for the Dutch.

MP: Toller's large expenditures necessitate constant production and courting of the market. In every corner of the many buildings that dot his jungle landscape, there is evidence of his voracious visual appetite. Curiously, Toller's painting studio is a stark exception. It is white, entirely bare, an empty space waiting to be filled. He admits that he applies the same discipline to his painting as he did to his skating career. He paints until he exhausts himself.

TC: A good day for me is when I can go to bed so tired, I fall asleep immediately. I need to push myself to that point or I feel dissatisfied with what I have accomplished. This is as good as it gets. I have a horrible acknowledgement. It happened once in skating and it is happening as we speak. This is the most fecund and enriched period of my life. This is when it is really good. Like all things, skaters, artists, you and me, we live in a circle. We don't live forever—we don't live in a linear way. I can say this to you but it's almost a secret. I am on top of my game. I have endless energy. My memory is at its height. My knowledge and experience is fuel for me, but I know that it can't last. Sooner or later, it will end. It all has to end. Nothing lasts forever. Some artists, as they age, paint out of desperation. They believe that just by painting another painting, they can live forever. I am so weak in some areas, but part of me is very resilient. I accept that my life will end.

Marion and I, joined at the hip as we are, have no idea what we are going to do with all our work.

There is a ton of stuff in this house. I'm different from the popes and the kings and pharaohs because I think it would be perfectly OK to live my life as I have and the day that I die, to evaporate like mist in the wind. Contrary to what people might think, I'm not afraid of being forgotten. What I think I want is just to give all my possessions away. That is one thing the Medicis found out—you can't take it with you. Tutankhamun took it with him, but most don't. I believe in thinking big, but what am I going to do with all this stuff? What if you bought this property and then you decided you had to do something with all this shit and you decided to have a big bonfire. You could be burning paintings worth millions—or not. I would rather give it back to people and let them enjoy it as I have. I don't want to go down in history, a legacy. I have lived my life in a huge circle, even with figure skating, with circle-eights, I have spent my life going in circles. I'm very aware of that. So, I accept the cycle, the beginnings and the ends.

Conclusion by Margaret Paul

It is easy to admire Toller Cranston for his obvious talent, but his personal discipline and commitment to hard work are what really distinguish him. Some time ago, I was interested to learn that so-called child prodigies have been observed to practice ten times longer than other children and Cranston is an excellent case in point. His dedication, combined with his natural ability, has brought him well-deserved renown. He was the Canadian national figure skating champion from 1971 to 1976. He won the World bronze medal in 1974 and the Olympic bronze in 1976, but quite beyond these successes in competition, Toller Cranston changed skating for good. Much as painters like Cezanne, Picasso, and Pollack were pivotal figures in the art world, Toller was equally significant in the world of figure skating. Is he satisfied with his achievements? As he himself has said, a bronze medal isn't the gold. Today, there are ever more canvases to be filled with paint and finished ones to be sold. At present, every artist in San Miguel is struggling to maintain his or her financial stability as tourism fluctuates and the world economy flounders. Despite the challenges, Toller manages to preserve his energy and ambition. The determined look in his eyes that cowed his fellow skaters is still there. Toller Cranston may be aging, but the horizon beckons and I have the feeling that this particular lion is destined to be forever on the hunt.

CONVERSATIONS WITH ARTISTS

IN SAN MIGUEL DE ALLENDE

M. B. PAUL

A note about the title

There is an allusion to Toller as a mountain lion and the title is a reference to his ongoing life in his books and through his art and his skating legacy, but also to the many different aspects of his life while he was alive. He was a brother, a son, a skater, a painter, a collector, a promoter of other people's work, a public as well as a private person, who kept many parts of himself to himself, so in that way, he had multiple lives.

CHAPTER 17

ALWAYS A FAN FAVOURITE

By Phillippa

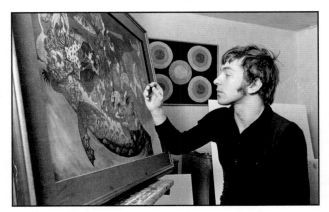

A lot of mail arrived at our Baie d'Urfé house in January of 1968 following the Canadian Figure Skating Championships in Vancouver. The messages were typewritten on elegant stationery, handwritten on flowery notecards, and printed in pencil on unadorned lined paper. They were, for the most part, from perfect strangers. And they all said essentially the same thing: "I don't know Toller Cranston, but I was in the arena in Vancouver last week. I know what I saw, and I know what I felt. And I know that four thousand people saw and felt the same thing. And although Toller didn't get the marks he deserved, none of us will ever forget him."

This is one such letter. It was from Al Ladret, a fisherman in Powell River, BC.

4739 Harvie Avenue,
Powell River, B.C.
18 January 1968

Toller Cranston,
Lachine Figure SkatingClub,
Lachine, Quebec.

Dear Toller:

Although I have never met you, I feel that I know you after watching the Canadian Competitions.

My wife and I and two of our sons were in Vancouver for the last three days of the competitions and although I am not familiar with the technicalities of figure skating, two of our sons, one six and the other sixteen, have been figure skating for the past four years and are very interested and involved in it. I am more impressed by what I see than what I know and this leads me to the reason for this letter.

When you skated your programme in the finals and at the end of the competitions, I thought it was the best performance I had ever seen. I dont think I have ever seen anyone put so much into something and do such an attractive job of it and as you are aware, four thousand other people thought the same thing.

There is no point in going into the kinky situation that may exist in the judging or why they did not give you the marks we all expected for that performance. It is important for you to know and remember that four thousand people, nearly all from the west coast, were with you all the way through your programme. Had you received the marks everyone thought you would get, you would have been remembered in a much more vague fashion. You now have an advantage and that is all of these people will never forget you and also the facts of this have been going around and I believe that you are now in a better position for what ever you may decide to do in the future.

As I said at the start, I know nothing about you and you may be not bothered by the outcome of the finals. You may be in a good financial position and have no problems about keeping going with your skating and you may be so well adjusted that none of it will make any difference to your skating career. I have however been thinking about the whole thing from a personal point of view and how terrible I felt when you were not given the highest marks for that one performance.

I was a young man who wasted the first twenty five years of his life. The way I wasted it was much more stupid, hopeless and non directional than most. For the next seventeen years(to date) I was able to take over my responsibility in life and start to look after and appreciate my family. At present I am a fisherman here in B.C. and we live a rather hand to mouth existance and this is not a complaint as I have been able to do the things for my young people that are required doing. They are also doing thier share in carrying the load of whatever endevour they want to become involved in. I consider myself to have been extremely fortunate to find out what I think are the true values of life and to be able to work along with my family.

Should both or one of my boys be so lucky and hard working as to reach the place you were last week, I have made myself the promise to see that somehow they are able to carry on. I realize this will mean a lot of hard work for them and for me.

So Toller, work on your figures and keep plugging. We are going to get to the next Canadian Competitions if we have to hitch hike and we are going to be looking for you to be there and hoping for you to win.

You will no doubt have received a mountain of mail and you have much more important things to do than answer letters and no answer to this letter is required. We just wanted to let you know how we felt and try to encourage you to keep with it.

Very best regards

A.A.Ladret

At that competition in 1968 in Vancouver, Toller had hoped to make the Canadian team. Although he made an impression with the audience and the press, his marks ranged from first to dead last and he did not make the podium. Or the National team.

He did however, meet Ellen Burka, the legendary coach who was to change his life.

With Ellen's guidance and support, Toller became Canadian Champion for the first time in 1971. He soon began to wow international audiences and rattle the cages of the international skating establishment. Whether he did or did not make the podium, he was a fan favourite. His exhibitions and shows, even his rehearsals, were packed.

After the World Championships competition in Bratislava in 1973, Toller received a handwritten letter from Prime Minister Pierre Elliot Trudeau.

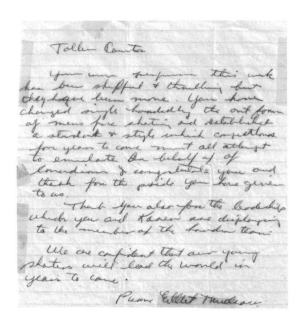

Toller Cranston

"Your performances this week have been skillful and thrilling but they have been more.
You have changed single handedly the art form of men's figure skating and established a standard and style which competitions for years to come must all attempt to emulate. On behalf of Canadians,
I congratulate you and thank you for the pride you have given us.

Thank you also for the leadership which you and Karen are displaying to the members of the Canadian team.

We are confident that our young skaters will lead the world in years to come."

Pierre Elliot Trudeau

Canada's Karen Magnussen won the gold medal at those 1973 championships. Toller finished 5th. Off the podium.

However, as Mr. Trudeau said, he did set a style and standard. He did make Canadians proud.

It seems that once in a long while, a skater comes along who is simply beyond or outside of anything that the figure skating establishment can wrap their heads around. It seems that frequently, despite the results, these skaters make such an impression that they become a Fan Favourite.

The audience knows. The audience knows and recognizes authenticity. They respond to creativity. They feel the honesty and they appreciate the struggle. The audience recognizes the courage it takes for athletes and artists to be true to themselves, to express themselves without compromise, and to persist when it's difficult— even in the face of obstruction, corruption, ego, and human frailty.

Toller was asked by *Maclean's* magazine in a 2004 interview: "What skating accomplishment are you most proud of?" He replied, "If that question had been asked years ago, I might have cited an event. Now, when I think about it, my accomplishment in skating was about being creative in a virgin sport. That's what I'm known for. It was never the medals that I won. I was really a thorn in the side of the establishment. It wasn't easy, and I think youth and ignorance propelled me, because somebody else would have given up. I was madly tenacious."

At the end of the day, it is not about the winning and the losing and the almost winning and the *oh…sorry, you are fourth again…*it is about the courage, creativity, and expression. It is about being true to yourself and taking the sport in a new direction.

Fan favourites may not always win the medals or be on the podium, but they inspire a new generation and they set the standard and style. They speak to the hearts and souls of the audience.

In 1968 in Vancouver, 4,000 people saw something extraordinary.

In 2020, more than 30 million people on TikTok and Instagram saw something in another intensely creative, unorthodox skater from Canada—Elladj Baldé.

What audiences see in Elladj is authenticity, courage, and creativity. They see a skater with whom they connect.

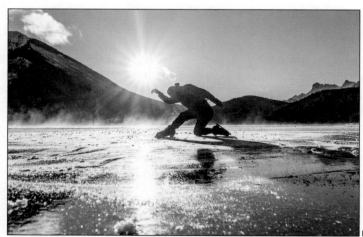

Elladj Baldé. Creative. Courageous. Authentic.

TOLLER CRANSTON: *Ice, Paint, Passion*

FINDING FREEDOM FOR SELF-EXPRESSION

By Elladj Baldé
Photos Paul Zizka

I am a skater. I am an artist. I know that. But it has taken me some time to come to a clear understanding of what that means. My mum is Russian and I grew up watching Russian figure skating. I remember trying to figure out what I wanted as an artist and who I am as an artist. My perspective was shifting from being achievement-based and goal-based, to wanting to explore artistry. That was when I fell on Toller. I fell in love with his skating. I started connecting with Toller and the ways that he was moving and expressing himself on the ice. I had never seen anything like that. He was so real and so authentic. He was who he was, and I find that in myself.

Like Toller, I have always had a bug for self-expression. I always want to authentically do what I want to do in the way I want to do it. But figure skating, with all its rules, can make you feel confined. I struggled with that for years. I actually changed my style, and how I skated, and what music I skated to in order to fit the mold of what figure skating told me I should do in order to be successful. But it didn't feel right. It didn't feel true to me.

Finally, I thought, OK, I have literally spent about eighteen years of my life doing this thing, but not because I was doing it for me. I was doing it to please Skate Canada, and I was doing it for other people. I felt like I was doing things that were not in line with who I was. I was feeling lost, unfilled, and frustrated.

In 2015, I went through a massive shift. I realized that the path of Olympic medals was not necessarily my path. I began to think seriously about what artistry means. I started focusing on what fulfilled me and that was human connection and performing, sharing my art and my craft with audiences, and making people *feel* things. Looking back, I now believe that if I had made it to the Olympics in 2014, I wouldn't be where I am today. I needed to go through that in order to find myself.

One person who played a massive role in me finding my authenticity is Gail Mitchell, who was one of my first teachers. She opened my eyes to operating from a space of love, versus ego; a space of truth versus inauthenticity. She was one of the first who introduced me to these ideas. And my wife, Michelle then took it to a whole other level. She made me believe in myself. Michelle is a professional dancer and choreographer. She doesn't have the lens of figure skating in what she choreographs so she is able to go to places that I wouldn't necessarily think of going because I have been so conditioned within the confines of figure skating. Michelle held space for me to be able to realize my talent, my gifts. She held enough space for me to realize what I could do in the world of figure skating.

During the first year of Covid-19, I wasn't able to perform or do shows. Michelle and I realized that no one was using social media as a vehicle of expression in figure skating, so we started making videos. That's when I realized that I had total freedom in what I wanted to do because it's just me, the camera, and the audience who are the people on social media. I don't need to filter my skating, and I don't need to do anything to please anyone. I can do exactly what I want to do.

I feel deeply grateful to social media. It has allowed me to heal. I feel like if Toller lived in this

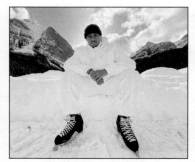
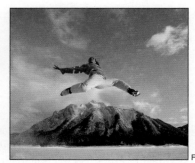

We created what we wanted to create and we put it out there.

time of social media, he would probably be able to heal, because social media allows you to share your art in the purest form.

We created what we wanted to create, and we put it out there. Because it was authentically created, because the intention behind the creation was real and human, people connected with it, and people shared it all over the world. The audience came to me. One person watches and shares and comments, then two, three, four, and then it's ten million, then it's thirty-two million. This community organically created itself because we authentically created what we wanted to create. It was truly just us simply wanting to create and wanting to inspire others to follow their own path. That intention was so pure that I think people really, really connected with it.

The most important thing for me now is being able to reach an audience that includes black, indigenous, and people of colour. These are not the typical audiences that you see engaged with figure skating, which is a very European, white, elitist sport. Now, if we can engage people that are from a BIPOC community, we are going to see skating shift.

Michelle and I have created the Skate Global Foundation that is an impact driven, global, not-for-profit organization built on three major pillars: Equity, Diversity and Inclusion (EDI); Mental Health; and Climate Change. With each special project or initiative, Skate Global Foundation

(SGF) engages and unites members of the communities at large to foster conversations and activate positive change within any and/or all pillars with which it was founded. SGF's first initiative includes an exclusive partnership with Canadian development leader EllisDon, where the two organizations will work together to build outdoor ice rinks in underserved communities across Canada, focusing on bridging the diversity gap within the sport. I am also a co-founder of the Figure Skating Diversity and Inclusion Alliance with a mission to foster a more diverse and inclusive figure skating environment for the next generation of athletes through policy change, program development, and funding.

I am realizing that I have an opportunity to showcase figure skating, and to put figure skating in places that haven't seen figure skating before. The possibilities are endless.

I wish for myself personally to one day have the kind of impact on figure skating that Toller had. I have made part of my mission to change figure skating—obviously in a different way—but to have the same kind of shift and the same kind of impact that he had in the figure skating community. I use Toller as an example, as a mantra for what I do.

Elladj represents the spirit of creativity and self-expression which Toller initiated. So, Toller lives on through all skaters who find the courage to be themselves—on and off the ice! —Haig Oundjian

CHAPTER 18

ADMIRATION AND INSPIRATION

By Phillippa

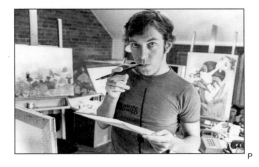

―――――――――― TOLLER ――――――――――

Patricia Beattie, a dancer friend, once said, "In our lives, if we can light one match in
someone's head, inspire, illuminate, influence…then we are successful…Just one."
If I were to review my life, I think it's fair to say I have lit at least one match.

There are Toller fans and boosters, believers and admirers right across Canada and around the world.
His impact on their lives is evident from this selection of thoughts and comments about his skating, his
values, his personality, or his art.

TOLLER'S SKATING, A CATALYST IN MY LIFE
By Ryan Stevens

Growing up in a small village in rural Nova Scotia wasn't always easy for me. I was a flamboyant, gay thirteen-year-old who didn't have many friends and was more interested in playing with my sister's Barbie dolls than she was.

I discovered figure skating when I was thirteen-year-old. The sport was booming after the whole Tonya/Nancy affair and on any given weekend, there was a new handful of professional competitions, shows and specials.

And so, my first exposure to the sport wasn't the amateur world of "double-trouble quadruple jumps" (as Belita once put it), but the magic and creativity of interpreting music. I marvelled at the versatile Liz Manley, and the unique Anita Hartshorn and Frank Sweiding. But I was transfixed by a then infrequently-seen skater who moved like nobody else, Toller Cranston. I had never seen anyone move like him before, nor have I since. There was something grand about him that commanded attention and respect.

After a couple years of watching, I got it in my head that I was going to skate—like Toller. The first couple years must have been quite comical. I had the arm movements down but I wasn't exactly a quick learner. I was in group lessons with kids half my age and, perhaps, not knowing what to do with me, I was cast as Jack Frost in my first ice show. I could barely do a Waltz jump and I favoured one leg very badly. I think if you asked anyone at the time, they would have agreed that I just wasn't going to 'get it.'

I was surprised as anyone when it all clicked. I learned axels, flying camel spins, and double jumps, but I was more interested in hydro-blading and creating unusual shapes and programs than I was in whirling around. I won four medals at the Provincial Championships in the artistic/interpretive categories that Ellen Burka helped imagine. I made wonderful memories of doing just what I dreamed of—interpreting music on the ice. I did some judging, then left the sport entirely for ten years to lip sync to other people's songs in drag shows.

When that got really old, I decided to come back to the sport, sharing my love of skating through Skate Guard Blog, my blog on figure skating history.

I think of Toller's skating as a catalyst in my life. Had I not been exposed to an art so unusual and special, had I not had someone like him I wanted to emulate—I don't think I ever would have had the courage to skate—or to command attention and respect in other aspects of my life.

Pj Kwong

Toller is the first celebrity I ever met (circa 1971). Even in practice, his skating had a single-minded purpose that often had other skaters watching from the side during his run-throughs. He's a man who has always been able to get me to "buy" what he is "selling," whether on the ice or on his canvas. I'm not the only one. He's widely credited with bringing artistic expression to the fore in men's skating. Full marks for being larger than life. An original. I put him #3 in the All Time Top 10.

Blanca Uzeta O'Leary

One day, when our son, Cav, was about six, Toller said, "Show up at the studio tomorrow and bring Cav. I'm going to teach him painting." So, I went to the art supply store and I bought him a little smock, a cute little water colour set, a couple of little brushes, and a 12" x 12" artist paper pad. When we arrived in the studio, Toller looked at all this stuff and said, "What is that? He is *not* using those water colours, and he is certainly not using that little pad. Bye-bye Mum. Go downstairs."

As I was leaving, I heard Toller saying, "Come here Cavanaugh," as he was tearing off a huge, giant sheet of paper—about 4' x 4'—saying "This is your canvas! We don't use watercolours in here. We use oil paints! These are your paints. Just go for it and don't worry about that smock. And make sure you take up the whole paper. **Be BOLD! Here, we are bold!"**

So Cav did. And he made a big, beautiful robot. A gray robot with wings. It is framed and it still hangs in Cavanaugh's room twenty years later. Any day you entered Toller's world, you entered a world engulfed with magic and vibrant colour. In the company of Toller, you always knew, bigger was better, more was better. Even now, almost every day, when some little event happens, I often think to myself, I wish Toller were here to see this. We miss him so much.

Cavanaugh O'Leary. Oil on Paper

193

Anita Dhanjal

I am an artist. Toller was my mentor. Working alongside him in his studio was an incredible learning experience. He taught me new skills, and he showed me ways to bring life to my painting. He pushed me every day. I learned to paint with the same passion, energy, and creativity that he carried within him. I completed seven paintings in five days. I had *never* done that. I can be a *real* artist and continue with my dream, live life, and be happy. I will miss him dearly as my mentor and friend, but I see that the new paintings that I am starting have a part of him instilled in them forever.

Grant Noroyan

I am a former three-time U.S. national competitor, double gold medallist, and principal skater with *Disney on Ice*. I was a great fan of Toller. I grew up in the Detroit area in Dearborn, Michigan. I remember watching the 1976 Olympics and seeing Toller skate. I fell in love with the sport mostly because of that Olympics, and in particular, Toller's skating. I also remember how much my mother loved his skating because he skated to Greek music and she is Greek. One of the most exciting moments for me was when I crossed the border from Detroit into Windsor, Canada to go and see Toller in *The Ice Show*. My parents knew how much I loved Toller's skating and they arranged for me to meet him. That was a moment I will not forget. Now, as a coach, I try to incorporate artistic movements and Toller's style and artistry into the choreography of my skaters. I am also a great fan of his art and am now the proud owner of about eight of Toller's pieces. I love and cherish them all.

Karen Abbey

I am reading *Zero Tollerance* for about the twentieth time.
There are some real-life zingers and lessons on human nature that I am learning
with humour, as I am becoming an adult late in life. Toller's artistry puts wind
under my wings. I miss him. He was a quasar never to be replicated.

Art and Leona DeFehr

Toller once described the exact moment that he became a painter—a serious painter.
He said that he was sitting on a bench at a function where Barbara Ann Scott had just been introduced.
The announcer had said, "This is Barbara Ann Scott who used to be a skater," Toller said the
words just went right through him. He knew in that instant that he didn't ever want to be
known as a *used-to-be*…he didn't want to spend his life as a *used-to-be skater*. He said,
"I threw my skates into the canal and I decided that from now on, *I am a painter.*"

Shelley MacLeod

It was the passion, the emotion, his being able to take raw emotion and give it a form on the ice. You'd watch him and think "OK, that's what pain feels like, that's what love feels like, that's what angst feels like." Toller was able to put form to it. It didn't matter if it was six in the morning or if it was an Olympic performance—he would give that same kind of passion, that same kind of drive and intensity. Every single time he skated.

German Llamas

I remember him every day. He was very special. The true is that I miss him a lot. He's not anymore with us. We feel sad. It took me a long time to believe it. Even my father was crying. It was hard for me to see my father cry, but we knew that we were losing a very important man in San Miguel. I cried too. He was as an angel to me and for many other San Miguel persons. My dad too. We love Toller. He was very special.

Deb Usher

He was way ahead of his time—maybe there will never be a Toller time but his whole concept and colour was amazing.

Paul Kowdrysh

There are a small number of artists with the ability to motivate and inspire me in my appreciation and the decision process in what I purchase and choose to collect. Toller Cranston is the artist that stands head and shoulders above the other artists in my preferred group. My admiration has little to do with the fact he is a fellow Canadian (though this helps). Instead, it is his diversity, uninhibited creativity, ability to challenge established barriers, push the limits with colour choices, and the symbolism that is expressed throughout his art—not only in his paintings, but in his line drawings, ostrich eggs, skulls, and other pieces. Where many may see his work differently from me; my ability to appreciate the placement of a certain cat, flower, arrow, strawberry (or bunch of), rat, skate, rabbit, hat, etc, extends far beyond my admiration of him as an athlete, (which first provided him with the ability to showcase his artistic talent) and as an artist; instead, I am able to relate these works to many of my life experiences as I share these works with all my children and they with their children when I pass. Toller, you continue to be missed and you continue to be appreciated.

Zdeněk Pazdírek

The Canadian team including Toller and Karen Magnussen were training in Vienna before going to Bratislava for the 1973 World Championships. Before they left Vienna, they had their skates sharpened but the sharpening stone had been set for an extremely deep groove. When the team got to Bratislava, they discovered that their skates were much too sharp and there was insufficient time before the competition to get those skates duller. The skaters were in a desperate situation. Their good friend, and Toller's fellow competitor, Ondrej Nepela, (1972 Olympic champion, and three-time World champion), recommended Dr. Ivan Mauer. The team was driven right to the skate sharpener's house and the son of Dr. Mauer re-sharpened their skates. While they waited, Toller drew a painting on the wall of Dr. Mauer's house. The Worlds was successful for the Canadians. Karen won and Toller impressed in free skating and finished 5th behind Ondrej. After the competition, members of Canadian team went to Dr Mauer's house to say thank you. Dr. Mauer lived in that house until he was well into his nineties. Now, his nephew, Ing. Ivan Mauer Jr. lives in that very house. He is still sharpening skates. Toller's painting is still there.

You can find Toller's painting and the signatures of the skaters on the Referencie section of Ing. Ivan Mauer's website: www.korcule-mauer.sk,

Astra Burka

Toller was totally eccentric. I remember the Fellini party in the backyard that was fun.
A picture was even published in the paper of me feeding grapes to a graphic designer.
And then all the coloured rabbits escaped. Somebody had brought all these rabbits
that were dyed different colours and they all escaped into our
North Toronto neighbourhood.

Joy Levine

I had spent two years diligently and faithfully going to Weight Watchers and happily,
I managed to cleave off a good amount of weight. At one point, I bumped into Toller in the streets of
San Miguel. Toller was hugely complimentary about my new look and at one point interrupted me and
said, "Joy, you look so fabulous! I don't understand why you are not married."
My response was, "*Gracias,* Toller." There was a slight pause.
And then I asked, "Is that perhaps a proposal?" He shrugged his shoulders and said,
"Well, we can talk!"

Jeanie Gooden

My favourite story is introducing Toller to my mother. We rang the bell and were
ushered into the property. Down the path came Toller wearing a bright red suit with his huge brimmed
hat. He carried a single rose. He knew that Mother was a minister's widow and that she was nervous
visiting Mexico. With a sweeping bow, he presented the rose and said, "Welcome Margie. While you
are here, I think you must drink more whiskey and have an affair." Mother, now in her nineties,
still laughs about that moment.
She will never forget Toller—nor will anyone who ever met him.

John Lennard

I had represented Canada in sports as well as being an international artist, so we shared
a lot in common. Toller actually coined the phrase which I have kept that I was a
"calculated bohemian." Of Toller's many qualities, I feel the most impressive is his ability
to focus in on the moment he was living. To spend time with him made you feel that life was not only
special, but it was also to be celebrated. This feeling and generous
spirit of life was a gift that flowed from him.

Christine (Chris) Coulton-Varney

I was born in 1960 and grew up on a family farm outside of Stratford, Ontario. Like all Canadians, I knew and loved watching Toller skate. My sister Rosemary once gave me a poster Toller had designed for the Inaugural Season of the Roy Thompson Hall and the Toronto Symphony. It was 1982–83 when we were all in our prime and had the world by the tail! That was when I learned that Toller was an artist. At the time, I was still living at home, travelling, and then, eventually, I went off to university. It was not until years later when I got my first full-time job in Calgary and my own apartment in lower Mount Royal, that I had my Toller Cranston poster mounted and framed. It was my first official piece of art. That poster has followed me through every move. I will never dispose of it. When I look at that poster, I think of those years as good times and how invincible I felt. It also makes me think of the song *"Those were the days my friends, we thought they'd never end."*

Louise Vacca Dawe

I skated on the same ice as Toller in Lake Placid in the mid-sixties. It was clear that he was a stand-out artist and ahead of his time. In later years, I got it into my head that I absolutely had to have, and should have, some of his originals. He was special. His art was special. It called to me.
Four pieces hang in my home. They still thrill me. I still love them.

Rob Leon

When Toller came to Toronto for his tribute show at the Varsity Arena, he said "There are just two things I need: a jock strap and a haircut." Thankfully, Martha took care of the former.
And I managed to find him a barber.

Greg Ladret

The summer of 1978 Toller was doing some coaching at the Cricket Club. He and my coach Bernard Ford convinced me to enter the Men's Interpretive event at the Thornhill summer competition, which I won. Having my name on that trophy along with previous winners, Toller Cranston, and John Curry was a major event for me.

Kim Manley Ort

Toller had music inside of him that had to come out through his body and his art. He brought flair and artistry like no one before him. He was a true original—an artist in every way. When my husband and I bought our first house, we decorated our living room around one of Toller's prints, a gift from my mom. The walls of our living room were bright pink to highlight the framed piece (which I still have). Toller Cranston felt his destiny from a young age and, although he definitely suffered from rejection at times, this never stopped him from doing what felt right. He inspired many, including me. Thank you, Toller. You'll be missed.

Hannah McCurley

Toller was a very special soul. He was everything you heard and know about him. Charismatic, larger than life, and he had an incredible photographic memory. We used to chat about art while we painted in his studio. Early in our friendship, he would challenge me in art history and test which paintings in the Uffizi were my favourite, where they were located, and the stories behind them. Not only did I pass his challenges, I gave him some of my own. He looked at me with a different eye then. Toller also loved to trade the juicy town gossip.

Anita Blyleben

Toller's Christmas 2012 party was over-the-top, as usual. He provided everyone with beautiful masks to wear during dinner. Afterwards, we took the masks off and since it had been a bit hot underneath and with all the candles and wine, my cheeks were perfectly round bright red cheeks. I was wearing my Austrian *dirndl* and I was sitting on Toller's lap and he said that I looked like a *Puffmutter* (a madam).

Laverne Remigi

I am so happy because I have just purchased a piece called *Under The Red Lantern*. I paid far too much for my limited budget, but I just needed to have one of Toller's creations on my wall. I recently lost my husband to cancer and Toller's brilliant colours and free-spirited style bring cheer to my heart again. Thank you, Toller.

Suzanne Wheeler Ally

I found a video in which Toller spoke about retiring to San Miguel and how San Miguel was about gearing up rather than slowing down. He spoke about how the social life in SMA has nothing to do with money, but with sharing artistic sentiments. He spoke about the virtually unlimited available activities being some sort of stimulus of the brain. Before the video ended, my husband Harry Ally, sitting next to me in our newly-completed retirement home of our dreams in the secret forest of Troy, Ohio, said, "Let's move there!" And we did.

Barb and Don Jackson

We have one of Toller's drawings. It is dated 1968 and is personally inscribed to Don on the back. We treasure it. We were recently in Kleinberg at the McMichael Gallery of Canadian Art. Toller should have something in there!

Bonnie Eccles

In 2002 I travelled to San Miguel de Allende to visit my artist friend, Mary Gay Brooks who was taking classes at Belles Artes. We had followed Toller's artistic and figure skating careers for years and we were excited to see his studio. He was working on a colourful, whimsical painting that was a model for a much bigger one commissioned by a bank in the United States. I was quite taken with the painting and bought it on the spot. To this day it graces my living room and brings me much pleasure. The following year Mary Gay rented his casita and was able to paint with Toller in his studio. He liked her because she didn't chatter incessantly. After a long battle with cancer Mary Gay, my dear friend, passed away in 2015. I can tell you we both loved his unique character and his amazing originality and creativity.

Hazel Pike (Boskill)

Unfortunately, in recent years skating appears to be more like a gymnastics routine. Skate, trick, skate, trick. There have been however, over the past couple of decades a few male skaters who have been enjoyable to watch. They have not been inhibited in expressing their feelings and movements while interpreting their music. I believe strongly this was made possible by the man who definitely changed figure skating: Toller Cranston.

Emery Leger

When Toller used to come to Shediac New Brunswick, he would call and say, "Emery, I would love to do some theatre and movement classes with all the skaters. But the kids will never know who I am." And I would say, "Yes, they will, because I am going to tell them who you are." Of course, the kids loved working with Toller.

At Worlds in 2013, Skate Canada was trying to do oral interviews with all their alumni and skating stars. I set up an interview with Toller who is notoriously unreliable. Toller arrived and my colleague called me on her cell phone and said, "Emery I've got Toller Cranston here!" and I replied, "Don't let him go! You can't let him get out of your sight! Get him a coffee! Just get him in that room." He did the interview and it went on like for an hour. The TSN/CTV guy said to me after, "Emery that's the best interview we've had." When Toller came out of the room he said to me, "Emery, that was my last interview. I am doing no more interviews." And sure enough, it was his last interview.

Silvia Katharina Grohs

I met Toller in the summer of 1977 in Garmisch-Partenkirchen, Germany, where he was in a show at the Olympic Ice Stadium. I was just eighteen years old and on a holiday with my mother. We were looking forward to seeing this exciting skater, who we only knew from television. It happened that we were staying at the same hotel. Since my English was not so bad at that time, the hotelkeeper arranged that Toller would share our table for breakfast and dinner. I was so nervous that I could hardly speak when the most beautiful person I'd ever seen took a place just across from me. He moved as graceful as a dancer and he inspired me in so many ways. He completely changed my life—it was a real obsession! I started to be a ballet dancer, bought a pair of skates, and began painting. These artistic activities have enriched my life for decades and still today, I enjoy those creative hours. Every time, Toller came to Germany, I arranged to meet him. My dream was to visit him in San Miguel de Allende. I cannot express the shock and total feeling of a personal loss when I heard about his sudden death. His talent and his personality were absolutely unique and still today, it hurts to think he's gone. The world has lost an angel.

Grant Waldman
Toller's teaching to us was to live life fully.

Monica Campbell Hoppé

Toller was a *force majeure*. Canadian visitors to San Miguel flocked to his studio, not just to see his paintings, but to meet the man himself, a Canadian icon. He loved music, especially my husband Michael's music, and played it so often and on repeat that it was enough to drive others in his studio to distraction. He opened his house, not just to friends, but to strangers. He didn't drink, do drugs, or smoke. He had terrible table manners. He dominated conversation. He was curious, intensely intelligent, well-read, and world-travelled. He was full of dazzling ideas. As a Canadian and representative of my country for twenty-eight years in the U.S., I was proud of Toller as an Olympian, and even prouder that we became his friends. He played a huge part in our permanent move to San Miguel de Allende. His passing is a big loss. Unique, larger than life, we shall never know anyone like him again.

Kimberly Kmit

My most vivid memory was a skating show I attended in Sudbury, Ontario with my
mother and her best friend. Toller glided onto the ice with such a flourish that I was
absolutely taken aback. I looked over at my mom and her friend and they were crying.
I attend international competitions every year and nothing compares to seeing a
skater live who is clearly inspired by Toller's passion for the "art" of skating.
I will never forget him.

Rodney Groulx

As a Canadian teenager who played recreational hockey, looking back at the iconic
athletes of my youth, it was easy for me to name great athletes like Guy LaFleur, Yvon Cournoyer,
or Larry Robinson. Back then, I would have been hard-pressed to name any track and field, tennis, or
any other Olympic athlete. But that was not the case for figure skating. I can easily recall spending time
with my family watching sports and we always knew when Canada's Toller Cranston
was going to be competing.

Janet Dunnett

The other day I picked up a copy of *When Hell Freezes Over* that was on the sale table at the Biblioteca.
It was 100 pesos. This was odd because all the other used books were 10 pesos or 25 pesos. I asked
the lady why this Toller Cranston book is so much more expensive and she said that was what the
volunteers wanted. They said Toller was very special and his book needed to be more.
I go to Toller's grave every year before Day of the Dead and clean it up.
He doesn't need me to do it but I need to do it.

Monica Friedlander

No one else I know is both so disarmingly direct, but kind, unconventional, yet funny.
He supported me in my efforts in opposing the new judging system in figure skating, which I believe is
killing the heart of this amazing sport that Toller helped shape.
His impatience with convention and his dogged insistence on always calling things
as he saw them were truly inspirational. To journalists like me, these
qualities were almost as important as his art.

Jeannie Yagminas

I was not into skating because of having been born with club feet, but I do
remember watching Toller on TV. He made it look so easy and wonderful.
I felt that he was a movie star.

Dawnette Brady

I was mesmerized by Toller. Video recording was clearly not available in the
early 1970s, but when Toller skated, I recorded the commentators on an old-school
cassette tape recorder. Who knows why a small girl in Oklahoma had such a love for a skating
Canadian— but I did. Many years later, I found myself combing YouTube for a video of Toller skating.
In my search I found that he was also a prolific artist.

Glenda Scott

When I phoned Toller in 2009, I identified myself as a Canadian who was looking to rent one of his casitas. "Be here at ten o'clock tomorrow," he answered and hung up. At 10 a.m. the next morning, he opened the door to his magic garden and let me into his world. I stood at the top of the stairs absorbing the spirit and ambience of 84 Sollano. That I was enchanted was not lost on Toller. Kindred spirits came together. I became The Wandering Widow and I called him The Squire. He wanted to know what I planned to do with my time. "I would like to paint," and he answered, "Good. You can work in my studio as long as you don't talk." He held court at his fascinating and informative breakfasts. The rule was: *Speak when spoken to and your answers had better be good.* He taught me about art and its many manifestations and he gave me exciting winters in the winter of my life. I never had a brother, but one like Toller would have been fun. I am privileged to have had him as a friend.

Kenn Jorgensen

Back in the early 1970s, the figure skaters were touring Europe after a World Championship and they were in Brøndbyhallen, Copenhagen, Denmark. I shot a great picture of Toller Cranston in one of his famous jumps with his legs way up high in *spagat*. Just before I took the picture, his trousers split wide open between his legs. It was a wonderful picture. The audience was cheering and screaming and laughing and Toller, like the pro he was, took an extra trip around the ice smiling the whole time. I delivered a large hard copy of that picture to the hotel where the skaters were staying and wished him the best of luck in all times. Now my question is: "Does this picture still exist?"

Lisa Biglin

I had the privilege of seeing Toller skate at the Oshawa Civic Auditorium years ago when he was an unknown filling in for Don Jackson. I met Toller afterwards and he autographed my program. I still have that program.

Mary Ellen McDonald

Back in the 1970s, we did a huge production of Rhapsody on Ice at the Winnipeg Arena. This was before *Ice Capades* and all those other travelling things and Toller was the headliner. To have Toller Cranston headlining this show was huge for us. We sold a lot of tickets. All the volunteers were mums, because back in the 70s, that is how it was and many of them were pretty strait-laced. Toller's dressing room was at the back of the house. Toller is getting ready. He's doing his makeup. I remember that one of the mums walked in to see how things were going and Toller is just being Toller. He is just standing there with absolutely nothing on. Not a stitch. And she's like "Oh my gosh! Oh my gosh! Oh my gosh!" And he just continued to talk to her and she's like "Where do I look? Where do I look?" She is absolutely mortified. For him, it seemed like second nature. She said, "Well, OK then," and she left. But she stood guard at the door saying, "OK, nobody else can go in there." But for me, the main memory was after the four nights of shows, there was the snaking line of all of us kids who had skated in the shows filing past Toller who sat at a long banquet table in the middle of the rink and signed *Strawberry Queen* prints. He stayed there till each and every one of us got a print signed by Toller.

Kurt Browning

When I look at his paintings, it feels like I am surrounded by what is a real colourful vision. Like a dream of what figure skating could be. Like I always feel like I am at home in his paintings. And it's that relationship between skater and artist. And then, I walk in and I feel like I know him personally and I know skating and I just love being around his art.

Karen Courtland Kelly

We created the World Sk8ting & Arts School + Academics Virtual Academy to support the development of young skaters into world class skating artists like Toller. As World Figure Sport's Chef de Mission of Education and Sport, I have the pleasure of witnessing the joy, the struggles, and the process of learning the art of skating combined with academics and a colourful range of the arts including drawing, painting, calligraphy, knitting, movement, and music. Our curriculum supports healthy physical, emotional, and spiritual growth and our school develops World Figure Sport's Skating Artists of all ages for the World Figure & Fancy Skating Championships on black ice.

My husband, Patrick Kelly, (Canadian Sprint Champion and 2x Olympian), and I treasure two memories where we witnessed Toller's artwork and the public's reaction to his extraordinary paintings. The first occurred when we helped organize his Art Exhibition at the 1980 Olympic Museum in Lake Placid, New York. We had the pleasure of directing and choreographing the *Miracles of Gold Ice Revue*, a fully costumed video technology ice show about the history of skating in Lake Placid with Toller as the Master of Ceremonies. *The Miracles of Gold Ice Revue* combined two spectacular experiences for the public, a star-studded legendary cast of champions with skaters of all ages from all over the world, and Toller's extraordinary artwork throughout the entire museum.

We also had the honor of attending the opening at Trump Tower in New York City when Toller presented his paintings to the Who's Who of fashion, art, and politics. Donald Trump (long before his presidency) and his family welcomed guests to the exhibition of Toller's original artworks in an incredible setting.

We are grateful for the blessing of Toller and his art in our lives. Toller's work is displayed in our World Figure Sport Skating Hall of Fame Collection along with his posthumous 2016 induction.

John Rait

Everybody wanted something from him. Everybody was there to take and very few people were there to give. The givers are the people that have stayed with Toller over the decades. The takers have come and gone several times. And there's always somebody new.

Niki Barbery-Bleyleben

We had the great privilege of meeting Mr. Fabulous many years ago. What an extraordinary blessing to be able to introduce one's children to a man who never lost his sense of wonder. A man who could magically layer colour upon the most black and white of circumstances. A man who knew exactly how to celebrate the best attribute life has on offer: the freedom of expression. He once told me as we were walking through the property, "What you see around you is your education. Of course, I know this because I was like them [children] once. They might not say much when they are little, but they are taking in the world around them all the time. And it all comes back. It's discussed. Children always remember." I will forever feel locked in an eternal spin around the dance floor with Toller—to the sounds of Roberto Carlos piercing our collective hearts.

Piensa en la alegría de vivir
De tener de nuevo una ilusión
Siempre hay esperanza si el amor te alcanza
Deja penetrar su luz - Roberto Carlos

Nataliya Shpolianski

Neither forty years ago, nor now, I can find the right words to describe Toller Cranston's performances. It's like the first love forever with me so I always collected material about him. In the Soviet Union, everyone loved Toller very much.

His entrances to the skating rink are something amazing—forcing you to look at him with bated breath and forget about everything that is going on around. I was a teenager at that time and was literally shaking from an overabundance of feelings when I watched Toller's performances! I am a big fan of figure skating, but no one ever made such an impression on me! I remember how I sobbed when Toller drowned his skates in the canal after the 1976 World Cup. I could not forget him for a long time, and when the Internet appeared, we had the opportunity to watch again. Many people remember and still love Toller from the former Soviet Union (I found a lot of admirers of his talent on the Internet). Toller, for me, is the personification of beauty and poetry in figure skating. He is a genius who is ahead of his time. It is a pity that he did not become a world champion, but even without that, he is a champion of human hearts. It is impossible to forget him. But he has such unrealistic and infinitely diverse movements. On the ice, he was able to give such forms to his body, his hands and legs and torso were unprecedentedly expressive. But I have never seen Toller "alive"—only on TV and on the Internet. But it does not matter. I will never forget this sorcerer and wizard of ice and the brightest person.

A Very Devoted Fan, Sandra Garrett

I have always been a great skating fan and I used to watch BBC TV's coverage. I find it difficult to explain why I, a Briton, preferred Toller's skating to John Curry's or Robin Cousins' except that it was more expressive. And he was a beautiful person. My earliest memory of Toller's skating was at the 1974 World Championships in Munich. Over the following years, I saw all the TV shows. I watched all the championships. During the 1980s, I contacted Canada House in London and they sent me photocopies of magazine and newspaper articles. I made my first visit to Toronto in October 1984 and purchased my first two prints from the Art Gallery of Ontario. I discovered that Toller was living in Cabbagetown and I plucked up courage and knocked on the door of 217 Carlton. Imagine my surprise when Toller answered the door. I asked him about future skating plans, but he had none. However, he gave me his telephone number. I phoned him several times whilst I was in Toronto, but no reply. On visiting the house a second time, his secretary, a Polish lady named Krystyna said, "Mr. Cranston is busy." I think that nowadays, I would probably be deemed to be stalking. I did read about an obsessive American lady who bombarded Toller with letters and phone calls. I purchased all his books and joined the Facebook Fan Club Page in October 2012. I commissioned my first original painting in 2013. I attended the *Magnificent Obsession* exhibition in Calgary in 2013 and purchased two more originals. I had my photo taken with Toller. He was so impressed that I had come all the way from England that he invited me to visit him in Mexico, which I did in March 2014. I attended the AGO Memorial event in June 2015 and the Ice Theatre of New York event in October, where I won another painting in the silent auction. I now have eight originals. My favourite skating performances are *Pagliacci, Valse Triste* and *Nicholas and Alexandra*. I don't have a particular favourite painting but I loved the red and gold ones.

Keith Walker
He was always true to his art, and, more importantly, he was always true to himself.
There are many millions of artists in the world but few that have made being
an artist the raison d'être of their entire life.

Jeanie Gooden
He would explain in extravagant detail how impossible it was to grasp
the fineness of his "skating ass."

Gary Reid
I idolized Toller first as a skater, second as an artist, and finally as a creative friend.

Casey Trudeau

I had the wonderfully unique and eventful pleasure of meeting him twice in his San Miguel home. I design houses in California and I was blown away by his studio, house and gardens. In 2008, a group of us thirty-something gals were visiting San Miguel. We met Toller and begged him to join us at the local club for drinks and dancing, which he did! He surely danced! We had an absolute ball and knew full well how special the evening was because we knew he wasn't keen on nightlife. I was honestly heart-broken by the news that Toller died. I am so appreciative to have met him. He had an impact on how I approach home design, and art, and life.

Sally Rehorick

As a judge, I didn't have the opportunity to judge his ice-art except at the national competitions. However, we shared Worlds a couple of times when he was with CBC and I was team leader for Canada. We had fun! Fond memory—I remember once he said I should wear black lipstick on the CBC platform during the Halifax Worlds (team leaders shared the CBC stand). So I did. And at a certain point in his broadcast, he turned around to me and declared the lipstick *divine*! I would add that he was kind. His empathy towards the skaters he was commenting on was deep and genuine. He always spoke truthfully.

Kym McKay

One year, Toller was the guest star at the Dundas Figure Skating Club end-of-the-year show. As a young skater, I was thrilled to be able to see one of my idols. He also had his paintings on display in the arena. It was the first time that I knew that he was a painter. It seemed such a radical thing to me that you could pursue two creative avenues and excel in both. I had never seen that before. Toller's example showed me that I did not have to choose one or the other—that it was OK to explore many avenues. I have continued to do that for my whole life. I became a competitive swimmer and a dancer. I am an artist, a fashion designer, and a visual merchandiser with my own business. Toller, by his example, showed me that it was OK to be creative and athletic at the same time and to explore any avenue of expression that I felt drawn to and not to limit myself to just one. It has made me a better person and a better artist.

I was fortunate enough to meet Toller again at a gallery showing in Toronto a few years before he passed when I purchased one of his painted ostrich eggs. I was able to show him the original program from the Dundas Skating Show which he had autographed for me & to tell him the story of how he inspired me both as a skater and as an artist. That egg is now one of my prize possessions. It inspires me creatively and reminds me every time I look at it to never limit myself.

Shepherd Clark

To some, Toller is considered as the "Salvador Dali of The Late 20th Century."
His desire as an artist was to sculpt a life that was not barred by inhibition or regret.
Toller's intellect and sense of humour provided the credibility necessary for his acceptance socially, that his message was not merely egocentric. He had a benevolent and relevant purpose for his life and artwork, which were truly one.

Hazel Pike (Boskill)

I remember shopping with Toller one day and we passed a woman trying on a ridiculous-looking hat. He stopped, looked at her, and said, "Madam, not for you!" I cannot begin to describe the stunned look on her face. He continued to walk on as if nothing happened. As we were leaving, he did a series of *grand jetés* down the central aisle of the mall.

Catherine M. Whelton

I was moved to tears each and every time I saw Toller Cranston skate.
Once, when he had an art show in Edmonton, Alberta, I had the opportunity to experience his art and best of all, to lovingly thank him. It was a dream come true to thank him—to personally thank him.

Christine Walter (Robbins)

We both trained with Eva Vasak in the 1950s and 60s and I have such wonderful memories of those days at the Town of Mount Royal Summer Skating School.
He gave me a little trinket all those years ago which I have hanging in my garden here in Perth, Western Australia. May he rest in peace and light.

OPP Cst. Dave Stewart

I used Toller Cranston's name just two days ago. I said,
"Any good hockey player is like Toller Cranston with a stick."

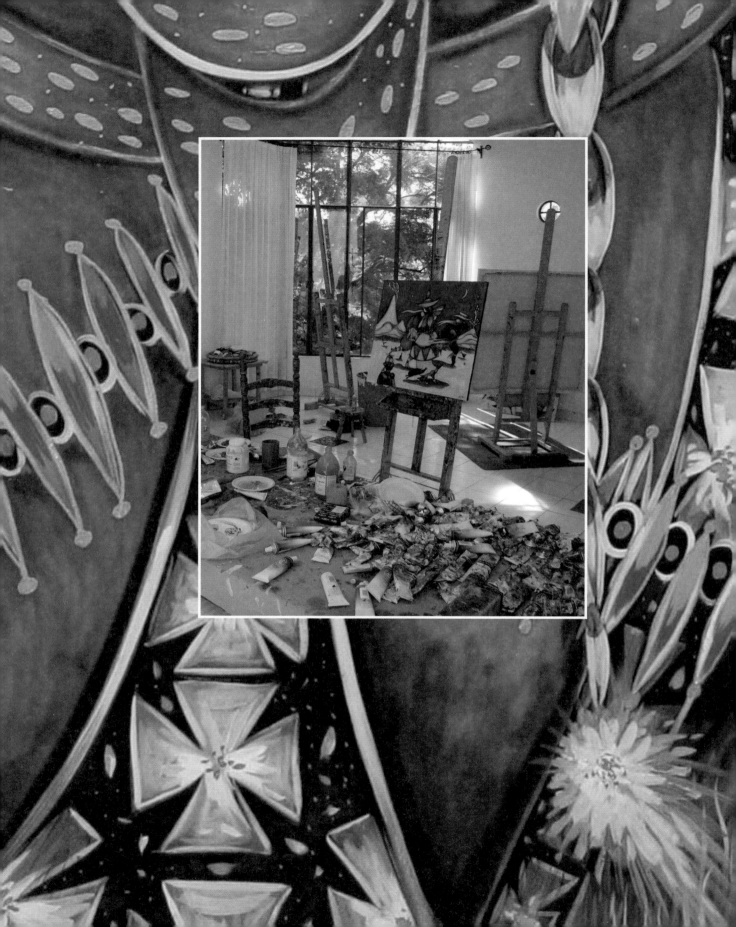

CHAPTER 19

THE MUSE

By Phillippa

Muse (n): *a source of inspiration especially a guiding genius*

A Muse was one of the traditional nine Greek goddesses who presided over the arts. But sometimes, one artist provided inspiration to another.

From plays to multimedia exhibitions to album covers, Toller is a source of inspiration that extends beyond the ice, the galleries, the photos, and the printed pages.

TOLLER
By Sky Gilbert

Toller Cranston was a fierce, outspoken, groundbreaking, queer artist. He spoke as openly as one could speak at the time about his sexuality, during a period when homophobia was common and, most of all, still publicly sanctioned. Pierre Elliott Trudeau dared to banish the government from the nation's bedrooms in 1967 (an edict which ultimately changed the laws—but not the hearts—of all Canadians). Just a few years later, between 1971 and 1976, Toller Cranston dared to challenge the traditional conception of what it is to be a man, through—not only his world-renowned figure skating performances—but his presence as a larger-than-life personality. Toller's figure skating performances were marked by their self-conscious artistry and their attention to human feeling.

Although he was an Olympic-calibre athlete with enormous physical strength and figure skating skill, Toller chose to highlight his performances as poetic and artistic happenings, even as personal expressions of his emotional needs. The persona he adopted during his figure skating performances was Oscar Wildean—that is, marked by flamboyant costumes, extravagant hand gestures, and an over-the-top aesthetic. Toller was obsessed with beauty, and the notion that art might offer us a one-way ticket to a fantasy paradise—an experience as far as possible from our daily, humdrum life on this earth. His aesthetic was informed by his own personal experience of being an effeminate man in a hostile world. His bravery in expressing his personality through his art—though he was much ridiculed and despised for it—served as a beacon of light, directing us out of what was a dark time for many LGBT people. We still have not reached the light at the end of that tunnel, as many still harbour old-fashioned notions of what it is to be a man (or woman). Toller challenged those notions and opened the door to a new, expanded, more generous, and empowering notion of maleness.

In my play *Toller*—produced in Hamilton, Ontario, and at the Toronto Fringe Festival in 2015 and 2016—I directed the beautiful and extraordinary David Benjamin Tomlinson in 10 short scenes. It was, I hoped, a valiant attempt to exemplify Toller's creative spirit, and summon his ghost into the room. With only some fabric and scarfs to manipulate in this theatrical dance, David Tomlinson and I were able to create a reasonable facsimile of Toller's universe. We ventured to explore the—at times tortured—reality of a man trapped by his own confessional honesty, in a world that doesn't understand. He creates fantasies that are much more alive in his own mind than in reality, and he relies on drugs and alcohol to find release and escape.

At the beginning of the play, Toller seems to be speaking to us from some vaulted heavenly enclave on high—his pronouncements are lofty and moving, and perhaps a little odd. As we begin to understand him, we laugh at him, then with him—sometimes both at the same time—until we realize that he is quite simply human, and very brave. Near the end of the play, his Mexican gardener/assistant tries to pull him back to the mundane quotidian, but fortunately for us, he does not succeed, and Toller concludes the play with several rhapsodies born from his own radical imagination.

From *Toller*: "What you see and hear—that is not real. It is only art that is real."

In *Toller*, I tried to pay tribute to a pioneer. It is possible that people won't completely understand Toller's enormous contribution to aesthetics and sexual politics for quite some time. But it's worth waiting until they do.

Page of script from Sky Gilbert's play *Toller*...

I know I shouldn't care what others think. I know I shouldn't. But how can one not? Especially when they are always thinking about you, gossiping about you, when your every move seems to cause concern because you are not like them. The 1976 Canadian Figure Skating Championship was my last Nationals competition. It was the night of Ronnie Shaver, everyone wanted Ronnie Shaver to win. I don't know why. Now you must understand that normally I would arrive at the competition with not only one costume but an armload of costumes—usually variations on a theme of black with sequins. This night—I don't know why—I suppose I was discouraged by all the enthusiasm of Ronnie Shaver and felt the need to impress—I made a rash decision. I chose, of all things, a bright orange blouse—it made me look like a giant pumpkin. I skated the warm-ups in that horrid orange wrap. At the last minute, thank God, I had the presence of mind to change into a simple black outfit. But I still didn't know how I would ever triumph over the crowd's enthusiasm for Ronnie Shaver—they loved him so much, they would never love me. And then, when it was my turn to skate, the announcer, I don't know who it was, but God bless him for what he did for me—he said something that no one is ever supposed to say at a Nationals competition. It was today what might be called politically incorrect. Maybe that's not the term. Announcers at the Nationals are of course, supposed to be the soul of neutrality, But I heard him say—and I couldn't believe the words, I still thrill to think about them. "Here he is, THE ONE AND ONLY Toller Cranston!"—Oh, I couldn't believe my ears! And you know something, because that one announcer, I don't remember his name, but because that one person believed in me so much as to call me the ONE AND ONLY Toller Cranston, because of him, I had the courage suddenly to skate my best. I suddenly appeared, as if from nowhere, the judges couldn't believe it was me because I had changed out of that horrid orange outfit. But because someone believed in me, because of the opinion of one other person, I skated like a dream. Everything was perfect and I won! It was the last time I triumphed at The Nationals. I can't help it. When someone believes in me, I just burst open...like a flower.

Toller was a terrifying figure to me as a closeted teenager growing up in rural Ontario. He was artistic, flamboyant, and outrageous; all the things I carried deep inside but was too ashamed to express. It would seem I have become the very thing I was so terrified of and, remarkably, I love the view.

David Benjamin Tomlinson, star of Sky Gilbert's 2016 solo play *Toller*

TOLLER (TOLLER-ON-THE-RUN PRODUCTIONS) 2016 TORONTO FRINGE
Review by Sam Mooney July 2, 2016

Wow! Two firsts for me. My first Sky Gilbert play and the first time I've seen David Benjamin Tomlinson. The play, *Toller,* was part of the 2016 Fringe Festival. I loved it. Except for the part I didn't love.

It's a beautiful production. The set is gorgeous: a wicker chair draped in long flowing white fabric, a small table with a candelabra, wine decanter and wineglass, and a small heart-shaped box of chocolates.

The play is a monologue, a series of stories and vignettes from Cranston's life. It feels like an impression of Cranston rather than a biography. Think of an incredibly beautiful, gay, tortured, and funny Jane Austen hero and you'll have an idea of the way that David Benjamin Tomlinson plays Toller.

The language is beautiful too. Very formal, very precise, and very extravagant. Again, it made me think of Jane Austen. It's almost musical and a bit hypnotic. Early in the show Tomlinson, as Cranston, says "I have a florid way of talking." I don't think that Cranston was ever that precise. Tomlinson is an amazing actor. He acts with his entire body. He uses the draped fabric to signal a change of topic. He shakes it and drapes it differently. Sometimes it's funny but sometimes it's frustrated, or angry. He cries real tears. So did a lot of people in the audience. It was a nice change to not feel like I was the only person crying.

…I don't think it matters whether or not you know who Toller Cranston was; you can still see Toller and love it, like I did. It's a beautiful play; the language, the acting, the set, everything.

THE FROST FAIR

Theatrical director Jennifer Brewin's vision for *The Frost Fair* is ambitious, outrageous, impossibly fabulous, colourful, and both ground-breakingly new and a throwback to yesteryear. In other words, it has all the characteristics that Toller would embrace.

The Frost Fair is an outdoor winter production that will be developed over the next four years. Its narrative structure features a multi-track storyline performed by multi-disciplinary actors. It is an immersive site-specific performance that blends the idea of the North American early 20th century traveling Vaudeville show with the Elizabethan winter fairs that spontaneously rose up on London's frozen River Thames. The objective is for *The Frost Fair* to become a feature of Canada's Winter Festivals for years to come.

Toller's eccentric and breathtaking paintings are the inspiration for the design. The set, costumes, and lighting will mimic his art—bursting with colour, rich tones, and saturated landscapes. The Company aims to recreate the feeling Toller's works evoke, that of a frozen winter night alive with emotion, intrigue, and personality.

Conceptually, *The Frost Fair* blends two specific performance modes. It mimics the social phenomenon that occurred when the River Thames froze over in Elizabethan London. This rare feat of nature brought Londoners onto the river in droves, where overnight an entire fair of performances, food, games, and shops would materialize. The frost fairs were spontaneous acts of social communion—anarchic, celebratory, and chaotic—a miracle of joy against nature's brutal

whimsies. These forms will be blended to create a large-scale production set outdoors during winter festivals.

Another influence is the vaudeville touring shows of the 1920s and 1930s which featured an eclectic variety of performances and genres, from the popular to the classical: opera, clown, magic, ballet, dragon dance.

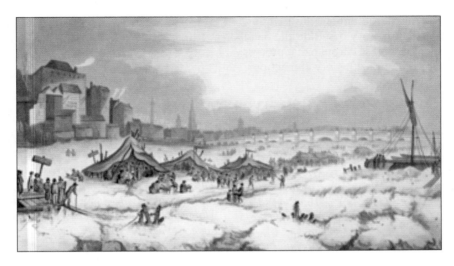

STATEMENT OF INTENT
By Jenifer Brewin

I aspire to create performances that live on the thin line between order and chaos. I direct primarily new work and facilitate collectively created scripts. Many are large productions performed in unusual places.

I aim to create an environment that frees people to bravely investigate how we behave as a society. I seek a form and a forum where high art and comedy can fuel important and relevant discussions about our lives. I am interested in the place where the state and the individual meet and collide, where the big picture of existence intersects with the smaller pictures of everyday life. I seek work that is populated with everyday characters—the deeply average person who for a moment accidentally trips into public view.

The social and physical landscape of the working environment informs my work in terms of theme and aesthetic. When the creative process begins, I head to the territory where human dilemmas ferment—borrowing from the dramaturgy of chaos, doubt, and desire, traveling from disorder to balance and back again.

I am driven to show off this country's unbelievable theatrical talent to the public; and to be part of those theatrical events that show off the best of what we are in community.

The project's engine is fuelled by a core group of stellar theatre makers. To bring this vision to life Jennifer is joined by Marjorie Chan, Nina Gilmour, Derek Kwan, Eponine Lee, Courtenay Stevens, and Jeff Yung. At different work sessions special contributing artists are invited to influence the creative trajectory in terms of music, sound, and design.

During an early workshop, the whole writing team, including twelve-year-old Eponine, went to the Donna Child Fine Art gallery in Etobicoke in 2019. One of the collaborators in that workshop is blind and she recused herself from the outing, instead she offered a challenge to the group: "Go and when you return describe the paintings to me." Instead of merely describing the paintings they each wrote a short story based on the detail and movement in the works. Through that process, characters emerged along with story and action.

The next phase of the creation process is to build the physical world of the play. Designers of the set, lighting, and costumes will integrate the images and colours in Toller's paintings with the script. The goal is for audiences to enter a living, moving, diorama of Toller's paintings where a magical story unfolds around them.

"We are inspired and delighted to be working with Toller's spirit."

HARVEST KITE FLYER BY JENNIFER BREWIN

It was supposed to be fun. The Plunketts and the Baxters gathered for what was to become an annual event.

The Plunketts were a sombre lot. They were sombre even before the unexplained disappearance almost a year before of their workhorse Tinker, an ancient Clydesdale. Never ones to let a sad event go unmarked, the family dressed in black to let the world know they were in perpetual mourning. The Baxters, on the other hand, were a lively and optimistic bunch. Their green, red, and blue outdoor woollens reflected their determination to not let the approaching winter get them down.

The Baxters wanted to cheer up their sombre neighbours. A picnic was planned.

I had my doubts. I lived in the house between them and I would be hard pressed to say who was easier to live beside—the boisterous Baxters or the pensive Plunketts.

It was the end of the harvest season and snow was in the air. It got cold—so cold that the pond had frozen over even before there was any snow.

The possibility of the year's first skate made the Baxters even happier... so they thought it would be fun to add skating as well as kite flying to the festivities. They announced that they were testing a new winter sport that combined the two. Kite skating. The Plunketts weren't much for skating or kite flying, but they agreed.

The event started out well but then the skies changed colour ... a beautiful lavender mixed with shades of rose and even a hint of heather ... the wind was strange ... like the sky, it was otherworldly and fierce.

Sandy Baxter was heaving hard on the kite; other Baxters were dashing about trying to catch umbrellas and prevent indeterminate objects from rolling away. The Plunketts, abandoned by the Baxters, were spinning on the ice and crying out for help as they tumbled about. Marguerite Baxter saved a basket of dark red fruitcakes and for some reason was skating quickly away.

It was all very dramatic but no one was hurt and I had a good time. But, I wasn't surprised when the Plunketts blamed the Baxters for, quote, "a poorly planned celebration" and announced they would be attending no more annual community events.

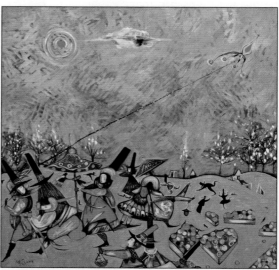

The Harvest Kite Flyer

A GHOST OF GLITTER
By Cesar Forero

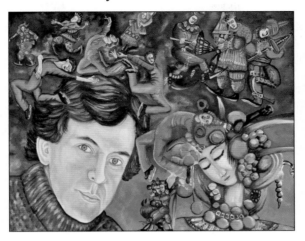

It was the time when playing soccer, baseball, or basketball on the streets of Bogota, Colombia was not enough for me. The colour television arrived, and with it, the Betamax. My parents would rent anything to try to keep us entertained and to deter us from too much "hanging out" on the street with our friends. One day, came a series of figure skating competitions and presentations which "blew my mind." The skaters moved as if they could fly. It was my discovery, my challenge, and I didn't know then, that it was to become my dream. One man stood out, or better yet, was the one who could fly above the limits of the sky. I don't think I could even learn how to pronounce his name, as we did not have those names in my country. The kids on my street were Fernando, Miguel, Mauricio, but Toller Cranston would have a bigger resonance on me. At that moment, an image of acrobatic elegance and a Ghost of Glitter were fixed forever in my head.

The renting of the videos was usually only for one day. But, if we rented several videos, we could keep them for more days. I used my lunch money again and again to always have my ghost's video. The video store owners saw me renting it so often

that one day they just gave it to me. Perhaps I had paid its price a few times and they felt sorry for me.

With no ice in Colombia, I became the kid on the street with the roller skates. Not having a single idea of the right technique, I still tried to do all kinds of jumps, or, at least try to move gracefully backwards and forwards. My father, who had been a talented soccer player, recognized my skills in sports and put me in soccer lessons. Luckily for me, nearby there was a rink on which people were starting to learn about figure skating and lessons were being given.

The Betamax later was replaced by VHS and then the DVD player, and with them, more videos were available. We had access to see the world champions and learn from the way they moved and executed the difficult jumps, spins, and magnificent lifts. There was something remarkable that had changed in the new videos—all the new figure skaters had become more graceful, more spectacular, as if my Ghost of Glitter had taught them all how to fly above the sky. I wanted to be like them, and I had to be part of the big sport

217

league. Perhaps one day, I could move as my Ghost of Glitter too.

In sports, everything moves very rapidly. The idols change quickly, but the iconic names are always remembered. I competed for more than seventeen years and enjoyed the thrill of winning and the exhilaration of representing my country. I felt the pride of having accomplished and completing my cycle to the best of my ability.

The political conditions in my country later became complicated and I had also become an adult. New challenges appeared and all of the sudden, I had found the relationship of my life. Now a couple, we made the decision to emigrate.

Canada became my adoptive home, but in such an immense place, it was very difficult to predict where to land. Destiny brought us to Kirkland Lake as if the path I was supposed to walk through was written from the beginning of my days.

A remarkable community opened their arms to host us, and then to embrace us. There was no need for a temporary shelter anymore. We had found our land and the creation of a new home took place and even a son came along. The day I gave my oath to become Canadian, I also understood from the speech given at the ceremony that as well as receiving my tranquility of a safe nation, it was my obligation to contribute to the people and the nation. Along with my dream of becoming an artist, I decided to run an exhibition called the Contemporary Art Exhibition (CAE), which would evolve into another important project in my life. A few years turned into a decade and the name of my Ghost of Glitter was always present in my surroundings.

Kirkland Lake, now my permanent home and strongly positioned in my heart, called me to be part of a remarkable project as the Centennial year was approaching. Toller Cranston was once again present. He had grown up in this town.

It was destiny that our paths should cross. As a remarkable artist, sportsman, and a legendary Canadian figure, we decided to bring back to our town the paintings, objects and design legacy of this unique being. Who knew? It was my responsibility to make this possible. My committee worked arduously to put together his retrospective, providing the opportunity to also showcase it in the neighbouring town's gallery to create a sister exhibition.

During the process and while advancing in the two-year project, I took the risk of making a portrait of my ghost. Studying his artwork, I could find embedded in movement and colour the energy that can be understood from someone that has been on skates day after day and year after year. In his picture space, everything seems to continue to be only a transition and a frozen moment. Most characters glitter in costumes that resemble the dance of life and the continued presence of being on the stage or on the ice-rink and in front of the judges. A colourful palette is enhanced by the strong brush strokes carrying thick chunks of paint. I see the gestures and marks on the ice from the skater in movement, performing a choreography translated onto the canvas. Strong and bulky images are balanced by the images and the gestures of the characters, which with their soft skin, carried somehow melancholic expressions. It is almost as if these characters were in the moment of a representation of dramatic music playing in the background for them as they performed for us. Elements that give the skaters the presence of an outdoor scene like hills, orbs, and blobs, appear on the composition as if the character was on a stage representing a scene with the presence of the sun replaced by a spotlight. In Toller's portrait paintings, animals appear as complementing the costumes, enhancing the composition. Discipline, commitment, and persistence are seen all over the place as if in a hurry to recreate for us the idea of a different universe.

I wonder at this moment, as Toller was able to

influence so many people as skater, creator, and artist, how far and how long will his legacy last. As for me, the kid from Bogota, Colombia, I can only say to my Ghost of Glitter, "Please do not skate too fast and too far from me, as we still have much to do."

TOLLERMANIA
Natalia Laluq

Natalia Laluq met Toller in 2011 when she was visiting San Miguel de Allende. Fascinated by his life story, she envisioned and produced *Tollermania*. Her unique interpretive work encompassed ceramics, incorporated painted images, and a stop-motion video that brought a skating performance of more than forty years ago, to life once again.

One and a half years in development, the project is a series of 452 handmade porcelain plates that are hand-painted in blue cobalt. It was presented as an installation as well as a stop-motion film.

At the opening of the *Tollermania* show in March 2014, the artist said:

> I have been a ceramics artist all my life. My intent with this project was to marry the facets of Toller's talent and glue his past and present in one art piece. My goal was to combine the oldest art medium, ceramics, with one of the newest, film. The result is Tollermania. When I first met Toller, I was overwhelmed with his creative energy. One may like or dislike his art, but one cannot ignore the presence of the Great Artist. I have been affected myself, and I chose to put this received energy into my project.

> I am sure that Toller painted himself in all his paintings. In my film, dedicated to Toller, I transformed his painting subjects into figures of him skating.

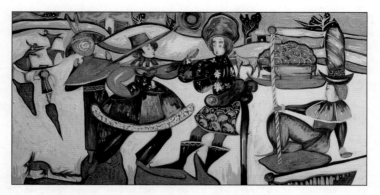

Toller's painting *Winter Market*, oil on canvas, 2008

The *Tollermania* Project is both a tribute and a farewell to hand-labour. I advocate for the importance of craftsmanship in our arts practices.

Ten months later, Natalia wrote...

Yesterday, Toller Cranston has died. The bright human is gone. There are not so many sparkling stars. Now we lost the one of the most lighted.

Pencil-on-paper sketch for the key frame, computer sketch drawing, and an actual porcelain plate. 2013.

TOLLER PORTRAIT
Charles Pachter

During the late 1970s and early 80s Charles Pachter often depicted his friends in casual and lighthearted scenarios, lounging, socializing, and at picnics. In this iconic print, a group of friends appear on a stylized/expressionistic landscape. The group of six individuals sitting on the ground depicts a picnic at the artist's farm in Oro-Medonte in 1978. There are two groups of three: left, Moses Znaimer, Toller Cranston, Ruby Bronstein; right, Marci Lipman, Lynn King, Venable Herndon. 250 serigraph prints were produced in 1980 from a transparency of the painting.

Six Figures In A Landscape, 1978

Portrait of Toller. Ink and Drybrush on Handmade Paper, 1979.

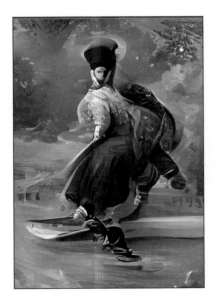

TRIBUTE TOLLER
Peter Rowe

Painter, filmmaker, and author Peter Rowe created this Tribute Toller using Artificial Intelligence software. "I gave the software as many instructions as I could and told it what painting style to use, and it came up with this tribute painting."

THE HEJIRA ALBUM COVER

Rolling Stone Magazine named *Hejira* Number 5 in top album covers of all time.

In November 1991, Rolling Stone magazine surveyed a panel of distinguished art directors, designers, photographers and editors for an admittedly highly subjective list of the 100 greatest album covers of all time.

1. *Never Mind The Bollocks... Here's The Sex Pistols* - The Sex Pistols
2. *Sticky Fingers* - The Rolling Stones
3. *Exile on Main Street* - The Rolling Stones
4. *Hotel California* - The Eagles
5. *Hejira* - Joni Mitchell

JONI MITCHEL HEJIRA

THE MAKING OF THE HEJIRA COVER
By Angela LaGreca, Rock Photo, June 1985

She found the word by accident, while thumbing through a dictionary. "I was looking for a word to describe running away from something honorably," says Joni, "*Hejira* comes from when Mohammed had to leave Mecca—it means leaving the dream, no blame."

…Joni had an idea: contact figure skater Toller Cranston, a bronze medallist whose dramatic, expressive style intrigued her, rent out a hockey arena and paint a highway down the middle of it, mist out the bleachers with sprayers, bring in a woman dressed up as a bride, and have Toller and the bride (Barbara Berezowski) do a series of romantic vignettes while Joni skated down the highway, "kind of gawky" on her *Hejira* followed by a limo driver weighed down with her "excess baggage."

"I was a painter first," says Joni Mitchell. "I trained as a commercial artist, as well as a fine artist. So when I began to record albums, I thought album art was a great way to keep both careers alive." *Hejira* may be her most haunting cover. "It represented the work pretty well. At that point my stock was up," Mitchell says. "They let me do all sorts of expensive things in terms of art. I think back now to an album like *Hissing of Summer Lawns*, when we did all this fancy embossing for the cover. Even Madonna couldn't get embossing these days."

In one of her concert videos, Joni Mitchell used a film background featuring Toller, during the song "Black Crow." The song featuring Toller runs from 42:45–50:03 in the video: https://www.youtube.com/watch?v=bLKb9Ms68ME&t=3633s

TOLLER CRANSTON: *Ice, Paint, Passion*

I PAGLIACCI TRIBUTE
By Corey Circelli

I began skating at the Cricket Club, Toller's long-time rink. My coach was Ellen Burka, Toller's long-time coach. In fact, Mrs. Burka used to call me "Little Toller." She would send me home with lists of his performances to watch, marvel at, and learn from. To say that Toller is an inspiration for me would be an understatement.

He was witty and flamboyant, both strong and soft, both masculine and feminine. But, more than anything, he was one hundred percent authentically himself. The way he performed, expressed, and emoted is still very much unmatched in the sport of figure skating. His way to quite literally paint the ice with his blades while embodying an all-encompassing story is the complete definition of performance art.

It is this spirit that I dream of honouring with my tribute program of Toller's legendary Pagliacci performance. The journey of creating this tribute is ever-evolving, as Toller's repertoire of movements could fill catalogues. But my choreographer David Miller and my coaches Brian Orser and Tracy Wilson and I approach it as the most exciting challenge. I try my hardest to pull from as many Toller sources as I can. I'm so excited to take on this challenge through my interpretation of Toller's skating and I can't wait to show it to the world. If I can capture a moment of that Toller magic even just once, it would mean the world to me knowing that I paid tribute to an idol.

Toller, I hope you're painting somewhere with a cup of strawberry tea and watching from above. This one is for you!

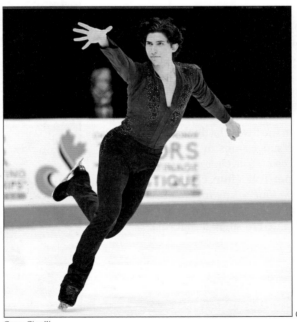

Corey Circelli

I AM A HOTEL, 1983 WITH LEONARD COHEN

Toller appeared in Leonard Cohen's film *I Am a Hotel* which has been described as "one of the more curious pieces in Leonard Cohen's illustrious catalogue." The film is essentially a long-form music video that was inspired by his song "The Guests."

The film tells the story, through music and dance, of the romantic yearnings of the hotel's staff and guests, with Cohen appearing throughout the film as the detached but sympathetic storyteller. *I Am a Hotel* was filmed at the King Edward Hotel in Toronto in 1983. The cast included Toller Cranston as *The Manager*, dancers/choreographers Robert Desrosiers and Anne Ditchburn as *The Bellhop* and *The Gypsy Wife*, and Celia Franca, founder of the National Ballet of Canada, as *The Diva*. The film was first broadcast in Canada in 1984, and went on to win a Golden Rose at the Montreux International Television Festival.

PORTRAITS NORTH OF 17 EXHIBITION
Sue Gamble

The Portraits North of 17 exhibition is a group show of paintings, prints and photographs by eight artists from across Northeastern Ontario that depicts the "characters" of Northern Ontario. Co-curators Bruce Cull and Dermot Wilson reached out to a select group of artists in the communities of Timmins, Kirkland Lake, the Tri-Towns and North Bay. I was one of the chosen artists.

I imagined Toller skating on the Swastika duck pond under the strawberry moon with the suggestions of motion and spins. I titled the piece Toller, *Come Float Over the Duck Pond*. The original inspiration was from Toller himself with his painting *Come Float Upon My Garden*. One of my lifelong friends had a reproduction of *Come Float Upon My Garden* in her apartment for years and years, so I wanted to suggest that title.

POEM
By David C. Brydges

Strawberry Journey Forever
(to Toller Cranston figure skater/artist)

"Doubtless God could have made a better berry,
but doubtless God never did."
(Dr. William Butler, 17th Century English Writer)

…Strawberry fields grew forever in your
obsessed imagination in the 1970s.
Became your signature symbol, appearing
in multiple paintings as heart shaped berry.
Giving Venus goddess of love a red living
room in your creation crazed art garden.
The strawberry associated with rose family,
only fruit having seeds on the outside….

…Your autobiography was titled, *When Hell
Freezes Over shall I Bring My Skates?*
Maybe paintbrushes and bag of strawberries too.
Always a dancer testing the waters of being
totally taller, a legend rising to new heights.
Fearlessly expressive, his flamboyance on and off
the ice earned accolades around the world.

STAMPS
By Olivia Montague

One of the tasks in my graphic design course at Sheridan College was to create a Canadian postage stamp. Some students chose topics like giant Canadian landmarks (Big Nickel), and Canadian plants, trees, and animals. My first thought was of multi-talented Canadian icon, Toller Cranston. I had been introduced to his work while interning at Donna Child Fine Art Gallery. I dedicated one stamp to his bold and colourful painting career, and one to his graceful and athletic years as a skater.
Little did I know—my instructor was a fan as well!

RECREO 75
By John and Sharon Garside

As neighbours of Toller's for eighteen years, we had always admired his gardens.
We were saddened by his sudden death, but happy we could purchase the
property and restore it to its original splendor. Restoration took two years and we carefully followed
the original footprint. We were even able to save some of Toller's artifacts. The finished project
captures Toller's sprit and even some of his art is now part of the house.

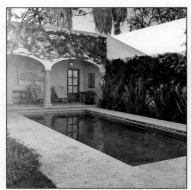 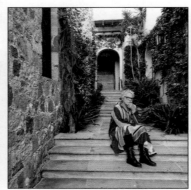

Phillippa thinking about how Alejandro didn't drown that day and about how the guys laughed as they lugged an 800lb. stone lion up these steps.

SUPPORT FOR ARTISTS
A FEW MEMORIES OF TOLLER
By Donna Parker

It took me a long time. At each chance meeting, I would lose my nerve. One day, however, we bumped into each other at the nursery and had a long chat. You had already turned to walk away when it happened…"Toller, I'd love you to see my work." You kept walking …. "Come for breakfast tomorrow, bring two pieces." Stunned, I managed to sputter, "What time?" Nine o'clock came the answer as you moved further away.

I arrived the next day dressed to the nines with two pieces of art, and my goddess book. As I walked into the dining area, he said "Now that's the way an artist should dress!" He looked at my work, purchased both pieces and invited me to paint with him for seven days. I jumped at the chance, my heart pounding, my demeanor cool and calm, although I felt I would surely faint. "When you come tomorrow, bring the pieces you have been working on." Over time, he became my mentor as well as my patron. As we worked together, he would wander by, make a suggestion, and keep walking. He never touched my work. I respected him for that.

MICHAEL HOPPÉ

Toller was hanging two of his paintings in our house during the morning on the day he died. Our friendship was initially based on my music, which he would play endlessly while he painted. Toller was the reason Monica and I moved here to San Miguel. We loved him greatly.

I recorded for Toller a memorial song I composed, sung by the Italian folk singer Giuditta called "Safe to Port."

Safe to Port

Thou hast come safe to port,
I still at sea,
The light is on thy head,
Darkness in me,
Pluck thou in Heaven's field,
Violet and rose,
While I strew flowers
That will thy vigil keep.

Thou hast come safe to port,
I still at sea,
The light is on thy head,
Darkness in me,
While I strew flowers
That will thy vigil keep,
Where thou dost sleep,
Love, in thy last repose.

Michael Hoppé

YOU FORGOT YOUR HAT
By Donna Parker

Alas!
So like you —
Suddenly, unexpectedly,
Shocking and shaking me
To the very core of my existence,
You left.
Not for a weekend
Or an extended getaway
Permanently!
Forever!
No warning
No goodbyes
No last words of wisdom
No kiss on the cheek -
You simply dropped dead!
Just. Like. That.

Suddenly, I was unable to breathe.
Where did my oxygen go?
Why was the world stuck in my throat?

You told me we had a sacred contract.
I agreed.
Was it really for only two years?
I didn't read the fine print.

I miss our conversations
About art, about spirit, about life.
The secrets we shared.
The plans we made.
I miss our energy
joined in the studio
painting, enjoying music, chatting,
dancing, laughing.

We loved each other
In the best possible way -
As friends - honouring
All the good bits
All the bad bits
All the in-between bits -

I know you are very close, for
We have spoken through
The oh so thin veil
A privilege I cherish.

I remember our first breakfast
In the old kitchen at the round table
Just the two of us.
You bought two of my paintings.
You invited me to paint with you in
Your studio.

At the door, while saying farewell...
You went back to the library
to get a book.
It was Paulo Coelho's, "The Alchemist"
I had read it years before.
"Read it, Donna. It will teach you
everything you need to know."
I walked away with the book in my hand
and instantly understood our relationship
was much more than earthly.

Just as suddenly as we had met
You were gone
quickly— quietly—forever.
You left with no fan fare
Like you might have left a party
When you were tired.
You strongly disliked goodbyes.

Knowing you has changed
me Toller. Forever.

Oh!...and Toller...
You Forgot Your Hat.

You Forgot Your Hat. Donna Parker, Oil on canvas.

CHAPTER 20

THE LEGACY AND THE LESSONS

TOLLER

What does *losing* mean? And what does *winning* mean? Twenty-five years ago, John Curry who was my great adversary did wonderfully to win the Olympics. I had lost and he had won. I was standing two inches below him on the podium and my life was *Now what do I do?* and his was *Now what can I do?* As Olympic champion, he had opportunities that a third-place finisher doesn't. John Curry died just a few years later.

So, who wins and who loses really? In the immediate picture if we win or lose is important… but it is only in time with age and experience that you understand that the loss was the right thing.

Maybe I was just one of those people that today can be used as a steppingstone. I don't know if I changed figure skating…but I was part of a narrative that was necessary in order to get to where we are today.[2]

After retiring from competitive figure skating, Toller moved to San Miguel de Allende, Mexico. For more than twenty-three years, he worked tirelessly to explore the limits of his own creativity, to inspire young athletes, and to mentor and support young artists.

Toller has always supported young talent. Artists. Athletes. Those with passion, commitment, a strong work ethic, a desire to reach for the stars. Toller's legacy is growing through initiatives that celebrate, honour, and memorialize the values by which he lived.

Tracy Wilson

The loss of the great Toller Cranston was shocking news. Going forward, we as a skating community can be inspired by his vision. He clearly saw the legacy he wanted to leave and took his career into his own hands. For him, it was about making a memorable and maximum impact and in so doing, moving an audience, bringing crowds to their feet and leaving an indelible mark on the sport. Toller once said, "I brought a hammer and a chisel, and I tried to wear away inhibition."

THE TOLLER CRANSTON AWARDS
Canadian Olympic Foundation and Skate Canada

In a unique collaboration, the Canadian Olympic Foundation and Skate Canada originated the Toller Awards in 2017. Named in honour of Toller, the awards recognize *courage, creativity,* and *expression* in young skaters in the Junior and Novice levels at Nationals. Olympic medallist, world-renowned for innovation and artistry, Toller brought freedom of expression to the sport of skating and became a legend.

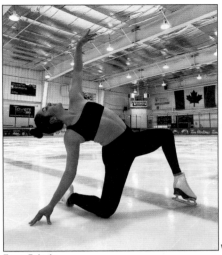
Emma Bulawka

AWARD INSPIRES RESILIENCE AND PATIENCE
By Emma Bulawka

Toller Cranston was an artist. The ice was his canvas. His blades were the brushes. His edges were the paint. His body was the masterpiece.

In 2018, I received the Toller Cranston Award. I am grateful and I will strive to honour and carry-on what Toller lived and breathed for in sport and life.

This award has inspired me in ways I never knew an award could. It taught me resilience and patience. It stretched my emotional and artistic limits on the ice. It has ignited a fire in me to demand more from within myself and to never settle for *ordinary*. After all, *ordinary* was the furthest word that could characterize Toller Cranston.

Every move came from deep within his soul. He skated with truth and raw emotion. He made each breath, step, move, split jump and extension, no matter how subtle, have a purpose behind it. He took us on a journey with him. He brought his art to life through his body.

He won medals. He won championships. But his relevance in sport ran much deeper than a piece of hardware hanging around his neck. He never failed to put on a show. His presence and resilience are qualities that I admire. He was not afraid to be himself, regardless of those who opposed. He was widely remembered, not for his technical acquisition, but for his unparalleled presence and passion, on and off the ice.

Since winning this award, I have continued to train and strive for new and bigger goals. Through the hard times, accident, injury, a disappointing result, I have learned so much about myself as an athlete and a person. I hope to use what I have learned for good to inspire myself and others with my story. We all have a story. We all have a purpose.

Though I was not alive during Toller's career, he has left a mark on me forever. He has inspired many other skaters and he will continue to do so for generations to come.

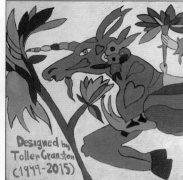
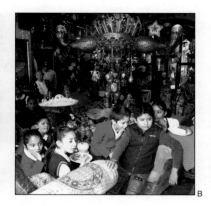

CHILDREN'S ART FOUNDATION
By Faith Fuller

The Mission of the Children's Art Foundation, a non-profit started by Hannah McCurley in 2010, is to help kids develop creativity through drawing and writing, to have fun, and to stay in school.

In 2013, Toller invited forty children from the Foundation's art class to come to his studio and paint ostrich eggs. As these children from the rancho Palo Colorado painted their eggs, they learned from the master to be brave with colour, fearless in imagination, and daring in design. After the painting session, they were invited to wander through the home and gardens, exploring the dream-like estate that was packed with incredible objects of art.

Hannah McCurley, founder of The Children's Art Foundation, said, "the children's eyes were popping very big seeing toy soldiers and millions of decorative objects. For all of them it was better than a trip to the moon and it was an experience they will remember for the rest of their lives.

The best support Toller gave me and the Foundation was the time he spent with the children—painting ostrich eggs in his studio and later painting a mural with them at the school across from La Fabrica Aurora."

Toller will be remembered by the people in San Miguel, especially the children. His extraordinary creativity, talents and generosity fuel the fire within that propels them to dream and reach for a different future for the better.

Hannah McCurley
These children who are now in their teens, will never, ever forget the experience of that amazing visit. Better than a trip to the moon. Thank you, Toller!

yo inc.

Toller Cranston understood his own skills, experiences, and attitudes and he used them to make a living and to make a life. *Yo Inc.* is a program that takes young people through an innovative process of thinking of themselves in new ways. Through this understanding, they identify and organize what they need to start a business, build a career, get a job, or manage a project. The interactive Program is grounded in the concept of inclusion and the belief in the talents and capacities of people.

Conditions in today's world are in constant change, and it's often hard to keep up. People are living longer, retiring earlier, and constantly seeking new ways to invent themselves. The Toller Cranston Foundation is committed to supporting and empowering young people and has partnered with business and non-profit organizations in San Miguel to deliver *Yo Inc.* in Toller's name. The unique program is adapted from *Smart Options* and *Ndrico Veten* created and owned by Baran & Baran.

THE BIBLIOTECA PÚBLICA, SAN MIGUEL DE ALLENDE

Toller's extensive personal library of books on art, architecture, design, and history was donated to the Biblioteca Pública where it has become a valuable permanent resource.

CANADA'S WALK OF FAME

Since 1998, Canada's Walk of Fame has promoted a national culture of excellence. *Our spirit. Our ideas. Our arts, culture and performance.* Canada's Walk of Fame represents the pinnacle of achievement in Canada. Toller got his star in 2003. It is on the south side of King St. West in Toronto, Canada.

CABBAGETOWN PEOPLE PROGRAM

Toller Cranston 1949 – 2015 Canadian Figure Skater and Artist Cabbagetown is one of the largest areas of beautifully preserved Victorian housing in North America. The enclave developed in Toronto from the mid 19th century. Over the years, many fascinating and remarkable people have called it home. The Cabbagetown People Program honours fifty of its most famous former residents. Toller Cranston's blue oval plaque is at #3 Metcalfe St.

N

GUADIANA PARK WALK OF FAME IN SAN MIGUEL DE ALLENDE

Guadiana Park in San Miguel de Allende is described in Tripadvisor as a "Nice little park. Appears to be popular with the locals." It also has a bit of a walk of fame with plaques set into the stone walkways that pay homage and tribute. Some dear friends of Toller—the Eytons, the Nicolls, and Haig Oundjian—sponsored a plaque for Toller that says *Toller, Friend, Artist and Olympian, 1949–2015*. Toller would be pleased that his plaque is smack in the centre of the nice little park right next to the fountain. Next to Toller, is a stone for *le Feiste Bacon*, a beloved dog, and next to that is one for *Sportbucket*, an African Grey parrot, and then there is *Cleopatra*, a cat. I do not think Toller would be at all unhappy to find himself in the centre of a memorial walkway for dogs and cats and a parrot in a nice little park in Guadiana.

AWARDS FOR OUTSTANDING PERFORMANCE
By Shepherd Clark, Founder, World Art

Figure skating is the world's most glamorous sport. It is dancing upon a crystal, the Jewelled Sport.

I see Toller Cranston at the very top of a short list of the legendary artists on the ice who combine global relevance, originality, and mastery. We have awarded Toller a place on the Crystal Stage for Outstanding Performance.

As one of our World Art legends, Toller deserves a special place in art history. His life was the stage upon which he truly chipped away at inhibition for himself and for many others. His desire as an artist was to sculpt a life that was not barred by inhibition or regret. Mr. Cranston's intellect and sense of humour provided the credibility necessary for his acceptance socially, that his message was not merely egocentric. He had a benevolent and relevant purpose for his life and artwork, which were truly one.

Toller's is a life that will never be lived again.

CARLETON HONORARY DOCTORATE CONVOCATION ADDRESS

Madam Vice-Chancellor: In recognition of outstanding contributions to international sport and Canadian cultural life. I request that you confer the degree of Doctor of Laws Honorus Causa on Toller Cranston.

"Years ago, I was sitting beside a former Olympic and World Champion from Russia. I was commentating at the time, and she said to me, "What does *fat* mean?" And I said, "Are you saying that I am *fat*?" And she said, *FAT*! And I realized it wasn't *fat* she was talking about, it was *fate*. And the difference between *fate* and *destiny* sort of harpooned me. I mention this because *fate* is an irrevocable state. It is unavoidable. But *destiny*, all of which you possess—is something which is quite flexible—there are circuitous routes of achieving one's destiny and I have spent my entire life chasing my destiny in the most unorthodox ways.

Now we move to the Olympic trials in 1968 in Vancouver. I was in fourth position, but only had a few points to climb up to make the Olympic team for Grenoble. I was the very last skater of the day...the last skater of the competition. For the first time, I was in good physical condition, and I skated very well. I mention this because it is pivotal to my career as a skater. I had a great standing ovation...when the marks came up and they were from 1st to 22nd. I had marks from first to last. Of course, I didn't understand what I had done wrong, and I became paralyzed with the shock of it. There was a kind of revolution that exploded in the audience and out from the audience came a woman who sort of pulled me under the stairs. She said, "They didn't know who you were and they didn't understand. You're ahead of your time and your time will come." I didn't know who she was and I just sort of nodded and cried. That woman was Ellen Burka. Ellen Burka, for any of you skating people, was one of the great coaches of the century. I moved into the basement of her house, stayed for twelve years and became a world champion.

That point is important because in seconds, your life can change. In seconds, lives can be altered. One must always continue to follow one's destiny.

My life as a skater and as a painter has been conspicuously creative. I have been privileged to have a creative life but it comes with a terrible price. Usually with destiny there is a price to be paid.

I wanted to speak to the graduates about things I have learned. Most important is to take the positive side of tragedy or failure. Failure is an important ingredient to one's life experience. One must always take the negative and turn it around.

Another very important thing learned in painting and in skating was how not to be afraid of things, and how to live one's life without inhibition. You have to say what you want to say, stand up for what you believe in, go after things, and never be afraid.

For me, this honorary degree is a validation of a very erratic unusual creative life and although I would never bend to establishment, I am grateful for the acknowledgement.

In closing, to all the graduates, I congratulate you. What you want to do is out there, if you are prepared to pay the price and embrace integrity."

CHAPTER 21

QUITE SIMPLY HUMAN

MY RIVAL. MY FRIEND.
By Haig Oundjian

Toller Montague Cranston. My arch-rival. A life of extremes, complexities, and colour. My closest friend in the world.

He would always say that his greatest fear was mediocrity—being nondescript, colourless, unmemorable. This translated into a life purpose.

He bore the name *Toller*. What? How do you portray the role or value of such a name? In German it means—*greater, brighter*. He loved performing—skating and the art of creative painting. Both gave him a license to individualism. In fact, both demand that!

So why are we surprised at the end result? He had huge creativity, courage of originality and he was never afraid of contravening tradition or testing the boundaries of convention.

Like all of us, he had the potential of multiple personalities, but all were driven by a common focus. He was willfully outrageous. He was bold in his choices in life. Bold in the colours and images in his paintings. If he had doubts, they were seldom revealed, except perhaps to a very few. He was selective and protective in his choice of private friendships, partners in life, companions.

Toller was lucky to have a friend like Haig.

He possessed the most acute sense of humour and a passion for knowledge. He was obsessed with reading. He was always the most amazing and generous host. Equally, he could sometimes be distant, indifferent, or even hurtful.

He loved humour, British banter, and often did battle with me in verbal intellectual jousting. His appetite for the ridiculous was founded in Monty Python.

With the (COF) Canadian Olympic Foundation Toller Cranston Memorial Fund, I am proud to keep alive his life message—*courage, expression,* and *creativity*.

TEA FOR TOLLER
By Beverley Smith

For a decade, Toller Cranston played the strawberry violin.

Picasso had his Blue Period. Cranston had his Strawberry Period. Cranston always subscribed to the maxim that, "If something is worth doing, it is worth overdoing."

In 1970, he walked into the home of a California coach and his psyche was ignited by her over the top, exuberant strawberry décor. He went home and painted *The Strawberry Queen*, which was followed in quick succession by *The Strawberry Patch, The Strawberry Tango, The Strawberry Sisters* and *The Strawberry Warrior*.

"Strawberries overwhelmed my paintings like juicy red barnacles on a ship's hull: clusters and clusters and clusters and more and more and more," he said in his autobiography *When Hell Freezes Over, Should I Bring My Skates?*

When serious art collectors began to think them trite, Cranston said he phased out the strawberry period, but sometimes, during a decorative work, "a strawberry pops out of nowhere and lands on the canvas." But not before Cranston's first television production of *Strawberry Ice*, a visual fantasy, a 1982 CBC production that won a string of awards and was broadcast in sixty-seven countries.

Out of the trunk of his coach Ellen Burka came an old video of that show, and that video begat Toller's *Strawberry Tea*, held at the Toronto Cricket, Skating and Curling Club a day before what would have been Cranston's 66th birthday on April 20, 2015. Cranston had died a few months earlier on January 23 of an apparent heart attack.

At the Cricket, the strawberries returned en masse.

There were chocolate-covered strawberries, strawberry cookies, strawberry scones, strawberry ice cream. Astra Burka, daughter of coach Ellen Burka, came dressed in red from head to toe. Red skirts, pink blouses, honoured the strawberry.

Best of all, was the star of the show, the costume that Frances Dafoe had designed for Sarah Kawahara, the Strawberry Queen in the film. While the video's colour had paled over the years, the costume had not. It stood resplendent at the front of the room, all intense pink petals of various shades, a work of art, indeed. Dafoe, herself, was at the party, seeing it again.

During the video, the crowd tittered when Osborne Colson gestured, as only he can on camera, wearing a costume that made him appear portly. Sandra Bezic arose from a clamshell. Peggy Fleming danced with the artist. Chita Rivera brought a sensual touch. Allan Schramm was the second lead, and seemed to be the force of evil, or the anti-artist that keeps returning like a bad penny, until Cranston throws him off his game, banishing him down a whirlpool into a black hole. That's when the strawberry court is free to come out.

Early in the story, a ghostly Toller floats out of his body and into a painting, taking a fantastical journey. Bodies float in this film. Is it any surprise that, in so many Cranston paintings, figures float above the earth, untied to convention, free of gravity and rules?

Downstairs at the Cricket, in a special display cabinet, was a figures medal that Cranston won during a Skate Canada International event. Yes, a figures medal. "His big problem was figures," said former international judge Jane Garden, who used to be Cranston's judge monitor, even

back from the time he trained in Montreal. "He had a rather free spirit toward what figures should be," said Garden, who said it was challenging but interesting to be his monitor. Garden discovered that Cranston executed the figures best when he laid them out on clean ice in front of a judge. So, every morning, she got into the habit of stopping by the club (she lived around the corner from the Cricket) on her way to school, and watched him do one figure. She'd look at it and continue on to her teaching job.

One morning, a CBC crew showed up to film Cranston. "They had somebody following him around the figure with a microphone to catch the sound of the blade," Garden said. "He laid out the best figure that morning that I'd seen in years. He rose to the occasion."

Shortly after that, Cranston won that figures medal. And when he returned to Toronto, he gave the medal to Garden, telling her that she was really the one who had earned it. Garden gave the medal to the club a couple of years ago, and during the tea, it was on display, an unusual trophy in Cranston's career. But Garden really came to the tea to talk about Cranston's "extremely generous nature." A tiny woman, she stood on a stool behind a massive podium to deliver her message.

When Cranston was on tour, he was always on the lookout for talented young skaters. When he found one, he'd let the Canadian Figure Skating Association know. He'd sometimes get them to perform on one of his tours or shows. He started up a bursary fund at the Cricket Club—and it was meant to help novice level skaters who needed encouragement. Garden was on that committee that made it happen. Cranston endowed it.

As interest rates fell, the endowment needed help. So, Cranston would donate items for silent auctions and the bursary has continued. "He said there were so many times along the way that he thought why was he pushing on, when nobody seemed to recognize his ability—which was partly because he was so off the wall," Garden said. "He said you need it when you're at that novice level. You need encouragement to keep at it and work. He said it doesn't have to be a huge amount, just enough that somebody cared enough to give you a couple of hundred dollars to help out."

He showed his generosity in other ways. During the 1970s, Cranston had opportunities to perform in Russia. He knew that Russian skaters had a hard time buying tights inside the country—after World War II, many European countries fielded skaters that showed up with darned and tattered tights. Coach Sheldon Galbraith, head coach at the Cricket, trained his skaters to take an extra pair with them—to help others.

Cranston would stuff his suitcase full of women's tights. And if he had to explain to Soviet customs why he brought so many, he'd tell them that he needed them "so his pants would ride smoothly as he performed, but that they didn't survive more than one performance. So, he needed many of them," Garden said.

He'd also fill his suitcase with fruits and nuts for coaches and officials and tell customs that they were his form of nutrition. In reality, he knew that people in Russia couldn't get the candied fruit they needed to bake Christmas cakes.

"He did all sorts of considerate things," Garden said. "Yet at the same time, he could be obnoxious, because he didn't do the thank-yous that people were expecting. But he did all these things that showed he really did care deeply about people."

Haig Oundjian, a former president of the British Ice Skating federation and a member of the British delegation that brought the Olympic Summer Games to London in 2012, was a skating colleague and long-time confidante of Cranston.

Oundjian was also a contemporary of John Curry, Cranston's greatest rival.

Oundjian also partook of strawberries and tea at the Cricket Club and noted how he worked to keep Cranston on the financial straight and narrow. "It wasn't that easy," he said. Cranston's typical retort in times of trouble was "Oh for god's sake, I'm an artist. What do you expect?"

But Oundjian also counselled Cranston on another of his great life regrets: that he hadn't won the Olympic gold medal in 1976. It ate away at him for years like rust on an old jalopy fender. Oundjian told of a wonderfully written 2014 book by British filmmaker/author Bill Jones called *Alone* a book about the tortured inner life of John Curry, Cranston's archrival—the one who had snatched Olympic glory from him.

"John was well behind Toller in the days of the old judging system," Oundjian said. "When you were behind, you stayed behind, correct?"

So, said Oundjian, Cranston had every reason to expect that he would remain ahead of the British skater, especially after a powerful skate at the 1974 world championships in Munich, Germany—when Curry had a disastrous performance. And, according to *Alone,* Italian-born coach Carlo Fassi was looking to bring a male skater to Colorado Springs, where he coached, in 1974.

To Cranston, Fassi said: "Toller, I have Dorothy Hamill here, as you know, I have all the facilities, and I want you to come on a full scholarship. I want you to come to Colorado and train with me and my wife and we will make you an Olympic gold medallist." He offered free lessons, free ice, even a car.

The book describes Fassi thus: "In a sport infected by politics, Fassi was a master politician; a professor of spin….Fassi prowled backstage tirelessly."

"Does that mean I have to leave Ellen Burka?" Cranston asked him.

"Yes," Fassi said. "You do. The offer is open right now. There's a ticket booked with your name on it. Come down."

Cranston didn't bite. He could not discard Burka so callously. "She's been a wonderful coach and a wonderful friend, given me great guidance and it's my feeling that between the two of us, I have as good a shot at the gold medal as anyone else," Cranston told Fassi.

According to Oundjian, who confirmed the facts with Cranston, Fassi was on the phone an hour later to Curry, offering him the same thing, an Olympic gold medal. "Within a day, John [Curry] was on a plane and Alison [Smith], his coach was dropped."

In later years, Cranston became very estranged from figure skating. "He really distanced himself," Oundjian said (although he still took enough of an interest to phone various Canadian coaches to give his advice on their protégés). "We had these long discussions at night when he said he was never appreciated, he was never understood and really. John came out of nowhere to win and "it was unfair."

Oundjian said he worked with Cranston to get him to come to terms with his skating career, and to "understand that in life, you don't always win everything. Actually, there is ultimately something that underlines your purpose in life."

Oundjian asked Cranston to describe himself. And because he refused to leave Burka in 1974, Cranston replied: "I'm a man who has values and I have substance and I couldn't do that to someone who has done so much to me."

The irony is, Curry died in 1994, penniless, and Cranston enjoyed a very productive artistic career.

Oundjian always tried to convince Cranston that becoming an Olympian is exceedingly difficult—some countries now don't get to send a representative at all and that in the Olympic movement, "medalist" is a key concept, rather than gold, silver, or bronze medalists.

Before Cranston died, Oundjian spent time with him in Mexico and believes the painter finally came to terms with his failure to win Olympic gold.

Cranston called Oundjian one morning in January before he died, and said, "Haig, I've had an epiphany."

"Another one?" said Oundjian.

"Yes," Cranston said. "Do you know who I am?"

"No," Oundjian said. "Why don't you tell me?"

Cranston said: "I'm an Olympian."

TOLLER

The number one rule in life is to know who you are and know where you fit. You spend your life, whether as an artist or as a human being, discovering who you are. And at the end of the road the successful person has achieved his full potential.[3]

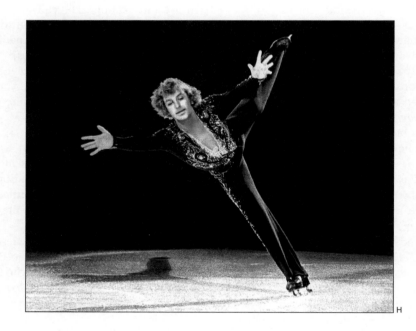

THE SKATING PAINTINGS

As my career in both skating and painting went up to an international level, I began to hate myself for doing one because I felt like I should be doing the other. I never seemed to have time to do either one well. It got so that every time I had to perform publicly, I would almost self-destruct. It drove me to a nervous breakdown. I couldn't face performing because I hadn't done my homework. I was always waiting for an inner-voice to tell me that this would be the last performance. The voice didn't come, and I kept going. Years went by. At some point, the knowledge passed through me that I had to give up the skating even though it was part of my DNA, part of my identity, part of my life, part of my personality. I had to give it up to go to the next level that was total dedication to art. I estranged myself from the skating world. I went cold turkey. I knew that to move on, I couldn't be dragging another world with me. I had to snip the umbilical skating cord. The punishment that I have to endure is that I revert to skating every night in my dreams. There was a time I actually thought God wanted me to make a comeback—but that was not the case.

What I have done is a series of skating paintings. It is not because I wished to paint about skating, and it's not because I was a skater. I am digging deep within my archival memory. I bring up images and feelings of movement and choreographic nuance and visuals that I might have seen. Anything that I can remember from the skating world I put into the canvas. It's a sort of exorcism—a way of getting it out of me. I am doing a series of skating paintings and it is helping to purge myself of the residue that is still there.[14]

A PROMISE FULFILLED
By Brenlee Carrington

Toller made me promise that when he died, I would write about him. I always cried at the thought of a world without him and he loved that I loved him so much that even contemplating his death made me tear up. When I was asked to contribute to this book, I felt compelled to say yes. I was fulfilling my commitment to Toller.

For almost thirty-nine years, Toller was my beloved friend, mentor, surrogate brother, and substitute father. My own beloved father had died when I was only eight. My admiration for Toller's genius was boundless and his belief in me meant more than words can ever say. Toller was always one of my greatest supporters just as I was one of his. We were kindred spirits. Toller's dedication in *When Hell Freezes Over, Should I Bring My Skates?* reads, "To Brenlee Carrington Trepel, a dear friend and a Canadian intellectual phenomenon."

Although we never lived in the same city, we spoke on the phone constantly. Toller and I enjoyed

a close and loyal friendship that lasted until what I didn't know would be our last telephone conversation on the morning of what turned out to be his last day. It was a cheerful and in-depth 30 minutes of our usual catching up first thing in the morning. Toller was making optimistic plans, with no sense from either of us that he would be gone later that night.

I remember when Toller was starring in *Ice* at Radio City Music Hall in 1983. I had to save up my hard-earned money but I flew to NYC to see him. His performance was pure genius and afterwards he took me for tea at the Palm Court in the Plaza Hotel before I returned to Winnipeg.

I remember meeting his mother who said that my red hair was a fiery crown. Over the years, Toller would paint my red hair along with my face in many of his paintings. Being Toller's muse was an honour I will cherish forever along with our friendship.

I remember that Toller loved that I became a human rights lawyer because Toller himself,

without ever even realizing it, was also a human rights advocate. He treated everyone with respect and dignity, regardless of who they were.

Being with Toller always meant intensely candid conversation, great laughs, magical memories and unforgettable adventures. Toller made the ordinary extraordinary and the extraordinary even more spectacular.

Over the years, Toller performed to many deeply moving songs including Engelbert Humperdinck's "Too Beautiful To Last," but the most memorable for me was when he skated to Donny Hathaway's version of Leon Russell's "A Song For You." This verse perfectly captured our friendship:

I love you in a place
Where there's no space or time
I love you for my life
You are a friend of mine
And when my life is over
Remember when we were together
We were alone and
I was singing this song for you.

A BRILLIANT SKATER, ARTIST AND FRIEND
By Duncan McLean

The reality is, Toller had already reinvented himself several times. From virtuoso world-champion skater, to caustic commentator to devoted coach—Toller had pushed the limits of a restrictive sport at every leap and turn. As a painter, Toller's work was like his artistry on ice. Graceful, sensual, provocative, at times dark, or exploding with colour and energy. Defying tradition and eschewing conformity Toller lived large. He craved attention and appreciation, but he also spoke the truth as he saw it—which often landed him on the wrong side of the establishment. He had a wicked sense of humour and could slay his critics

with a mere word or two. Toller was brilliant. He should be honoured as one of Canada's most remarkable creative forces for changing the Canadian landscape in so many ways. Toller was a friend. He was generous, he was fun, he was both a social animal and a solitary man, a mercurial temperament who would disappear for months and then return with bravado.

Toller will be missed. By me, by those who had the chance to enter his magical life, and everyone touched by his creative legacy.

TOLLER CHANGED MY WORLD
By Shelley Walters Dalley

My world changed at the age of seventeen when I started training at the Cricket Club in Toronto with Ellen Burka. A unique soul would change the artistry in my skating, open my eyes to looking at the world through rose-coloured glasses, and colouring outside the box! Toller was that soul.

Welcoming me to the club took weeks, as Toller was cautious and watched me as intently as a lion eyeing its prey. When it was his turn to skate his program, I stepped off the ice and gave him the respect he deserved. Next up was me! He skated close to my starting pose, almost toying with me. I looked at him and turned my head, held it up high, as if to say, now it's my turn! Toller liked people with backbone. From that day on a new friendship began. I would walk with him to Ellen's house, after long hours of skating, have a bite to eat and then sit quietly as he would paint.

My husband, Richard Dalley, Olympian and U.S. Hall of Fame inductee, knew Toller when they were doing shows on the international tour. Life with Toller was never boring, always an adventure, sometimes of shock value and other times just pure artistry at its best. In South Africa, Richard was Toller's golf partner. I don't think Toller ever held a golf club in his life! Because of the wildlife and the snakes in the region, it was mandatory to have a caddie. Toller would purposely hit the golf balls down the ravines to watch the caddies try to retrieve the golf balls amidst a den of snakes and other creatures.

Ironically, Toller would be the matchmaker that brought me and my husband Richard together. When Toller met my first husband, he instantly did not like him. He asked me, "what on earth are you doing with that rock? He's weighing you down. He is boring." Toller was never one to mince words. He either really liked you, or not at all. He didn't have time or patience for the in-between. Toller was correct, the rock is long gone and it has been twenty-nine years of marriage, thanks to Toller.

FROM A BOX OF UNSORTED SNAPSHOTS
By Sandra Bezic

Our relationship was complicated at times. But, like family, we had an unspoken bond that lasted a lifetime. I first met Toller one summer in Lake Placid, when I was about eleven years old. My mother had felt compassion for this extraordinary young skater with an unusual name, who was living in someone's garage and appeared to be struggling. He had put on display in the 1932 Olympic rink lobby, a collection of small, brooding, black ink sketches that he was hoping to sell. When my mother saw these, she shared her thoughts with my father and despite not being very wealthy themselves, my parents decided to commission a painting. I'm pretty sure this was his first real sale.

We became friends a few years later when Toller moved to Toronto to train with our coach, Ellen Burka. We won our first national titles the same year, and continued on in tandem—five more for him, and four more for my brother, Val, and me. Mrs. Burka gave Toller structure and taught him discipline, and we all watched in awe as his genius thrived. His drive pushed us all. Those days and

years training at the Cricket Club were filled with his larger-than-life drama and passion. Dodging Toller's lack of spatial awareness on the ice, and his flying free leg, became a honed skill. I know a few survivors will chuckle at that thought.

Together, we travelled the world competing and performing exhibitions. On free days, Toller would grab my arm and we'd walk each city for hours. He took me to as many art galleries as we could fit in, and we'd meander through backstreets discovering treasures in antique shops which, of course, he'd snap up. What a powerful education for a young girl. Of all the experiences we shared, these are still my most vivid.

Like a box of unsorted snapshots, I have flashes of so many memories from every stage of our lives. Toller holding court, telling tales with his legendary humour. Hilarious and fantastical stories further embellished for every new audience. The sound of

his laughter. His self-deprecating awareness of his insatiable need to be the centre of attention. His paint-stained fingernails, and how soft his hands were from all the oil. The evolution of his art from sombre and black to an explosion of colour that mirrored his growing confidence and awakening expression on the ice. Witnessing over and over his power to cause audiences to weep, and leap to their feet. He was a misfit, and a bohemian, and yet surprisingly traditional. He always paid for our coffee or dinner. One day, he cornered me to grill me about my parenting philosophy. He wanted to make sure that my son was receiving a rigorous, classical education.

It was Christmas, and I was sitting beside my mother who was unaware and in her final days. I felt the urge to text our dear friend, Shelley MacLeod, who happened to be sitting next to Toller in Mexico. I'm grateful for our last heartfelt exchange. It was just a few weeks before he left us too. I hope I told him I still have that painting.

THE IRONY, THE IMPACT, AND THE LESSONS
By Brian Orser

It certainly was ironic that in 2015 Toller passed and the announcement was made during the men's freeskate at Nationals. Even more ironic was that the champion was Nam Nguyen, my student. For me, it was a special moment to have my first Senior Men's national champion as a coach, and at the same time the emotional roller coaster of hearing of Toller's sudden death.

Toller always had an impact on my life as a skater. I was young enough that Toller helped mold the athlete I became, the artist I could only dream of, and the generous human being he was. Yes, generous! LOL. Many people didn't see the generous side of Toller as it was normally draped

in flamboyancy and flair. I watched Toller and wanted to become the star he was. I wanted to be the athlete he was and to have an impact in my own way. I truly believe he admired my skating and for many years, I had the privilege to work alongside him on various tours and exhibitions. I remember on my first tour Toller asked me if I had any plans for my new-found wealth of income from earnings—and before I could utter any financial plan I had in mind, he said "SPEND! SPEND! SPEND!" Then followed with his big laugh.

The stories of Toller on the road are too many to put in one chapter, but I can say that I hung onto

every word he said. There was always a lesson in history, geography, and English literature. He also said, "Never let the truth get in the way of a good story" Anyone who knew Toller is now having a good chuckle. True or not, the stories were captivating and highly entertaining.

The best part is that to this day, he is talked about with joy and a memory that we are all so grateful to have known him.

A

HE HATED GOODBYES
By Edythe Anstey Hanen

Though Toller lived in the wonderland he created, he was painfully human. Despite his successes, his flamboyant reputation, his look-at-me posturing—the face that he presented to the world—he was so very vulnerable. At close range, that shadow was always there and visible to anyone who was paying attention. He would not want to be remembered in that way, but he also would not have denied its truth.

There are hundreds of Toller stories. We all somehow found our way into Toller's world and we all have our stories. It seems impossible that we now must find a way to say goodbye. His death is exactly the kind of event that Toller would insist on being discussed at length around the breakfast table.

There is also something crazily appropriate about his sudden and unexpected death. Leaving his own party, before anyone knew he was gone, was what Toller did. He hated goodbyes.

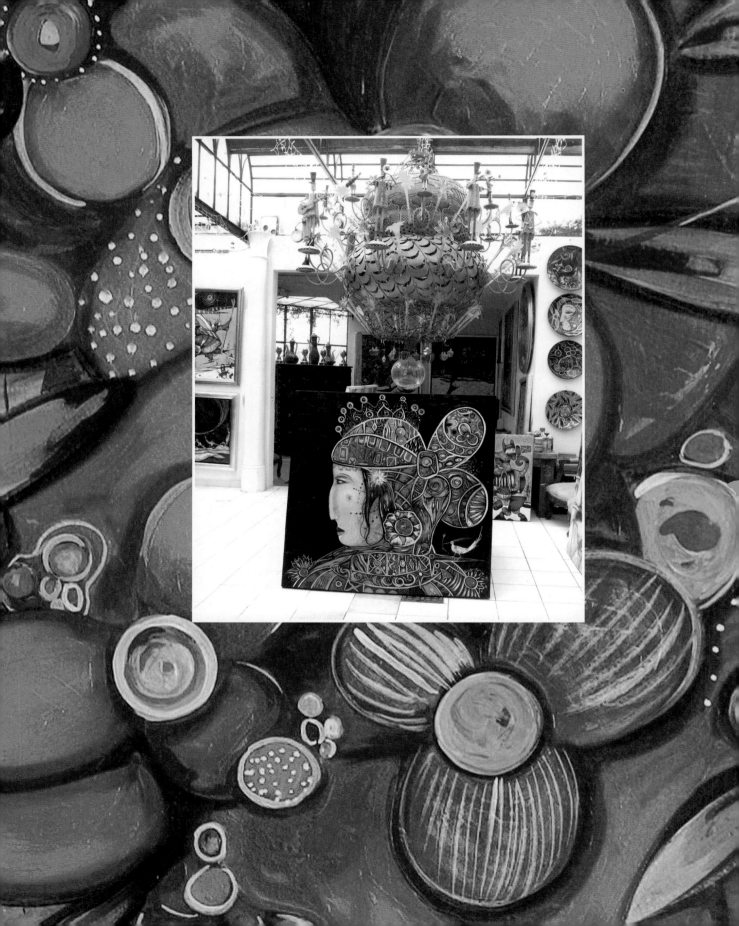

CHAPTER 22

BE CREATIVE NOW

By Phillippa

In an interview in 2014, barely a year before he died, Toller said: "I can't stand saying that I'm sixty-four…it is most embarrassing. When people say something about the Olympics in 1976…that's like forty years ago…OMG how could it have all gone so quickly?"[6]

He was only sixty-five when he died on January 23, 2015. Of course one wonders why? Why so young? Maybe it was because he had packed the accomplishments of many lifetimes into sixty-five years. Maybe it was because he never looked after himself, didn't tend to any worrying signs, symptoms and twinges…lived on jellybeans and cake and oceans of black coffee…and worked like a maniac. Maybe it was because…just because.

It has, however, occurred to me that had my brother lived another twenty or so years, which would have been a reasonable expectation given that he was an athlete who lived at altitude, walked everywhere, never smoked, and didn't drink much—if he had lived another twenty years, I would be dead. Not only would I be long gone, but so would Toller's cohort of fellow competitors, colleagues, collectors, friends, and admirers—all the skaters, artists, influencers, gallerists, leaders, and media personalities—all those with the experience, perspective, and credentials to reflect on Toller, to come together on this journey that celebrates and honours an important Canadian and a remarkable human being.

Perhaps after all, there was some luck and some purpose in the timing. I like to think so. I like to think there is karma.

My mother, our mother, Stuart, drilled into us at a very young age that anyone, everyone was replaceable. No one was indispensable.

But in the case of Toller, I am not so sure.

In January 2015, Skate Canada wrote: "There will only ever be one Toller. What most people will remember was the way he took hold of a crowd the moment he skated onto the ice. Even when he didn't win, Mr. Cranston was the source of conversation. Typically, it would revolve around what he did and how he did it—the flair of it all. On the Saturday evening, after the men's freeskate in Kingston, Ontario there was a moment of silence to honour the death of a showman. His likes we may never see again.

Mr. Cranston was 65."

TOLLER

Now I think, OMG I am so lucky that I didn't come *fourth*. Being on the podium in *third* is so much better than being off the podium in *fourth*. But, at that last competition, my personal goal was to win and everyone expected me to win. So, when I didn't, it was a very terrible thing.

But, there is always positive to be learned from the negative. I think God did not want me to win and God put me on the podium third. As it turned out, it was the perfect place for me because I spent the next many, many years trying to prove that I was deserving of more than the bronze medal. It became a catalyst. It was the *raison d'etre* to be better than I was.

For many others, their lives climaxed with a gold medal and then spiraled down to very unspectacular ends. Mine was the exact opposite. Mine spiraled up.[14]

Toller lived by these rules:

- You can't ever fake it.
- Always give the best you can.
- Strive to make a life that has impact.
- Watch for the signs.
- Accept the struggle.
- Embrace failure as your friend.

- Speak out. Stand up.
- Never be afraid.
- Live without inhibitions.
- Discover where you fit.
- Chase your destiny. There are many ways to get there.

BE CREATIVE NOW
By Edythe Anstey Hanen

His advice to my daughter was something she has never forgotten:
Be creative now.

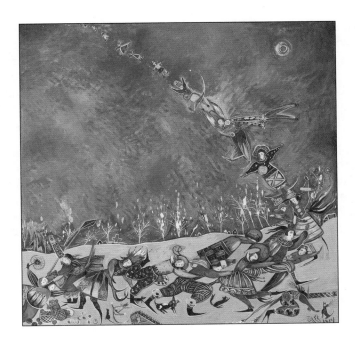

WE ALL FLOAT AWAY SOME DAY
By Donna Parker

Toller was one of the best friends I had in San Miguel. I'm sure many people feel the same. He had the magical knack of giving a person exactly what they needed and in return, he had a gift for extracting what he required from them. It was a mutual admiration society.

Toller was my dear friend, mentor, confidant—my inspiration, my encouragement, my oak tree, my painting companion. We painted together for two years. He wanted me there because, and I quote, "I don't have to teach you. You know what you're doing ... and you don't bug me." We had a strong spiritual connection which I shall miss terribly. He was very psychic as am I. He felt my abilities were underdeveloped and he once told me, "You are a little demi-witch who needs more practice!" I roared with laughter.

Never to be forgotten, larger-than-life, multi-faceted, gifted, eccentric, clever, moody, Toller knew exactly who he was and lived every minute to the fullest. Never afraid to admit his pitfalls, or purport his genius, he had experienced it all. The good. The way over-the-top. The bad. And the very, very ugly.

He was enthusiastic about the new blue/green palette he was working with. He wanted a challenge—something where his beloved red was banned from the canvas. I watched him work and I loved the new series. There was an undercurrent to his painting. Like he knew time was running out. His painting *We All Float Away One Day*, made me wonder. *The Ship* made me wonder. The day *We All Float Away One Day* sold, I cried. I wasn't sure where the tears came from or why, but there they were. They promoted him to march me upstairs for one of our chats. At some deep level, I think he was aware time was of the essence.

One of the most difficult things I have ever had to

do in this lifetime was say goodbye to Toller. We had a strong spiritual bond. I miss that terribly. We shall see each other again one day. *Toller, have your paint brush ready!* In the meantime, I will be hearing your voice as I paint. I will be listening to the music we enjoyed in the studio. I will see you entering the studio with paint on your pants and your arms, carrying a "little something" for me from the Tuesday market. I will always envision you showing off your new purchases—twirling like a model while I laughed and told you (in my best British accent) how amazing you looked. I was assured of laughter from you, which always thrilled me. Every time I shop in Dolores, I shall remember our trips and wonder if the economy is crumbling without your frequent visits.

Every life Toller touched has their very own version. Each and every one of us are blessed to have known him. I don't think many people actually know how much Toller gave back to the world with absolutely no fanfare. Just gave and moved on. A more generous man I have not met in a very long time.

Then, as suddenly as our relationship began, it was over. You were gone. No goodbyes. No fuss. Just quickly and quietly left this world like you might have left a party. I turned to speak to you. Your chair stood empty. The fragility of life suddenly unnerved me. I shall miss you forever and a day.

TOLLER

Against all odds I persevered…where some skaters evaporate…I lived along for another twenty years. I had to accept the fact that I was an artist that happened to skate… [2]

Toller, you really pulled it off.
Emery Leger

TOLLER CRANSTON: *Ice, Paint, Passion*

Toller Cranston
1949-2015

"He is his own work of art."

The Globe and Mail, 2003

ACKNOWLEDGEMENTS

To Robert, my graphic designer for more than twenty-five years who has an uncanny
ability to understand what this book needed, and the creative genius to breathe life
and beauty into every detail.

To Sam, my editor, who has been tactful, helpful, constructive, patient, and enthusiastic.
I shall never again light a candle without shrieking with laughter and wondering if we
made the right call on the thorny question of *candelabra* or *candelabras*.

To Ken Whyte, my publisher, who made the commitment to
share this journey. I am grateful.

To Donna Child and Christopher Talbot, the gallerists, for their unwavering support
of Toller and their capacity to stay committed through the last long years
of seemingly endless challenges.

To the contributors who stepped up, opened their hearts, and went beyond—
especially Pj Kwong, Haig Oundjian, Debbi Wilkes, and Jeanne Beker
with whom it all began.

To Susan Page, whose wisdom, experience, and advice have provided
light and direction.

To Ben, for the same reasons, and for reminding me to just get to the point.

To Lander Rodriguez and Scott Umstattd and all the photographers,
who never said no.

To Jim Armstrong, Dan Baran, and Leigh Carter, the eagle-eyed proofreaders who
challenged every ellipsis, corrected misplaced commas, and made the
manuscript stronger, cleaner, and much more consistent.

To the team at Sutherland House
Shalomi, Serina, Sarah, Leah and Jordan.

To the skaters, artists, and children who inspired Toller.

To the staff at Casa Toller who saved his life every day.

To Pedro who saved mine.

To the friends and fans who always knew that Toller was special—
as an athlete, an artist, a colleague, a patron, a friend.

To June and Tony Eyton, who believe as I do, that Toller should have an arena
named in his honour, should have streets bearing his name, and should be
included in the history books as a noteworthy Canadian.

To all my women friends who are brave and strong and amazing and for
whom quitting is never an option. Thanks to Mimi, Chipper, Donna,
Linda, Marge, Chris, Nancy, Barbara, Anne, and especially Janet.

And to Dan and Dundee,
your unconditional support means the world to me.

CONTRIBUTORS AND SOURCES

This book is filled with powerful images and lively accounts from those who knew Toller, saw him perform, or were part of his world of art. Whether it's an image, a single sentence, or a newly composed passage, we thank each of the contributors who have shared their work, their thoughts, and their experiences. In the highlights that follow, you'll discover more about the contributors, photographers, and sources cited for this project.

IN MEMORIAM

Alex Trebek
Anado McLauchlin
Barbara Sears
Benjamin Wright
Boris Spremo
David Street
Ed Flume

Ellen Burka
Gary Slipper
Leonard Cohen
Ludmilla Protopopov
Maria Antonia Muñoz Santana
Mayer Shacter
RM Vaughn
Ruth Ann Whipp

CONTRIBUTORS AND SOURCES

Adrian Rangel
Adriana Benediktson
Alex Trebek
Anado McLauchlin
Anita Bleyleben
Anita Dhanjal
Anne Philpot
Antonio Sanchez
Art and Leona DeFehr
Arturo Lopez
Dr. Arun Kumar
Astra Burka
Barbara Berezowski
Barbara Lamb
Barbara Sears
Benjamin Wright
Beverley Smith
Blanca Uzeta O'Leary
Bonnie Eccles
Boris Spremo
Brenlee Carrington Trepel
Brian Orser
Casey Trudeau
Catherine M. Whelton
Cesar Forero
Charles Pachter
Chita Rivera
Chipper Roth
Christine (Chris) Coulton-Varney
Christine Walter (Robbins)
Christopher George
Christopher Talbot
Clive Caldwell

Corey Circelli
Cst. Dave Stewart
Cylla Von Tiedemann
Danielle Earl
David Benjamin Tomlinson
David C. Brydges
David Dunkley
David Street
Dawnette Brady
Deb Usher
Debbi Wilkes
Deirdre Kelly
Dick Button
Dick Loek
Diego Fernando Gomez Espinoza
Don Jackson
Donna Child
Donna Meyer
Donna Parker
Dorothy Leamen
Duncan McLean
Edythe Anstey Hanen
Elaine George
Elladj Baldé
Ellen Burka
Emery Leger
Emma Bulawka
Eric Nemer
Faith Fuller
Felix Gomez Morales & Gloria Espinoza
Briseño
Gary Reid
Gary Slipper

German Llamas
Glenda Scott
Grant Noroyan
Graciela
Greg Ladret
Haig Oundjian
Hannah McCurley
Hazel (Pike) Boskill
Hugo Sanchez
Jaki Fuerte Chan
Janet Dunnett
Jay Koppelman
Jeanie Gooden
Jeanne Beker
Jeannie Yagminas
Jennifer Brewin
Joann Hetherington
John and Sharon Garside
John Rait
John Lennard
Joni Mitchell
Jorge Pena
Joy Levine
Joyce Hisey
Julian Mendl
June Eyton
Karen Abbey
Karen Courtland Kelly
Karim Remtulla
Keith Walker
Kenn Jorgensen
Kim Manley Ort
Kimberly Kmit

Kris Nahrgang
Kurt Browning
Kym McKay
Lander Rodriguez
Laverne Remigi
Leonard Cohen
Leo Oppenheim
Linda Hampton
Lisa Biglin
Louise Vacca Dawe
Margaret Failoni
Margaret Paul
Mario Alvarado
Martha Lowder Kimball
Mary Ellen McDonald
Mayer Shacter
Melissa La Porte
Michael Hoppé
Mike Flynn
Monica Campbell Hoppé

Monica Friedlander
Nadim Kara
Natalia Laluq
Nataliya Shpolianski
Niki Barbery-Bleyleben
Oleg and Ludmila Protopopov
Olivia Montague
Paul F. Kowdrysh
Paul Zizka
Peter Rowe
Pj Kwong
Richard Lander
RM Vaughn
Rob Leon
Rodney Groulx
Ron Base
Ruth Ann Whipp
Ryan Stevens
Sally Rehorick
Sam Perez

Sandra Bezic
Sandra Garrett
Sarah Kawahara
Scott Umstattd
Dr. Sepp Schönmetzler
Shelley MacLeod
Shelley Walters Dalley & Richard Dalley
Shepherd Clark
Silvia Katharina Grohs
Sky Gilbert
Stephan Benediktson
Sue Gamble
Susan Page
Suzanne Wheeler Ally
Tony Eyton
Tony Scupham-Bilton
Tracy Wilson
Veronica Tennant
Zdeněk Pazdírek
Zsuzsi Pauli-Almassy

CONTRIBUTOR BIOS

Adrian Rangel worked for, cared for, and solved problems for Toller for more than 15 years.

Adriana Benediktson, artist and interior decorator, is a Canadian with Dutch and Colombian roots. Over many years, Adriana and her husband Stephan enjoyed a deep friendship with Toller and shared mutual interests in shopping, entertaining, and good conversation.

Alex Trebek won six Daytime Emmy awards, holds a Guinness World record for hosting Most Game Show Episodes (8,000 episodes of Jeopardy!) and received a 2011 Peabody Award for "encouraging, celebrating and rewarding knowledge." He worked with Toller on *Stars on Ice* 1976–80.

Anado McLauchlin is an Assemblage/Mosaic Artist who, along with his husband Richard and trusted assistant Carlos, created the Casa de Las Ranas Compound which includes The Chapel of Jimmy Ray Gallery. People from every corner of the world flock to the *campo* in the desert highlands of Mexico to view the extraordinary installation.

Anita Bleyleben is an Austro-German author and underwater film-maker who moved to San Miguel de Allende with her husband and son in 1978. The former Miss Bavaria and Toller were very close friends and seized every opportunity to be together to build towers of ice-cream, paint ostrich eggs, and zip around town to find hidden treasures among the craft workshops.

Anita Dhanjal is an artist who creates surrealist and abstract paintings that speak about beauty, colours, meaning, life—what is here today, gone tomorrow, and was there yesterday.

Anne Philpot spent 35 years working in developing countries and 20 years fundraising for numerous charities. She helped plan Toller's 2015 celebration of life and extensively photographed the property.

Arturo Lopez is the funeral director from Inhumaciones Lopez, a family-owned San Miguel business since 1945. Arturo's knowledge and experience made the first very difficult days manageable.

Dr. Arun Kumar, from Dehra Dun, India is an inspirational and devoted medical doctor, a proud philanthropist, and a worthy opponent for Toller's proclivity for verbal gymnastics.

Antonio Sanchez is a brilliant artisan and frame maker, a Kung-Fu Master, and a very good and very decent man.

Art and Leona DeFehr. At the age of 5, Art was sweeping floors in the small family-owned furniture factory in Winnipeg. In the years after a Harvard MBA, he grew Palliser Furniture into a leading international manufacturer with more than 2,000 employees in Canada, Mexico and Indonesia. The DeFehrs work with equity-based organizations like Habitat for Humanity, The Carter Center, Cooperative Coffees, Cafe Campesino, Mayan Families, fulfills another important part of their life; to make the world a better place by bringing attention to underserved communities. Art is a prolific and respected writer, a member of the Order of Manitoba, and an Officer of the Order of Canada.

Astra Burka is an architect, author, filmmaker and the daughter of Toller's legendary long-time coach, Ellen Burka. Astra directed and co-produced a documentary about her mother called *Skate to Survive*. She is the creative producer behind *Boots & Blades: The Story of Canadian Figure Skating*, the digital skating exhibition at the Bata Shoe Museum.

Barbara Berezowski and partner David Porter were twice Canadian Ice Dance champions, five-time members of Canada's world team, Olympians and World Professional Ice Dance Champions. They starred in Toller Cranston's *Ice Show*. Barbara was Miss Toronto, a Miss Canada Finalist, and was voted by journalists as Miss Moscow, Miss Charm on Ice in Germany, and Miss Olympia at the Innsbruck 1976 Olympic Winter Games.

Barbara Lamb has worked in 45 countries on international development initiatives focused on community development. She is a writer, a bridge player, and a Lego enthusiast. She published her first novel, *Peril*, in 2021. Toller was a childhood friend.

Barbara Sears called herself an "editorial and visual researcher." Her contribution to Canadian history is evident in her work on dozens of books (with journalist and historian Pierre Berton, ballet dancer Frank Augustyn, and comedian Dave Broadfoot) as well as documentaries created by some of Canada's best producers and directors. Her other interests included ballet, figure skating, movies, and horse racing. She wrote about Toller for *Maclean's* magazine.

Benjamin Wright has been described as "a lion in the sport of figure skating." For more than seven decades, he served as a referee or judge at six Olympic Winter Games, 23 World Championships and 25 Nationals. He was the President of the United States Figure Skating Association and is in the United States Figure Skating Hall of Fame. He passed away in 2019 at the age of 97.

Beverley Smith is an award-winning journalist and author of four best-selling figure skating books. A reporter for The Globe and Mail for 35 years, she is best-known for uncovering judging scandals in the sport, years before the infamous dealings at the Salt Lake 2002 Olympic Winter Games. She has covered seven Olympic Games.

Blanca Uzeta O'Leary is a lawyer, former Member-At-Large of the U.S. Democratic National Committee appointed by President Obama, an activist and campaigner working to get Democrats elected at all levels of national and Colorado state government. She has served on the Board of various organizations devoted to youth, arts, education and Latino community issues and she was a key member of Toller's A-list inner circle.

Bonnie Eccles is a friend, retired teacher, travel agent and an admirer and supporter of Toller Cranston and his legacy.

Boris Spremo is Canada's most renowned news photographer of his generation. Over the course of a 38-year photojournalism career that took him to every corner of the world, he won more than 300 regional, national, and international awards, became a member of the Order of Canada and the Canadian News Hall of Fame, and was given a Key to the City of Toronto. His autobiography, *Boris Spremo*, captures an astonishing array of moments in history, politics, sport and celebrity in addition to chronicling a life of struggle, resilience and success.

Brenlee Carrington Trepel, K.C. was appointed King's Counsel. She was recognized by the national Women's Legal Education and Action Fund (LEAF) for advancing women's equality, won the Manitoba Bar Association's Equality Award, Community Involvement Award, Law Society of Manitoba's Montague Israels Q.C. Prize, and Volunteer Manitoba William Norrie arts and culture award. She is a former talk show host, broadcaster, and journalist who interviewed everyone from Toller to Mother Teresa to Muhammad Ali.

Brian Orser is a Canadian former competitive and professional figure skater. He is a double Olympic silver medallist, World champion, and eight-time Canadian national champion. As a professional, he skated with *Stars on Ice* for almost 20 years. He has coached multiple skaters to Olympic and World titles. He is a Member of the Order of Canada, won an Emmy Award for *Carmen on Ice* and has been elected to the Canadian Sports Hall of Fame and the Canadian Olympic Hall of Fame.

Cesar Forero born in Colombia, welcomed by Canada, is an artist in every fibre of his being—a painter, sculptor, dancer, ceramic artist, former world skating champion and now an artistic force in northern Ontario teaching, mentoring, inspiring, creating and organizing. Cesar and his partner Tony have brought colour and rhythm to the beating heart of Kirkland Lake and all across Northern Ontario.

Charles Pachter is a painter, printmaker, sculptor, designer, historian, lecturer and one of Canada's leading contemporary artists. His iconic pop images of the queen, moose, and maple leaf flag celebrate Canada's cultural heritage with wit and whimsy. He holds four honorary doctorates and is an Officer of the Order of Canada. His work has been exhibited at the Art Gallery of Ontario, the Royal Ontario Museum, and the McMichael Gallery.

Chipper Roth is a long-term resident of San Miguel, and as a teenager in 1963, lived in the property that became Toller's. A former acupuncturist, Iyengar yoga teacher, and adventure travel outfitter mountain guide, she now runs a guesthouse during the winters and spends summers in British Columbia. She was a friend of Toller's during his final years, and misses him greatly.

Chita Rivera is a legendary actress, singer, and dancer who has been nominated for the prestigious Tony Awards 5 times and won twice for Best Leading Actress in a Musical. Most recently, she appeared on Broadway in Kander and Ebb's musical *The Visit* (2015). In 2018, she received a special Tony Award for Lifetime Achievement in Theatre.

Christine (Chris) Coulton-Varney is a dreamer, a problem-solver, and an open, authentic and remarkable soul who grew up on a farm outside Stratford Ontario, graduated from Wilfred Laurier University and has been based in Calgary for more than 30 years. She describes herself as "maybe getting older, but not washed out or washed up yet!"

Christopher George was the editor of Canadian Historical Art and a contributing writer for the Canadian art and design magazine, ARABELLA. He developed "DepARTures"—a regular series of articles written on the appreciation of abstract art. Art has been a lifelong obsession for Chris and his wife Elaine, a photographer.

Christopher Talbot is an international arts promoter and visionary gallerist with a shrewd eye, inventive imagination, and a genius for branding. His relationship with Toller spans decades. He has established extraordinary arts installations, openings, and events worldwide. He manages international sales and marketing for the sculptures of Salvador Dali and he also represents renowned Australian surrealist Charles Billich.

Clive Caldwell is the owner of Toronto's prestigious Cambridge Group of Clubs (The Adelaide Club, The Cambridge Club and The Toronto Athletic Club). Clive was a professional squash player capturing over 35 professional singles and doubles events over a 20-year career. He served as President of the Canadian Professional Squash Association and the World Professional

Squash Association (WPSA) and is credited with developing the WPSA into the most significant professional squash tour of its time. In 2010 he co-founded the Urban Squash Toronto program; a charitable program combining athletics and education that supports under-served youth.

Corey Circelli
Member of the Canadian National Senior team, international competitor, 6-time Toller award winner, consistently recognized for his courage, creativity, and expression. Along the way, he has been coached by the best—Ellen Burka, Brian Orser, and Tracy Wilson.

Cst. Dave Stewart is a police officer with the Ontario Provincial Police.

Cylla Von Tiedemann is a German-born photographer living in Toronto. Renowned for her dance portraiture and live theatre photography, she is also a respected visual designer for the stage. Cylla has collaborated with artists around the world, teaches photography, and has presented creative workshops at multiple universities across Canada.

Danielle Earl has made a name for herself in the sports photography world. She leads a diverse team of creative professionals at Danielle Earl Photography who specialize in capturing national and international skating, dance, and gymnastics competitions.

David Benjamin Tomlinson is an actor and writer who has explored many different storytelling and performance approaches— comedy, improv, theatre, film, TV. He was Toller in Sky Gilbert's one-man play *Toller*. He played Linus in multiple seasons of *Star Trek: Discovery*.

David C. Brydges is a cultural entrepreneur and community legacy builder based in Cobalt, Ontario. He is the artistic director of the Spring Pulse Poetry Festival in Northern Ontario. Memberships include Stroll of Poets, Parkland Poets, Ontario Poetry Society, Haiku Canada, and League of Canadian Poets. In 2021 he was appointed the first Poet Emissary for the Ontario Poetry Society replacing a yearly recognition of the Poet of the Year. David has six chapbooks published including his latest Vaulting to Venus and one full-length book, Vagabond Post Office.

David Dunkley is an international award-winning milliner and Official Milliner to the Running of the King's Plate. David Dunkley Fine Millinery was voted The Best One-Of-A-Kind hats in Forest Hill and Yorkville and One of Toronto's Top Ten Hat Shops.

David Street began his professional career in 1967 as the youngest staff photographer with Toronto Life Magazine. At the same time, he began a photo-journalist style for magazines and was widely published in Canada and abroad. David is also known for his personality portraiture but perhaps best recognized for his ballet photography.

Dawnette Brady is a lifelong dedicated fan of a true genius on and off the ice.

Debbi Wilkes is a Canadian and North American figure skating champion, World bronze and Olympic silver pairs medallist with partner Guy Revell. Wilkes has spent her working life involved with figure skating as a broadcaster for CTV, an author, and a coach. She led the CTV team that uncovered rigged judging at the 1999 World Championships. From 2006 to 2014, she has served as the director of sponsorship and marketing for Skate Canada. She was inducted into the Canadian Figure Skating Hall of Fame in 2001.

Debra Usher is an internationally recognized artist, successful business woman, and the Founder and Creative Editor-in-Chief, of ARABELLA Magazine, the premier Canadian art, architecture and design magazine. She is originally from Calgary and has lived and worked in Australia, Toronto, and Los Angeles.

Deirdre Kelly is a critically acclaimed writer whose articles have appeared in major fashion, arts, and culture magazines. She was a long-time features writer for The Globe and Mail and is the author of the best-selling *Paris Times Eight* and *Ballerina: Sex, Scandal and Suffering Behind the Symbol of Perfection* (Greystone Books). A two-time recipient of Canada's Nathan Cohen prize for critical writing in addition to many journalism awards, she reviews dance for www.criticsatlarge.ca. Her most recent book (*Fashioning the Beatles: The Story of the Look That Shook the World*), was published by Sutherland House Books in the fall of 2023.

Dick Button is a two-time Olympic champion and five-time World champion. A graduate of Harvard Law School, he had a decades-long career in television broadcast journalism, created a variety of made-for-television sports events, and became figure skating's best-known analyst, well known for his frank and often caustic appraisal of skaters' performances. He won an Emmy Award in 1981 for Outstanding Sports Personality, Analyst.

Dick Loek is a professional photographer and photojournalist.

Diego Fernando Gomez Espinoza a former employee at the Casa Toller property and member of the Tacos Don Felix restaurant family.

Don and Barbara Jackson. Don Jackson captured four Canadian titles and won a bronze medal at the Squaw Valley 1960 Olympic Winter Games. He won the 1962 World Championship in Prague, where he landed the first Triple Lutz in international competition. He is a member of the Order of Canada and has been inducted into Canada's Sports and the World Figure Skating Halls of Fame. At age 76, he appeared in two *Stars On Ice* shows performing a duet with Kurt Browning. His skating included an axel and a waltz jump. He is the founder and inspiration behind Jackson Ultima Skates. Don and his wife Barbara, also a skater, continue to mentor, support and inspire skaters of all ages.

Donna Child has been a leader and innovator in Toronto's Arts and Culture community for more than 30 years. In 2016, she established the Toronto West Arts Collaborative, a dynamic not-for profit arts organization devoted to promoting, developing, and supporting emerging mid-career artists. The Donna Child Fine Art Gallery is pleased to work in partnership with the Toller Cranston Estate to support, promote and preserve the legacy of Toller Cranston, the artist.

Donna Meyer is a world traveler and an award-winning travel writer (NATJA Gold Award for 2018), blogger and photographer. She has traveled to more than 30 countries and lived in five. She created Nomad Women in 2014 to inspire and empower women who travel—or want to.

Donna Parker is an artist who returned to Vancouver Island after years in San Miguel de Allende where, at his invitation and insistence, she regularly painted with Toller. Her work including prize-winning quilts and commissioned stained glass windows hangs in collections in Canada, the U.S., Mexico, Australia, and the Cayman Islands.

Dorothy Leamen is an international judge and inductee in the Canadian Figure Skating Hall of Fame.

Duncan McLean is a recognized leader and innovator in the Canadian auction industry. His more than 40 years of experience with Waddington's includes specialized knowledge in Canadian art, with a focus on Inuit art.

Ed Flume was charming, indefatigable, and thoroughly professional in battling endless obstructions, corruption, and stupidities as he led the way through convoluted legal and real estate processes in Mexico.

Edythe Anstey Hanen From Bowen Island, B.C., Edythe is an award-winning novelist (*Nine Birds Singing*) and writer who has published articles, short stories, and poetry in literary magazines as well as in The Globe and Mail, National Post and the Hamilton Bay Observer. During 18 winters spent in San Miguel, Mexico she and her partner shared countless breakfasts with Toller.

Elaine George is a photographer who taught Phys Ed and English for 32 years with the Peel Board of Education. Art has been a lifelong obsession for Elaine and her husband, Christopher.

Elladj Baldé is one of the most sought-after professional skaters in the world. He is a Canadian former elite level competitive figure skater who has taken his talent to the web where he has attracted an audience of 30 million on TikTok and Instagram. He is a co-founder, alongside his wife Michelle Dawley, of the Skate Global Foundation, an impact driven global not-for-profit organization built on three major pillars: Equity, Diversity and Inclusion (EDI), Mental Health and Climate Change. He has served as both choreographer and judge on *Battle of the Blades,* hosted red carpet events, provided commentary for Olympics and international championships, and is an ambassador for major brands including Canada Goose, Versace, and Ray-Ban.

Ellen Burka was a Dutch national champion in 1946 and 1947 before becoming a coach in Toronto. Finding Canadian figure skating rigid, she decided to blend it with ballet and modern dance. She coached Toller to multiple championships and made him a presence on the international scene. Ellen Burka attended over 24 World Championships and 7 Olympic Games with her skaters. Her daughter Petra became a world champion and Olympic medallist. Ellen is a member of the Order of Canada and revolutionized the style of figure skating with her pupil Toller Cranston.

Emery Leger was the long-serving archivist at Skate Canada, the largest figure skating association in the world with more than 5,000 coaches working at 1,200 skating clubs. Emery was previously the director at the Mariposa Moncton National Training Centre. As a coach, he brought skaters to national and international medals and inspired them to skate with passion and desire, to have fun, and to better know and appreciate our rich Canadian figure skating history.

Emma Bulawka from Kelowna, B.C. is a past winner of a Toller award for "courage, creativity and expression." Now a senior, she continues to spend countless hours on the ice drawing on her reserves of grit, perseverance, and passion, and honouring what she has learned from Toller.

Eric Nemer was the long-time owner of the iconic restaurant *Hecho en Mexico* that is immensely popular with San Miguel's expat community especially the Canadian Snowbirds. *Hecho* was Toller's favourite place in San Miguel and he chose it many years ago as the venue to display his paintings.

Faith Fuller is a filmmaker and entrepreneur who has produced dozens of award-winning videos including the PBS documentary *Briars in the Cotton Patch*. She travelled worldwide for Habitat for Humanity International capturing the inspiring true stories of families and communities that were being transformed by the home building organization. She is currently the Founder/Publisher of Desktop-Documentaries.com. At the time of Toller's passing, Faith had been working with Toller to increase his online presence.

Felix Gomez Morales & Gloria Espinoza Briseño, owners of Tacos Don Felix, one of the best restaurants in San Miguel—a favorite of both Mexicans and expats, and Toller's go-to choice for Sunday lunch.

Gary Reid is a photographer based in San Miguel de Allende, Mexico.

Gary Slipper is a Canadian-born surrealist painter who has assimilated aspects of the fine and folk art of contemporary Latin America and blends it with the European tradition in his work. His subjects are fantasy, dreams, spiritual, mythology, portraits, nudes, and figures. Toller was always a huge admirer.

German Llamas Owner of Antigua Llamas, Arte Mexicano, one of the most beautiful art and design shops in San Miguel de Allende, was long-time friend of Toller who was a regular customer both on the days when he did have pesos, and on the days when he did not.

Graciela was Toller's maid for many years and without doubt is the world's best bed maker. Why would you even try?

Grant Noroyan is a former three-time U.S. national figure skating competitor, double gold medallist and principal skater with Disney on Ice. He is a now a coach, and choreographer (two-time national synchro coach) based in the USA.

Greg Ladret is a professional figure skater, magician, entertainer, story teller, bit part actor, and writer wannabe. He has performed throughout Canada, the U.S., Europe, Asia, and everywhere from Dubai to French Polynesia. He had the opportunity to perform trick roping in a scene with Jack Lemmon in *The Long Way Home*, and a short scene with Meg Ryan and Adam Brody in *In the Land of Women*. His repertoire includes magic, trick roping, juggling, and balloon twisting, sometimes done on skates.

Haig Oundjian is a financier, a two-time Olympian, European medallist, Free Skate champion, three-time British national champion, and Guinness World Records holder. He served as the President and Chairman of the U.K. National Ice Skating Association. He was also majority owner of Watford F.C. with Sir Elton John during a meteoric period of success. He is the founding sponsor of The Harefield Academy High School and was a delegate of the successful London 2012 bid team. He is currently chairman and owner of FCB Bruno's Magpies. He co-founded the COF Toller Awards with Toller. Most significantly, he is the only person on the planet with whom Toller never had a falling-out. They were admirers of, respectful of, supportive of, and devoted to each other for more than five decades. Haig was often called upon to help restructure Tollers financial affairs.

Hannah McCurley is a Canadian artist who was born in Vietnam. In 2010, she created the Children's Art Foundation (CAF) a non-profit organization in San Miguel de Allende, Mexico to teach art to underprivileged children to bring the joy of creativity into their lives.

Hazel Pike (Boskill), a fellow skater, member of the National team, and a dear friend who shared many Toller moments both on and off the ice. It was her father who proposed Toller as a member of the Cricket Club, thereby facilitating his move from Montreal.

Hugo Sanchez began as a *trabajador* at Casa Toller and is now a worker, fixer, father, husband, and jefe. He has expertise in logistics, an impressive Rolodex of tradespeople, an eclectic range of skills, and a relentless capacity to step up, show up, and make things happen.

Jaki Chan is a multi-talented, multi-skilled, ridiculously strong, and super inventive jack-of-all trades who can make any living thing flourish and any broken thing work.

He worked for Toller for many years and was the only one on Toller's staff who could also juggle and walk on his hands.

Janet Dunnett is the Author of *The Dwindling A Daughter's Caregiving Journey to the Edge of Life*. Professionally she worked in international development as a project officer, program developer, evaluator, and sometimes in the trenches where things actually get done. She is from Qualicum Beach, British Columbia.

Jay Koppelman first met Toller when he was sent by a magazine in 2008 to photograph him at his home in San Miguel. He co-founded the Studio 18 gallery in Ajijic, Mexico and is the author of the inspirational photography book *The Through Line* that is about the celebration of dark and light in photography and in our lives. Jay is a TED speaker and his work is part of the permanent collection at the Museum of Modern Art in Cuenca, Ecuador. He lives in Mexico and works as a curator for a photography agency based in New York City.

Jeanie Gooden is an American painter who lives and works in San Miguel de Allende and the United States. Her work is deeply influenced by the architecture and culture of central Mexico and hangs in galleries and private and corporate collections around the world. Her paintings are non-representational and have a sculptural feel. Typically large scale, her heavily layered paintings are created on canvas with the use of paint, metal, nail heads, textiles and hand stitching.

Jeanne Beker is a Canadian journalist, media personality, and fashion entrepreneur. She was the host of Fashion Television for 27 years; style editor at TSC; journalist, speaker, author, and proud Canadian. She launched Citytv's ground-breaking show The NewMusic, is the author of five books, a Member of the Order of Canada, an inductee on Canada's Walk of Fame and recipient of the Special Academy Achievement Award from the Canadian Academy of Cinema and Television.

Jeannie Yagminas is a world-class bridge player, world-class scone maker, and long-time Toller admirer.

Jennifer Brewin is a multiple award-winning theatre artist who specializes in new work with an emphasis on large-scale, outdoor performance. Winter landscape is the backdrop for many of her productions. She has created outdoor winter plays for British Columbia's Caravan Farm Theatre, the National Arts Centre's English Theatre at Dow's Lake, and Toronto's Evergreen Brick Works. She creates stages and stories that are theatrical and often comedic, evoking important discussions about modern life. She lives in Regina, SK.

Joann Hetherington is the owner of Zocalo, a not-to-miss women's clothing store located in Gibsons, B.C. She is also a great supporter and seasonal San Miguel neighbour of Toller who is "forever knocked out by his passion and his creative brilliance."

John and Sharon Garside were long-time neighbours of Toller in San Miguel and became the owners of Recreo 75 after Toller died. They have magnificently transformed the property while retaining many original elements of Toller.

John Lennard has been an international athlete, artist, and painter. John Lennard has exhibited at the Armory show in New York and is represented by the Roberts Gallery in Toronto.

John Rait became the World Professional Ice Dance champion with partner Shelley MacLeod in 1980. His professional skating career also included a stint with *Stars on Ice*. He was a casting director, talent agent, photographer and art gallery owner. A passionate, generous, and articulate man he is devoted to exploring art in its many forms.

Joni Mitchell, OC, is a Canadian singer-songwriter. Drawing from folk, pop, rock, and jazz, Mitchell's songs often reflect social and environmental ideals as well as her feelings about romance, confusion, disillusionment, and joy. She has received many accolades, including nine Grammy Awards and induction into the Rock and Roll Hall of Fame in 1997. Rolling Stone called her "one of the greatest songwriters ever." AllMusic has stated, "When the dust settles, Joni Mitchell may stand as the most important and influential female recording artist of the late 20th century."

Jorge Pena has done pretty much everything including once crewing a boat for John Wayne up the Pacific Coast. He knows more about the political, artistic, and cultural history of Mexico than anyone and he tells the stories with passion and colour. He founded La Union, the packing, shipping storage company that handled both Toller and his paintings for more than 20 years. The staff he assembled is amazing.

Joy Levine is a proud Canadian, a San Miguelense, an active volunteer, director of Amistad Canada, a philanthropist. and avid supporter of introducing young Mexican opera singers to the world.

Joyce Hisey was the 1952 Canadian silver dance medallist and went on to become a long-serving and effective volunteer and official, leaving her mark on the sport of figure skating from the club to the world level. She was a judge and referee for more than 40 years, a member of ISU Council, the CFSA Board of Directors and Chairman of the Officials Development Committees

Julian Mendl is a professional freelance photographer based in Toronto who specializes in high-end real estate and corporate marketing events.

June Eyton is a key member of Toller's elite inner circle. She admired, supported, promoted, advocated for, and understood Toller at a deep level. Toller utterly trusted and depended on the friendship of June and her husband Tony.

Karen Courtland Kelly, MA, is an Olympian, Chef de Mission of Education and Sport for the World Figure Sport Society, Skating Educator, Researcher, Archivist, Consultant, Professional Performer, and Choreographer. She is also a World Figure Sport's Skating Hall of Fame Member and International Official representing the USA.

Karim Remtulla, PhD, is an academic and published author focused on the impact of digital learning on aesthetics, work, and identity. Karim and his husband Nadim's love of art began almost 25 years ago, when they went on their first date.

Keith Walker is a photographer whose portfolio of aerial imagery is among the best in the world. He is torn between his love of being in the air with camera in hand and working on his own fine art images.

Kenn Jorgensen is a freelance sports photographer from Denmark.

Kim Manley Ort is a contemplative photographer and writer who learned how to be meditative practicing school figures at the local ice rink. Figure skating in some ways led her to photography and taught her to be fully in the moment, open, and aware.

Kimberly Kmit is a lifelong skating fan who has made friends from all over the world travelling to competitions. She is an Admin Assistant with the United Steelworkers Union and a volunteer at a local mission, serving coffee and meals to the hurting and homeless in Sudbury, Ontario.

Chief R. Kris Nahrgang is a multi-disciplinary artist who tells stories in wood, stone, and traditional oil media. He is a dancer, film maker, and a writer-producer. He is Chief of the Kawartha Nishnawbe First Nation and a tireless advocate for the rights of First Nations communities.

Kurt Browning is a three-time Olympian, four-time Canadian and four-time World Champion and has been awarded the Lou Marsh Trophy for top Canadian athlete. He holds an Order of Canada and was inducted into Canada's Sports Hall of Fame and Canada's Figure Skating Hall of Fame. He has provided colour commentary for figure skating on NBC and ABC, and is currently working for CBC. Kurt has been part of *Stars on Ice* for 29 years.

Kym McKay is an artist, fashion designer, and a visual merchandiser.

Lander Rodriguez studied graphic design in Mexico City and to this day works on a diverse range of projects in San Miguel de Allende, many of which combine design and photography. Lander founded two successful design firms. He has photographed many homes in Mexico and the United States and has designed several books on photography, art, and other subjects. In addition to design and still photography, he does aerial photography and video.

Leonard Cohen is one of music's most revered and prolific visionaries— a hugely influential singer-songwriter, poet, novelist, and film maker whose career spanned nearly 50 years. He is a Companion of the Order of Canada, member of the Canadian Music Hall of Fame, the Canadian Songwriters Hall of Fame, and the Rock and Roll Hall of Fame. More than three hundred performers made his *Hallelujah* famous with their versions long before the song was included on the soundtrack for *Shrek* and as a staple on *American Idol*.

Leo Oppenheim is a skater, slackliner, squash player, Indo Boarder, instructor, personal trainer, athlete and fitness enthusiast.

Linda Hampton has touched many lives through her work as a highly respected executive coach with an international clientele. She is present and available for friends, and an inspiration for her familia mexicana. She has an eye for art, a limitless capacity for gratitude, and an unrivalled BS detector.

Louise Vacca Dawe, a former figure skater, became US Jr. Champion and represented Cornell University and the USA in the World University Games in1972 where she placed

fifth. She retains her passion for skating and her love and respect for Toller's paintings.

Lourdes Argote, a devoted friend, a talented artist, was the gatekeeper at Intercam Banco and the one person able to steer Toller through innumerable brushes with financial calamity.

Margaret Failoni Originally from New York City, she is a writer, curator, collector, mentor, critic, and advisor. After earning a BA in Art History, she joined Pan American World Airways as a way to see the museums and archeological sites of the world. For more than 35 years, she lived in Italy where she ran a successful Gallery and Prints Publishing Company and curated for the Ministry of Tourism. After moving to Mexico, she concentrated on curating exhibitions for Museums and influential galleries and on discovering and supporting young talent.

Margaret Paul. In 2014, author Margaret Paul of Victoria, B.C., interviewed a number of artists in San Miguel and assembled their conversations in her book *Conversations with Artists in San Miguel de Allende*. Her powerful and revealing interview with Toller was just a year before he died. She says, "Growing up in the pastures of central Alberta gave me a connection to the earth that left me curious, resilient, and mostly unafraid. I consider myself to be a pretty ordinary woman who has been very lucky.

Mario Alvarado Kindness, caring and customer service characterizes Mario who was the long-time manager of the iconic *Hecho en Mexico* restaurant in San Miguel and now manages restaurants in the South of Spain.

Martha Lowder Kimball grew up in Albany, New York. She has written more than 800 magazine and newspaper articles on a wide range of subjects including figure skating. She collaborated with Toller on *Zero Tollerance, When Hell Freezes Over,* and *Ice Cream.*

Mary Ellen McDonald is Senior Director of Operations at Skate Canada, the national governing body responsible for the development and administration of skating in Canada.

Mayer Shacter and his wife Susan Page own the world-famous Galeria Atotonilco located near San Miguel de Allende. He was a ceramic artist whose career flourished for 27 years before he began to concentrate on dealing in fine antiques, vintage mid-century modern furniture and decorative arts. His eye for beauty, innovation, and quality craftsmanship was highly refined. He took great joy in

searching out the best artists, purchasing their finest work, and often commissioned special and unique pieces for the gallery.

Melissa La Porte is curator of the vibrant Temiskaming Art Gallery located in Northern Ontario.

Michael Hoppé is a multiple award-winning Grammy nominated composer, record producer, and recording artist who lives in San Miguel. Michael's music was always inspirational for Toller who would play it at top volume hour after hour as he worked in his studio. Michael's *Requiem* was recently performed in San Miguel by the Chorale San Miguel. His discography contains almost 40 albums, heard on all the digital platforms, including numerous videos on YouTube featuring his music.

Mike Fynn has no depth perception and is color blind. He never went to art school and has no degrees. He does, however, have a passion for photography and he photographs that which is beautiful or inspirational. He photographed Toller. He lives in Denver.

Monica Campbell Hoppé is a media-relations specialist who tirelessly celebrates life, counts her blessings, and helps her garden grow.

Monica Friedlander, Livermore, California

Nadim Kara, CHRE is a Human Resources professional devoted to global and Canadian organizational transformational leadership through driving strategy achievement and cultural innovation. Nadim and his husband Karim's love of art began almost 25 years ago, when they went on their first date.

Natalia Laluq is a Kyiv-born artist who lives and works both in Canada and Ukraine. She works primarily in painting and ceramics spreading her attention into film, animation, sculpture, and embroidery for special projects. Showing locally and internationally for more than 30 years Laluq won several art prizes, and grant support from Ontario Arts Council. More info about Natalia can be found at her website: laluq.art

Nataliya Shpolianski lives in Israel, writes in Russian, is a generous and passionate fan and somehow managed to collect the most astounding and extensive collection of Toller Cranston photographs, videos, and images anywhere in the world.

Niki Barbery-Bleyleben is a Bolivian sociologist living in London with her Austrian husband Max and their two

daughters, Philomena and Luna. Toller's pointed boots adorn their living room and the ostrich eggs they painted together sit joyfully on the upright piano. His spirit is with them always.

Oleg and Ludmila Protopopov are Two-time Olympic Gold Medallists, four-time World and European Champions, three time winners of Dick Button's World Professional Championships, the Protopopovs are recognized as perhaps the most exquisite and creative pairs skaters of all time.

Olivia Montague is a Toronto area visual artist. She has a background in floristry and visual merchandising and has focused her education and career on colour theory, design, and aesthetics.

Paul F. Kowdrysh is President and Chief Executive Officer for Protair-X Solutions Group (PSG). He previously spent 24 years traveling nationally and internationally as a turnaround and profitability specialist assisting organizations in growing their businesses.

Paul Zizka is an award-winning mountain landscape and adventure photographer based in Banff, Canada. A prolific adventurer, Paul's journey to capture the "under-documented" has taken him to all seven continents, as well as to each of Canada's provinces and territories. He has several coffee-table photography books, as well as limited edition prints of his images.

Peter Rowe is an artist and an award-winning writer, director, producer, and cinematographer. He has scripted feature films and has acted as director/producer on more than 180 projects including the 49-part TV series, *Angry Planet* that was filmed on extreme locations all over the world. His books include *Ablaze: Ten Years that Shook the World; Music vs The Man*; and *Adventures in Filmmaking*. His latest book is called *Out There: The Batshit Antics of the World's Great Explorers* and is published by Sutherland House.

Pj Kwong is an author who has been hip-deep in figure skating her whole life first as a skater, then as a coach for over 25 years, a commentator, blogger, and social media voice for CBC Sports and other international networks since 2001. She is a PA announcer at international events including 10 Olympic Games, a FIFA World Cup, Pan Am and European Games.

Richard Lander is a blogger at *The Gangs of San Miguel de Allende*.

Rob Leon, designer, writer, creative director and father. He is currently the principal of Potion Creative. Rob met Toller when they collaborated on a 1997 tribute show honouring Toller's skating and painting careers.

Rodney Groulx is a Senior Partner at Pxlworks Inc. in Almonte, ON. He and his partner began with a cup of coffee and an idea that they could do high quality large format print and graphics better, bigger, faster, and less expensively than anyone. That was 2006 and they are still at it.

RM Vaughan is a New Brunswick author, playwright, and poet, former Writer in Residence at UNB, and a trailblazer for LGBT artists. He articles on culture have been published in a wide variety of publications including This Magazine, Momus.ca, and Canadian Art online. His short videos play in festivals and galleries across Canada and around the world.

Ruth Ann Whipp was an active member of The Toronto Cricket Skating and Curling Club for almost 70 years. She served on the Board of Directors, chaired the Heritage Committee, and created the Skating Wall of Fame. Like Toller, her friend, she was kind, caring, strong willed, hard-working, and fun,

Ron Base is a writer— twenty novels, two novellas and four nonfiction books. He is a journalist—newspapers, magazines, and movies. He has travelled the world and interviewed everyone from John Wayne, to Paul Newman, to Meryl Streep, Woody Allen, Jane Fonda, and Clint Eastwood, He has worked on film projects with film-making legends John Boorman and Roland Joffé.

Ryan Stevens is a former figure skater and judge from Halifax, Nova Scotia. For a decade, he has explored fascinating and fabulous figure skating history on his blog Skate Guard. He is the author of the skating reference books *Technical Merit: A History of Figure Skating Jumps*, *The Almanac of Canadian Figure Skating* and *A Bibliography of Figure Skating*. He has written content for "Skating" magazine and U.S. Figure Skating. He has also been consulted for historical research for numerous museums, as well as television programs on CBC, ITV and NBC.

Sally Rehorick participated in six Winter Olympic Games, as an international judge, member of the Officials Assessment Commission, team leader of Canada's national figure skating team, chef de mission for Canada's 2002 Olympic Winter Team, and Director of International Client Services for the Organizing Committee of the 2010 Olympic Winter Games in Vancouver. She also officiated at numerous World Championships and is a member of the International Skating Union's eLearning Project Team.

Sam Perez is a photographer based in San Miguel de Allende, Mexico.

Sandra Bezic is an Olympian who won multiple Canadian Pairs championships competing with her brother, Val. She has a remarkable career as a choreographer at the highest international levels, and as a television commentator for major skating events including Olympic Games and World Figure Skating Championships. She was the director, co-producer, and choreographer for *Stars on Ice*, for which she won an Emmy Award in 2003 and she served as a judge on the CBC television program *Battle of the Blades*. She wrote a book called *The Passion to Skate*.

Sandra Garrett from St Annes-on-Sea, England has been, for more than four decades, a fan and a collector with a bottomless passion for, and interest in, everything Toller.

Sarah Kawahara, a Japanese-Canadian figure skater and choreographer, is the winner of two Emmy Awards and an inductee of World, Skate Canada, U.S. and Professional Skaters Association halls of fame. She won an Emmy Award in 1997 for *Scott Hamilton Upside Down* and was the first skater to win the Best Choreography Emmy. She won her second Emmy in 2002 for choreographing the opening and closing ceremonies of the Salt Lake 2002 Olympic Winter Games. She joined the *Ice Capades* at age 17 and skated with the show for seven years. She is married to actor Jamie Alcroft, with whom she has three children. They live in California.

Scott Umstattd is an artistic observational photographer. His assignments have led him to travel to over a dozen countries. His current work, *The Tribes of San Miguel*, is a photographic deep-dive into the indigenous dance culture of Guanajuato, Mexico. The project has been blessed by tribal elders and is supported by the city of San Miguel de Allende.

Dr. Sepp Schönmetzler is an Olympian and former German national champion. He produces the German figure skating magazine *Eissport-Magazin*.

Shelley MacLeod grew up in Northern Canada. She and her partner John Rait were 1980 World Professional Ice Dance Champions and performed around the world

with Toller including a 6-week run in his show at Radio City Music Hall (NYC,1983). The pair starred in multiple Toller TV specials and appeared weekly in *Stars on Ice*. In recent years, Shelley has found success as a songwriter.

Shelley Walters Dalley and **Richard Dalley** have been married for 30 years. She is a U.S. and Canadian gold medallist. He is an Olympian, winner of 15 international competitions, double World Professional Champion, six-year star of *Ice Capades* and Member of U.S. Hall of Fame.

Shepherd Clark competed in 18 U.S. Figure Skating Championships, is a former Olympic and World Team Alternate, and a six-time World Figure & Fancy Skating Champion. He has performed the greatest variety of figure designs of anyone in skating history and is the first skater to achieve a perfect mark in World Figure Sport. He founded The WORLD ART Champions Museum, in Orlando, an art museum featuring figure skating.

Silvia Katharina Grohs is an academic scientist of Romance languages. She grew up in the village of Oberwinter surrounded by the mystical castles and fairy tales of the romantic Rhine-valley. She played piano and sang Baroque and Renaissance chorales. Inspired by Toller`s flamboyant talent, she fell in love with painting and ballet. She became a lifelong addict to beauty and says, "Thank you, Toller, for putting that spell on me!"

Sky Gilbert is one of Canada's most controversial artists' voices. He founded *Buddies in Bad Times Theatre* in Toronto more than 40 years ago. Drag queen, novelist, playwright, director, filmmaker, teacher: there is a street named after him in Toronto — Sky Gilbert Lane. Dr. Gilbert is a Professor Emeritus at the University of Guelph where he taught for 24 years.

Stephan V Benediktson is an Albertan who worked as an oil field roughneck and then as an engineer and executive in various positions in the oil business in Canada and internationally. He is a farmer/rancher, property developer and a grandson of noted Icelandic Canadian Poet, Stephan G Stephansson.

Sue Gamble from Swastika ON studied fine art and geology at university, after which she worked in mining exploration while maintaining a home studio for painting and printmaking. She paints from her home studio in the Boreal forest on Kenogami Lake. Her award-winning paintings reflect imagination, environment, nature, animals, people, and experience.

Susan Page is the Founder and long-time Director of the San Miguel Writers' Conference and Literary Festival. Repeat Oprah guest, she has been conducting workshops for both singles and couples, nationally and internationally since 1980. She is the author of six books including the international bestseller, If *I'm So Wonderful, Why Am I Still Single?*, which was translated into 22 languages and is celebrating its 32nd year in print. Her international speaking and media career has taken her to 26 states, Canada, Korea, Australia, and Mexico. She lives in San Miguel de Allende, Mexico. She and her late husband Mayer Shacter established the famous Galeria Atotonilco.

Suzanne Wheeler Ally is an artist and proud resident of San Miguel.

Tony Eyton enjoyed a wide-ranging federal public service career that included assignments abroad as Executive Director of the Asian Development Bank, Ambassador to Brazil, and Consul General in New York. He served as Director General of the Canadian Trade Commissioner Service, Deputy Minister in the Department of Industry, Trade and Commerce, and as Chairman of the Canadian International Trade Tribunal leading bilateral trade negotiations and managing international trade disputes. For many years, Tony and his wife June tried mightily to corral their dear friend Toller's wild spending impulses, and to bring some order to his chaotic lifestyle.

Tony Scupham-Bilton is a freelance historical researcher who was born during a thunderstorm in the summer of 1960 and was brought up in a village in north Nottinghamshire. He attended the sort of school which practiced "history for girls, geography for boys," but developed a love of history none-the-less. He is a member of the International Society of Olympic Historians specialising in lgbt+ participation.

Tracy Wilson and partner Rob McCall were seven-time Canadian Ice Dancing champions, Olympic and three-time World bronze medallists, World Professional Champions, and performed extensively with *Stars on Ice*.

Tracy Wilson has worked as a figure skating analyst for American and Canadian TV networks and has written for TSN. She is a coach, choreographer, an AIDS activist, and an ambassador for S'port for Kids Foundation.

Veronica Tennant, C.C., was for 25 years Prima Ballerina with The National Ballet of Canada dancing with such luminaries as Rudolf Nureyev and Mikhail Baryshnikov. Now an award-winning filmmaker, she recently produced *Christopher Plummer: A Memoir*. Her stage credits include movement director for Margaret Atwood's *Penelopiad* and leading roles acting with the Shaw Festival. She has published two children's books, *On Stage, Please* and *The Nutcracker*, and holds five honorary degrees. Veronica is one of UNICEF Canada's National Ambassadors, a recipient of The Governor General's Performing Arts Award, and a Canada Walk of Fame inductee. In 2003 she was elevated to Companion of the Order of Canada, the Order's highest honour.

Zdenek Pazdírek was skating since he was three years old. He has been an optimistic, hardworking skating coach for more than 30 years and has worked with World and Olympic Teams. He is a former lawyer, a previous two-time Czechoslovakian Senior Men's Champion, Olympic and World competitor, and was the principal skater in the European company of *Holiday on Ice*. He lives in BC.

Zsuzsi Pauli-Almássy is the 1969 World bronze medalist, a three-time European medalist, and a five-time Hungarian national champion.

Toller Cranston
Resumé & Career Highlights

Athlete, artist, illustrator, author, designer, choreographer, coach, commentator,
and star of award-winning television specials and films.

Figure Skating Achievements

Three-time World Free Skating Champion
World Professional Figure Skater of the Year, 1988
Olympic Bronze Medallist, Innsbruck, 1976
World Figure Skating Bronze Medallist, 1974
Awarded seven perfect marks of 6.0 at World Championships, 1972-1975
Six-time Canadian Champion, 1970-1976
Junior Canadian Champion, 1964
Skate Canada International Champion, 1973 and 1975
Gold Medal, Canada Winter Games, 1967
Silver Medal, North American Championships, 1971
World Professional Champion, 1981, 1983, 1985
Winner of the World Skate Challenge, 1977, Labatt's Pro-Skate Montreal, 1982, Labatt's Pro-Skate Edmonton, 1982, Labatt's Pro-Skate Toronto, 1982, International Professional Championships, 1982, World Cup of Skating, 1982
Toured with *Stars on Ice, Holiday on Ice,* and *Skate the Nation*

Honours and Awards

Officer of the Order of Canada, 1977
Canadian Athlete of the Year, 1975
Canada's Walk of Fame, 2003
World Figure Skating Hall of Fame, 2004
Skate Canada Canadian Figure Skating Hall of Fame 1997
Canada Sports Hall of Fame, 1997
Canadian Olympic Hall of Fame, 1976
Ontario Sports Hall of Fame, 1996
World Figure Hall of Fame, 2016
World Figure Skating Hall of Fame 2004
International Order of the Olympics, IOC
Sports Federation Athlete of the Year, 1974
Special Olympic Order, Canadian Olympic Association, 1995
Order of Merit, City of Toronto, 1988
Cabbagetown People Program, 2001
International Sports Broadcast Award, 1990
German Skating Association Award of the Decade, 1994
World Professional Skater of the Year, 1988
ISU Award for Most Creative Skater of the 20th Century, 2002
Honorary Degree LL.D., Carleton University, 2011
Artist in Residence, Harvard University, 1986
Performer in Residence, University of Maine, 1985
Official Artist of Skate Canada, 2013

Television and Live Theatre Shows

The Ice Show, Palace Theatre, NYC 1977
Ice, Radio City Music Hall, NYC 1983
Dream Weaver, TV, 1979
Strawberry Ice, TV, 1982
Magic Planet, TV, 1983
The True Gift of Christmas, TV, 1985
CTV's *Stars on Ice*
NBC's *The Big Show*
U.S. television specials *The Snow Queen: A Skating Ballet and Romeo and Juliet on Ice.* 1983
Film, *Ice Princess*, 1996
Shadows and Light, Joni Mitchell's concert film, 1980,
Joni Mitchell's *Hejira* album cover, 1976
I Am A Hotel, Leonard Cohen's Film, 1983
Television commentator for the World Championships and numerous international events for CBC. Perennial judge at the World Professional Championships and other professional competitions.
Performed in North America, Europe, China, Japan, Africa
Guest judge for *Battle of the Blades*, 2010
Official Artist of Skate Canada, 2013
Coach and choreographer for elite skaters including US Champion Christopher Bowman and 1995 world champion Lu Chen

Awards

ACTRA Award for TV Special
ANIK Award for TV Special
Montreux Award for TV Special
San Francisco International Film Festival Award for TV Special

Paintings

Created an estimated 20,000 original paintings that are in prominent private and public art collections worldwide (including World Figure Skating Museum, and the International Skating Union). He participated in more than 300 exhibitions mostly one man shows across Canada, the U.S., Mexico, France, Germany, Switzerland and Hong Kong. Designed posters for the National Ballet of Canada, CBC, Chanel, and the Stratford Summer Music Festival

Books

- *Toller*, #2 in the Canadian non-fiction charts, with Elva Oglanby, Gage Publishing. 1975
- *A Ram on the Rampage.* 1977
- *The Nutcracker*, E. T. A. Hoffmann, Retold by Veronica Tennant. Illustrated by Toller Cranston. 1985
- *Zero Tollerance: An Intimate Memoir by the Man Who Revolutionized Figure Skating* with Martha Lowder Kimball. 1977
- *When Hell Freezes Over: Should I Bring My Skates* with Martha Lowder Kimball. 2000
- *Ice Cream: Thirty of the Most Interesting Skaters in History*, with Martha Lowder Kimball. 2002

Exhibitions and Legacy Projects

Canadian Olympic Foundation and Skate Canada Toller Awards for courage, creativity and expression in Young Skaters, 2016 to present

Toller Cranston Memorial Fund, Canadian Olympic Foundation, 2016 to present

Posthumous Awards

Children's Art Foundation 5th Anniversary Award
Ice Theatre of New York 30th Anniversary Gala Award, NYC, NY
World Figure Hall of Fame Inductee, Lake Placid, NY
Art Recognition Award, Contemporary Arts Committee, Northern Ontario

2023

Exhibition Galería Intersección Arte Contemporaneo, San Miguel de Allende, Mexico
Exhibition Sub Solo Gallery, Sao Paulo, Brazil

2022

Metamorphosis Photography Exhibition, Truth Gym Gallery, Victoria, BC
Scotiabank CONTACT Photography Festival, Donna Child Fine Art Gallery, Toronto
Donation in Support of Patronato Pro Ninos, San Miguel de Allende, Mx
Donation in Support of San Miguel Literary Sala, San Miguel de Allende, Mx
Donation in support of Arts Programming, Biblioteca Pública San Miguel de Allende, Mx
Podcast #3Turn3 with Pj Kwong and Haig Oundjian. Skate Ontario YouTube: https://youtu.be/NHubhRcsEW8
Canadian Olympic Foundation Toller Award Scholarships Presented

2021

Inauguration of the Toller Collection at Biblioteca Pública, San Miguel de Allende, Mx
Turkey With Toller, Thanksgiving Fundraiser, Biblioteca Pública, San Miguel de Allende, Mx

Launch of Yo Inc. Entrepreneurship Program, San Miguel de Allende, Mx
Podcast, Whistler Rotary Club: *Toller: Life and Times*, Whistler, BC
Canadian Olympic Foundation Toller Award Scholarships Presented

2020

Donation in support of Children's Art Foundation Art Auction, Rosewood Hotel, San Miguel de Allende, Mx
Canadian Olympic Foundation Toller Award Scholarships Presented

2019

Toller Exhibition, Museum of Northern History, Kirkland Lake, ON
Toller Exhibition, Temiskaming Gallery, Temiskaming, ON
Stories from the Notebooks: Life and Times, Temiskaming Gallery, Temiskaming, ON
Toller Exhibition, *Fabulous Florals* Exhibition, Artworld Fine Art Gallery, Toronto, ON
Canadian Olympic Foundation Toller Award Scholarships Presented

2018

Art Recognition Award, Contemporary Arts Committee, Northern Ontario
Toller Exhibition, Prints and Line Drawings, Artworld Fine Art, Toronto, ON
Toller Exhibition, Mario Oliva Gallery, Fabrica la Aurora, San Miguel de Allende, Mx
Canadian Olympic Foundation Toller Award Scholarships Presented

2017

Canadian Olympic Foundation Toller Award Scholarships Presented
Donation in support of Manitoba Figure Skating Association

2016

World Figure Hall of Fame Inductee, Lake Placid, NY
Toller Open House, Arnprior, ON
A Terrifying Obsession Exhibition, Art Evolution Gallery, Calgary, AB
Toller Exhibition, Artworld Fine Art, Toronto, ON

2015

Celebration of Life, Art Gallery of Ontario
Ice Theatre of New York 30th Anniversary Gala Award, NYC, NY
Donation to Ice Theater of New York, 30th Anniversary Gala
Donation to Lindt & Sprüngli (CA) Ltd., 30th Anniversary Gala
Children's Art Foundation Award, San Miguel de Allende, Mx
Art Auction in support of Children's Art Foundation, Rosewood Hotel, San Miguel de Allende, Mx

Citations and Attributions

Toller Quotes

1. Interview with Toller Cranston, *Conversations with Artists in San Miguel de Allende,* Margaret Paul, 2014
2. Interviews with Toller Cranston, pjkwong.com
3. Carleton University Honorary Doctorate Convocation Address, Ottawa, June 8, 2011
4. The Toller Cranston Documentary - Pentimento Gallery, produced for BRAVO Tv, 2006. https://www.youtube.com/watch?v=URKahEXUdsU
5. *Toller,* a film by Pen Densham and John Watson, Insight Productions, Toronto, 1977
6. *Toller Cranston: A Terrifying Obsession,* Art Evolution, Shaw TV, November 2013
 https://www.youtube.com/watch?v=ejTG9IBDFsg
7. *When Hell Freezes Over Shall I Bring My Skates?* with Martha Lowder Kimball, 2000
8. *Zero Tollerance: An Intimate Memoir by the Man Who Revolutionized Figure Skating,* Martha Lowder Kimball, 1997
9. *Toller Cranston A Painter First. A Skater Second. An Artist Always,* Donna Meyer, published in Experience San Miguel
10. *Portrait of a Skater as a Young Artist: Just what does Toller Cranston have to do to prove his genius?* Barbara Sears for Maclean's Magazine, March 1, 1975
11. *Unseen Forces: Introducing the Boys in Toller Cranston's Back Rooms,* Ron Base, Macleans Magazine, July 11, 1977
12. Toller Cranston, legendary figure skater, remembered, Daily Xtra, https://www.youtube.com/watch?v=d7B4d1hz9DI
13. Ryan Stevens, Skate Guard Blog
14. CPAC The Builders of Canada

Photo Credits, Sources, and Attributions

A. Lander Rodriguez
B. Scott Umstattd
C. Cylla Von Tiedemann
D. Keith Walker
E. Jay Koppelman
F. Paul Zizka
G. Boris Spremo
H. Mike Flynn
I. Sam Perez
J. Dr. Sepp Schönmetzler
K. Gary Reid
L. Charles Macnamara
M. Library and Archives Canada
N. Phillippa Baran
O. David Street
P. Dick Loek
Q. Danielle Earl
R. Anne Philpot
S. Christopher and Elaine George
T. Julian Mendl
U. Michael Hoppé
V. Courtesy of Charles Pachter
W. Courtesy of Emma Bulawka
X. Courtesy of Karim Remtulla and Nadim Kara
Y. Courtesy of Natalia Laluq
Z. Unknown
AA. Courtesy of Richard Schultz
BB. Bibliothèque et Archives nationales du Québec
CC. Deutches Bundesarchiv

269

Bibliography: Books, Articles, Film, Video

From books and articles to television programs and YouTube videos, we gratefully acknowledge the use of various sources for Toller's quotes, stories, recollections and citations throughout this book.

Books by Toller Cranston

Toller, Elva Oglanby (Author), Toller Cranston (Illustrator), David Street (Photographer)
Gage Publishing, 1975

The Nutcracker by E.T.A. Hoffmann
Retold by Veronica Tennant. Illustrated by Toller Cranston, McClelland and Stewart, 1985
A Ram on the Rampage, Toller Cranston, Gage Publishing, 1977

Zero Tollerance: An Intimate Memoir by the Man Who Revolutionized Figure Skating, Toller Cranston with Martha Lowder Kimball, McClelland & Stewart, 1997

When Hell Freezes Over: Should I Bring My Skates?
Toller Cranston with Martha Lowder Kimball, McClelland & Stewart, 2000

Ice Cream: Thirty of the Most Interesting Skaters in History
Toller Cranston, McClelland & Stewart, 2002

Miscellaneous Books and Articles

Beyond great, Toller Cranston was revolutionary in men's skating
Deirdre Kelly, The Globe and Mail, January 2015

Conversations with Artists in San Miguel de Allende,
Margaret Paul, 2014

Idol turned friend, Toller Cranston was mesmerizing
Jeanne Beker, The Globe and Mail, January 25, 2015

Legendary Canadian figure skater Toller Cranston dead at 65
Lori Ewing and Neil Davidson, The Canadian Press
January 24, 2015

Portrait of a Skater as a Young Artist: Just what does Toller Cranston have to do to prove his genius? Barbara Sears, Macleans Magazine, March 1, 1975
https://archive.macleans.ca/article/1975/3/1/portrait-of-a-skater-as-a-young-artist

Ryan Stevens, Skate Guard Blog
http://skateguard1.blogspot.ca
http://www.facebook.com/SkateGuard

Toller Cranston A Painter First. A Skater Second. An Artist Always,
By Donna Meyer, date unknown, published in Experience San Miguel

Toller Cranston, Figure Skating Innovator, Dead at 65.
Pj Kwong, CBC
https://www.cbc.ca/sports/olympics/winter/figureskating/toller-cranston-figure-skating-innovator-dead-at-65-1.2930759

Toller Cranston: The *Maclean's* Interview, 2004
Republished by *Maclean's* January 24, 2015
https://www.macleans.ca/news/canada/toller-cranston-the-macleans-interview-2004/

Toller Cranston, *Peacock with a Paintbrush*
Sarah Hampson, Special to The Globe and Mail, March 29, 2003
https://www.theglobeandmail.com/arts/art-and-architecture/from-the-archives-toller-cranston-peacock-with-a-paintbrush/article1012248/

Unseen Forces: Introducing the Boys in Toller Cranston's Back Rooms
Ron Base, Macleans Magazine, July 11, 1977

Film and Video

A Man To Remember (Classic): A should-be world champion on the ice in Moscow.
https://youtu.be/UHBvw8VoP9k

Best on Ice Toller Cranston 1975 Moscow News Ex
https://youtu.be/-AGzo1lrl4M

Carleton University Convocation, Toller Cranston, June 8, 2011
https://youtu.be/nBjuDOKieYU

Casa Toller, San Miguel de Allende, Mexico
Video of the house and property, 2015
https://youtu.be/YcZ6SBWVWUY

CPAC The Builders of Canada
https://www.cpac.ca/en/programs/builders-of-canada/episodes/50060641/
Canadian artist and skating legend Toller Cranston sits down with Tasha Kheiriddin in 2001 to discuss how he revolutionized the sport of figure skating— and how he became just as well known for his paintings.

Ellen Burka
https://youtu.be/GOs7v-_oOl8
Toller Cranston's coach Ellen Burka shares her memories of the start of the relationship she shared with her famous student. For more on this story visit Pj Kwong's blog at www.pjkwong.com for more information and link to the Toller Cranston Memorial Fund page.

Interview on Breakfast TV (Citytv), November 21, 2013
https://youtu.be/R8DdCMpCQm4

I Am a Hotel with Leonard Cohen, 1983
https://www.facebook.com/watch/?v=485156438759630

Ice Theater of New York: 2015 Benefit Gala - Toller Cranston
Video tribute honoring Toller Cranston.
https://www.youtube.com/watch?v=egw2VcPpqS8s

Joni Mitchell used a film background featuring Toller, during the song
Black Crow. The song featuring Toller runs from 42:45–50:03
https://www.youtube.com/watch?v=bLKb9Ms68ME&t=3633s

Raising the Maple Leaf Flag, Ottawa, 1965
https://youtu.be/L6NGnVgI75o

Skate Canada
https://skatecanada.ca/2015/03/therezwill-only-ever-be-one-toller/

Sky Gilbert Does Toller Cranston
Closet Case - Episode Sixteen
The Buzz, Raymond Helkio
https://www.youtube.com/watch?v=tcczXP_ug1g

Starry Starry Night, Stars on Ice, 1981
1981-82 SOI Toller Cranston Starry Starry Night.wmv

Strawberry Ice, 1982
https://www.youtube.com/watch?time_
continue=51&v=fpbnfL0CKdM

Should Toller Cranston's Figure Skating be considered a visual art?
https://fredericks-artworks.blogspot.com/2009/12/should-toller-
cranstons-figure-skating.html?m=0

Toller Cranston, Canadian figure skater dies at 65
CBC News: The National, January 26, 2015
https://youtu.be/d5ykrP08kjc

Toller, Children's Art Foundation
https://www.youtube.com/watch?v=ZYvCZZ1joc8s

Toller Cranston Documentary, Pentimento Gallery, 2007
Produced for BRAVO Tv in June of 2006 and aired in 2007. It is about
the life and artwork of Toller Cranston.
https://www.youtube.com/watch?v=URKahEXUdsU

Toller Cranston - Figure Skater, Painter, CAF Supporter - 1949-2015,
Dieter Storr
https://www.youtube.com/watch?v=yPWSwVI8vfw&feature=youtu.
be

Toller Cranston, *Firebird* 1982
https://www.youtube.com/watch?v=Yc0gCtyw_Gc

Toller Cranston, legendary figure skater, remembered
Daily Xtra. https://www.youtube.com/watch?v=d7B4d1hz9DI

Toller Cranston: Live Presentation, A Terrifying Obsession Exhibition
Chris Talbot, Art Evolution, 2013
https://youtu.be/6DE_McZd93A

Toller Cranston, Minto Follies

Toller Cranston Minto Follies.wmv

Toller Cranston Tribute Video, Ice Theater of New York, (ITNY),
2015
https://youtu.be/egw2VcPpqS8
https://youtu.be/giCKH7QYvuAs

Totally Toller!
A tribute to the original king of skating Toller Cranston. Made by
Floskate
https://www.youtube.com/watch?v=GB5K6AdC5LA

Totally Toller Pro: The Artist
https://www.youtube.com/watch?v=18WUjL7Sf5s
Made by Floskate

Toller Cranston The Art of Being, Bravo TV

Toller Cranston 1976 World Figure Skating Championships.
https://www.facebook.com/100000910505398/
posts/4964906723549629/

Toller Cranston 1975 World Championships Documentary
A Film by Pen Densham, 1977
https://youtu.be/DZxjQ3NQjw4
A rare documentary on Toller which charts his progress through the
1975 World Championships while taking a peek behind the scenes of
his skating. Very interesting stuff with some gorgeous old footage of
the 1975 World Championships. Includes interviews with his coach
Ellen Burka

Toller, In Memory, Waddingtons, Duncan McLean
27/01/15 https://www.waddingtons.ca/in-memory-of-toller-
cranston/

Toller Cranston, 1980-1981 World Professional Landover Artistic
program, La Rondine
https://youtu.be/otH4Ed1IjUQ

Toller Cranston - 1976 Olympic Winter Games, Short Program
https://www.youtube.com/watch?v=xD5VNcWh79Q

Toller Cranston, 1974 World Championships Short Program and Long
Program
https://youtu.be/y7AZboQ0R08

Toller Cranston, 1973 World Figure Skating Championships
Exhibition
https://youtu.be/gvP0m7AOC3w

Toller Cranston, 1971 Canadian National figure Skating
Championships, Long Program
https://youtu.be/jC7fizOwrDI

What Makes San Miguel So Special?
https://www.youtube.com/watch?v=JyLmeld6oYs&t=15s

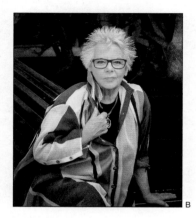

Phillippa Cranston Baran holds a BA from Queens University and an MA in Film from UCLA. She is an award-winning writer/producer, former university film professor and, for several years, a dairy goat farmer. These journeys each have their own colourful and outrageous stories but the combination of success, setback, and craziness helped equip her to write about her very famous brother. She is also a sister who was there from the beginning and quite literally bears the scars—a faded gash on her left thigh attests to the time when her younger brother kicked her with his skates when she refused to twirl him.

In the process of writing this book, she had to deal with corruption, extortion, and threats by gun-toting thugs. Like her famous brother, she is not a quitter. The author acknowledges that she could never have written this book if her brother were still alive. He would have demanded an utterly impossible work ethic and more flexibility with the truth than even she could accept. She is understanding of his quirks, fiercely proud of his talent, and committed to sharing his story.

The author welcomes every opportunity to speak about her brother in-person or via Zoom events. You can connect with her at phillippacranstonbaran.com

Toller Cranston. The Paintings
A Terrifying Obsession

Toller Cranston was a fearless, creative force —authentic in everything he said and did. He was an artist and an athlete who once observed that "Leonardo Da Vinci, as brilliant as he was, could not execute a double axel." For Toller, painting and figure skating were inseparable artistic expressions—*a terrifying obsession*. He was a six-time Canadian champion and two-time Olympian who introduced theatricality and artistic expression to his sport and changed it forever. His artwork was just as distinctive. You know a Toller Cranston the moment you look at it. You can recognize a Toller Cranston painting if you drive past it at 100 miles an hour, just as you might a Picasso, or a Warhol. He created more than 20,000 original paintings and participated in more than 300 exhibitions around the world. xToller Cranston died in 2015 in Mexico. His headstone in San Miguel de Allende reads *Toller, Artist, 1949-2015*.

The book contains images of more than 400 paintings as well as quotes from the artist about life, death, skating, and art.

Toller Cranston: Casa Toller, The Property in Mexico

In 1992, Toller Cranston, artist, figure skater, two-time Olympian, and larger-than-life personality acquired a rambling estate property in the World Heritage Spanish Colonial city of San Miguel de Allende, Mexico. Over the next twenty-three years, he created an extraordinarily magical, utterly dazzling property that was designed to surprise, enchant, and delight. It was indescribable by design. Nothing was random or scattered. And for Toller, too much was never enough.

The property was not just his home. It was a studio, a gallery, a classroom, a showplace. Through stunning photographs and never-before told stories from Toller's Mexican staff, the book reveals the full dimension of Toller Cranston's creativity when he was given a canvas that extended from one ancient cobblestone street to the next.

The End